DISCOVERING THE GREAT MASTERS

"Rosemary is for remembrance."

*The Art Lover's Guide
to Understanding
Symbols in Paintings*

PAUL CRENSHAW

WITH REBECCA TUCKER &

ALEXANDRA BONFANTE-WARREN

UNIVERSE

(PAGE 1, 3 AND 5)
EUSTACHE LE SUEUR.
Fortitude Brings Peace and Plenty
(DETAIL).

DISCOVERING THE GREAT MASTERS

The Art Lover's Guide to Understanding Symbols in Paintings

Published by Universe Publishing
A Division of Rizzoli International Publications, Inc.
300 Park Avenue South
New York, NY 10010
www.rizzoliusa.com

© 2009 Universe Publishing

PROJECT DIRECTOR:	Ellin Yassky
BOOK DESIGNER:	Kevin Osborn, Research & Design, Ltd., Arlington, Virginia
COPY EDITOR:	Deborah T. Zindell

PHOTOGRAPHY CREDITS

Alinari/Art Resource, NY: pp. 56, 59

Art Resource, NY: pp. 8 (bottom), 14 (middle)

Bildarchiv Preussischer Kulturbesitz/Art Resource, NY: pp. 130, 133, 134–135, 228, 231, 232–233

Giraudon/Art Resource, NY: pp. 304, 307

HIP/Art Resource, NY: p. 15 (bottom)

Erich Lessing/Art Resource, NY: front cover, title page, opposite, pp. 8 (top), 9 (top), 9 (bottom left), 10 (top and bottom), 11 (top and bottom), 15 (top), 16, 24, 27, 28, 31, 38, 41, 42, 45, 52, 55, 80, 83, 84, 87, 88, 91, 92–93, 94, 97, 98, 101, 108, 111, 116, 120–121, 122, 125, 126, 129, 136, 139, 140, 143, 144, 147, 148–149, 154, 157, 164, 167, 168, 171, 178, 181, 186, 189, 190–191, 192, 195, 210, 213, 220, 223, 238, 241, 248, 251, 252, 255, 256, 259, 260–261, 262, 265, 266, 269, 270, 273, 274–275, 280, 283, 284, 287, 294, 297, 298, 301, 302–303, back cover

Foto Marburg/Art Resource, NY: p. 11 (middle)

The Metropolitan Museum of Art/Art Resource, NY: p. 14 (top)

National Gallery, London/Art Resource, NY: p. 14 (bottom)

The Philadelphia Museum of Art/Art Resource, NY: p. 13 (top)

Réunion des Musées Nationaux/Art Resource, NY: pp. 13 (bottom), 182, 185, 224, 227, 234, 237

Scala/Art Resource, NY: pp. 9 (middle and bottom right), 12 (top and bottom), 15 (middle), 18, 21, 32, 35, 36–37, 46, 49, 50–51, 60, 63, 64–65, 66, 69, 70, 73, 103, 105, 106–107, 112, 115, 116, 119, 120–121, 144, 150, 153, 158, 161, 172, 175, 196, 199, 200, 203, 204–205, 206, 209, 214, 217, 218–219, 242, 245, 246–247, 276, 279, 290, 293

For René Magritte image:
© 2009 C. Herscovici, London / Artists Rights Society (ARS), New York

2009 2010 2011 2012 / 10 9 8 7 6 5 4 3 2 1

PRINTED IN CHINA

ISBN-13: 978-07893-1891-6

Library of Congress Catalog Control Number: 2009901015

CONTENTS

DISCOVERING THE GREAT MASTERS

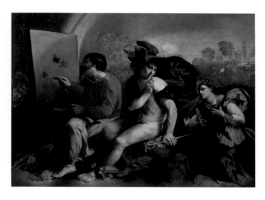

Dosso Dossi (ca. 1479–1542).
Zeus, Hermes, and Virtue.
Kunsthistorisches Museum, Vienna.

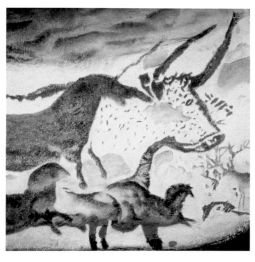

Hall of the Bulls, Lascaux, Perigord, France (ca. 15000 B.C.E.) (detail).

A Few Words About Images

"Shhh …," Hermes commands Virtue with a simple gesture of finger to lip in Dosso Dossi's *Zeus, Hermes, and Virtue.* The painter is not to be disturbed. Robust and athletic, fleet of foot with winged ankles and a *petasus,* his winged cap, Hermes was far more than just a messenger of the gods. He was two-faced, god of boundaries yet erotic transgressor, cunning thief but protector of merchants, divine trickster while font of ancient astrological and philosophical truth, escort of Psyche to Mount Olympus and psychopomp leading souls to the underworld. Inventor of fire and lyre, Hermes Trismegistus, thrice-great, he was also called. Mercurial by his own nature, yet he would command another to stop, be quiet, and allay all anxiety?

Virtue, a child of nature in verdant dress, adorned with floral wreath and bracelets, seeks an audience with Zeus to beseech him and the other gods to cease their idle pleasures and intervene favorably in the world's affairs. Does Hermes deny Virtue a meeting with the Lord of Olympus, or does his gesture convey a wisdom of its own? "Come forth quietly and observe," he might be saying. Recognize that Zeus has laid aside his destructive thunderbolts and taken up palette, brush, and mahlstick. An ancient writer once praised the painter Apelles for depicting things that could not be painted, such as lightning, and his image of Zeus with his thunderbolts that seemed to come out of the picture gained eternal fame. Yet Zeus turns out to be a more remarkable inventor than any mortal artist. He eschews his usual activity, a deceptive metamorphosis to escape his wife's notice while engaging in an interlude with another goddess or ensnaring a human in the conquest of mortal flesh. "Look closer," Hermes might implore, and see that his father, King of the Heavens, creates butterflies, souls resurrected from their grubby earthbound existence as caterpillars to become color and beauty, buoyant flight, grace itself. Painting is no empty pursuit, but a secret pleasure of the soul. A painting is like a poem, descriptive, evocative, and nuanced, lifting the spirit to moral understanding, but it is mute, without voice, needing no words.

The makers of the first paintings known to the world are no longer able to tell us their stories themselves, and little residue of their culture remains intact. We marvel at the charm of cave paintings made tens of thousands of years ago, and yet if we look to them for clues to some eternal aspect of humanity, we are likely to come away disappointed. The disenchantment stems not merely from our inability to fully decode the imagery and the intentions of the artists, but also from the recognition that we need to know more about their culture to understand their art, and therefore it is less universal than we might have hoped.

In places like Lascaux, the transformation of natural spaces by the hand and ingenuity of man is no less astonishing than Michelangelo's Sistine Chapel. The paintings in Lascaux's so-called Hall of Bulls, for example, cover the walls and ceiling of the cave in a grand diorama. Some figures, like the detail shown here with a bison's head and several other animals, are larger than six feet tall and stretch even longer in the body, and were painted higher than a person's reach can extend. Altogether, Lascaux contains more than 600 paintings and another 1,500 images engraved into the rock. Discovered by accident in 1940, the decorated portions of these caves were remote from the living quarters, pointing to their use in rituals and particular ceremonies rather than decoration. To make these images, artists worked by the flickering light of stone lamps containing animal fat, which

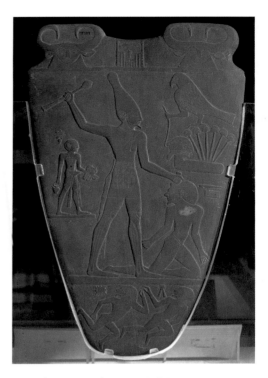

burns longer than oil but dimmer than candles. Many of these lamps have been found in the caves. There is little sense of narrative here, just an accretion of images, one over another, in black and red, large and small, singular and in herd. Remarkably, contrary to the earlier interpretations of these animals ritually representing the hunt, it turns out they have little to do with the actual diet of the cave dwellers, and instead display the animals in a highly naturalistic fashion, including many of their mating rituals of the wild. They would seem, then, to be less self-centered survival invocations than we at first thought, although they may have played a role in magical and social initiation rites.

Written language and pictures have been intimately bound since the dawn of civilization. In Egypt and Mesopotamia, writing systems grew from pictorial conventions, in the form of hieroglyphs and cuneiform script, respectively. Art and words together invoked authority. One of the earliest objects from ancient Egypt to combine hieroglyphs with the imagery of power is the stone relief tablet called the Palette of Narmer. It shows a king (only in later times did Egyptian leaders adopt the title pharaoh) named Narmer conquering his foes. He is rendered large and erect in the center, emphasizing his strength in contrast to his wriggly enemy. Narmer wears the crown of the kingdom of Upper Egypt. The hieroglyph in the upper right shows the falcon god Horus, sacred to Narmer, astride a figure with the head of a man, similar in facial type to the enemy below, and the body of a papyrus plant. The enemy is thus identified as a citizen of the land where the papyrus grows, or the Delta region of Lower Egypt, and we can decipher the image with some clarity. We know that around this time, roughly 5,000 years ago, such a unification of the lands of the Nile River Valley did occur, but we are left to guess whether this artifact represents a historical accomplishment attributable to this one individual, or merely the designs, ambitions, or spurious claims of its patron. In this case, even though we can figure it out for the most part, the image makes its own reality, and we lack the information to definitively confirm or deny its terms.

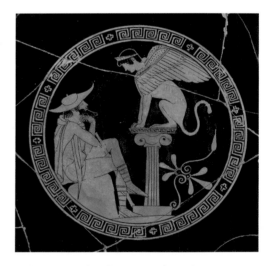

Egypt (1st Dynasty), ca. 3000 B.C.E. *Palette of King Narmer.* Egyptian Museum, Cairo.

When we encounter a picture that catches our attention but doesn't seem to make sense, it can be an uncomfortable experience, particularly if the image falls within our cultural purview or personal experience but does not coalesce into a recognizable pattern or fit into an expected niche. We sometimes feel the need to consult a higher power, or at least someone with greater expertise, to reveal some tangible truth. However, like Oedipus consulting the sphinx, inquiry usually begets a riddle, and even if we figure it out our rewards may be tinged with peril.

Oedipus discerned the answer to the sphinx's question, that a man crawls on four legs in the morning as a baby, on two legs in the afternoon as a youth, and three legs in the evening when elderly and assisted by a cane. His keen wits were rewarded with marriage to the widowed queen of Thebes, but his initial good fortune was inevitably doomed. When the town was besieged by ill times, he vowed to find the murderer of the former king, not knowing that he himself had committed the act and that he had unwittingly married his mother, whom he had not known since he was abandoned as a child. The Greek painter of a kylix, or drinking vessel, made in the fifth century B.C.E. cleverly showed Oedipus seated in a gesture of thoughtful repose, his chin resting on his hand and his legs crossed, but dangling his foot represented more than a mere comfort. The first syllabus of Oedipus's name meant "I know," while the whole of his name meant "swollen foot." His father had pierced his ankles and condemned him at birth after receiving a prophesy from the Oracle at Delphi that he would be killed by his son. Ironically, Oedipus did not know the cause of his foot injury, or his real parents. In other words, he did not know his own name, and he did not recognize that, being lame at birth and having difficulty learning to walk, the sphinx's riddle applied to him most of all.

Oedipus Visiting the Sphinx. Greek (Attic), 5th century B.C.E. Museo Gregoriano Etrusco, Vatican Museum, Vatican State.

Beginning about 700 years ago, artists of the Renaissance consciously looked back to these ancient cultures, and to particular artistic prototypes, in order to revive some of the glories of times past and to reach higher in their own age. They borrowed ideals, motifs, and poses, and mixed them with their own, largely Christian-centered, sensibilities to create a new era of celebrated masterpieces. Paintings like Dossi's *Zeus, Hermes, and Virtue* and Botticelli's *Birth of Venus* (*see also* page 88) exemplify this trend. The *Venus pudica*, or modest Venus, was an ancient Roman type of statue popularized by a famous invention of the Greek sculptor Praxiteles in his *Aphrodite* of the island of Knidos. Venus draws attention to her physical charms by gently concealing—not very successfully—the most desired parts

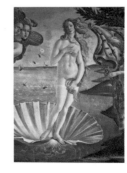

Sandro Botticelli (1444/45–1510). *The Birth of Venus (detail).* Ca. 1484. Uffizi Gallery, Florence.

Venus pudica. 1st century, B.C.E. Roman. Museo Nazionale Romano, Rome.

of her body. Botticelli appropriated the posture and position of the hands of the ancient statue, and he quite clearly understood its appeal. He was not content to produce a mere copy, however. He expanded on the existing canonical example by referring also to a lost painting by Apelles, the famous Greek painter mentioned earlier, showing Venus emerging from the sea and wringing out her hair. Apelles was said to possess a quality of grace in his work that none could match, but Botticelli enhanced the *Venus pudica* model with his own sensuous attention to her long, flowing hair and the accentuated silhouette of her limbs and hips. He further added other divinities of the winds and seasons to create a gentle breeze and to playfully mock her nudity. The result was one of the most delightful paintings of all time.

THE ENIGMATIC ARTIST AND SECRETS OF THE STUDIO

This book looks not only at what is represented in the paintings, but also peers into the artists' lives and times, to see them at work in the studio. The curtain pulled aside in the foreground of Vermeer's *Art of Painting* (*see also* page 284) alludes to an ancient contest of illusionistic skill. The Greek painter Zeuxis had portrayed a bunch of grapes so lifelike that birds descended to peck at them, but he was outdone when he subsequently called upon his rival Parhassios to reveal his painting behind the curtain, not realizing that the curtain itself was actually painted. Vermeer's drape is also a device of revelation, serving as an entrée into the secret sanctum of the artist. What goes on in the artist's chamber has often been mysterious to patrons and the public. In reality most artists did not lead the solitary existence that much of the lore, literature, and films would have us believe. Models, assistants, students, family members, colleagues, and clients would have been constantly present.

The interaction between artist and model, particularly, has been an intriguing subject in art for centuries. Vermeer's picture and Joos van Winghe's *Apelles Paints Campaspe* (*see also* page 210) demonstrate two variations on the theme of the male artist gazing upon a female model. Vermeer hides the face of the artist, not allowing us to see his passions and leaving us to fill in the blanks of his features and character. This image has affected both the scholarly and the popular interpretation of Vermeer's personality. In the novel *Girl with a Pearl Earring* by Tracy Chevalier, and its film adaptation, for example, Vermeer was portrayed as calculating, morose, and inhibited as he fell in love with his maid while she modeled for him. Van Winghe, on the other hand, gives us an artist who wears his emotions on the sleeve of his outstretched arm. The names of most artists' models have proved ephemeral, even as their physical features endure. Some were undoubtedly hired hands, chosen for an aspect of beauty or vulgarity that allowed them to be typecast into a prefabricated storyline. Other models must have been family members, students, or neighbors, captured because they came cheaply and spontaneously. Such interactions were thematized in literature and myth, as in the ancient story of Pygmalion falling in love with his own statue or this episode of Apelles, who became enraptured by the concubine of the Emperor Alexander the Great. The fact that models sometimes disrobed in the studio provided another level of fascination, and the potential for scandal increased when academies of art started employing them to pose before groups of young, almost exclusively male, students. Artists took advantage of the unusual aspects of their lifestyles and workplace to create a certain aura about themselves and their work.

Producing a painting was nothing short of an alchemical exercise. Starting with nothing but an idea and a talented hand, a transmutation occurred within the artist's realm. It was as if base materials were changed into gold. Three support surfaces were typical: frescoed walls, where the pigments chemically bonded with the plaster as it dried, or wooden panels or canvas. Some highly collectible paintings were made on unusual supports, like copper or even stone such as slate. Wood panels were coated with gesso, a blend of gypsum, plaster, water, and animal glue, and sanded to a polish. Canvasses were woven linen treated with rabbit skin glue to keep the oils from seeping through and causing deterioration of the fabric. They were strung with cords pulled taught in a wooden framework called a stretcher. Pigments were formed from all kinds of natural materials, and sometimes the most unexpected combinations. White paints were made from lead carbonate exposed to vinegar in the open air, then scraped and melted at various temperatures. The dust and the paint itself were poisonous if inhaled or ingested. Also toxic were vermillion, a green made from

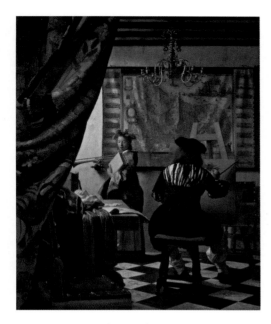

JOHANNES VERMEER (1632–1675).
The Art of Painting. 1665.
KUNSTHISTORISCHES MUSEUM, VIENNA.

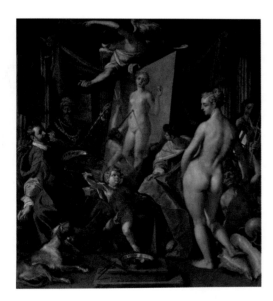

JOOS VAN WINGHE (1544–1603).
Apelles Paints Campaspe. CA. 1600.
KUNSTHISTORISCHES MUSEUM, VIENNA.

mercury-laced cinnabar, and orpiment, a yellow made with arsenic. Expenses varied, too. Blacks could be made cheaply from wood charcoal or expensively from burned ivory (called bone black). Blue likewise could be made in several ways. It was produced economically by crushing smalt, a glass containing cobalt, as long as it wasn't ground too finely. At medium expense was azurite, found in mines of copper and silver, but it worked better in tempera, where egg yolk was the binding medium, rather than suspended in oils, which turn it dark and muddy. The most expensive of all Old Masters pigments by far was ultramarine blue, manufactured from precious lapis lazuli imported from the Middle East. The labor expenses added further to the cost of the finished pigment. The stone had to be crushed and the brilliant blue powder separated from the veins of quartz and golden flecks of pyrite in a protracted process of water dissolution. Exotic new pigments were introduced over the course of time. Indian yellow, imported from the Far East, was produced from the urine of cows fed only mango leaves. New kinds of scarlet red and violet were produced from the dried bodies of a female insect that clung to cactus plants found only in the Americas. Expert painters thus had to be curious about the world in many respects, and many were amateur botanists, geologists, and chemists.

Artists also had to learn history, mathematics, and philosophy. Stories of the past came alive only when artists understood well the narrative action, the characters, and the passions that drove them. Painters had to visualize these events in fictive space, using a storehouse of pictorial devices to render color, light and shadow, volume and form on a two-dimensional surface with the illusion of three dimensions. Distant backgrounds could be articulated by mimicking observed phenomena, the bluish haze of the atmosphere or diminution of scale as objects receded in space, as seen in the view through the window of Joos van Cleve's *Madonna and Child* (*see also* page 164). Painters in Italy in the early fifteenth century learned to render space in a methodical way, by using a system of linear perspective, plotting receding floor plans in relation to horizon lines and the vantage point of the viewer. The finer points of such skills and techniques were closely guarded workshop secrets, but invariably once the skills were put on display in finished products for all the public to admire, they were quickly imitated.

Albrecht Dürer's 1504 *Adam and Eve* demonstrates how artists stood at the intersection of so many other intellectual and manual endeavors in the Renaissance. His engraving is first of all a virtuoso performance in representing light, volume, and a multitude of textures with fine linear details. It is also a manifesto, of sorts, on idealized proportions of the human body, appropriate to the first beings.

The notion of an ideal canon of proportions had been inherited from ancient Greece and Rome, passed along through the ages in written tales and preserved physically in the battered remains of sculpture that were readily dug from the ground in crude archaeological treasure hunts. Dürer's Adam was based in part on an ancient statue that was found in Germany in 1502 (the original has been lost, but is known from a bronze cast made later in the sixteenth century), while his Eve is a reconfigured *Venus pudica*. Dürer was influenced by Italian culture and its respect for ancient forms, but his visualization of paradise was the thick forest primeval of his German homeland. Numerous animals inhabit this land, but the choices were not random. These particular creatures symbolized the four humors, or temperaments, characteristic of the four bodily fluids and indirectly related to the four basic elements of the earth and the seasons, that were essential to the understanding of physiology and medicine at the time. The lethargic ox embodied the influence of phlegm carried in the lungs—the phlegmatic humor—that resulted in laziness and gluttony. The rabbit was active and fertile, representing the sanguine humor of blood, prompting lust and lechery. The cat was quick-tempered and therefore choleric, generated by yellow bile and bringing forth the vices of pride and wrath. The elk was considered a solitary creature, and thus fitting for the melancholic humor that resulted from the other secretion of the liver, black gall or bile, and brought despair and avarice.

Many illnesses were ascribed to an imbalance in the humors, too much of one kind or another, an outlook that gave rise to barbaric "cures" like bloodletting. From preparatory drawings that have survived we know that Dürer belabored the issue of Adam's complicity in the Fall. Before the

Joos van Cleve (1485/90–1540/41). *Madonna and Child* (detail). Ca. 1525. Kunsthistorisches Museum, Vienna.

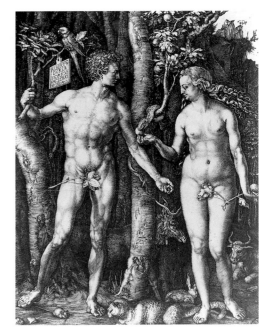

Albrecht Dürer. (1472–1528). *Adam and Eve.* 1504.

Youth of Magdalensberg, Austria. German (16th-century copy after a lost ancient Roman original). Kunsthistorisches Museum, Vienna.

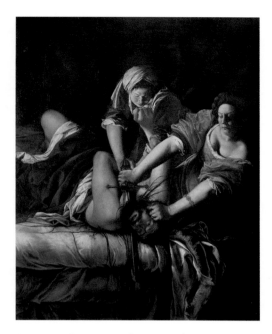

ARTEMESIA GENTILESCHI (1597–CA. 1653).
Judith and Holofernes.
UFFIZI GALLERY, FLORENCE.

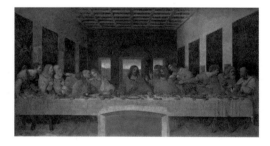

LEONARDO DA VINCI (1452–1519).
The Last Supper. 1498.
SANTA MARIA DELLE GRAZIE, MILAN.

dreadful sin and expulsion, in Paradise everything was in perfect balance and harmony: the cat does not pounce on the mouse, for example. However, the fig leaves of shame have already sprouted, and when Adam and Eve accepted the forbidden fruit from the serpent, portrayed with a peacock's crown to allude to pride, the deadliest sin, they unleashed the noxious fluids in the body and brought sickness into the world.

Knowing the biographies of artists can enrich our understanding of their work in ways that go beyond the symbols and narratives of the images. When Artemesia Gentileschi decided to paint the subject of Judith and Holofernes it was not an original choice for a subject. Many artists gravitated to the story before and since, offering as it did an opportunity to portray both beauty and violence, with qualities of valiant effort and heroic virtue. Judith had rescued her people from the onslaught of the armies of Holofernes, general to Abuchadnezzar, by beguiling him, getting him drunk, and then slaying him. But Artemesia disdained the typical sexualization of Judith's features—she did not sacrifice her virtue, the text makes clear—in favor of demonstrating the protagonist's strength, both her physical might and her intense conviction. Artemesia realized that if such a scene were to be realistic, Judith might need the help of her maidservant Abra, not just standing by but forcefully restraining the powerful general's violent convulsion. The painting would be a masterly achievement if the story ended there, but it does not. Artemesia herself had suffered a personal tragedy only a few years earlier as a teenager, having been raped by her father's colleague. Did she turn to this subject as a vengeful retort, a pictorial payback, or for her own psychological healing? Did her friends and patrons appreciate the mordant irony? We'll never know for certain what her exact motivations were, but we can definitely say that she persevered and went on to more success than any other woman painter of her era. Artemesia forged a niche market, of sorts, for subjects of famous heroines. Artemisia's manner of representing stories like Judith and Holofernes differed from versions by her contemporary male artists in ways that must have been inspired by her gender and by her personal circumstances.

The "aura" of famous artists and their work has not been diminished by modern mass reproduction and circulation. Leonardo da Vinci, painter and draftsman, designer and inventor, the prototypical Renaissance Man who was expert in many fields, is more famous than ever thanks to fiction like Dan Brown's *The Da Vinci Code.* Paintings in the Renaissance, as we will explore, were not meant to be secret codes per se, but they were sometimes meant to be difficult to figure out, or esoteric, or encompass an exclusive body of theological or philosophical knowledge. Their meanings, though, were not hidden, but were there on the surface all along. Leonardo's *Last Supper* (*see also* page 102) was not arranged as an encoded letter but like a shock wave. Leonardo studied explosions and movements of air and water as an engineer and weapons designer. His studies of natural phenomena are reflected in his composition of the apostles' collective and individual responses to Christ's revelation that one of them would betray him. Some of his male figures might appear feminine to our eyes today, but they were meant to express a sense of grace by their delicacy and fluid movements. Our attention to the manual skills and ingenuity that brought these artists praise initially and everlastingly has only increased, along with our visual acuity. We are more than ever accustomed to fleeting and flashing visual signs, conveyed by advertisements, film, and television, and now the Internet. In that inundation we have much in common with the citizens of early modern Europe, who saw a flood of art invade every corner of church and home, office and public square: altarpiece panels painted in glistening oil-based pigments and bonded into wet plaster walls and ceilings; sculpture adorning architecture and presented on its own in the round, cut from enormous blocks of quarried marble or cast in bronze from wax and terra cotta molds; ceramics, glass, metalwork, and furniture decorated profusely with imagery; a glut of reproducible media such as woodcuts, engravings, and etched images with the advent of the printing press. Moreover, all of these fresh channels engaged innovative systems of representing light and shadow, textures, volumes, and spatial illusions. Artists elevated their social standing by convincing humanists and courtiers that their profession entailed more than mere craft, that it was an intellectual pursuit on par with the liberal arts, a means of delight for the senses, stimulation of the mind, and nourishment of the soul.

The Conceits and Deceits of Symbols

Creating convincing illusions was a requisite skill for artists from the Renaissance forward, but mimicking nature alone was rarely satisfactory. No matter how plausibly realistic their work may seem, it was always a construction, observations made alongside a sequence of decisions about subject, composition, and style. By employing symbols, allegories, and other means of association and allusion, artists were able to expand the intellectual appeal of their work. Symbols in the visual arts are representations of characters, colors, objects, or figures that are meant to communicate an idea or concept that may have no physical component. After all, one can hardly depict something that cannot be seen, so a substitution was necessary if the art was to maintain its representational character. The usefulness and effectiveness of such signs depends both on the facility of the creator and the understanding of the viewer. By their very nature, symbols are more than, or at least other than, what they appear to be. They may be evocative and expansive, providing rich layers of exegesis to an otherwise innocuous image, or they may deceive by insidious means to hide true intent under a veil of enigma or overarching illusionism.

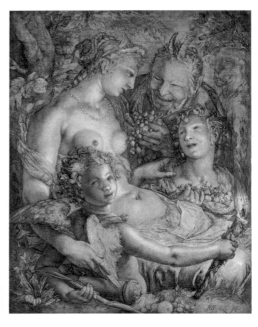

HENDRICK GOLTZIUS (1558–1617).
Sine Cerere et Libero friget Venus (Without Ceres and Liber, Venus Grows Cold).
THE PHILADELPHIA MUSEUM OF ART.

Many symbols seem perfectly appropriate to a singular connection, to mean one particular thing, but in fact they are always dependent on the accompanying setting, attributes, or subject. In other words, the same symbolic item may have very different meanings, based on the context of the representation. The format of this book, with its interleaved pages and cutout windows, offers an active and engaging viewing experience, but it also divorces details from the whole, albeit momentarily. In and of themselves, those details are actually meaningless, like individual pieces of a puzzle. Only together does the picture make sense.

Grapes form a prime example, as they could be symbols of virtue or vice. The subject of Hendrick Goltzius's elegant penwork on blue prepared paper and heightened in gouache and touches of red derives from the ancient dictum told by Terence and Horace, "*Sine Cerere et Libero friget Venus*" ("Without Ceres [the goddess of grain] and Liber [god of wine, equivalent to Dionysius or Bacchus], Venus grows cold"). The saying was explained in various editions of Erasmus's *Adagia* in the sixteenth century: food and drink, offered by Ceres and Bacchus, nourish desire, embodied by Venus. The grape stands for wine, which in turn "liberates" the baser instincts of humanity. While the gist may be universally known to young lovers, recognizing the textual tradition and larger world of ancient personifications indicated a keen intellect in the Renaissance and Baroque periods. An experienced and knowledgeable art lover would have recognized that Goltzius furthered the conceit by showing Cupid holding his bow behind his back, and turning to the viewer as if asking whether he should warm Venus's heart with his torch.

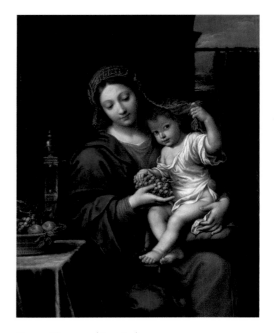

PIERRE MIGNARD (1612–1695).
Virgin of the Grapes.
THE LOUVRE, PARIS.

Quite different are the grapes in Pierre Mignard's *Virgin of the Grapes*. More than just a tasty treat that Mary offers to her toddler, the grapes symbolized the future events of Christ's Passion. The transubstantiation of the bread and wine into the body and blood of Christ is a central component of the Catholic mass, so the grapes would have been easily recognizable in their intent to viewers of the seventeenth century. The symbol is hardly veiled, even though Mignard seems to suggest there is something to be revealed by the gentle gesture of the child playing with his mother's head covering and by the curtain that partially hides the landscape behind them. This same concept was employed by Jan de Heem in a beautiful but fairly straightforward manner in his *Eucharist in Fruit Wreath* (*see also* page 248), and by Hugo van Goes in the *Portinari Altarpiece*, with a much more complex array of plant symbolism, as seen on page 60. Mignard clearly did not desire a riddle, but preferred a sweet and charming human interplay.

By the late nineteenth century, artists like Mary Cassatt in her *Mother and Child* largely eschewed overt symbolism, adopting a secular approach rather than a Christian identification for their characters. The nudity of Cassatt's child is not about the *Corpus Christi*, the sacrificed body of the savior on display, nor is the fruit on the table symbolic of his redemption of the original sin of Adam and Eve. They are just daily activities, taking a nap and having a snack, caring for a child, eternal in a sense but in this scene a slice of modern life. Cassatt's decision to include these types of details, along with her focus on the human tenderness of the embrace and interaction between

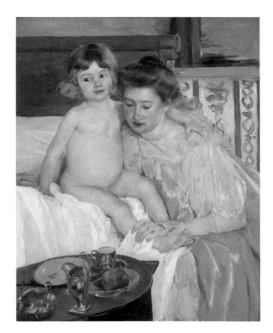

MARY CASSATT (1844–1926).
Mother and Child (Awaking from Nap). CA. 1899.
THE METROPOLITAN MUSEUM OF ART,
NEW YORK.

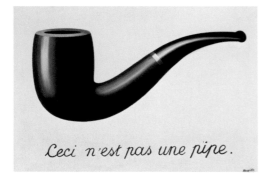

RENÉ MAGRITTE (1898–1967).
The Treachery of Images (This Is Not a Pipe). 1929.
LOS ANGELES COUNTY MUSEUM OF ART.

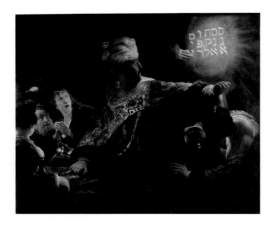

REMBRANDT VAN RIJN (1606–1669).
Belshazzar's Feast. 1635.
NATIONAL GALLERY, LONDON.

mother and child, offered a fresh incarnation of aspects that had already been ingredients in the religious precedents. Her objects may not be symbols, per se, but they are richer by the association with, or variance from, a long-standing tradition.

The Renaissance heritage of interpreting visual symbols formed a foundation for the ideas of Sigmund Freud and the advent of modern psychoanalysis of dreams and childhood recollections. Much of modern science and philosophy was based on seemingly universal understandings of basic human character, but even Freud acknowledged that such symbols could be easily misinterpreted. "Sometimes a pipe is just a pipe," he said. The Surrealist artist René Magritte treated this idea in his painting *The Treachery of Images (This Is Not a Pipe)*. Magritte reminds us that images taken for granted are in fact merely constructions. He makes us painfully aware of that by painting in a style that was purposely schematic in its hard outlines, coarse shadows, and lack of context or atmospheric effects. The meanings attached to representational images are thus fraught with ambiguity at best, and deceit, at worst.

MYSTIFYING AND CLASSIFYING

Religious strife in the Renaissance and subsequent eras brought devastating warfare and drastic social changes, and pictures played a central role in disputing dogma and confirming convictions. Disagreements among Protestants and Catholics centered not only on theological issues of the sacraments and salvation or hierarchical structures of the Church, but also on the manner of presenting ideas to the public. Images were charged with power, an instrument for the influential, a source of pride for the populace, and a passion for a new breed of patron, the collector.

Many Protestant regions whitewashed all earlier decorations in churches and stripped them of all potentially idolatrous altarpieces. Artists turned to safer, more secularized, categories of production like still life and landscape, or modern subjects of everyday life, yet still these were often saturated with symbols and metaphors that stressed morality and virtue. Many Protestant artists like Rembrandt turned to subjects in the Hebrew Bible for powerful themes of virtue and precedents for direct connections to divine interaction. In his version of the Feast of Belshazzar the Dutch artist turned to Jewish scholars, probably the Amsterdam rabbi Menasseh ben Israel, to help him explain why the prophet Daniel was able to read the script that mysteriously appeared on the wall while others could not. Ben Israel suggested it was written not in the typical Hebrew fashion, but vertically, as one sees in Cabbalistic texts. The phrase, properly interpreted as "*mene, mene, tekel, v'parsin*," foretold the division and destruction of Belshazzar's realm. Quite literally, the handwriting was on the wall, and Rembrandt left no doubt that this was a direct intervention from God by showing his divine hand emerging from a cloud to inscribe the glowing letters.

In the seventeenth century, a period that we generally call the Baroque era, Catholics challenged the Protestant Reformation with their own orthodoxy. They valued images as a means to reinvigorate the worship of holy figures. Gian Lorenzo Bernini's *Ecstasy of St. Theresa of Avila* was a sculpted altarpiece, part of a dynamic chapel that he had designed for the Cornaro family in Rome in the 1640s. Like the culmination of a theatrical performance, Theresa of Avila is enraptured by an angel of Heaven, who pierces her with a sacred arrow. This was no cupid, but Theresa had made use of the metaphor of a sexual encounter to make her point, that the desire for God far exceeds any physical sensation. Bernini has captured this feeling not only in Theresa's facial expression, but also in the voluminous undulating drapery that surrounds her. Stone has been given the illusion of lighter materials, smooth flesh, feathered wings, even cloud. It seems to defy gravity as Bernini manipulated his marble in a manner that no other artist dared at the time. The ensemble, complete with natural light from a hidden window cascading down bronze rays, was meant to exhort the public to a similar enthusiasm for God's love.

The *Allegory of Sight* by Jan Breughel and Peter Paul Rubens (*see* page 214) represents not an actual collection but an ideal *kunstkamer*, or art chamber, the forerunner of the modern museum. Such collections easily blended ancient statuary, modern paintings, jewelry, and curiosities. In the early days of the Renaissance, innovations in art were driven by familial patronage of churches and town squares. This public art drove competition among artists and also among patrons trying to outshine

DISCOVERING THE GREAT MASTERS

*The Art Lover's Guide
to Understanding
Symbols in Paintings*

GIOTTO DI BONDONE
(1267–1337)

The Last Judgment

1306

FRESCO
CAPPELLA SCROVEGNI, ARENA CHAPEL, PADUA

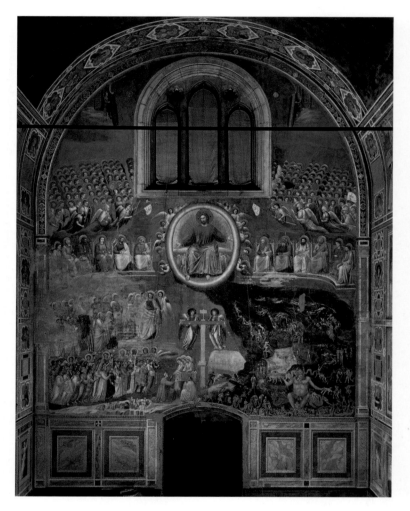

ENRICO Scrovegni purchased the site of an ancient amphitheater in Padua in the year 1300 to build his palace and a family chapel that came to be called the Arena Chapel. He engaged the Florentine artist Giotto di Bondone, already in town working on another commission, probably expecting something of a bargain. Giotto, while prodigiously talented, was still fairly young. Scrovegni's father, Reginaldo, had made his fortune by unscrupulous money lending; so infamous was he that he was mentioned among the damned in Dante's *Inferno*. The patron's motivation in constructing the chapel was to expiate his father's sin and repair his family's reputation, but he probably had little expectation that in the process he would commission a groundbreaking work of art that would help usher in a new era of the Renaissance.

Giotto's frescoes covered all four walls and the barrel-vaulted ceiling of the small chapel. Two main cycles run along the side walls, depicting the life of the Virgin and the life of Christ. These tender and emotional narratives coupled with advanced architectural renderings and evocative landscapes would have been enough to secure its fame. The entry wall, however, became most widely influential: it was filled entirely by a scene of powerful artistic innovation, the *Last Judgment*.

Christ sits in glorious judgment at the center of the scene, surrounded by a rainbow mandorla of light and angels. The colors of the light are formed by hundreds of individually depicted feathers, recalling passages from the Psalms about the Lord's wings and feathers. His outstretched hands dictate the action throughout this crowded ensemble, raising those who will gain salvation to his right and casting down to his left those condemned to a fiery fate in Hell. A tightly structured host of angels occupies the sky above, and two angels at the very top unfurl the heavens. The apostles sit enthroned on a horizontal band level with Christ. On the lower left, the dead rise from their graves. The souls that will enter Heaven do so in disciplined procession. First among the elect is a woman, probably the Virgin Mary, who turns back to offer her hand to a poorly preserved figure, probably meant to represent John the Baptist. Giotto employed a hierarchy of scale to indicate the relative importance of the types of figures in this broad scene. A second, lesser band of people also ascends toward Christ. In contrast to the clarity on the left side, four rivers of fire emanate from Christ's mandorla into the lower right quadrant, directing streams of smaller naked bodies in disarray, submerging them into the dark abyss. There they are tortured by demons or crushed and devoured by the devil himself.

In the center directly above the doorway, at the foot of the crucifix, a cluster of angels greets Enrico Scrovegni himself, together with an Augustinian monk who supports a replica of the chapel. Giotto thus made clear that this entire project was Scrovegni's offering to Christ in hope of his own salvation.

PAUL AND PETER (SHOWN HERE) FLANK
CHRIST ON SILVER THRONES. LIKE ALL
CREATION, THE APOSTLES ARE IN A
HIERARCHY, VISIBLE IN THE STYLES
OF THEIR THRONES. THEY GESTURE
AND GRASP THEIR ROBES, DISPLAYING
ANXIETY FOR THEIR FELLOW HUMAN
BEINGS AT THE LAST JUDGMENT.

THE FOUR BRANCHES OF THE
RIVER OF HELLFIRE SORT THE
DAMNED BY THE THREE GREATEST
SINS: AVARICE, LUST, AND PRIDE.
THE DREADFUL CHAOS OF THE
INFERNAL REALMS CONTRASTS
WITH THE LUMINOUS AND
ORDERLY KINGDOM OF GOD.

THE CROSS DIVIDES THE SAVED, ON
CHRIST'S RIGHT, FROM THE DAMNED,
ON HIS LEFT. THE LETTERS IN THE
SMALL RECTANGLE AT THE TOP
STAND FOR "JESUS OF NAZARETH,
KING OF THE JEWS," PLACED THERE
BY CHRIST'S TORMENTORS.

FEARING THE LAST JUDGMENT ON
BOTH HIS FATHER'S AND HIS OWN
BEHALF, ENRICO SCROVEGNI OFFERS
A MODEL OF THE CHAPEL TO THE
VIRGIN, WHO STANDS BETWEEN
SAINTS JOHN AND CATHERINE.
THE PRIEST IS SCROVEGNI'S FRIEND,
THE CANON ALTEGRADO DE'
CATTANEI.

THE DEVIL'S POSTURE PARODIES
CHRIST'S—A REMINDER THAT LUCIFER
WAS ONCE THE MOST BELOVED AND
BEAUTIFUL OF THE ANGELS. JUST AS
USURY UNLAWFULLY GENERATES
MONEY, SO DOES SATAN APPEAR
TO BE GIVING BIRTH.

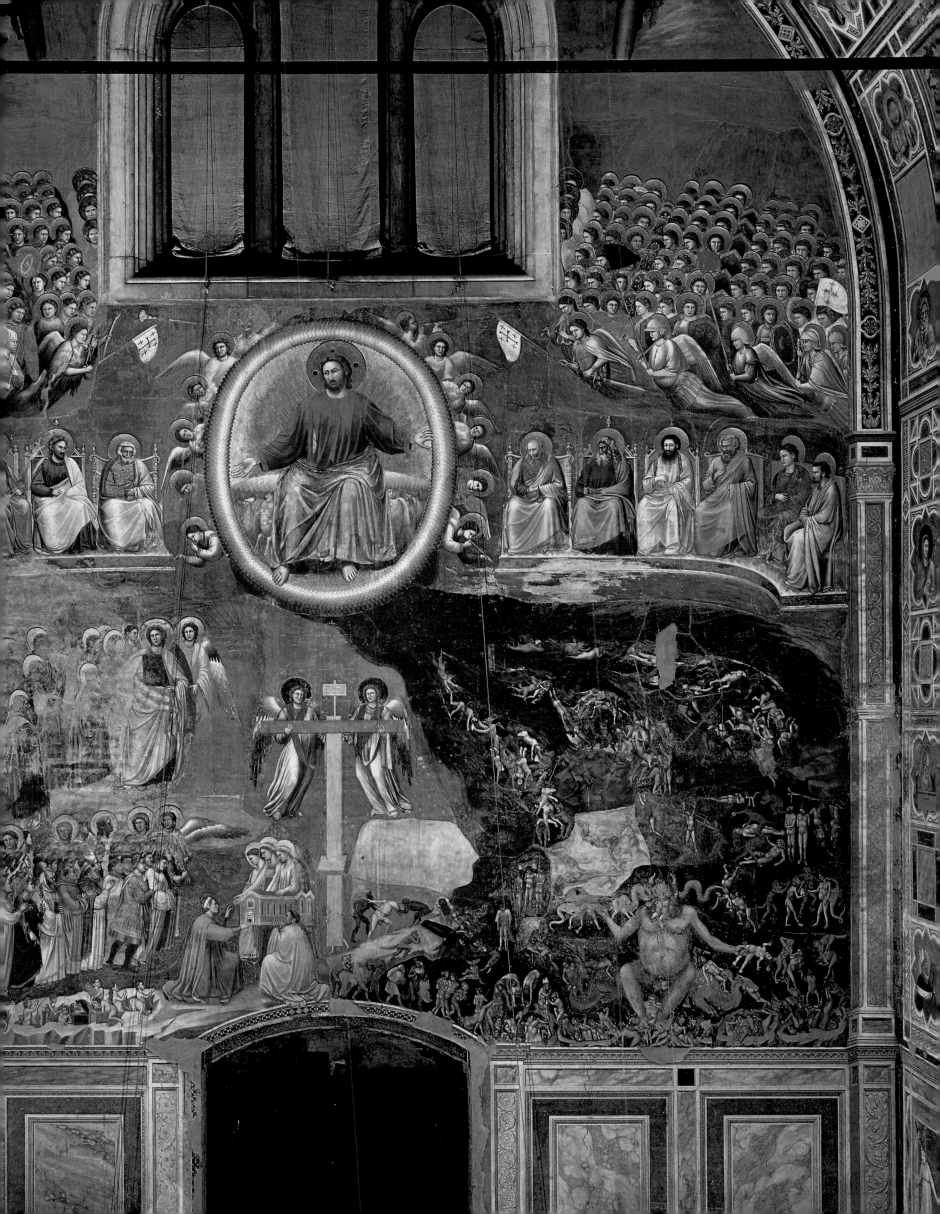

Secrets of the Animal World

ANIMALS appear in the art of all times and places, from ancient cave paintings to twenty-first-century installation art. They intrigue us by their elusive affinities to us and their no less mysterious differences. In European art, one of the most evocative of creatures is the horse. It stands for power in every sense, including the compelling force of desire. The horseman who reins in a rearing steed in Leonardo's enigmatic *Adoration of the Magi* (page 70) may symbolize rationality—the higher nature—disciplining the appetites. In the European social hierarchy, the "lowborn" were considered more susceptible to their animal nature. Since only the aristocracy was permitted to ride, in Gentile da Fabriano's magnificent, teeming *The Adoration of the Magi* (page 24), the many handsome steeds emphasize the nobility of the great of the earth who humble themselves before the Child. In the same work, the exotic animals bespeak the kings' foreignness, but also represent the infinite variety of God's creation.

As the age of exploration advanced, and Europeans traveled into unknown territory, unicorns, dragons, and other emblematic creatures who were thought to exist, gradually were banished to the realms of the imagination. The unicorn does, however, exist among the denizens of the *Paradise* panel of Hieronymus Bosch's *Garden of Earthly Delights* (page 116). These lovely mythological animals were much prized for their horns, which could detect and neutralize poison—here, the unicorn dips its horn into the pond from which it drinks. In their purity, but perhaps also in their connotations of masculine power, they were also associated with Christ. As European commerce expanded, once-exotic beasts became almost commonplace pets. Because they resemble human beings, but were—like all animals—believed to be without souls, monkeys came to represent the impulsive, unenlightened part of people. In Jan Steen's *In Luxury, Look Out* (page 266), the monkey at the top of the scene represents the presiding spirit of the disorder below.

Artists used more familiar beasts to explain the mysteries of salvation theology. An ox and an ass appear in countless Nativity and Adoration scenes—though not in the Gospel account of the event. These modest farm animals point to the humility of Christ's birth, but also symbolize those who recognized Christ as the Son of God, and those who would not. In Gentile da Fabriano's *Adoration* (page 24), the ox gazes at the Christ child with devotion, while the ass looks away. In Hugo van der Goes's *Portinari Altarpiece* (page 60), it is the other way around.

It is not surprising that animals as ubiquitous as oxen, for example, would have different symbolic meanings. Viewers would have identified the evangelist-painter in Maerten van Heemskerck's *St. Luke Painting the Virgin* (page 182) from the ox beside him. The symbols of the four evangelists come from the visionary Apocalypse, where they represent emanations of the divine. Also from Apocalypse, and from numerous sources in the Old and New Testaments, is the depiction of Christ as the mystical sacrificial lamb. This symbol appears, for example, in both Jan van Eyck's *Ghent Altarpiece* (page 32) and Jan Provost's *Christian Allegory* (page 172).

In God's orderly universe—and in the Neoplatonic system dear to the Renaissance—hierarchy reigned. The highest creatures fly in the air, the most spiritual of the elements. The Holy Spirit, vehicle of the mystery of the Incarnation, appears as a white dove in Annunciations, and with the Father and the Son in representations of the Trinity, such as Albrecht Dürer's *Adoration of the Trinity* (page 140). In the folk imagination, however, nighttime was the province of evil and danger. In Francisco Goya's *The Spell* (page 290), as in the *Paradise* panel of Hieronymous Bosch's *Garden of Earthly Delights* (page 116), the owl represents the dark realms. But whether high or low, holy or profane, animals in art powerfully mirror the infinite range of human fears, fallibilities, nobility, and aspirations.

LEONARDO DA VINCI.
The Adoration of the Magi.
This rider on horseback symbolizes the restraint of unruly passions (page 70).

GENTILE DA FABRIANO.
The Adoration of the Magi.
Exotic beasts represent God's dominion over all the Earth (page 24).

HIERONYMUS BOSCH.
The Garden of Earthly Delights.
Unicorns stand for exceptional purity (page 116).

JAN STEEN.
In Luxury, Look Out.
Monkeys are emblems of the animal part of human nature (page 266).

HUGO VAN DER GOES.
The Portinari Altarpiece.
One animal recognizes Christ as the Son of God, the other does not (page 60).

MAERTEN VAN HEEMSKERCK.
St. Luke Painting the Virgin.
The ox is the symbol of Saint Luke the evangelist (page 182).

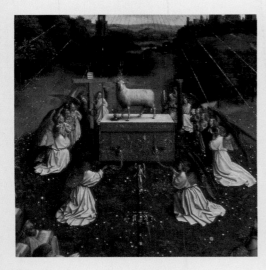

JAN VAN EYCK.
The Ghent Altarpiece.
The lamb represents Christ, sacrificed to redeem humanity from Adam's sin (page 32).

ALBRECHT DÜRER.
The Adoration of the Trinity.
The white dove symbolizes the divine spirit (page 140).

FRANCISCO DE GOYA.
The Spell.
Owls indicate spiritual darkness (page 290).

Gentile da Fabriano

(CA. 1370–1427)

The Adoration of the Magi

1423

Tempera on panel
9 ft. 10 in. x 9 ft. 3 ⅜ in.
Uffizi Gallery, Florence

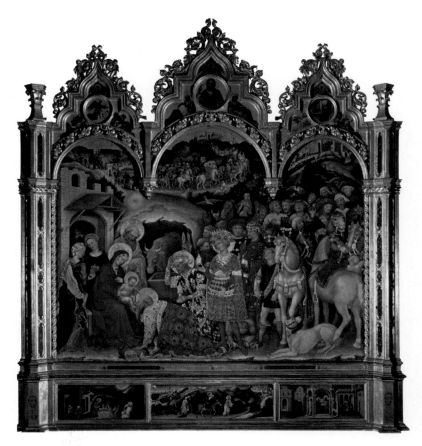

Gentile da Fabriano was one of the most sought-after artists in Italy in the first decades of the fifteenth century. In 1423 he completed an altarpiece representing the Adoration of the Magi for Palla Strozzi, the richest man in Florence, for the sacristy of the Church of Santa Trinita. In this location the clergy donned their vestments to carry the host to the altar, and Gentile reflected the purpose of the sacristy in two ways: first, in the fabulous draperies that adorn the dozens of figures here, including of course the three kings from the East, and second, in the subject itself, the Adoration, which was the first demonstration of the body of Christ (the *Corpus Christi*) to the public. So packed is the scene with exuberance and details that the crowd seems to burst out of the tripartite Gothic framework.

The view develops in a continuous narrative. In the top left arch, the Magi stand atop a mountain where they first view the miraculous star. The mountain is surrounded by a sea, which takes them on their journey to the Holy Land. In the center arch the kings arrive in a splendid parade to enter Jerusalem. In the right arch they approach the walls of Bethlehem. In the foreground they visit the Holy Family, with the Christ child seated on his mother's lap. Gentile created a rhythmic movement with the first Magus prostrated to kiss the feet of the child, the second in the process of kneeling, and the third still standing. Moreover, the kings demonstrate deference to the majesty of Christ: the first has taken off his crown and placed it on the ground, the second removes his as he approaches, and the last, the youngest, still wears his sign of worldly merit. The rush of anticipation is shown by the servant who bends down to remove the third king's spurs.

The rest of the kings' entourage illustrates a cavalcade of activity. Figures and beasts are seen in frontal and rear projection, faces turn in all directions, and brocaded draperies, floppy hats and turbans, and bands of jewelry create a continuous flow from one figure to the next. The rich ornamentation and array of gilded details made this one of the most exquisite altarpieces of its time. A wealth of comical vignettes occupy the scene, with the attendants (in the left-middle area in the painting) telling jokes, animals chasing one another, and soldiers molesting a traveler (in the upper right archway). Exotic animals, including cheetahs and monkeys, are also seen throughout.

In the predella panels below, Gentile demonstrated his skills with three different types of settings. These are among the earliest panoramic views with realistic lighting effects in Italian art. Earlier paintings were mostly filled with gold backgrounds, just as the sliver of sky is rendered in the main panel of the altarpiece. On the left predella, a night scene sparkles with the Nativity and the Annunciation to the shepherds in the background. The sources of light are within the painting itself, emanating from Christ in the center, to illuminate his mother, the cave, and the building from below, and from the angel in the background. In the center predella, the Holy Family trudges along a curving road in a horizontal mountainous landscape on the flight into Egypt. On the right, the Presentation in the Temple reveals Gentile's mastery of a complex architectural and spatial rendering for its time.

Sumptuous displays of this sort were popular in courtly circles throughout Europe in the early fifteenth century, and in the 1930s the art historian Erwin Panofsky coined the term International Style to refer to this phenomenon.

Tradition held that chivalry, symbolized by this aristocratic hunting falcon, dated back to the classical period, the wellspring of the Renaissance. The bird's outspread wings and its position in the center of the arch also suggest the Holy Spirit, through whom Christ was conceived.

Like the camel beside it, the monkey comes from the exotic lands of the Magi. Though monkeys symbolize lower human nature, or folly, they were also exotic pets, collected by wealthy and urbane noblemen.

The precious container the king holds resembles a ciborium, the vessel containing the Eucharist. It would have been almost on axis with the tabernacle—and its ciborium—on the altar below.

A page removes the golden spurs of the young king. Traditionally, the three Magi are portrayed as the Three Ages of Man: one young, one in his prime, and one elderly.

This handsome hound starts at the sudden movement of the horse beside him, but stays still. His muzzle may similarly indicate restraint.

JAN VAN EYCK
(1390–1441)

The Arnolfini Portrait

1434

OIL ON OAK
32 ⅜ X 23 ⅝ IN.
THE NATIONAL GALLERY, LONDON

"JOHANNES de Eyck fuit hic/ 1434" (Jan van Eyck was HERE/1434). The stylized Latin inscription on the rear wall provides the clue to understanding the genesis of this uncommon portrait. The artist thus proclaimed himself witness to this unusual ceremony, and he would have us believe that this event took place exactly as he has shown. To further bolster the claim, he rendered himself and another man standing in the doorway before the couple, visible in the reflection of the convex mirror.

A well-dressed man, sporting fur trim on his long velvet cloak and a bulbous chapeau, exchanges vows of matrimony with a woman, equally alluring in her voluminous green dress, similarly trimmed in ermine. He raises a hand in solemn oath, and cups her hand in his. They stand not in church but in an urban domestic interior. The full-length format of the double portrait might have been expected were the couple noble, but they are not. A description written a few generations later when the painting entered the Spanish royal collection reveals that the man was named Arnolfini, presumably referring to Giovanni Arnolfini and his wife Giovanna Cenami. He was an Italian merchant working in the Netherlands. The fact that they lived in a foreign land at this moment in their lives, distant from friends and family, provides a reasonable justification for the painting: it is their proof of marriage, and the artist engaged every means at his disposal to ensure that it was a reliable and convincing document of the event.

The painting is embellished with details that allude to the sacrament of marriage. The dog was a common symbol of fidelity. The single lit candle was likely a part of actual rituals that emphasized the unity of the couple. On the wall, the mirror with small roundels representing the Passion of Christ and prayer beads hanging from a nail also demonstrate the sanctity of the space and the devoutness of the couple. A figurine of St. Margaret, patron saint of childbirth, adorns the bedpost behind the woman's head. A small broom emphasizes her expected role as keeper of a well-maintained house. Her placement next to the bed, with her green dress set prominently against the red, suggests a gendered role, just as his position next to the window indicates that his responsibility is to work outside the home.

The abundant fabric that the woman bunches before her belly certainly makes her appear pregnant. This is accentuated by the fashion of dress and an ideal of beauty that celebrated swelling hips in the female form. The open curtains of the marriage bed may also allude to

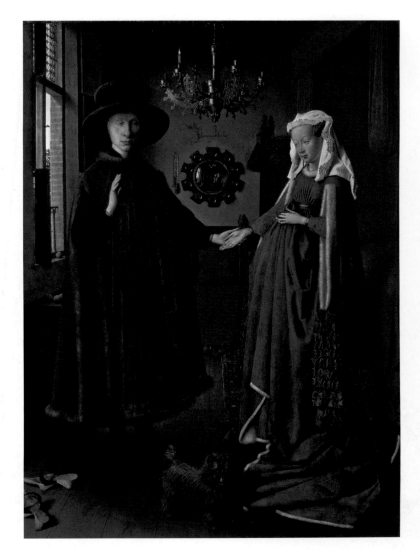

their consummation of the marriage, but rooms in the fifteenth century were not as purpose-specific as they are in our time, and it was not unusual to find a bed in any particular room. In reality, many weddings did take place following unexpected pregnancies, but it would have been nothing short of scandalous to portray a woman in such a state. Rather, Van Eyck probably intended to allude to the potential of her fecundity, and this would have been seen as virtuous, since procreation was an important and expected aspect of the sacrament of marriage.

THE CHANDELIER HOLDS A SINGLE
LIT CANDLE REFERRING TO THE
"MARRIAGE CANDLE" THAT WAS
CARRIED IN THE BRIDAL PROCESSION.
IT WAS THEN PLACED IN THE NUPTIAL
CHAMBER UNTIL THE MARRIAGE WAS
CONSUMMATED. IT MAY ALSO ALLUDE

The chandelier holds a single lit candle referring to the "marriage candle" that was carried in the bridal procession. It was then placed in the nuptial chamber until the marriage was consummated. It may also allude to the presence of Christ, the light in the world that extinguished all other lights.

"Jan van Eyck was here"— elegant graffiti serving as a kind of testimony that the event depicted is authentic.

Giovanni Arnolfini traded in textiles and fur at the Netherlandish court, evidenced by his fur-trimmed garment.

The artist's presence is reflected in the mirror—its roundels depicting the Stations of the Cross—along with another witness to the ceremony, the whole room therefore visible. The costly mirror, together with the fur and other expensive household items, indicate the high social station of the new couple. The dog was added later.

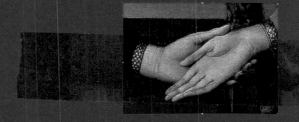

The tender joining of hands draws only slight attention away from the often-asked question: Is she pregnant? The candle, the image of St. Margaret, patron saint of mothers, on the bedpost, and the bed itself allude to childbearing as integral to the sacrament of marriage rather than suggest a "shot-gun" wedding.

Both figures have removed their shoes. Was this a symbolic gesture to sanctify the domestic setting? The color red, used for Giovanna's shoes and bedding, often symbolized passion. The colors of her clothing have been interpreted to suggest various other characteristics: green for amorous affection, blue for faithfulness, and the white of the ermine trim for purity.

JAN VAN EYCK
(1390–1441)

The Ghent Altarpiece

1432

OIL ON PANEL
11 ½ x 15 ⅛ IN. (OPEN)
CATHEDRAL OF SAINT BAVO, GHENT

ELLOW artists traveled from near and far to marvel at Jan's use of oil paint. A legend arose that he had in fact invented the technique of using oil as a binding medium rather than egg yolk, as had been used in tempera paint for centuries. The legend is not true, but certainly Jan was among the first to fully master the range of possibilities for portraying light and shadow, smoothly blending colors together to gain a mirrorlike finish that reflected the natural world with spectacular accuracy. *The Ghent Altarpiece* was one of his first masterpieces, one of the major monuments of the early Renaissance.

The exterior of the altarpiece, including the main scene of the Annunciation to the Virgin Mary, is painted largely in grisaille, a monochromatic technique. The exceptions are the portraits of the donors, Jodocus Vyd and Isabel Borluut, whose color vividly contrasts with the fictive stone statues of St. John the Baptist and St. John the Evangelist. Sculptural altarpieces were generally much more expensive owing to the costs of materials, but Jan's conceit of the five fictive stone figures provides a triumph for painting over its more costly sister art of sculpture. Surmounting the altarpiece are Old Testament prophets Zachariah and Micah and a pair of sibyls.

On the occasions that the altarpiece was opened, viewers were treated to a dazzling display of color and light that traversed from the earthly world to a heavenly realm. On the lower register, a parade of saints, holy figures, and virgin martyrs converge toward an octagonal fountain of life and the altar with the Lamb of God. Angels surround the altar, swinging censers and bringing forth the instruments of Christ's Passion, including the column, whip, lance, and the cross. The Holy Spirit descends from above.

Recent research has strongly reaffirmed that the sections of the altarpiece representing the Adoration of the Lamb were the original commission, given not to Jan but to his elder brother Hubert van Eyck. The altarpiece remained as such for several years, until it was acquired by Jodocus Vyd who, with Hubert's death, hired Jan to expand it greatly. An inscription was subsequently written on the frame that honors both artists. Though his paintings are otherwise completely unknown, the inscription reads, regarding Hubert, "none better could be found."

Jan completed the altarpiece in 1432. Prior to that time, he had been the valet de chamber, a king of personal assistant, and official painter to Duke Philip the Good in Bruges. *The Ghent Altarpiece* seems to have been his first large-scale painting project. His earlier training was in manuscript illumination, and he brought a miniaturist's touch and attention to detail to the larger scale of this project, with astounding results in the upper portions. A multitude of minute observations are recorded, from sparkling reflections in jewels and metals to golden brocaded threads, and individual strands of hair in the figures. Overall, the transitions of light into shadow to create three-dimensional illusions were groundbreaking for his day, as was the saturation level and intensity of his oil-based color.

God the Father reigns upon a throne on the upper register, wearing the pope's three-tiered tiara. A regal crown laid at his feet suggests the

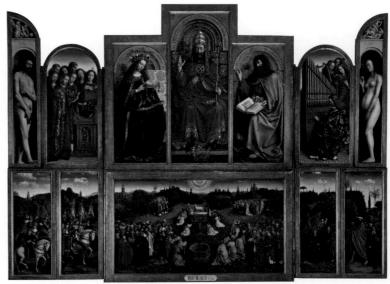

The Ghent Altarpiece (OPEN)

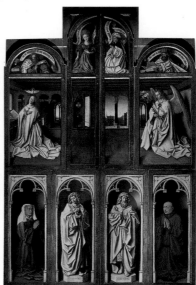

The Ghent Altarpiece (CLOSED)

transition to the earthly world below. He is surrounded by the Virgin Mary and St. John the Baptist, traditionally the primary intercessors for mankind at times of judgment. All three are resplendent in jewels and fine fabrics. A chorus of angels and nude figures of Adam and Eve flank them. The flesh of Adam and Eve is set off against a dark background, making them almost tangible. Adam's toes cross over the threshold of the panel, further reinforcing the illusion that he is a real man, standing in a niche above the head of the viewer. Jan's depiction of these nudes, unadorned and natural in their proportions and build, set a precedent in Northern European painting of the Renaissance, quite different from Italian art, which was highly influenced by Roman antiquity and its ideals of beauty. Together these figures form a cycle of Fall and Redemption.

The Virgin Mary sits to God the Father's favored side. Her humble piety is demonstrated by reading, while her majesty is shown by the splendor of her crown and mantle.

The Father sits enthroned as judge. He offers a benediction with his right hand and wears a crown reminiscent of a papal three-tiered tiara, embellished with sizeable precious stones. The rays of reflection demonstrate Jan's early mastery of the medium of oil paint. More than twenty inscriptions run through the altarpiece, adding religious exegesis to the visual image.

John the Baptist's prophecies foretold the coming of Jesus, and he, along with the Virgin Mary, were typically shown adjacent to Christ or God the Father at times of judgment, acting as intercessors on behalf of humanity—a grouping known as the Deësis.

The ornate royal crown at the Father's feet provides a transition to the earthly realm in the panel below. The Holy Trinity is formed by the Father above, together with the Dove of the Holy Spirit and the sacrificial lamb representing Christ below.

Devout, holy figures approach the altar, including Old Testament and pagan peoples, confessors, Just Judges and Holy Warriors, Holy Hermits and Holy Pilgrims. Virgin martyrs carry palm branches as signs of victory of the soul over the flesh.

The adoration of the lamb is a symbol of Christ's sacrifice. To the right of the altar, angels hold the column on which Christ was tortured and the whip and other instruments used against him. To the left, angels carry his crucifixion cross and the lance that was used by the Roman centurion to stab Jesus in the side. The angels in the front swing censers.

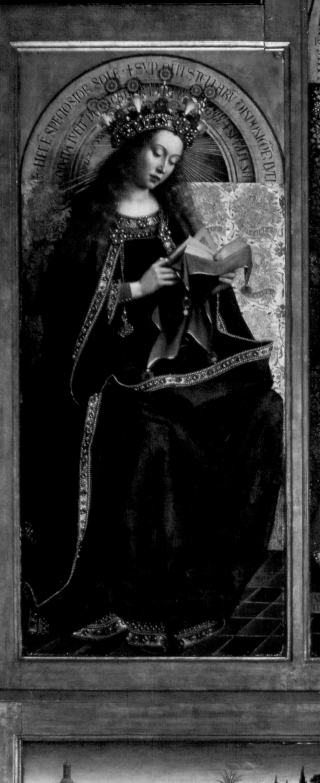

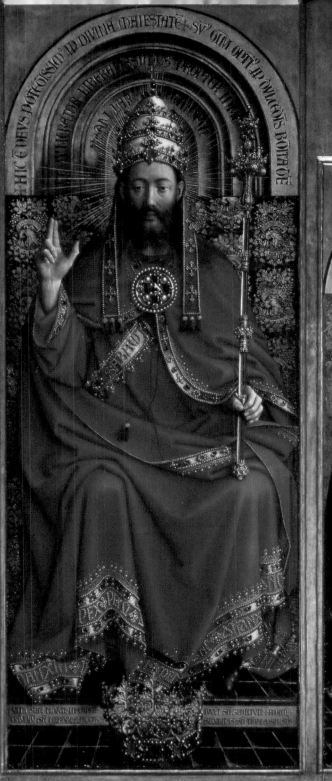

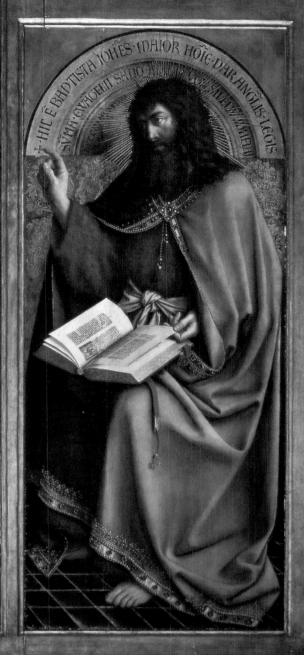

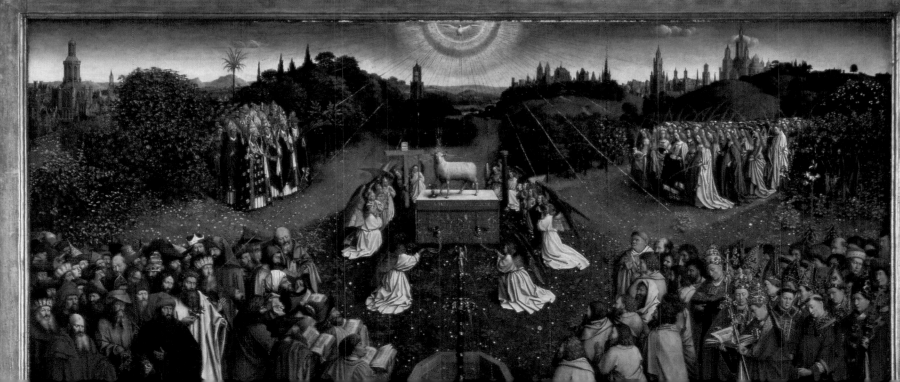

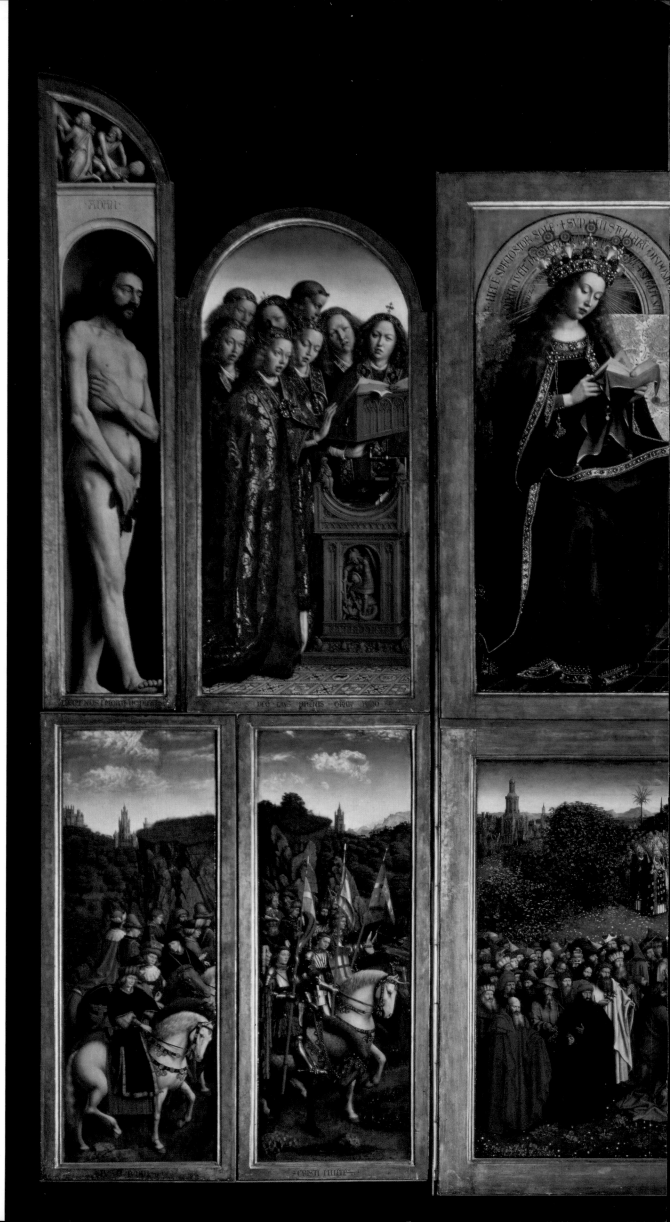

JAN VAN EYCK
(1390–1441)

The Ghent Altarpiece (OPEN)
1432

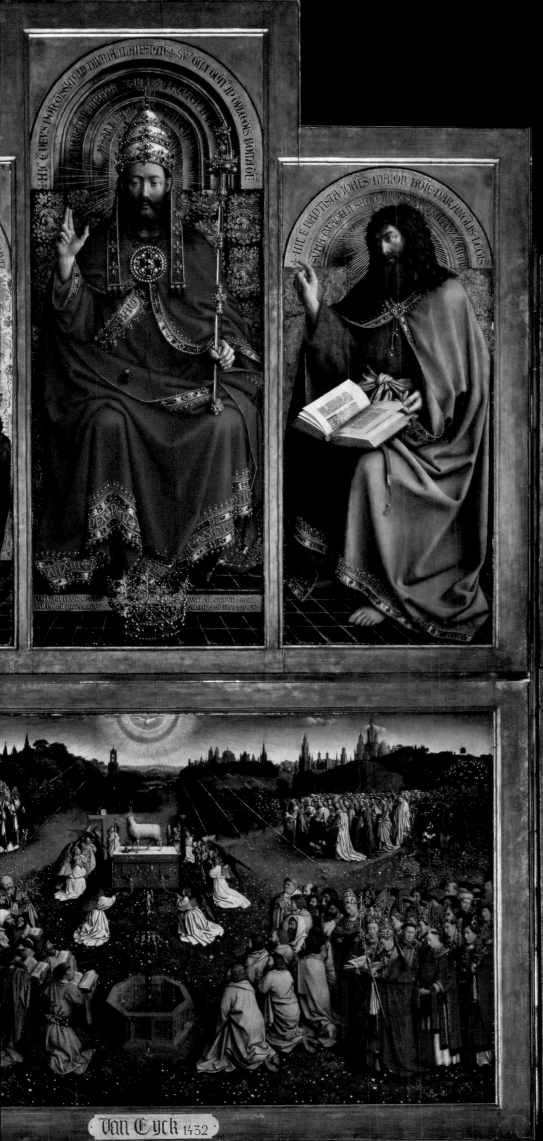
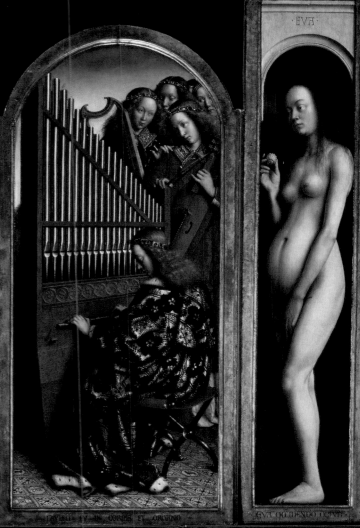

JAN VAN EYCK
(1390–1441)

The Chancellor Rolin Madonna

CA. 1435

OIL ON PANEL
26 X 24 ½ IN.
THE LOUVRE, PARIS

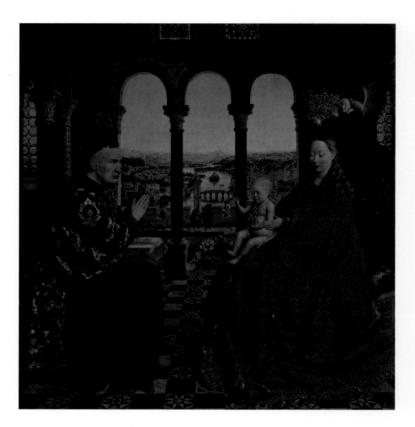

THE practice of including a patron's portrait within an altarpiece became a popular device in the fifteenth century to blend the contemporary world of the audience with the historical realm of the religious figures to be worshipped. Van Eyck's Madonna with Chancellor Rolin is an excellent example: the space of the chancellor's loggia is transformed by his visionary experience. Not only does Rolin demonstrate his piety by kneeling in prayer and reading from a book of hours, but the Madonna and Christ child actually appear before him in his own palatial residence overlooking a city reminiscent of, but not exactly depicting, Bruges.

Signs of wealth and social station abound in the chancellor's luxurious residence. The wealth of Bruges lay in its fabric trade, to which the garments depicted here attest. Rolin's gold brocade jacket is trimmed with mink. The floor is inlaid with colored marbles, possibly imported from Italy, as the Flemish had begun major trading and banking enterprises with merchants of Genoa, Venice, and Florence. The column capitals and arcade are carved with exquisite designs of acanthus, interwoven vines, and floral decoration familiar in French Gothic architecture. His surroundings are also infused with religious and political associations. The tripartite arcade opening onto the natural world in a general way may be associated with the Holy Trinity. The stone relief frieze running above the Rolin's head illustrates the Expulsion of Adam and Eve, metaphorically presaging Christ's redemption of mankind's original sin, the murder of Abel, and the Drunkenness of Noah.

Beyond the arcade lies an outdoor garden and walkway, where two men peer over the ramparts to view the goings on along a river not unlike the channel Zwin, which provided Bruges with access to the sea. The population of Bruges swelled to 40,000 residents at this time, thanks to its mercantile success and the patronage of the ducal court. The secular areas of the town are situated on the left bank, behind Rolin. On the right, framing the Christ child, the buildings are predominantly religious structures. Numerous tiny figures amble about town, crossing the bridge and unloading wares in the riverboats. The crenellated battlements indicate that the chancellor's palace is also an urban fortress. Next to the men there are two peacocks. While these birds are usually associated with pride because of their brilliant plumage, they were also associated with immortality and Christ's resurrection because of an ancient belief that their flesh never decayed.

Before the chancellor, the Christ child offers a blessing with his right hand, and holds a small glass orb surmounted by a cross, symbolic of his triumph over the world. The center of the cross contains a garnet stone, its red color associated with the Passion of Christ. The ends of the cross are decorated with fleur-de-lys tracery, an emblem of the kings of France. A cluster of live lilies appears in the garden in the center just beyond the arcade. This flower was sacred to the royal house of France because of its association with the purity of the Virgin Mary. They are accompanied in the garden by roses, also sacred to the Virgin, who was sometimes called the "rose without thorns."

Further allusion to majesty is given by the angel who descends to place a magnificent crown onto the head of the Virgin Mary. Significantly, the Virgin does not pay attention to the honor, as her eyes are fixed upon the child. Her voluminous red robe, another sign of the Passion, is encrusted with pearls and jewels along its golden edging. In this way Jan showed his skills at rendering reflections and various surfaces. His mastery with the oil paint thus became a substitute for the real precious materials of altars and reliquaries of the time. The Madonna and Child are presented to appear just as tangible as the chancellor and his surroundings.

Nicolas Rolin, chancellor of Philip the Good, Duke of Burgundy, may have made this gift in expiation. On the capital just above his head is represented the biblical episode of the drunkenness of Noah.

According to one interpretation, the wide, placid waters symbolize the river that runs through the New Jerusalem, prophesied by Revelation.

The Christ child blesses the painting's patron with one hand and holds the orb of the universe with the other. The Virgin both displays her son and restrains him, as if she could prevent what is foreordained.

The sunburst tiles carry our gaze through an enclosed garden containing lilies, roses, and irises—more symbols of the Virgin—to a parapet and two figures in contemporary Burgundian dress.

A crown and a jewel-edged red robe identify Mary as the Queen of Heaven. A row of tiles separates the world of the patron and the otherworldly dimension of the Virgin and Child.

ROGIER VAN DER WEYDEN

(1399/1400–1464)

The Annunciation

CA. 1440

OIL ON PANEL
33 ⅞ x 36 ¼ IN.
THE LOUVRE, PARIS

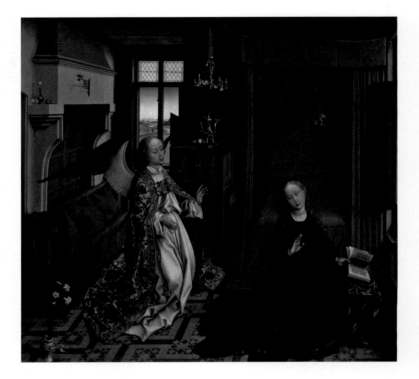

ACCORDING to the Gospel of Luke (1:26–38), the archangel Gabriel was sent by God to the town of Nazareth to visit a virgin betrothed to a man named Joseph, of the house of David. "Hail, favored one! The Lord is with you," the angel announced to Mary. But she was greatly troubled at what was said and pondered what sort of greeting this might be. Then the angel said to her, "Do not be afraid, Mary, for you have found favor with God. Behold, you will conceive in your womb and bear a son, and you shall name him Jesus. He will be great and will be called Son of the Most High, and the Lord God will give him the throne of David his father, and he will rule over the house of Jacob forever, and of his kingdom there will be no end."

Rogier van der Weyden went to great lengths not only to illustrate the events of the passage, but also to indicate the time of year, nine months before Christmas, or March 25. He took great liberties with the setting in order to increase its relevance to his contemporary audience. Outside the rear window, a hilly townscape shows the green fields and budded trees of spring, while the mountains in the deep distance are still capped with snow. The shutters are open to bring fresh air, and the fireplace is covered by wood panels with deadbolt locks to fix it in place into the stone mantle, to hide the singes of the firebox.

Rogier's master, Robert Campin, was one of the first artists to set an Annunciation into a contemporary household, and Rogier expanded on these precedents with numerous detailed observations of daily life that are nonetheless imbued with religious significance. The chamber in general was meant to recall the tradition of a marriage chamber, a *thalamus virginus*. The bridegroom is not Joseph, however, but Jesus himself, who is present enthroned in the golden medallion surrounded by pearls hanging at the rear of the bed. The suggestion of union between mother and son was not incestuous, but an indication of Mary's role as Mother Church, married to God. Interestingly, the red cloth canopy of the bed, which may be associated with Christ's Passion, is not supported by posts but by a sequence of wires attached to the ceiling beams and the fireplace. The canopy thus forms a visual baldacchino above the Virgin, indicating her glory.

Just as she does in the gospel passage, however, Mary does not recognize her own majesty. She receives the angel with humility, indicated by her seat on the floor next to a small cloth-covered hassock or reading table.

The closed fireplace, a rotating metal candleholder, and a chandelier empty save for a single unlit candle represent potential sources of man-made light that go unused. Rogier concentrated instead on natural light and reflections. While this seems sensible because it is a day scene, the writings of Saint Bridget may have been recalled, particularly her suggestion that the radiance of Christ would obliterate the other lights of the world. A pitcher and basin allude to Mary's purity, and this idea is reiterated by the glass vessel on the mantel, through which the sunlight passes to create a shadow and glimmering reflection on the wall. Here again an allusion is made: God's entry into the womb of Mary without spoiling her virgin purity was likened to light that passes through glass without breaking it.

Two fruits are depicted on the shelf next to the glass vessel. The pomegranate's many seeds were once sacred to Proserpine, the pagan daughter of the earth goddess Ceres, who was taken to the underworld by Pluto but returned to renew the earth each spring. This eternal cycle of rebirth led to an association with Jesus's resurrection in Christian symbology. The orange was synonymous with an apple in the Netherlands, referring to the fruit of the Tree of Life and the original sin of Adam and Eve that was redeemed by Christ's sacrifice.

The panel was once the centerpiece of a triptych that showed a donor on the left panel and a meeting of the pregnant Mary and Elizabeth, she pregnant with John the Baptist.

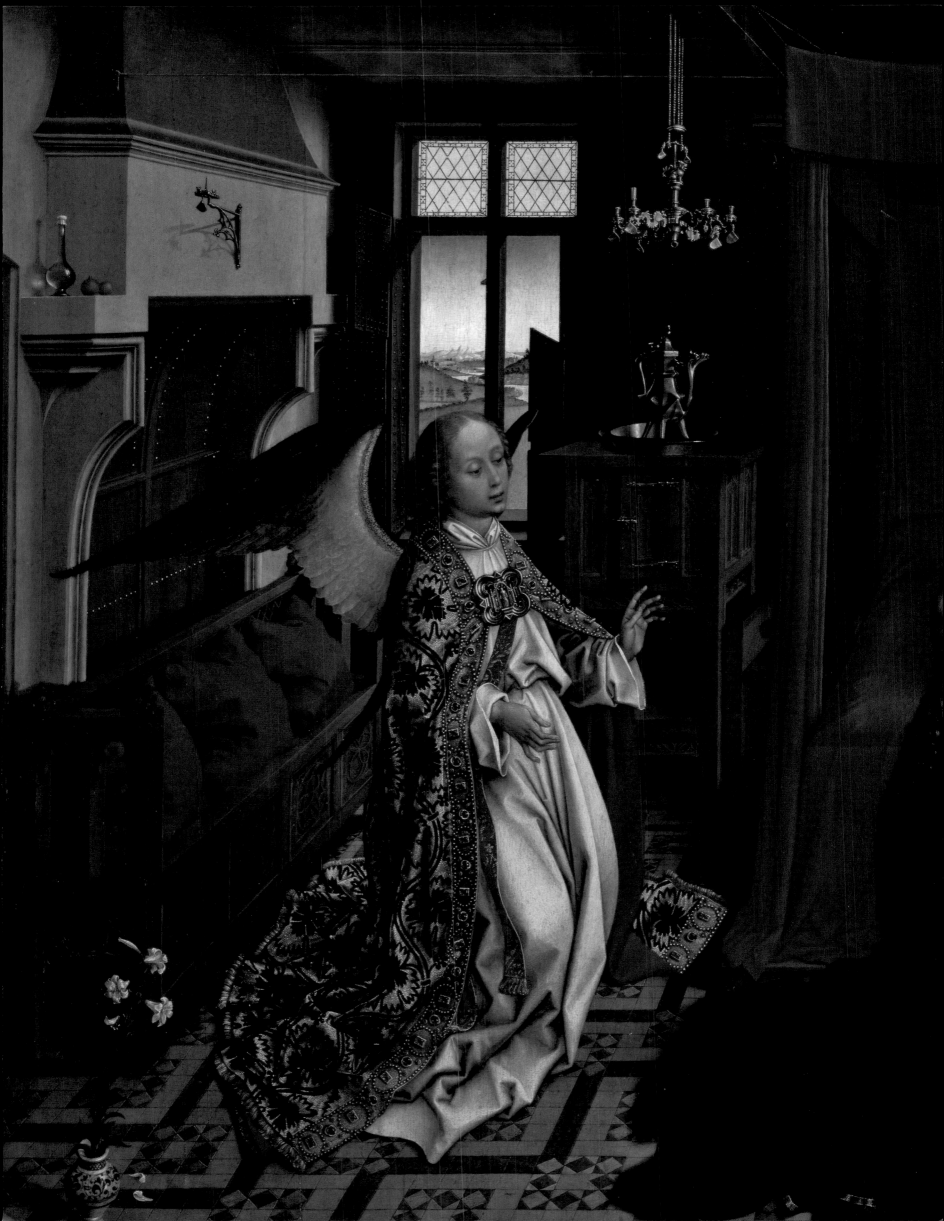

Rogier van der Weyden

(1399/1400–1464)

The Deposition from the Cross

Ca. 1435

Oil on oak panel
86 ⅝ x 103 ⅛ in.
The Prado, Madrid

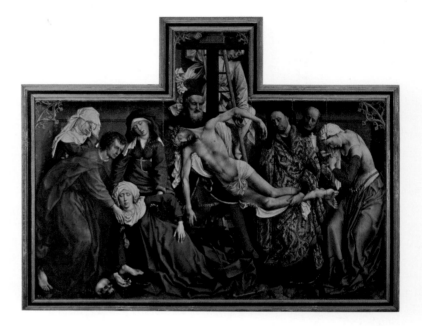

Rogier van der Weyden's *Deposition from the Cross* is one of the most theatrically gripping altarpieces of the Northern Renaissance. The drama unfolds in a boxlike stage, marked in the corners of the frame by late Gothic tracery, and limited in depth by a gilded background. The hill of Golgotha is indicated by the earthen ground, with the skull and a bone of Adam strewn below the fainting Virgin Mary. The bones of Adam refer to the original sin that Christ's sacrifice redeemed. All of the figures are nearly life-size—a remarkable point because one would normally have expected sculptural figures at that scale. They press against the top and bottom of the framework, and within this compacted space takes place a narrative of overwhelming empathy.

Rogier's key figures are posed with striking gestures that communicate compelling emotional presence. The central focus is on Christ's dead body. He has been removed from the cross and is supported at the torso by the bearded Joseph of Arimathea and at the feet by the richly robed Nicodemus, upon whose cheeks tears glisten. But Christ is in fact tipped, rather artificially, toward the viewer in order to display the *Corpus Christi*, the body of Christ, that together with the blood that pours from his wounds symbolize the sacramental transformation of the Eucharistic host and wine that would have taken place on the altar below during Mass. While the blood is evident, strewn from Christ's wounds on his chest, hands, and feet, the tone is not marked by gore, but a peaceful harmony achieved through the solemn expression of Christ and those around him, and by the rhythms that Rogier created in the poses. The Virgin's swoon parallels Christ's sway, their limp arms forming a duet dancing in space.

Mary is supported by John the Evangelist, almost always fully gowned in red, and by one of the holy Marys, probably Mary the mother of James. She, Mary Magdalen, and Mary Salome were often called the Three Marys; the Gospels cite their presence at the Crucifixion, and they later discovered the empty tomb of Christ. Mary Magdalen, shown on the right by Christ's feet, weeps with extraordinary pain. Her fingers are clasped tightly in prayer, but the pose is, again, highly artificial. To actually strike this pose would almost pull the right arm out of its socket. A recent suggestion

about the Magdalen's garments at first seems scandalous: her dress has seams that are stretched at her belly, an indication that she may be pregnant. On the one hand, this may have simply been an identifying characteristic, much like her décolleté neckline: prostitutes often became pregnant, so this feature may be an indication of her previous profession. There was likely a theological connection as well, perhaps a reference to the rebirth that she found in Christ.

The Deposition from the Cross was originally intended for the chapel of the Confraternity of the Archers of Leuven, as indicated by the crossbows in the lower spandrels of the tracery. The painting was subsequently acquired by Mary of Hungary, Regent of the Netherlands, and then became the property of her nephew King Philip II of Spain, who deposited it in the Escorial, northwest of Madrid. It remained there until the twentieth century, when it was removed to the Prado Museum.

The emotions of the figures are diverse and specific. The women's turbanlike headdresses recall the humble social status of Christ's intimates.

Joseph of Arimathea gave Christ the tomb he had made for himself. According to legend, at the Crucifixion, Joseph gathered Christ's blood in a cup used at the Last Supper. That chalice became the Holy Grail.

Tradition holds that Mary neither aged nor died, but is only sleeping until the Last Days. According to certain medieval tales, Mary did not suffer birth pangs until her son's death. In her faint, she is paler than her dead son.

The parallel poses of the Virgin and Christ extend to the hands, reinforcing Mary's *compassio*, or empathy for her son's Passion.

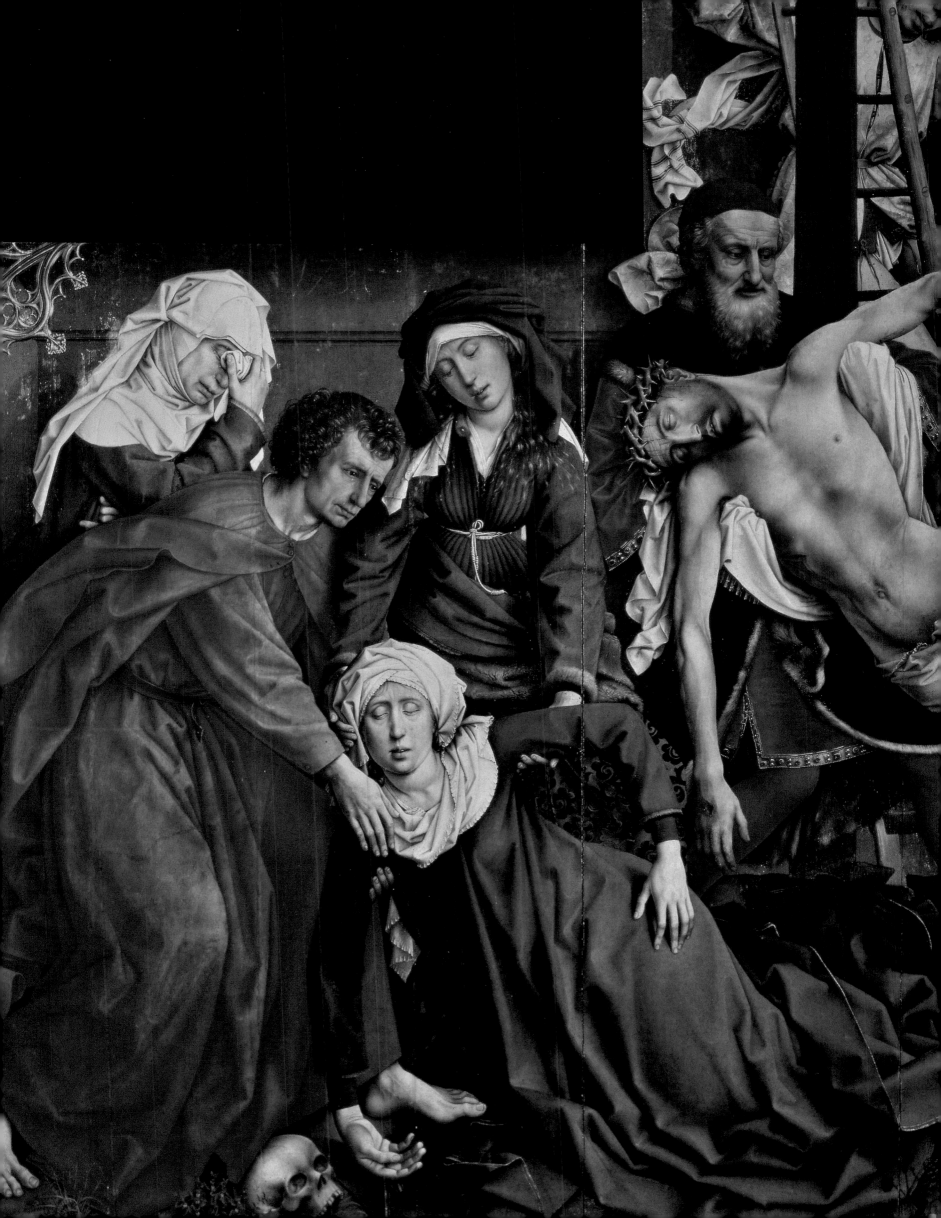

ROGIER VAN DER WEYDEN
(1399/1400–1464)

The Deposition from the Cross
CA. 1435

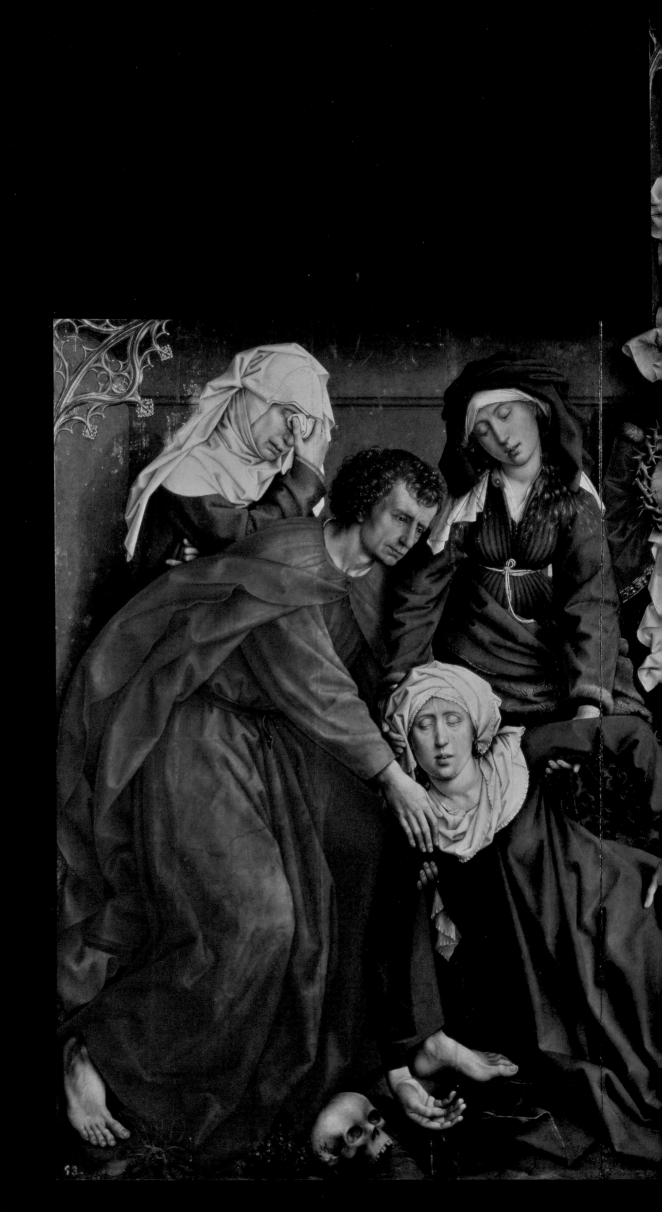

A CITY IS VISIBLE IN THE DISTANCE. ACCORDING TO A MEDIEVAL WRITER, MARY IN NAZARETH WITHDREW INTO HER ROOM, FAR FROM THE CITY AND THE COMPANY OF MEN, SO THAT HER PRAYERS MIGHT BE UNDISTURBED AND HER REPUTATION UNTOUCHED.

THE EWER AND BASIN MAY REFLECT MARY AS FOUNTAIN, ONE OF HER TRADITIONAL ATTRIBUTES, OR CHRIST AS THE PROPHESIED "FOUNTAIN OF LIVING WATERS." A PITCHER MIGHT ALSO REFER MORE GENERALLY TO PURIFICATION.

THE SCONCE, LIKE THE CHANDELIER, IS WITHOUT A CANDLE. IN THE CHRISTIAN TRADITION, THE WORLD IS AWAITING THE LIGHT, THAT IS, CHRIST.

GABRIEL, DRESSED AS AN OFFICIATING PRIEST, APPEARS TO POINT TO THE CABINET DOOR. THE CABINET MAY THUS SUGGEST A TABERNACLE, THE PLACE WHERE THE EUCHARIST IS KEPT IN A CATHOLIC CHURCH. THE SLIGHTLY OPEN DOOR MAY EVOKE THE INCARNATION TAKING PLACE.

GABRIEL'S RICH GOLD VESTMENT IS APPROPRIATE FOR AN IMPORTANT FEAST DAY OF THE VIRGIN. THE LIONS ON THE ARMS OF SETTEE RECALL THOSE ON THE THRONE OF SOLOMON, MAKING THE FURNITURE THE SEAT OF WISDOM—ANOTHER OF MARY'S APPELLATIONS.

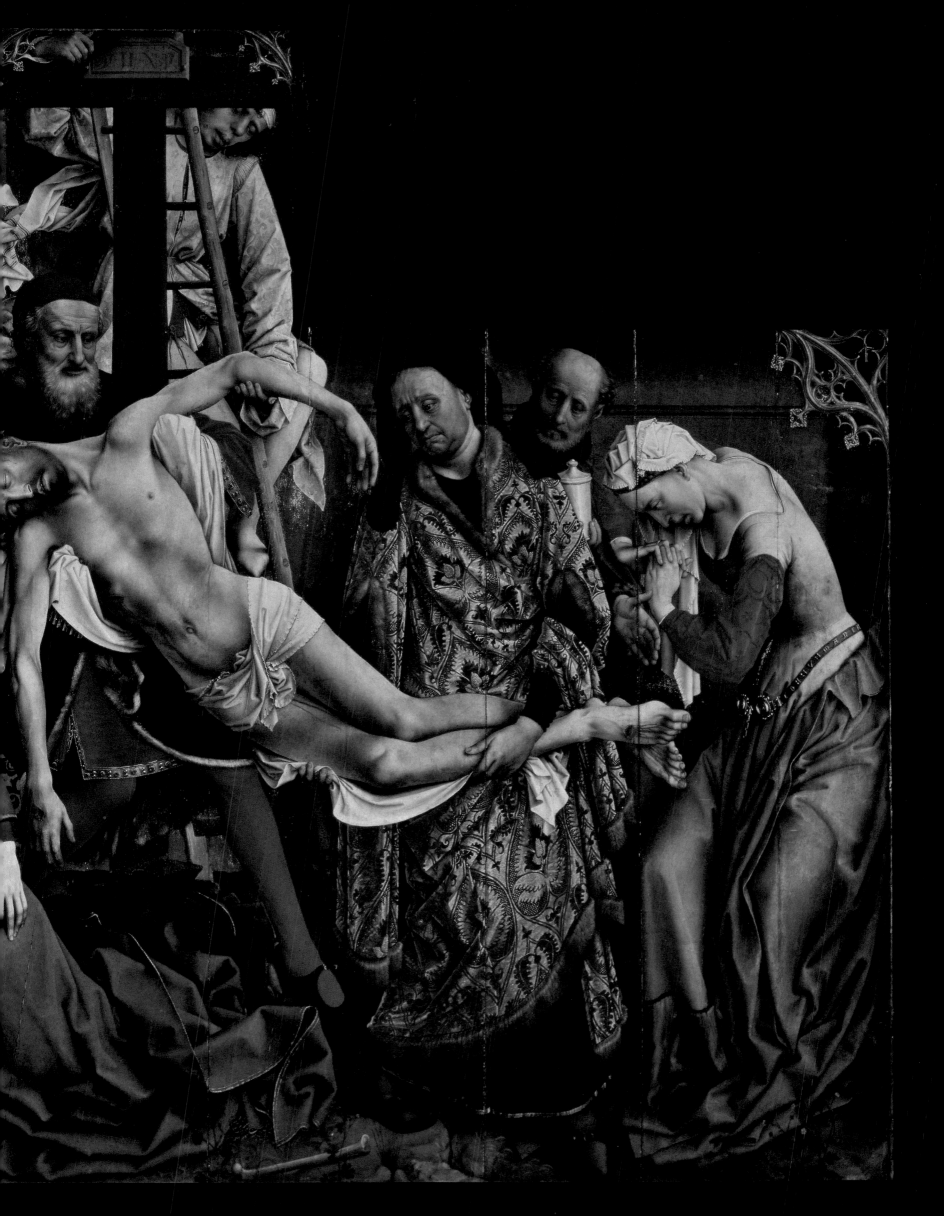

FRA ANGELICO

(CA. 1400–1455)

Christ Mocked

1441

FRESCO
73 ½ X 59 ½ IN.
MUSEO DI SAN MARCO, FLORENCE

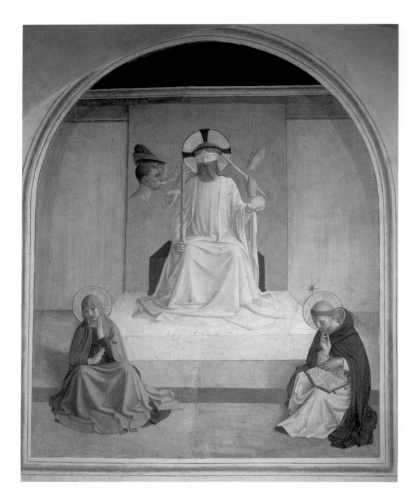

GUIDO di Pietro, also known as Fra Giovanni da Fiesole and called in the Renaissance by his nicknames Fra Angelico or Beato (Blessed), even though he did not earn that formal accolade until modern times, lived a life of piety dedicated to religious art. He worked almost exclusively in the service of the Dominican Order in Fiesole, and then at the Church of San Marco in Florence for Antonino Pierozzi, later canonized as Saint Antonine.

The decaying buildings of San Marco were given to the Dominicans in 1436, and, financed by the Medici, the church and adjoining monastery were completely refurbished. Between 1438 and 1445, Fra Angelico and his assistants, probably also monks, decorated the chapter house, corridors, and forty-four monks' chambers. Eventually Fra Angelico himself became prior of San Marco.

Fra Angelico's works are generally noted for graceful, delicate forms inhabiting light, idyllic spaces. In the private spaces for the monks at San Marco his style differs in tenor, as his scenes lighten the heart without sacrificing the severity or seriousness of the institution's purpose. The cells of the monastery were anything but ornate. They were deliberately spare, tight spaces with bare plaster walls adorned by a single large fresco on one wall. Fra Angelico limited his color schemes to luminous but muted harmonies of pastels, and his narratives, even when lively, retain a sense of calm resolve established by resolute horizontals and vertical compositions, reserved gestures, and somber expressions. Here, in the scene of *Christ Mocked*, Fra Angelico displayed his versatility, combining his normal simple charm with a profound sense of mystery.

Each decorated chamber includes a Dominican monk demonstrating precise gestures of piety, reflection, and reverence in relation to a gospel scene. In the chamber adorned with this painting, the monk on the lower right and the lay woman to the left seem to take no notice of the vision behind them. The disjointed scene at the rear shows Christ seated on a simple block, holding an orb and scepter, but his majesty is mocked. He is blindfolded, and a mysterious head and hands surround him. The imagery is based on gospel accounts of Jesus's torture by the temple guards and the Romans before his crucifixion. According to Luke (22:63–65): "The men who were guarding Jesus began mocking and beating him. They blindfolded him and demanded, 'Prophesy! Who hit you?' And they said many other insulting things to him."

Other details conflate episodes from the other three Gospels. Matthew (27:27–31), for example, tells: "Then the governor's soldiers took Jesus into the Praetorium and gathered the whole company of soldiers around him. They stripped him and put a scarlet robe on him, and then twisted together a crown of thorns and set it on his head. They put a staff in his right hand and knelt in front of him and mocked him. 'Hail, king of the Jews!' they said. They spat on him, and took the staff and struck him on the head again and again. After they had mocked him, they took off the robe and put his own clothes on him. Then they led him away to crucify him."

The harshness of the scripture is beguilingly tempered by Fra Angelico's harmony of pastel colors, the softness of the outlines, and the simplicity of the composition. Rather than a scene to incite anger or pity at Christ's demeaning treatment, Fra Angelico achieves an image that inspires deep, quiet reflection.

ONE OF CHRIST'S TORMENTORS
DERISIVELY DOFFS HIS HAT
AND SPITS CONTEMPTUOUSLY.
THE DISEMBODIED HEAD AND
HANDS CONVEY A DEGREE OF
ABSTRACTION AND UNREALITY
THAT CONTRASTS WITH
CHRIST'S SCULPTURAL, EVEN
MONUMENTAL, PRESENCE.

CHRIST'S BIFURCATED BEARD
CORRESPONDS TO "LENTULUS'S
LETTER," A DESCRIPTION
BELIEVED TO BE CONTEMPORARY
WITH CHRIST. THE SLIGHT BUT
ELOQUENT TWIST AND TURN OF
HIS HEAD INDICATES HIS HUMAN
NATURE, THE PART OF HIM
SUFFERING HUMILIATION
AND VIOLENCE.

CUFFED AND BEATEN AND
GIVEN AN ORB OF THE HEAVENS
IN RIDICULE, CHRIST IN HIS
MONUMENTALITY IS MORE
REAL THAN HIS DISEMBODIED
TORTURERS.

FRA ANGELICO'S GENTLE IRONY
ASSERTS THAT CHRIST, THE
TRUE KING OF HEAVEN, WAS
MOCKED AS A FALSE ONE. HIS
WHITE ROBE FORETELLS THE
RESURRECTION, WHILE THE
RED ON WHICH HE SITS
SYMBOLIZES BOTH ROYALTY
AND THE PASSION.

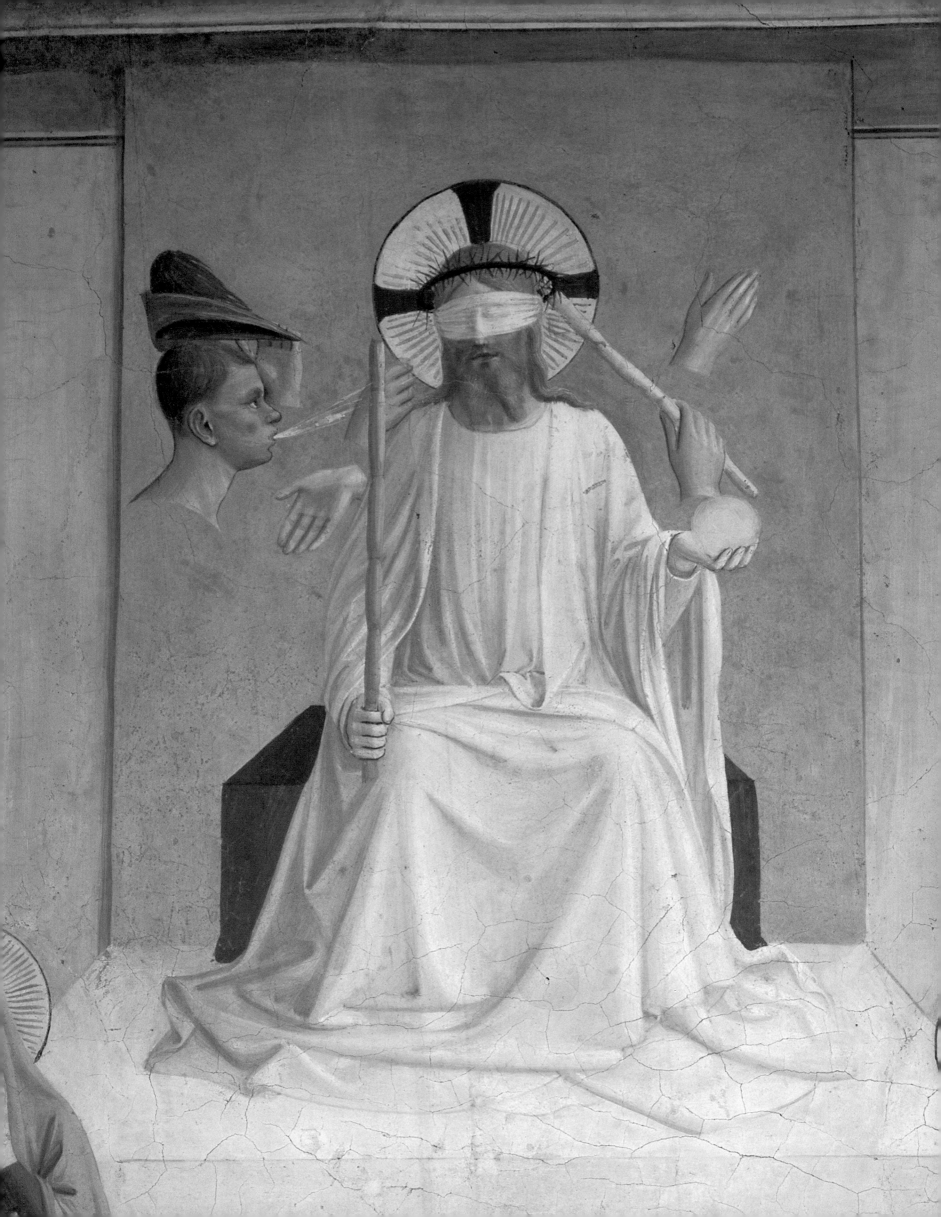

PIERO DELLA FRANCESCA

(1416/17–1492)

The Triumph of Federico da Montefeltro

CA. 1472

OIL AND TEMPERA ON PANEL
18 ½ X 13 IN.
UFFIZI GALLERY, FLORENCE

A CHARIOT pulled by white horses moves across the scene. An expansive landscape of hills, rivers, and fields dotted with trees stretches across the background. The chariot is crowded with people who flank a man in armor seated at the center. Underneath the scene, separated by a piece of painted architecture, is an inscription. It is painted to look as if carved into marble.

This scene is a remarkable piece of personal propaganda on behalf of Duke Federico da Montefeltro. It forms the back side of a portrait of the duke that was also painted by Piero; a matching pendant shows Federico da Montefeltro's wife, Battista Sforza.

Born an illegitimate son of the former duke, Montefeltro was a *condottiere*, a renowned military general available for hire to the highest bidder. Armed with his own independent army, a comprehensive understanding of both classical and modern techniques in the martial arts, and a driving ambition, Montefeltro took over leadership of the duchy of Urbino in 1444. In addition to his military skills, Montefeltro had training in classical education, including poetry, arithmetic, and the arts. He read, and admired, classical literature, and assembled a famous library of texts. Montefeltro was a passionate collector, spending more money than any other ruler of his day on the arts. In paintings, architecture, and other media, Montefeltro used art to assert his claim to power, to establish the nature of his leadership as benign and beneficial, and to display his magnificence, erudition, and power.

Many of Montefeltro's interests can be seen in this work. In particular, there are several overt references to the Imperial Roman past, here brought triumphantly back to life in the person of Montefeltro. The chariot and the folding field chair on which Montefeltro sits were both Roman objects used by Roman generals. Behind the sitter, a winged figure (either a Roman *nike*, or Victory figure, or a Christian angel) crowns Montefeltro with a laurel wreath. Since ancient times, laurels signified a victor. Below, the inscription is carved to resemble a Roman inscription. Like those texts, it records history and claims a position of importance for the subject.

Other details are tuned to the audience of Urbino in the 1470s. The secondary figures on the chariot are the four Cardinal Virtues, familiar to Christian audiences. Justice, with her scales and sword, sits facing the viewer. Prudence, in yellow, sits looking into her mirror. Behind her, Fortitude grasps her column and looks across at the viewer. Temperance is seen from the back— her usual bridle is not visible. A putto, the personification of love, drives the chariot. The serene and productive landscape behind is a generalized portrait of the landscape around Urbino. Viewers would have easily read the figures as referring to Montefeltro's own virtues as a leader, the Roman elements as a reference to his military triumphs, and the landscape as a message about the benefits of his enlightened rule. The Latin inscription below flatters those viewers who shared Montefeltro's interest in arcane classical learning.

Piero's crystalline painting suffuses the scene with bright noonday sunlight. An expert in perspective, Piero makes space and placement

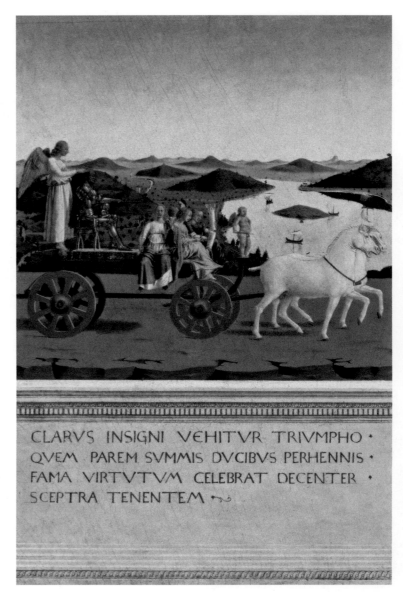

CLARVS INSIGNI VEHITVR TRIVMPHO ·
QVEM PAREM SVMMIS DVCIBVS PERHENNIS ·
FAMA VIRTVTVM CELEBRAT DECENTER ·
SCEPTRA TENENTEM ·

absolutely logical in their recession into depth (note the carefully articulated horses' legs, or the obscured view of Temperance). Even the landscape behind is painted with a kind of preternatural placidity, under an eternally blue sky. In addition, Piero's use of color was symbolically vested and visually important: the white horses convey purity, as does the Victory/angel. Blue, red, and yellow (the fundamental primary colors) tie Montefeltro and the Virtues together, relating him explicitly to their attributes. The painting is a pictorial tour de force, and a blatant piece of self-promotion by the patron. In the service of that goal, Piero makes logic, rationality, and clarity appear both natural and eternal—all under Montefeltro's rule.

THE ANCIENT ROMAN MILITARY
PROCESSION KNOWN AS A
TRIUMPH PROVIDED A SYMBOL
EMBRACED BY RENAISSANCE
EUROPE. FEDERICO'S ARMOR
IDENTIFIES HIM AS PRIMARILY
A SOLDIER, THE SOURCE OF HIS
FAME AND POWER. A CUT IN THE
LANDSCAPE VISUALLY EXTENDS
THE LINE OF HIS SCEPTER.

THE SUGGESTION IS THAT
FEDERICO DA MONTEFELTRO WAS
MASTER OF ALL WE SURVEY. THE
REGULAR PATTERNS OF GENTLE
HILLS AND TREES CONVEY PEACE
AND PREDICTABILITY. ON THE
RIVER, SHIPS ARE COMING IN,
IMPLYING COMMERCE AND
PROSPERITY—FURTHER
BENEFITS OF PEACE.

JUSTICE'S POSTURE IS FIRMLY
PLANTED, TO RESIST THE
JOSTLING PRODUCED BY THE
TURNING WHEELS, WHICH
MAY STAND FOR CHANGES IN
FORTUNE. HER FRONTAL
PLACEMENT BEFORE THE
LANDSCAPE SHOWS THAT
JUSTICE GOVERNS ALL.

A COLUMN INDICATES
STRENGTH AND STABILITY,
WHILE A BROKEN COLUMN
MAY INDICATE ADVERSE
CIRCUMSTANCES, WHICH IS
WHEN FORTITUDE EMERGES.

HUGO VAN DER GOES

(CA. 1440–1482)

The Portinari Altarpiece

1476–1479

OIL ON PANEL
8 FT. 3 ⅝ IN. X 19 FT. 2 IN.
UFFIZI GALLERY, FLORENCE

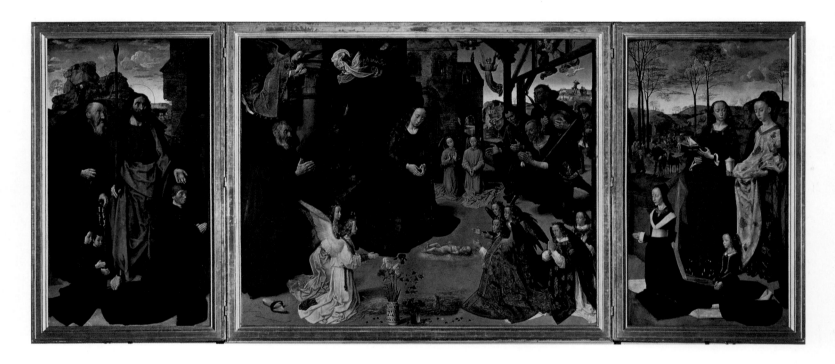

UGO van der Goes was one of the great visionary painters of the later fifteenth century. In some ways his work was deliberately old-fashioned, harkening back to medieval principles in manipulating space and scale, and seeking the viewer's emotional response rather than rational appreciation. His masterpiece was the giant 8 x 19-FOOT *Portinari Altarpiece*, ordered in 1475 or 1476 by an Italian banker living in Flanders, and sent back to his family chapel in Florence. It caused an immediate sensation.

The triptych represents Tommaso Portinari with his two sons, Antonio and Pigello, on the left panel. Saint Anthony Abbott, the hermit tortured by demons, and the apostle Thomas, marked by the spear of his martyrdom, present them to the scene of the Nativity in the central panel. In the distance is a scene of the Flight into Egypt. Portinari married his wife, Maria Baroncelli, when she was only fourteen and he thirty-eight years old. Maria and their eldest child, Margherita, are shown in the right panel, accompanied by Mary Magdalen, who is holding a jar of ointment that she used to tend Christ, and St. Margaret, an early Christian martyr who was imprisoned because she refused to marry the prefect of Antioch. When St. Margaret was tortured and devoured by Satan in the form of a monster, her cross caused the monster to burst open and she escaped unharmed. The monster's head emerges from the ground beneath her feet. In the distance, a kneeling beggar points the direction to the Nativity to a dismounted horseman, while the three Magi and their entourage advance along the winding road.

A third son, Guido, was born to Tommaso and Maria in 1476 and is not present, thus giving a plausible date for the painting. Hugo likely could not have made such an involved painting much later in his life, for in the years following he entered a monastery called the Roode Klooster, where he was treated for profound melancholy and madness.

The main panel must have struck Italian audiences as especially moving. In the south, the Nativity was usually presented as one of the Joys of the Virgin, but here the spirit is profoundly serious. The scruffy shepherds on the right, first to be informed of Christ's birth in the distant top right of the panel, arrive and kneel in genuine worship. Van der Goes always portrayed the poor and humble of heart in a positive light. On the left, Joseph looms large and similarly grave in his prayer. He has removed his shoe, like Moses before the burning bush, to honor the sight of God and the sacred ground. The Virgin Mary looks down at her radiant son with sorrow as he lies bare on the ground, "the living bread which came down from heaven" (John 6:51). His frailty is a portent of his future suffering. Curiously small in scale are two clusters of angels wearing priestly vestments. These are exactly the types of vestments prescribed for assistant priests at the first solemn mass to be said by a new priest. The Christ child is thus both priest and the sacrifice itself. The foremost angel of the right group wears a cope with the word "sanctus" repeated, alluding to the segment of the Mass just before the transubstantiation of the bread and wine. This is symbolized on the ground in the center. The wheat represents the bread, and the grapevines of the left vase represent the wine, of the Mass that is transubstantiated into the body and blood of Christ. The flowers and their colors were chosen by Van der Goes, who was an expert in medicinal plants, to highlight aspects of the Passion and salvation.

THE HARP IS OFTEN ASSOCIATED
WITH THE BIBLICAL KING DAVID,
BELIEVED BY CHRISTIANS TO BE
AN ANCESTOR OF CHRIST. THE
INSTRUMENT WOULD THUS
IDENTIFY THE STRUCTURE
AS—LITERALLY—THE HOUSE
OF DAVID.

LIKE THE DONORS—AND THE
ORIGINAL VIEWERS OF THE
TRIPTYCH—THESE TWO WOMEN
ARE DRESSED IN CONTEMPORARY
COSTUME AND PLACED OUTSIDE
THE HOLY CIRCLE. THEY APPEAR
UNAWARE OF THE EPOCHAL EVENT
TAKING PLACE, A WARNING TO
THOSE OF TEPID FAITH.

THE ANGEL'S OPEN PALMS
EXPRESS WONDER. THROUGHOUT
THE PAINTING, THE FIGURES'
VARIOUS GESTURES ADD
EMOTIONAL AND SPIRITUAL
DEPTH TO THE SCENE.

ORANGE LILIES PORTEND CHRIST'S
PASSION, WHILE THE WHITE AND BLUE
OF THE IRISES STAND FOR THE VIRGIN'S
PURITY AND HER TITLE OF QUEEN OF
HEAVEN. COLUMBINE SYMBOLIZES BOTH
THE HOLY SPIRIT, THROUGH WHOM THE
INCARNATION TOOK PLACE, AS WELL AS
MELANCHOLY. THE LATTER MEANING
COULD RELATE TO MARY'S FUTURE
GRIEF AT HER SON'S DEATH, OR THE
ARTIST'S OWN AFFLICTION.

ON THE EDGE OF THIS
PRIESTLY VESTMENT, SANCTUS
APPEARS THREE TIMES, AS IN
THE LITURGY OF THE MASS,
WHERE EACH ITERATION IS
ACCOMPANIED BY THE RINGING
OF A BELL, TO AWAKEN THE
FAITHFUL TO THE MYSTERY OF
THE TRANSUBSTANTIATION.

WHEN HE LIES ON THE
GROUND, THE CHRIST
CHILD SYMBOLIZES
THE HUMILITY OF THE
GODHEAD MADE MAN.
THE RAYS AROUND HIM
ECHO THE SHEAF OF
WHEAT SYMBOLIZING
THE EUCHARIST, THAT
IS, CHRIST'S SACRIFICE
REPEATED IN THE CERE-
MONY OF THE MASS.

HUGO VAN DER GOES
(CA. 1440–1482)

The Portinari Altarpiece
1476–1479

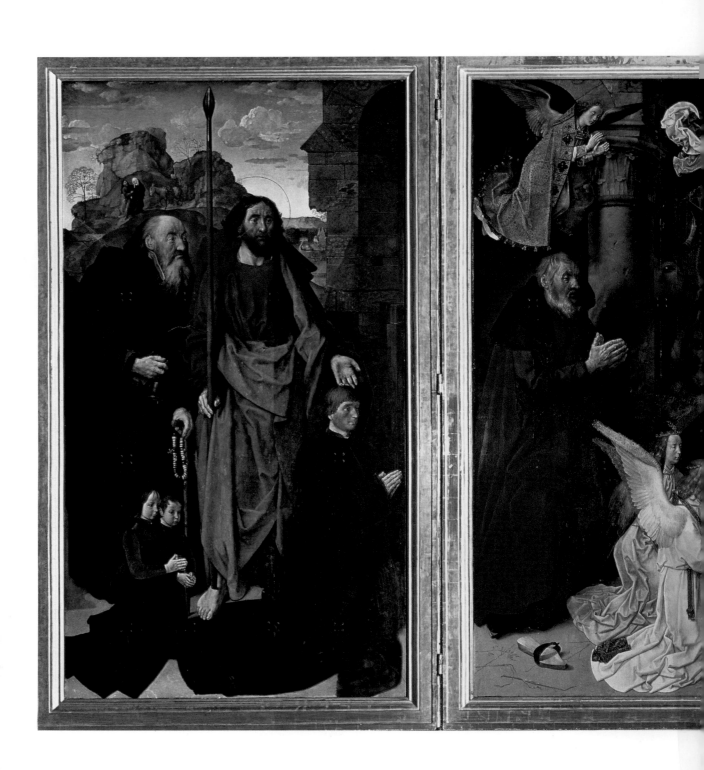

LIKE THE OTHER OBJECTS IN
THE *studiolo*, THE CARDINAL'S
HAT IS CONTEMPORARY WITH
THE PAINTER, NOT THE
SUBJECT. IT IS ONE OF
THE SAINT'S ATTRIBUTES,
HOWEVER, BECAUSE OF HIS
SERVICE TO A POPE.

JEROME'S STUDY IS VERY SMALL AND
COMPACT. RENAISSANCE THEORISTS
LIKE LEONARDO BELIEVED THAT SUCH
studioli MADE IT EASIER TO FOCUS THE
MIND. THE HEBREW SCROLL, PRAYER
BEADS, AND WRITING INSTRUMENTS
ARE EMBLEMS OF JEROME'S ACTIVITY:
HIS SCHOLARSHIP, PIETY, AND PROJECT
TO RENDER THE BIBLE IN LATIN—
MORE ACCESSIBLE THAN THE ORIGINAL
HEBREW AND GREEK.

DIVINE INSPIRATION IN
THE FORM OF A POWERFUL
WHITE LIGHT SHINES ON
THE AGED SCHOLAR, AS IF
A VISIBLE COUNTERPART OF
THE INSCRIPTION ABOVE
THE SCENE. HIS INTENSE,
CAREWORN GAZE RECALLS HIS
REPUTATION FOR IRASCIBILITY.

THIS EXCERPT FROM THE
PSALMS, LIKE THE HEBREW
QUOTE ABOVE, BRINGS OUT
JEROME'S STRONG PENITENTIAL
INCLINATION: HE IS OFTEN
SHOWN BEATING HIS BARE
BREAST WITH A STONE.

THE BOOK ON THE LECTERN
ILLUSTRATES THE USE OF THE
BLACK AND RED INK IN THE
VIALS ATTACHED TO JEROME'S
DESK. RED WAS FOR SIGNI-
FICANT PASSAGES OR, IN
CALENDARS, IMPORTANT
RELIGIOUS FEAST-DAYS,
THAT IS, RED-LETTER DAYS.

DOMENICO GHIRLANDAIO

(1448/49–1494)

St. Jerome in His Study

1480

FRESCO
72 ½ X 46 ⅞ IN.
CHURCH OF OGNISSANTI, FLORENCE

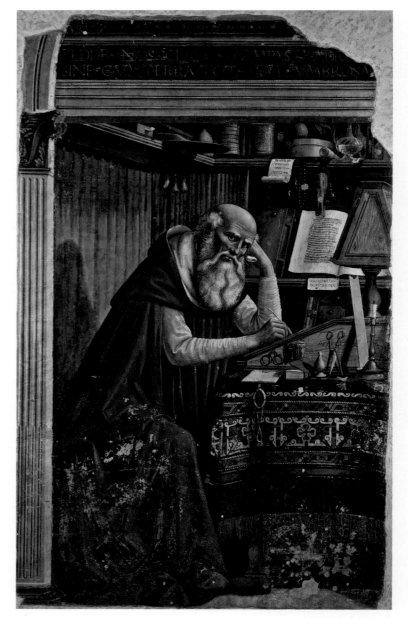

GHIRLANDAIO'S *St. Jerome* was painted in 1480 for a member of the Vespucci family and positioned to the left of the door leading into the monks' choir in the Church of Ognissanti in Florence. The most famous member of this family, the merchant, cartographer, and explorer Amerigo Vespucci, would soon give his name to the continents of the New World. On the opposite side of the door was Botticelli's *Saint Augustine*. Here two of the major artists in Florence went head-to-head in an artistic challenge. Most observers felt that Botticelli's figure was more fluid and graceful, and some derided Ghirlandaio's as being too static. Ghirlandaio had based his image on a painting of Saint Jerome in the Medici collection, thought to have been painted by Jan van Eyck but now attributed to that great master's follower Petrus Christus. The positions of the saint's body, head, and arms are quite similar to the Northern European precedent, as are the concentration on surface textures and the play of light.

Jerome is perhaps shown engaged in his translation of the Bible from Greek to Latin, part of which came to be known as the Vulgate, during the fourth century C.E. His familiarity with languages is related through the texts in Latin, Greek, and Hebrew scattered throughout the scene. The frieze above, taken from a hymn to Jerome by the fifteenth-century jurist Johannes Andreae, reads: REDDE NOS CLAROS RADIO[SA] / SINE QUA TERRA TOTA EST UMBROSA (Illuminate us, O radiant light, otherwise the whole world would be dark). The slip of paper at the center of the lower shelf is a Greek text from Psalm 51, and translates as "O God have mercy on me according to your great pity." On the top shelf is a slip of paper with Hebrew text that is only partially legible. The top two lines include the names of angels Kemuel and Uzziel, and the second two read in translation, "I still call out in anguish/My lament is troubling me."

The date of the painting is inscribed as if carved into the side of Jerome's writing taboret. Hanging on the side are a pair of eyeglasses and two glass inkwells for dipping his quill pens, one in black for the main text and the other red for rubricating. The two colors of ink can be seen splattered about on the desk. He also has a couple of small books, a turned wooden tool perhaps used to emboss gilding, a pair of scissors, a rule for measuring and drawing lines for text, and a candle to work diligently into the night. The cloth covering the table contains a complex geometric pattern, reminiscent of Persian carpets. This would be an appropriate item for Jerome, since after studying in Rome he made a long pilgrimage to the Middle East, spending time in Antioch and Constantinople, and a period as a hermit in the Syrian desert. Later he established a convent and monastery at the site of the Church of the Nativity in Bethlehem. A lectern surmounts his portable bureau, and there are more books on the shelves, although the majority are covered by the green curtain spread behind him. Along the top shelf are his cardinal's hat, anachronistic Islamic majolica jars called *albarelli*, fruit

and a container, two glass carafes, and an hourglass. The jars, a type associated with apothecaries, may refer to the healing powers of Christ. Jerome, too, was regarded as a healer of mankind. The fruit is a common symbol of redemption of sin, and the carafe with water and light reflections is a motif often seen, especially in Eyckian painting, as an attribute of the Virgin Mary to refer to her purity. As the light passed through the carafe without disturbing it, so was Mary's virginity untarnished by her divine pregnancy. Jerome was one of the earliest, and staunchest, defenders of Mary's purity. Prayer beads and a pen case and inkwell hang down from the shelf.

A RIDER ON A HORSE SYMBOLIZES THE RESTRAINT OF UNRULY PASSIONS. LEONARDO WOULD REUSE THIS FIGURE FOR HIS UNFINISHED *Battle of Anghiari.*

IN A CHRISTIAN CONTEXT, THE VICTORY REPRESENTED BY THE PALM TREE IS USUALLY MARTYRDOM. THE TREE IS ON AN AXIS THAT FALLS BETWEEN MARY AND THE CHILD, PERHAPS SYMBOLIZING THE CRUCIFIXION THAT WILL DIVIDE THEM OR CHRIST'S TRIUMPHANT RESURRECTION.

THE CHRIST CHILD'S GESTURE TO THE KING STRENGTHENS THE DIAGONAL LINE THAT FORMS ONE SIDE OF AN EQUILATERAL TRIANGLE, THE MOST STABLE OF GEOMETRIC FORMS, WHICH ALSO RECALLS THE TRINITY.

CREATING A SECOND TRIANGLE IS THE FIGURE OF ONE OF THE THREE KINGS. HE HOLDS WHAT APPEARS TO BE THE LID OF A CONTAINER, PERHAPS TO RELEASE THE SCENT OF FRANKINCENSE OR MYRRH INTO THE HOLY SCENE.

THIS GESTURE OF WONDER MAY BE DIRECTED AT THE STAR THAT GUIDED THE THREE KINGS, OR AT A VISION OF THE CRUCIFIXION IMPLICIT IN THE WOOD OF THE TREE.

LEONARDO DA VINCI

(1452–1519)

The Adoration of the Magi

1481

OIL ON PANEL
8 FT. X 8 FT. 1 IN.
UFFIZI GALLERY, FLORENCE

LEONARDO da Vinci began *The Adoration of the Magi* in March 1481. The painting, for the monastery of S. Donato at Scopeto (outside Florence), was commissioned by the monks with the proceeds from a recent gift. The altarpiece was to show the Adoration of the Magi (Kings) and to be completed within twenty-four to thirty-six months; unfortunately, Leonardo left Florence in the winter of 1481 for Milan, never to return. The *Adoration* remains an unfinished work, famous both for its masterful execution and its unrealized potential. Even though a later hand has strengthened the dark wash, the painting shows strong tonal contrasts. These represent an early stage in the painting process, when Leonardo set out the highlights and shadows of the composition. Here, the Virgin and the kings were clearly brightly lit, while the crowd around her would have emerged out of the shadows.

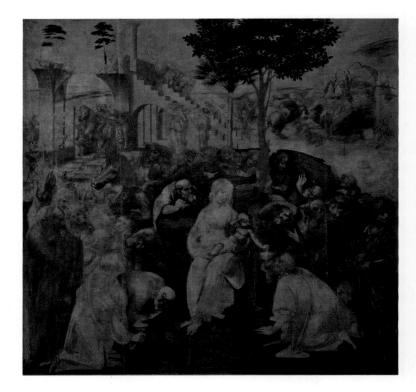

In the painting, the primary focus is on the Virgin. She sits holding the Christ child in the center foreground; the three kings kneel to her right and left. Surrounding them, and clambering over the rocky hill behind her, are many other figures. These folks appear to be drawn magnetically to the scene; they stare, gesticulate, and peep over the outcrop at the holy figures. An expansive landscape fills the far background, with a large but ruined building populated by figures and horsemen on the left. On the right, more horsemen joust and fight. The prevalence of these muscled animals locked in combat may convey the passions of the human condition or the uncontrollable force of nature.

The Adoration of the Magi tells the story of the three kings from the Nativity narrative in the Bible. Having been guided by a divine annunciation, the kings arrived in Bethlehem twelve days after Christmas. Their arrival and recognition of the divinity of the child became known as Epiphany. Subserviently kneeling, the kings offer tribute in the form of gifts (gold, frankincense, and myrrh) to the child. The gifts underscore Jesus's dominion over the world of men (even though he was only a baby). In Florence, scenes of the presentation of gifts by the kings were extraordinarily popular, probably because the Florentine merchants saw the scene as a justification of their own pursuit of material riches. In return, Jesus's recognition of the kings' gifts as worthy ones sets a divine seal of approval on the possession of wealth. The lower-class types on the right side are the shepherds, who stand for the masses in this populist religion. Their expressions of amazement, consternation, and faith operated both as a virtuoso demonstration of Leonardo's expressive naturalism, and as a marker of the transparent simplicity of the poor.

The building on the left is a symbol of the pagan Roman world; its destroyed state indicates the triumph of the new church, represented by a sketchy stable in the far right background. The large piers with the remains of sweeping arches may refer to the Roman Basilica of Maxentius and Constantine. Carefully constructed using the geometric forms of linear perspective, the building provides a frame for the retinue of the kings to move about. On the plaza, women (perhaps sibyls, ancient prophetesses) stand, while under the destroyed arches horses and riders mill about. One reaches out to restrain a frenzied horse, her gesture conveying the force of virtue over the animal passions. A similar effect may be seen in the dramatic contrast between the peaceful Virgin and child and the roiling emotions of the encircled onlookers. According to Christian thinking, they, too, will be brought to peace by the events unfolding.

Two trees grow on the hill behind the Virgin. Their prominent placement at the apex of the hall suggests a symbolic meaning. One is a palm tree, representative of victory, and in its graceful erectness is a metaphor for the Virgin from the Song of Songs. The other has yet to be fully identified, but may be an ilex tree, from which the crucifix was fashioned. Thus even though Jesus is shown here as a contented baby, his ultimate death by crucifixion is prefigured in the tree behind him.

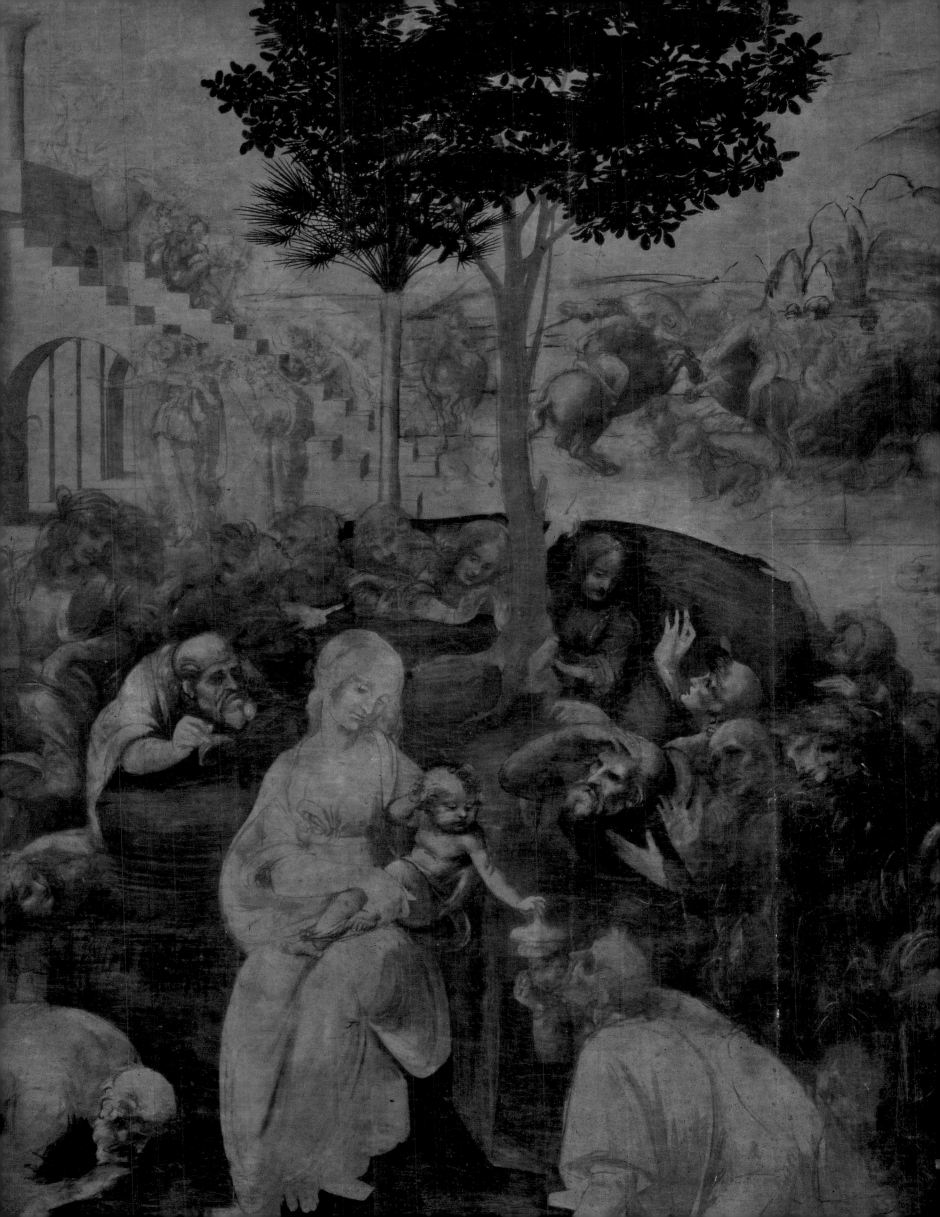

SANDRO BOTTICELLI

(1444/45–1510)

La Primavera (Spring)

CA. 1480

TEMPERA AND OIL ON PANEL
95 ⅝ x 96 ⅞ IN.
UFFIZI GALLERY, FLORENCE

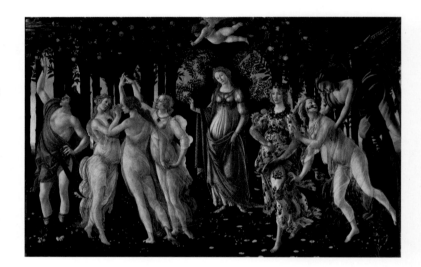

THIS painting is an allegory, using classical myth to invoke poetic thoughts about love, marriage, and nature. Venus stands in the center of a garden, her right arm outstretched in a gesture of welcome to the viewer. Behind her is a grove of fruit-bearing trees; their black trunks, inscribed against the blue sky beyond, frame the back of the space. Underfoot, the ground is carpeted with flowers and plants, while the lush canopy above is dotted with dangling fruit. In this zone of ripeness and fertility, presided over by Venus, a group of figures enacts a variety of mythological stories.

The composition begins at the right, as Zephyr (a wind god) swoops down from the sky. His long wings and bluish coloring, as well as his tempestuous advance, signal his atmospheric origin. In both hands he grasps the supple body of the wood nymph Chloris. The story depicted here is based on a tale recounted by the ancient writer Ovid. Zephyr's passion for Chloris led him to pursue her against her will; as a result of their union (and despite the fact that she was less than willing), Chloris became Flora, goddess of spring. Botticelli makes the transition from virginal nymph to goddess visually evident in several ways. The transparent white robes on Chloris shift to become the gorgeous embroidered gown of Flora. As well, he paints Chloris's turning body so that it intertwines with the figure of Flora, linking the two. Lastly, Chloris emits from her mouth a string of flowers. This strange detail may refer to a line in the story from Ovid's poem *Fasti*, which says, "her lips breathe spring roses." Botticelli shows her poetic transformation in concrete form; the flowers from her mouth merge with the blossoms on the costume of Flora, and in her lap. As Flora strides confidently forward, casting flowers everywhere, she represents the epitome of fertility, beauty, and youth.

This story of (at least one kind of) love and marital union is matched on the left side of the painting. The Three Graces dance in a circle. Their linked arms make a graceful pattern across the surface of the painting, while the elegant profiles of their bodies are revealed through the clinging drapery. The Three Graces were the daughters of Zeus and Eurynome. They personify the attributes of the perfect woman: beauty, sensuality, and chastity. Their relationship to love is made clear in the figure of Cupid hovering over Venus. Blindfolded, Cupid aims his arrow at one of these lovely ladies, starting the cycle of love again.

The connection of the painting with poetry has long been noticed. All the women conform to the Petrarchan ideal of feminine beauty: blonde hair, blue eyes, white skin, red lips, and curvaceous, fecund bodies. In the celebration of youth, enjoyment, the beauties of nature, and the joys of the season, the painting may reflect poems by Horace and Poliziano greatly admired at the time. The poetic aspect of the painting may also explain the lack of a continuous, specific narrative. Instead, the vignettes invite musing on the themes of love, beauty, marriage, and the seasons.

By contrast, the figure of Mercury turns away from the Graces. Looking to the upper left, Mercury, the messenger god from the ancient pantheon, is identified through his winged boots and the caduceus in his hand. With it, he reaches up, bringing attention to the clouds hovering in the upper left corner. The figure of Mercury and his mysterious action have been variously interpreted, ranging from his role as protector of this sacred garden (he dispels the clouds) to an admonition to pay attention to higher things (he points the way). Separated from the rest of the group, Mercury clearly plays a different role in the painting than the other figures. He may serve as the incarnation of active, intellectual pursuits—versus the more physical and sensual activities on the right.

The painting was probably a wedding gift, given at the occasion of the nuptials of Lorenzo di Pierfrancesco de' Medici and Semiramide Appiani in 1482. Though we do not know the patron, documents tell us that in 1498 the Botticelli painting hung in the chambers of Semiramide in the couple's home in Florence, over a daybed. While some suggest that the Venus figure here is a representation of Semiramide herself, and Mercury is Lorenzo di Pierfrancesco de' Medici, no firm evidence for such identifications survives. Rather, the painting and its associated poetic texts reflect the love of physical things (nature, beauty, spring, and fine painting) and the taste for abstract thinking (classical learning, poetry, theology, and art) that made the Renaissance such a compelling period in history and art.

VENUS'S FEATURES, LIKE FLORA'S,
ARE BOTH POETICALLY IDEALIZED
AND SPECIFIC. THIS QUALITY HAS
INSPIRED SPECULATION ABOUT
THE IDENTITY OF THE MODEL
OR MODELS.

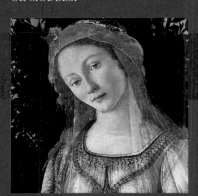

THE METAPHOR OF FRUIT-
FULNESS IS LITERALLY
OVERARCHING.

VENUS OVERSEES BEAUTY,
HARMONY, AND ABUNDANCE.
BENEATH THE SIGN OF CUPID,
THE GENTLE, FRUITLIKE SWELL
OF HER BELLY SUGGESTS
FERTILITY.

FLORA IS ABOUT TO STREW THE
FLOWERS SHE HAS GATHERED.

DISHEVELED, VULNERABLE,
AND TERRIFIED—PERHAPS
LIKE A VIRGIN BRIDE—
CHLORIS ATTEMPTS TO FLEE
WHAT IS ABOUT TO BEFALL
HER. THE ARTISTS IS
SHOWING HER TRANS-
FORMATION TO SERENE
PLENITUDE AS A RESULT
OF THE SEXUAL CONGRESS
THAT TAKES PLACE.

SANDRO BOTTICELLI
(1444/45–1510)

La Primavera (Spring)
CA. 1480

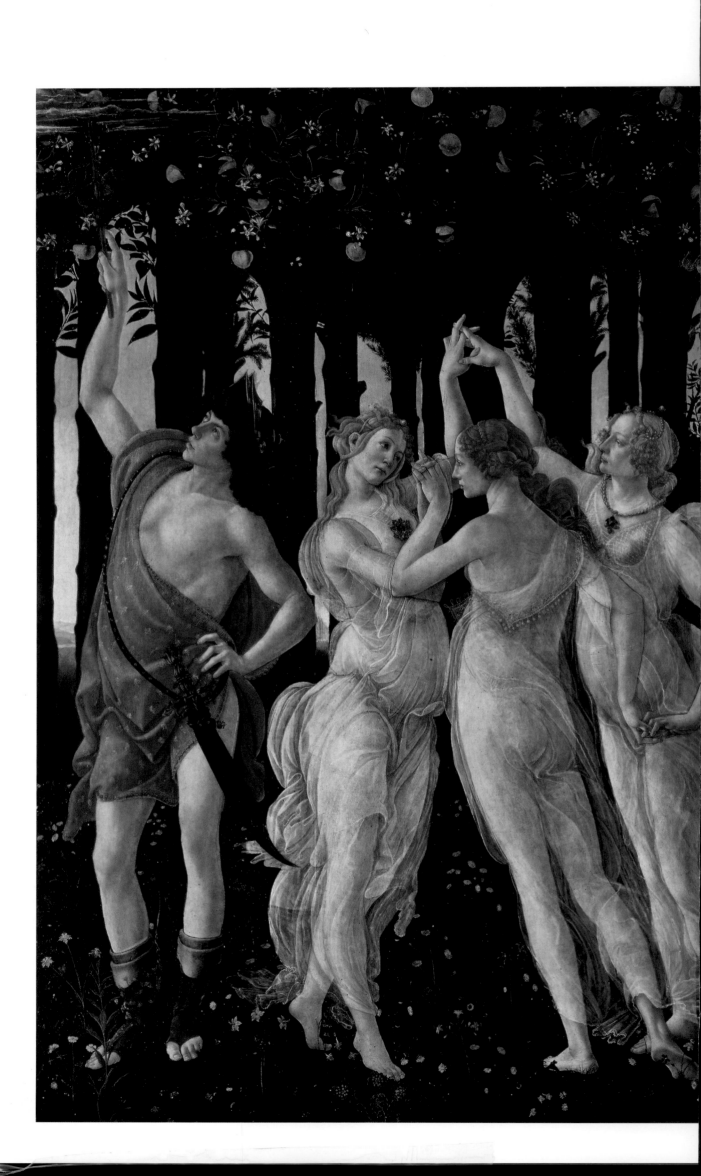

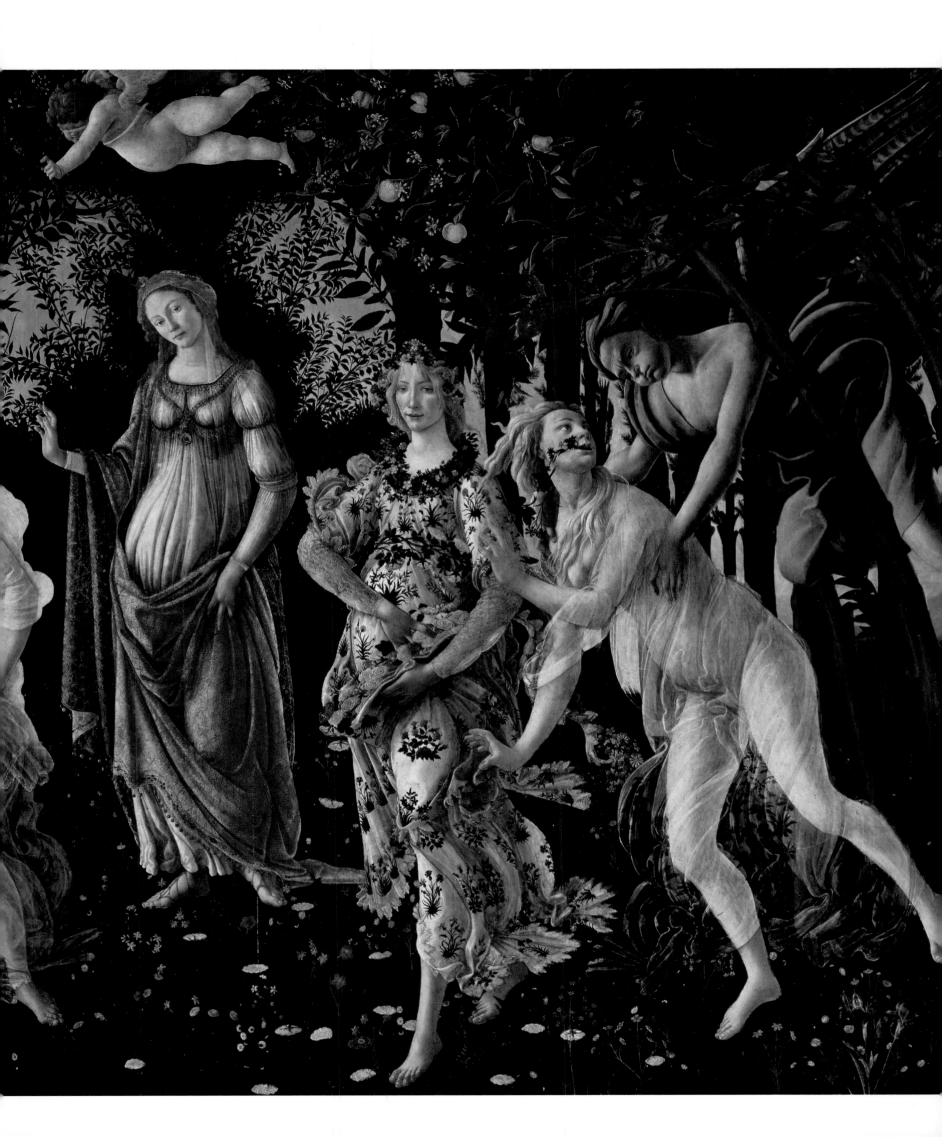

PIETRO PERUGINO

(CA. 1450–1523)

Marriage of the Virgin

1499–1504

OIL ON PANEL
92 ⅛ X 72 ⅞ IN.
MUSÉE DES BEAUX-ARTS, CAEN

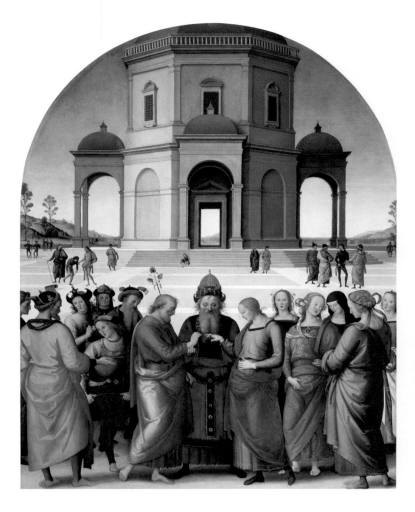

THE *Marriage of the Virgin* is an altarpiece, commissioned for a chapel within the Cathedral of Perugia, Perugino's home town. The composition is organized symmetrically, with groups of figures on either side of the central priest. At the very center, in the foreground, Joseph is about to place a ring on the outstretched finger of Mary. Behind, a plaza stretches back to a temple—its centralized plan and classical details emphasize its antiquity. Various figures are scattered on the plaza. They demonstrate Perugino's mastery of the technique of scientific perspective. First publicized by Alberti, perspective allowed artists to use math and geometry to convincingly create the illusion of three-dimensional space on a two-dimensional surface. Its use became a signal of modernity and ability among Renaissance artists.

The marriage of the Virgin is an apocryphal tale, one that does not appear in the biblical Gospels. The probable source for this scene is Jacopo da Voragine's *Golden Legend*, a thirteenth-century compendium of popular stories that elaborated and enhanced biblical narratives. According to the *Golden Legend*, when Mary was fourteen and living among the women in the temple, the high priest decreed that she should be married. He called all the eligible men who were descendants of the house of David to bring a rod to the temple; the man whose rod burst into flower would marry the desirable virgin, Mary. Joseph, despite his advanced age (Perugino paints him as bearded, balding, and weathered), was the husband designated by God.

Perugino embeds the narrative in the reactions to the marriage and the background figures. The suitors gather behind Joseph. Opulently dressed, they are clearly eligible bachelors, and some are angry about being rejected; one breaks his rod over his knee. The suitor in the left corner provides a different, more appropriate response. He gestures to Joseph and reminds the others to accept their fate, since Joseph had been chosen by God. A similar lesson is taught in the middle ground behind this group, where another man enacts his despair and anger by breaking a rod; a figure looking remarkably like the resurrected Christ reminds him of God's will. On the right side, other men with rods discuss the event, providing exemplars of resignation and acceptance. A solitary young man with a different kind of rod sits on the steps of the temple; his short, hairy costume suggests that this may be John the Baptist, awaiting the birth of Jesus to come. However, the lack of halos complicates the identification. The suggestion of subsequent scenes in the narrative continues in Mary's gesture; she lays her hand on her slightly rotund tummy with a conscious gesture, reminding the viewer that the Incarnation had already occurred. The painting uses these details (pregnancy, birth, resurrection) to suggest, around this event, the unfolding of the divine narrative of salvation.

Since the chapel in the cathedral contained the relic of the Holy Ring (thought to be the original wedding ring of Mary), the altarpiece focuses on the giving and receiving of the ring as the central moment. Both

Joseph and Mary are shown in peaceful acceptance of the marriage, and by extension, of the later events of the Christian narrative. The important role played by the Church in this narrative is made obvious not only by the central priest, who guides their hands together, but by the looming building behind him.

In the Renaissance, marriage rituals were not entirely codified, as they are today. Marriage was a legal, financial, and social institution as well as a religious sacrament, and it was not unheard of that couples would marry in private by exchanging vows, documents, and cash payments without entering a church. Indeed, the variety of ways to be married is the central problematic in Shakespeare's later drama *Measure for Measure*. From the position of the Church, however, marriage was a sacrament established by Christ's recognition of the marriage of the couple at Cana. In their view, marriage should be administered by, and controlled by, appropriate clergy. This altarpiece makes that case forcefully. Perugino's perspective system sets the figures in a logical space that leads relentlessly back to the temple. The brightly lit doorway at the center, directly above the priest, gives an aura of divine sanctity to that figure, even though he is dressed in the kind of outlandish costume that, in the Renaissance, stood for the Hebraic world.

Then and now, the Old Testament and the New: the architecture of the temple suggests a Renaissance church. The empty space represents the unrepresentable deity.

The blossoming frond recalls Old Testament miracles. It is also a metaphor for the Redemption that is coming to fruition.

The placement of the ring—just off axis—calls attention to it. Besides its connection with the holy relic in the chapel, the circle, in its perfection, is the symbol of God.

Perugino accentuated Mary's round belly with shading in her traditional blue mantle, her attribute as Queen of Heaven.

This virile young suitor breaks his sterile rod in frustration. More than good looks will be required of Mary's husband. The men are divided from the women, just as they would be within the church for which this altarpiece was made.

GIOVANNI BELLINI

(1431/36–1516)

Virgin and Child Enthroned with Saints

1505

OIL ON CANVAS TRANSFERRED FROM PANEL
16 FT. 5 ½ IN. X 7 FT. 9 IN.
SAN ZACCARIA, VENICE

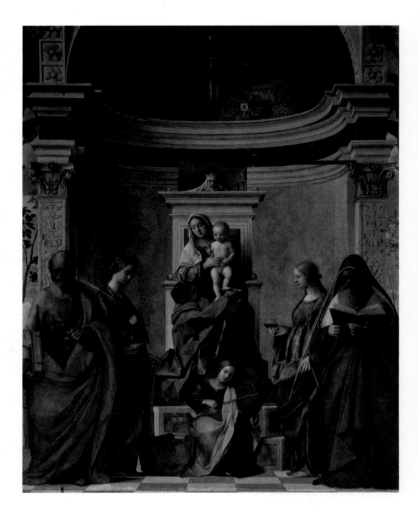

THE San Zaccaria altarpiece is a type of devotional painting known as a *sacra conversazione* (sacred conversation). Bellini shows an open portico with four saints and an angel musician arranged around an enthroned Virgin and Child. St. Peter, dressed in imperial purple and brilliant orange, is at left; an apostle and the first pope, he holds the keys that were given to him by Christ. Next to him is St. Catherine of Alexandria, holding a fragment of a wheel. A royal princess, she was known for her virtue, as well as her rhetorical ability on behalf of Christianity. The emperor Maxentius planned to torture her with a spiked wheel, but it was miraculously destroyed by a thunderbolt from Heaven.

On the right side stands St. Jerome, one of the four fathers of the Church. He wears a cardinal's red robe and is engrossed in a book. Jerome was famous for translating the Bible into Latin: his version, known as the Vulgate, was the official text of the Christian church. Behind him stands an unknown saint. Her palm frond indicates that she was a martyr, and she holds a small jar filled with a green liquid. The four saints shown here do not participate in any narrative, or convey any kind of meaning as a group. Instead, they probably were chosen to reflect the needs of the patrons, as was typical for this type of painting. On the far right and left are slivers of trees and an alpine landscape; the whole scene is bathed in golden sunlight, which recalls the beauty of God's creation.

Though nothing happens in this painting, it is a central work in the Venetian Renaissance. Filled with luxurious, ornamental materials painted in exquisite detail with glowing, vivid colors, the painting mediates between the visible world and the sacred realm. Bellini paints a vaulted space similar to the chapels existing in the church itself, complete with classical details. The space thus appears to be an extension of the physical space of the church. The open tiled floor reaching forward also enhances the sense of direct access to the figures.

However, Bellini also complicates this vision of the sacred figures. Close inspection of the space shows that Bellini consciously manipulates our first sense of this space. For example, the two standing saints at either side frame the scene, but also block the viewer's entrance (as does the angel). The female saints are placed behind and slightly inside these male figures. These female saints appear to stand inside the apse, yet in front of the throne. However, the throne itself is ambiguously placed. It appears to be under the vault, but behind the throne an embroidered cloth of honor hangs from an architectural tie rod set at the front of the space. The space is thus simultaneously naturalistic but illogical, extensive but compressed. Similarly illogical is the perspective system used here, which requires a viewing position well above the viewer's head. Such subtle deviations from expectation vie with the vivid naturalism so that the viewer is both enticed and disoriented. Bellini makes a point, beautifully, about the gap between this world and the sacred one.

Inside the sacred world, then, the saints gather around Mary and Jesus. Mary, in her traditional blue mantle and red robe, grasps the baby Jesus, who makes a blessing gesture with his right hand. Above them, painted as if sculpted into the throne, is the head of God the Father. The embroidery (in the shape of pomegranates, a symbol of the Resurrection) makes a virtual halo around him. In naturalistic terms, Bellini illustrates the central Christian figures: divine father, human son, and the woman who bridged the two. Perhaps the radiating introspective calm of the painting—almost psychological in its intensity—is intended to illustrate the power of reading, prayer, and contemplation to access God.

The church of San Zaccaria was the oldest and most respected nunnery in Venice. Founded in the ninth century, it contained an important collection of relics and art, and was occupied by noble women from the elite families of the Veneto. The fact that the female saints are positioned in closest proximity to Mary may reflect the primary viewing audience of women. Though the prestige of San Zaccaria meant that it was frequently visited by outsiders, the painting may also present an underlying message about women's spirituality and their privileged access to the sacred world embodied here.

THE CROWNED AND BEARDED
FACE MAY BE GOD THE FATHER.

THE CROWNED AND BEARDED
FACE MAY BE GOD THE FATHER.

THE CHRIST CHILD MAKES A
BLESSING SIGN WITH THUMB
AND FIRST TWO FINGERS
RAISED, INDICATING THE
TRINITY.

ST. CATHERINE OF ALEXANDRIA'S
INWARD GAZE EXPRESSES HER
SPIRITUALITY AS WELL AS HER
INTELLECTUALITY.

SAINT CATHERINE OF
ALEXANDRIA RESTS HER HAND
ON THE WHEEL THAT MIRA-
CULOUSLY BROKE WHILE SHE
WAS BEING TORTURED. HER
HAND ALSO APPEARS TO TOUCH
THE VIRGIN'S ROBE, PERHAPS
INDICATING A PATRON
SHARING THE SAINT'S NAME.

THE GLASS VESSEL THE SAINT
HOLDS DISPLAYS ELEGANT
VOLUTES, RECALLING VENICE'S
PRIMACY IN THE PRODUCTION
OF THIS MATERIAL.

THE *cartellino*, OR SMALL PIECE
OF PAPER, GIVES THE LATIN
FORM OF THE ARTIST'S NAME—
JOHANNES BELLINUS—AND
THE DATE IN ROMAN
NUMERALS—MCCCCCV.

SANDRO BOTTICELLI

(1444/45–1510)

The Birth of Venus

CA. 1484

5 FT. 8 IN. X 9 FT. 1 ⅝ IN.
TEMPERA ON CANVAS
UFFIZI GALLERY, FLORENCE

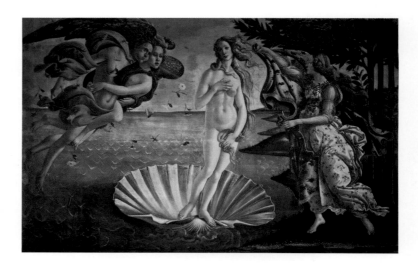

BOTTICELLI'S *Birth of Venus* is one of the most famous images of female beauty in Western art. In this quite large painting, Venus stands at the center, poised on the edge of a shell. The setting shows a landscape; two-thirds of it is undifferentiated sea, while at right one sees an abbreviated view of an undulating coastline with dense trees, the island of Cythera. Land, sea, and the blue sky are all washed evenly by a bright light that shines from upper right onto the figures. Though they are in nature, the figures do not seem to participate in the natural setting; the lack of detail in the landscape (note the formulaic depiction of waves) and the steep dive into the distant space put attention squarely on the foreground figures.

Venus is the center of this work, both visually and metaphorically. Despite the famous title, her birth is not actually illustrated. Venus sprang from the foam of the sea, and in this painting we see her already mature, being washed ashore on the shell of a scallop. She is blown by the wind god Zephyr on the left; the breeze is indicated by lines emanating from his puffed cheeks. The lapping waves around her shell show that she has come gently to rest on Cythera's shores. Venus's form has been the subject of much discussion. She is the first fully nude image of the goddess since antique times. The stance, with tilted hips and shoulders (known as *contrapposto*), derives from classical models, as does her gesture of modesty (known as the *Venus pudica* pose). Botticelli certainly saw examples of classical statuary in the Medici home, one of which (the *Medici Venus*) shows almost this exact pose.

But Venus here is more than just a re-creation of a classical type. Her long golden tresses, dark eyebrows, white skin, and round breasts re-create the ideal model of beauty of the late fifteenth century, which was based on the poetry of Petrarch. One might notice how Botticelli has departed from naturalism in her figure: the neck is very long, the shoulders strangely slanted, and the weightless stance quite bewildering. Unlike contemporaries such as Andrea Mantegna and Leonardo da Vinci, Botticelli appears unconcerned with representing visible reality; his is a vision of godlike grace, beauty, and sensuality, and thus is less concerned with such details as form, volume, or modeling. In fact, Botticelli's painting re-creates a famous but lost painting by the celebrated ancient painter Apelles, court painter to Alexander the Great; this reference to the classical model may explain why his style appears so self-consciously non-naturalistic, and instead of nature emphasizes elegance, refinement, and sophisticated courtliness.

The painting contains several layers of meaning. First is the narrative itself, which tells of Venus's arrival on Cythera and shows her being greeted by a Hora (a classical figure representing the hours, or seasons) with a flowered robe. Venus's association with love can be found in the golden-haired nymph Chloris, who clings to her husband Zephyr, as well as the roses strewn about the painting. Roses are Venus's flower, and some myths say that they were born at the same time as the goddess. The scene also functions as a representation of the arrival of spring. The wind of Zephyr is clearly a gentle breeze that warms the earth and causes flowers to bloom (note the rose blossoms falling from around his figure). The Hora also embodies spring. She is dressed in a gown embroidered with daisies, primroses, and cornflowers (all spring plants), a garland of myrtle (a tree associated with Venus and love) adorns her neck, her waist is girt with pink roses, and blue anemones bloom at her feet.

Another interpretation draws upon philosophy to explain the painting. The Neoplatonic thinker Marsilio Ficino, in a letter to a member of the Medici family, described the concept of Humanitas as a classical goddess. The terms of his description are very close to Botticelli's painting, inspiring many art historians to interpret the Venus here as an allegory. Her pristine and beautiful form could thus be seen as an embodiment of the human soul, touched by divine love, while the other figures stand for the relationship of divine love to the earthly realm. Such an explanation merges Christian thinking with the classical Platonic philosophy so popular in the educated circles of the Medici. Botticelli worked for the Medici family, and was intimate in that circle, which included poets, philosophers, and historians as well as artists. Though we do not know for whom the painting was made, in it Botticelli beautifully merges major trends of the Renaissance: he takes a classical goddess, forms her as a Renaissance beauty, and frames the whole in a cloak of poetry, allegory, and philosophy. Such a construction could not fail to please in Florence in 1484—just as *Venus* continues to please audiences today.

The *Medici Venus* covers both breasts. Here, one breast is exposed—the patron, after all, probably wanted a naked lady—but Venus's gesture is that of a nursing mother, further implying her role as inspiration for generation.

The different plants that adorn Hora's neck, body, and dress allude to the changing seasons and passage of time.

Time to get dressed! Hora brings the nude Venus an embroidered robe, billowing in the breath of Zephyr, the spring wind that has blown her ashore.

Her ostensibly modest gesture, which Botticelli borrowed from the *Venus pudica*, is lightly erotic. Venus's sexuality was a symbol for fruitfulness of every kind.

The abstract, calligraphic strokes denoting sea foam are as idealized as the rest of the work. The wavelets enhance the message of ceaseless change that permeates the scene.

SANDRO BOTTICELLI
(1444/45–1510)

The Birth of Venus
CA. 1484

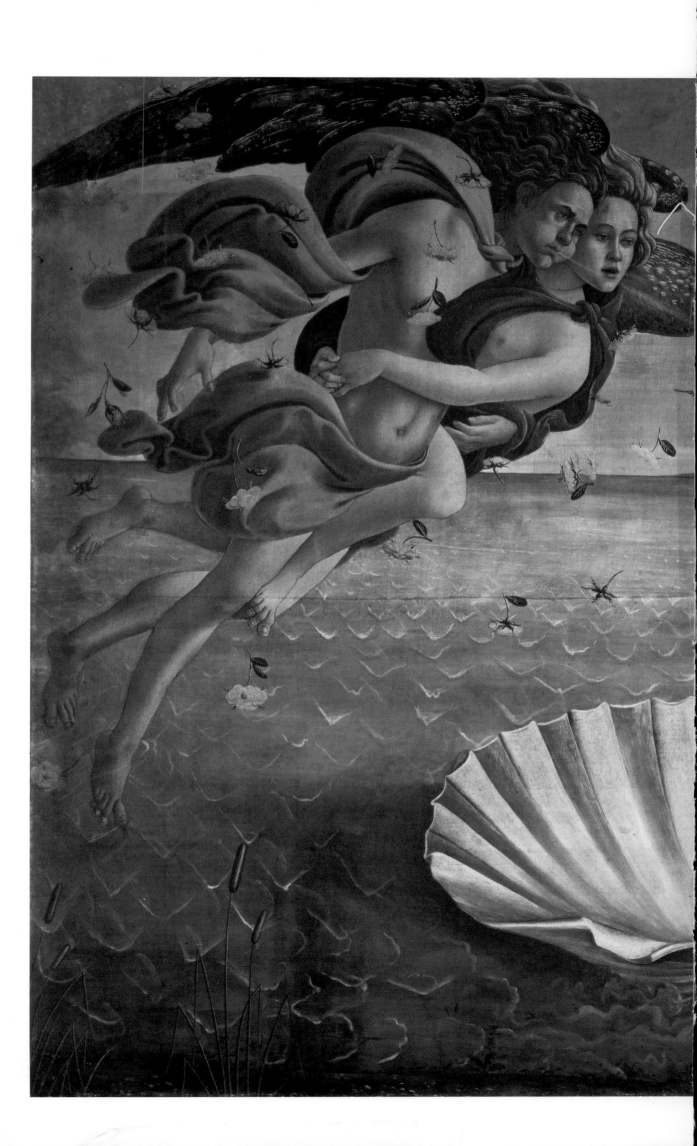

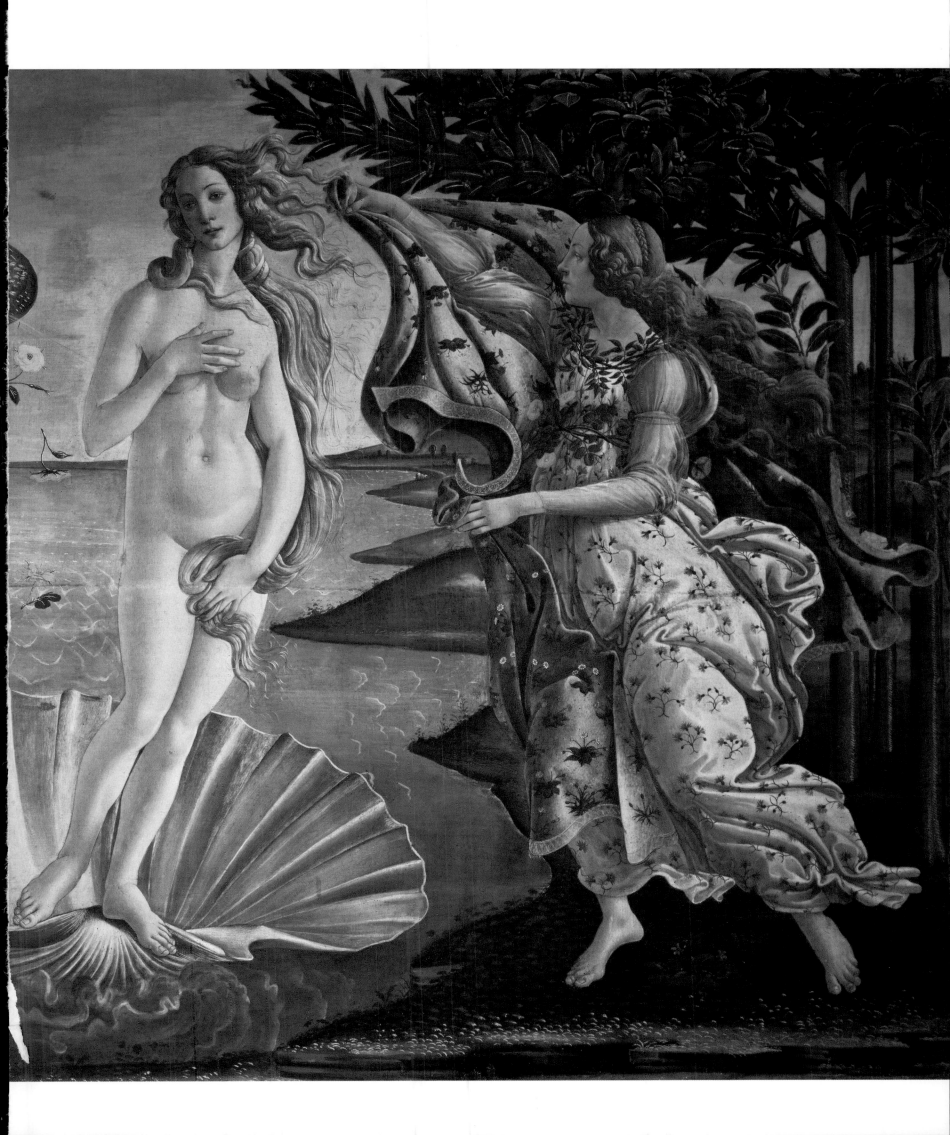

ANDREA MANTEGNA

(CA. 1431–1506)

Madonna della Vittoria

1496

TEMPERA ON CANVAS
9 FT. 2 ¼ IN. X 5 FT. 3 IN.
THE LOUVRE, PARIS

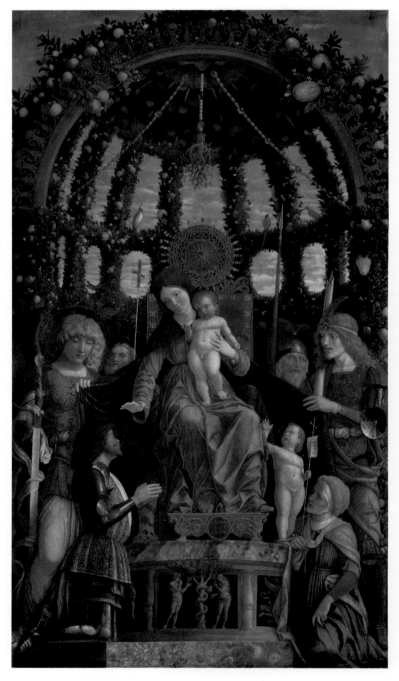

MANTEGNA worked as the court artist for the aristocratic Gonzaga family, who ruled Mantua. The painting, as the title declares, is about victory. As a Christian work of art, it glorifies the Virgin, Child, and saints, and emphasizes their role in helping the viewer achieve salvation. It is also a piece of political propaganda. The painting celebrates Marquis Francesco Gonzaga, argues for the connection of the Gonzaga to the divine, and asserts their power to rule.

At the center, the Virgin and Child sit enthroned. This is the Virgin as Queen of Heaven (*regina caeli*, inscribed on the base of her throne). The throne lifts her both physically and metaphorically above the level of saints, and sets her far above the viewer's zone. A relief on the circular base of the throne shows the Fall of Man, the moment of original sin. The baby above provides the means to salvation by absolving mankind of that sin. A flower-and-fruit-filled bower encircles the Virgin. This is the *hortus conclusus* (enclosed garden), commonly used as a symbol of the Virgin's purity. Apples, pears, and melons grow plentifully in the plant-covered architectural forms. Birds frolic among the boughs. The fecundity and plenty of the Virgin's realm are made visible. Above, a piece of coral hangs from the vault. A rare, exotic, and highly valued object, coral was also thought to have healing and protective powers.

Around the throne are six saints who have been assembled to reference themes relevant to the patron. St. Andrew and St. Longinus, patron saints of the city of Mantua, peek over the back of the throne from left and right respectively. Both saints are connected to the relic of the Holy Blood, kept in the church of St. Andrew in Mantua. In front of them stand the archangel Michael (at left) and St. George (at right). They were military figures, known for victories at arms against evil forces. They hold out the Virgin's mantle so that it encompasses and protects the front figures (a format known as the *Madonna Misericordia*). At left, the patron, Francesco Gonzaga, in full armor, kneels and makes a pious gesture. The Virgin leans over to him, lowering her hand over his head. The gesture, a maternal one connoting protection, is emphasized by dramatic foreshortening and bright lighting, contrasted sharply with the dark drapery behind, and is mimicked by the Christ child. Together, the Virgin and Child are visual testament to the strength of Francesco's connection to the divine. The last figures are St. Elizabeth, the old lady kneeling at right and patron saint of Isabella d'Este (wife of Francesco), and her son, the infant St. John the Baptist (holding a toddler-sized staff with a cross).

The painting ostensibly celebrates Francesco's victory over the French forces of Charles VIII at the Battle of Fornovo. The marquis publicly attributed the renewed might and vigor of his exhausted men to the efficacy of the Virgin, who answered his prayers and allowed them to rout the enemy. Facts, however, tell us that Francesco's performance as a general was actually so poor that he was called in front of the council of allied Italian states to explain himself. This altarpiece is a public relations spin on the part of Francesco.

Francesco, in fact, did not pay for the altarpiece—it was paid for by a local Jew, Daniele da Norsa, who had been accused (unjustly) of defiling an image of the Virgin painted on his home. As punishment, Francesco ordered da Norsa to pay for the altarpiece. Mantegna's altarpiece remains a prime example of the power of art to persuade, and of the power vested in the patrons who control art for their own purposes.

White birds perch within the bower of sweet-smelling citrus blossoms and symbolize purity and the soul. The presence of specific birds renders Paradise immediate, while their exoticism may refer to the global reach of Christianity.

The parrot, believed to stay dry in the rain, is a symbol of the Virgin. The lance is an instrument of the Passion. The long-tailed bird that also contemplates the symbol of Christ's suffering surely has a meaning, now lost.

The carnations are red, the color of Christ's future Passion. The flowers stand for the nails of the Crucifixion, as well as for faithful love—here, God's sacrifice for humanity.

The small standard bears the adult St. John the Baptist's words: "Behold the Lamb of God, behold him who taketh away the sins of the world."

The Virgin leans forward, extending her hand in a personalized gesture of protection. Gonzaga smiles at her, emphasizing their personal relationship.

The inscription below the Virgin's right foot quotes the first words of a hymn to her: "Queen of Heaven, rejoice! Hallelujah!"

ANDREA MANTEGNA

(CA. 1431–1506)

Pallas Athena Expelling the Vices

CA. 1499–1502

TEMPERA ON CANVAS
5 FT. 3 ¼ IN. X 6 FT. 3 ⅞ IN.
THE LOUVRE, PARIS

THIS painting was commissioned by Isabella d'Este, wife of Francesco Gonzaga, Marquis of Mantua. Isabella came from a noble line with a significant history in the collecting of art. She was a talented musician, a discerning patroness, and—uncommon for a woman in the Renaissance—deeply interested in the classical world and humanist learning. In the rarified culture of the Mantuan court, where patronage and display played important political and social roles, Isabella thrived. She ordered musical works, bought expensive instruments, hired philosophers and tutors, collected antique objects, and commissioned many works of art. Since Mantegna was the court artist for the Gonzaga family, Isabella worked often with him. Always short of money, Isabella frequently had to pawn her jewelry to pay for her art, but still she strove for large and important commissions that broke the mold for female patronage in the period.

This painting was part of Isabella's *studiolo*, a private chamber in her apartments used for study and retreat with intimate friends. The paintings in the *studiolo* were classical allegories that contained a moralizing Christian message. Famous painters throughout Italy produced the other works in the cycle.

The setting is a verdant garden constructed of arcades covered with plants and ivy on two sides, with a rough, darkened wall on the third side. A pool in the foreground gives access in front of the wall at far right to the space outside the picture. Through the arcade one sees a peaceful landscape with nude figures, probably a form of Arcadia. Fantastic red rocks loom over the garden in the upper left, lit dramatically by the rising sun. Allegorically speaking, Mantegna's lush garden represents the mind, which can be occupied by either virtuous or dangerous thoughts. The roses, flowers, lily pads, and generally lush plants suggest the natural innocence and fertility of the intellect. The figures in the foreground, by contrast, personify vicious and evil thoughts or inclinations.

The female tree form at the left corner is Daphne, the Greek nymph who escaped from Apollo with her virginity intact by becoming a tree. Wrapped around her is an inscription in Latin, Greek, and Hebrew, calling for the Virtues to return to the garden from which they have been expelled. Three of the Cardinal Virtues (Temperance, Fortitude, and Justice) wait in a cloud in the sky; the fourth, Prudence, has been imprisoned in the stone wall at right. Her presence is marked by another floating inscription. Clearly, wantonness and vice have driven out good thoughts, and are sullying the pristine garden of the mind (note the floating scum in the water of the pool). It is up to a chaste and wise goddess to save the situation.

An angry Pallas Athena (Wisdom) charges into the garden from the left, holding her shield and lance (broken as a sign of honorable combat) at the ready against a horde of figures. Mantegna uses all his artistic invention to create visualizations of the evils crowded into the foreground. However, some of the concepts remained obscure, and difficult to translate visually, so small Latin inscriptions for each figure confirm their identities.

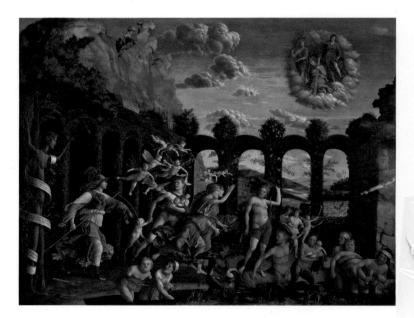

Flying away from Pallas is a female satyr (Luxury), grasping her monstrous children. Winged Amors follow, carrying bows; their wings bear multiple eyes to indicate inconstancy. Two clothed nymphs run right, crying out to the figure of Venus at center. Venus is the core Vice. She stands on the back of a centaur, a monster famous for his animal appetites. The green cloth that plays around her body may connect her to Fortune, and emphasizes her capriciousness. Though looking down, Mantegna paints Venus's provocative pose to show her false modesty and deceitful nature. Outwardly beautiful, she represents unbridled lust and dangerous sensuality. The centaur plucks at her wrap to indicate it is time to leave; a satyr with the face of an animal leads the way. He carries two more Amor figures who will no longer kindle the flames of love. In the lower right corner, Avarice and Ingratitude carry a fat figure (Ignorance) out of the painting. The figures in left foreground, in the water, also leave. They are Idleness (with no arms), being led by Inertia. They move toward a dark figure with a hermaphrodite body and a monkey's face who is "Immortal Hatred, Fraud, and Malice."

The moral of the allegory is clear: chastity and wisdom will create a mind in which the Virtues rule, and the Vices are eliminated. The relationship of the moral to Isabella is also evident, since this was her *studiolo*, and her commission. Why Isabella felt impelled to demonstrate her own virtuousness so publicly may have to do with the difficult social expectations for women in high position during the Renaissance. Isabella's own desire for fame, and interest in traditionally male occupations such as classical learning and commissioning art, also compromised perceptions of her as chaste, humble, confined, and all other things expected of women. Isabella used her art commissions to demonstrate her own virtue without giving up her position as an influential, important patroness of the arts in Mantua.

THE BUSHES ATOP THE ARCADE ARE DIFFERENT FROM ONE ANOTHER, BUT THE "GOLD" FRUIT—POSSIBLY ORANGES—SUGGESTS THE GARDEN OF THE HESPERIDES.

A FEMALE SATYR FLEES WITH HER CHILDREN BEFORE PALLAS'S FURY. ONE OF THE ROBED NYMPHS CARRIES A BOW, ATTRIBUTE OF DIANA. THE OTHER, BEARING AN EXTINGUISHED TORCH, MAY BE CHASTITY.

THE GODDESS OF LOVE, HER HAIR IMPECCABLY COIFFED IN THE CLASSICAL STYLE, IS UNCONCERNED BY HER SISTER-GODDESS'S ENERGETIC RIGHTEOUSNESS. THOUGH HER SUBJECTS REPRESENT THE UGLY CONSEQUENCES OF VENUS'S RULE, SHE HERSELF IS NOT SO EASILY REMOVED.

THE FOUR PURSES CONTAIN SEEDS OF THE BAD, THE WORSE, AND THE WORST. TWO FURTHER BURDENS ARE JEALOUSY AND SUSPICION. IN ADDITION, HER/HIS BONDS MAY VISUALIZE A VERSE IN THE PSALMS: "UPON THE WICKED HE SHALL RAIN SNARES."

IN ANCIENT MYTHS, CENTAURS DISPLAYED UNBRIDLED LUST AND OFTEN ENGAGED IN VIOLENCE AND EVEN RAPE. NYMPHS WERE ESPECIALLY VULNERABLE TO THESE BESTIAL CREATURES. TAMED IN THIS COURTLY CONTEXT, THIS CENTAUR SEEMS ALMOST WISTFUL FOR THE VIRTUOUS BEAUTY OF WISDOM'S VANGUARD.

LEONARDO DA VINCI

(1452–1519)

The Last Supper

1498

TEMPERA AND OIL ON PLASTER
13 FT. 9 IN. X 29 FT. 10 IN.
SANTA MARIA DELLE GRAZIE, MILAN

LEONARDO illustrates the Last Supper from the Christian New Testament in this famous masterpiece of the Renaissance. Painted in a novel technique that departed from tradition, the fresco was renowned for its meticulous capturing of realistic detail. Unfortunately, the medium was unstable, and already in 1517 was deteriorating. Despite its ruined condition, it is still admired today for its sophisticated fusion of theological and philosophical concepts within a compelling, expressive scene of remarkable naturalism.

The Last Supper was the final meal Jesus shared with his apostles. The meal took place at a house outside the walls of Jerusalem, where the twelve apostles gathered together in privacy and Jesus (with foreknowledge of coming events) prophesied his capture and death. Several events happen during the meal: first, Jesus blesses bread and wine and passes the food around to the disciples. This sharing is the foundation for the Christian ritual of the Eucharist (also known as Holy Communion, or the celebration of Mass). By consuming the meal, which prefigures Jesus's flesh-and-blood sacrifice, the apostles achieve communion, or unity, and represent the first members of the Christian congregation. Next, Jesus announces to the apostles that one of their group will betray him—and soon. Though they protest, he concludes by telling them that, in fact, all the apostles will abandon him once he is dead.

Traditionally, images of the Last Supper illustrated the first of these scenarios. Since the Eucharist is central to the Christian religion, representation of it was common during the Renaissance, most often on the walls of dining halls of monasteries and convents.

Leonardo departs from that tradition in this rendering. His fresco was in a monastic refectory, but the scene merges the Eucharistic element in the Last Supper narrative with a new one from the Gospel of John. Seated upright at the table, Jesus spreads his arms and points to a cup and bread on the table. He also announces his impending betrayal, which is represented as the dramatic crux of the scene. The shock of his declaration ripples through the group like a wave; the apostles start back and raise their hands in amazement and despair. Leonardo enhances the divinity of Jesus by framing him in front of three light-filled windows (symbolic of the Trinity) and an arch in the architecture above him, to serve as a reference to a halo. (No haloes are shown here, since they are symbolic forms, not natural ones, and Leonardo insisted upon absolute naturalism.) The perspective system leads directly to Jesus's head, so that the viewer focuses automatically on him at the epicenter of the action.

Each of the twelve apostles captures a distinct emotion in response to Jesus's announcement. Leonardo's drawings and writings document his attempt to distill in each figure a single, essential human emotion, which he called "the states of the soul." Identifiable and real, the apostles here become a visual encyclopedia of what it means to be human. At the far left, three apostles (Bartholomew, James, and Andrew) lean forward in disbelief: Andrew raises his hands to express rejection. At the left of Jesus is John the Blessed, whose long, flowing hair and beardless face mark him

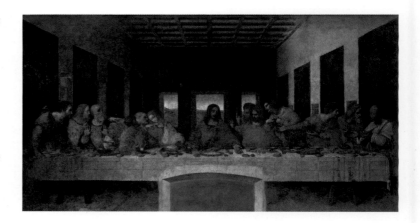

as the youngest and, in some accounts, most favored apostle. Here, he sinks to the side, overcome by despair while the older Peter (in white beard and blue robe) grabs his knife and gestures angrily. The knife points toward Bartholomew, who was later to be martyred by being flayed. On the far right side, the group of Matthew, Jude Thaddeus, and Simon heatedly discuss the implications of Jesus's statement. Next to them Thomas, James, and Philip gesture to the heavens as a demonstration of faith.

Judas, in profile, is the only one to contradict the wavelike motion of the group. Solid, dark, and triangular in shape, he clutches a moneybag in his right hand. It holds the thirty pieces of silver paid to him for his betrayal. Judas's swarthy complexion, the shadow cast over his figure, and his contorted posture all symbolize his corruption. Leaning heavily on the table, Judas's right elbow knocks over a container of salt, a sign of carelessness as well as bad fortune. With his left hand Judas reaches for a piece of bread. This gesture is filled with significance, since Jesus also reaches for the same piece. In the Gospels, Jesus presents this as a means of identifying his betrayer.

Leonardo has arranged the figures into pyramidal groups. Around the solid triangular apex of Jesus, the crux of the painting, the apostles form four groups of three. Numerology is significant here: three represented the Holy Trinity as well as the Theological Virtues (Faith, Hope, and Charity). The four groups may refer to the four elements (earth, water, fire, and air) as well as the four Gospels and the four Cardinal Virtues (Prudence, Justice, Temperance, and Fortitude). The number twelve signifies not only the apostles themselves, but references universal and natural truths: the months of the year and the hours of the day and night.

Leonardo carefully paints the dishes and glasses on the table to show reflections as well as transparency; the folds of the tablecloth and the texture of the bread are carefully rendered. Even the space of the depicted room, with tapestries hanging in a matched row, reflects the refectory itself. The intention is to make the scene as real, as visceral, and as emotionally powerful as possible. As the apostles gesture and talk, and in themselves express the cosmic truths of the world, so the monks in the refectory would be encouraged to examine their own souls.

THE YOUNG JOHN
WAS THE "BELOVED
DISCIPLE." HIS
ANDROGYNOUS BEAUTY
CONTRASTS WITH
PETER'S WHITE HAIR
AND BEARD AND
SOMEWHAT COARSE
FEATURES; BOTH ARE
CONVENTIONAL
REPRESENTATIONS OF
THE TWO APOSTLES.

CHRIST'S FACE IS GENTLE,
SORROWFUL, AND RESIGNED.
HIS ROBE IS RED, THE
COLOR OF THE PASSION,
THAT IS, THE SEQUENCE OF
VIOLENT EVENTS HE WILL
SUFFER AS A HUMAN BEING,
CULMINATING IN HIS
CRUCIFIXION. HIS CLOAK
IS BLUE, THE COLOR OF
HEAVEN. THESE HUES
SYMBOLIZE HIS DUAL
NATURE AS GOD AND MAN.

THOMAS'S INDEX FINGER
POINTING SKYWARD BECAME
ONE OF LEONARDO'S MOTIFS,
MOST NOTABLY IN A SERIES OF
PAINTINGS OF JOHN THE
BAPTIST, WHO WITH THIS
GESTURE INDICATES THE COMING
OF CHRIST. IT IS ALSO THE
FINGER THE DOUBTING APOSTLE
WILL PLACE IN CHRIST'S WOUND
AFTER THE RESURRECTION.

CHRIST'S RIGHT HAND
REACHES FOR A DISH AT THE
SAME TIME AS JUDAS, THE
APOSTLE WHO WAS ABOUT TO
BETRAY HIM. LEONARDO'S
PAINTING DEPICTS TWO
SEPARATE MOMENTS IN TIME:
THE ESTABLISHMENT OF THE
EUCHARIST, AND THE MOMENT
FOLLOWING CHRIST'S
PROPHECY THAT ONE OF THE
APOSTLES WOULD BETRAY HIM.

WITH HIS LEFT HAND, CHRIST
POINTS TOWARD THE BREAD,
INSTITUTING WITH HIS WORDS
THE SACRAMENT OF THE
EUCHARIST. HIS EXTENDED
ARMS CREATE A TRIANGLE, THE
MOST STABLE OF FORMS. IN
THIS CASE, THE FORM MAY
SUGGEST THE EUCHARIST AS
THE FOUNDATION OF THE
CHRISTIAN LITURGY.

LEONARDO DA VINCI
(1452–1519)

The Last Supper
1498

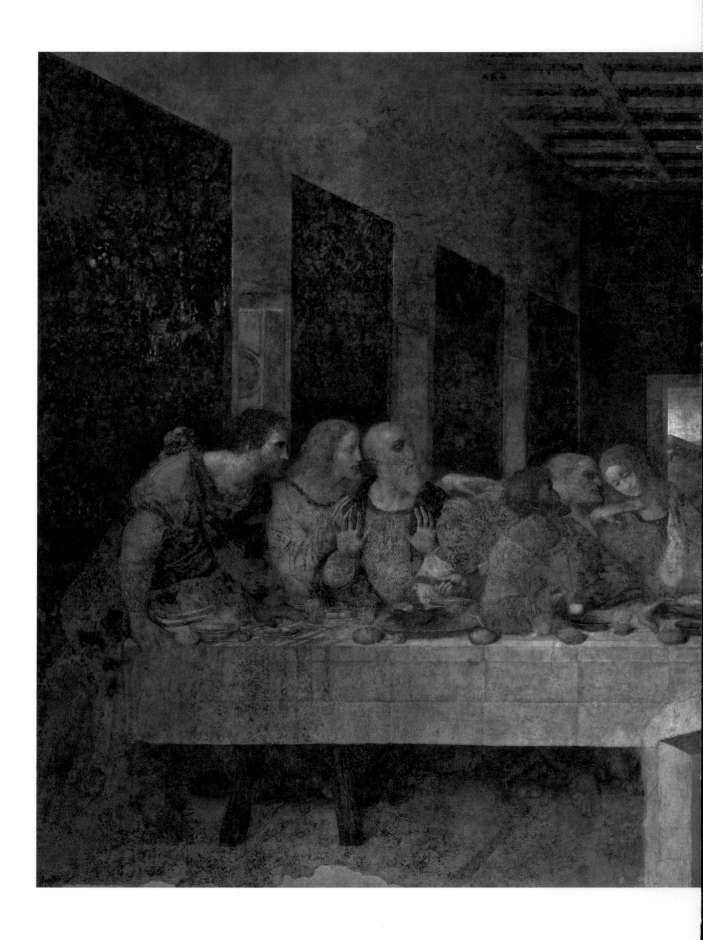

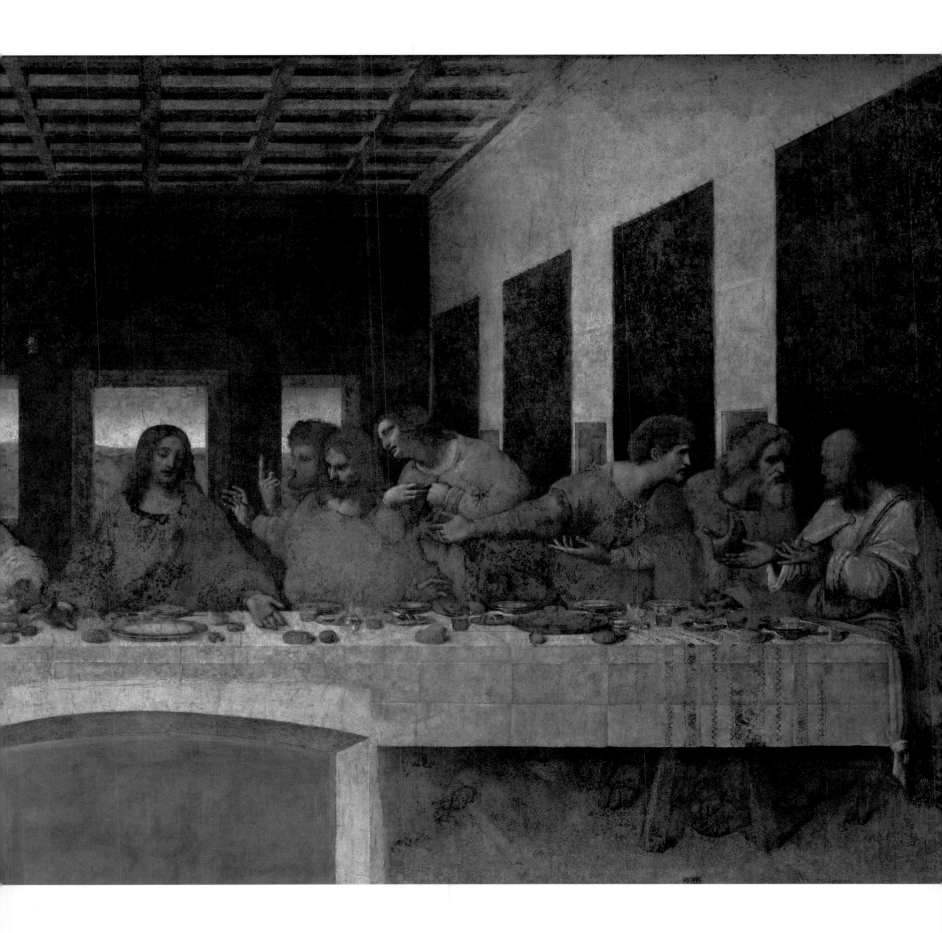

LEONARDO DA VINCI
(1452–1519)

Mona Lisa

1503

OIL ON PANEL
30 ¼ X 21 IN.
THE LOUVRE, PARIS

THE *Mona Lisa* is the best-known painting in the world. Yet many viewers are puzzled by the seeming simplicity of the painting, which depicts an apparently ordinary woman (probably Lisa Gherardini, wife of the Florentine merchant Francesco del Giocondo). There are many ways to approach the *Mona Lisa*—for example, one could discuss its departure from the traditional Renaissance manner of depicting women, and how it breaks stereotypical gender norms in its direct frontal stance and challenging outward gaze. Following Freud, some read in the painting Leonardo's own attitude toward the sitter, or toward women in general. The painting itself provides plenty of material for discussion, however, without resorting to overly academic justifications for its fame. Leonardo depicts Mona Lisa in a remarkably casual, transient manner. She pauses, leans, and looks at the viewer. The beautiful face smiles, and we are hooked.

The woman is centrally placed in the picture plane; her body forms a stable pyramid in the composition. She stands at a parapet or ledge, and behind her is a low wall. After that, the space jumps precipitously back to a faraway landscape. Her body is turned slightly away from the viewer as she rests her left elbow on the ledge. She looks at the viewer, and her hands and face appear in frontal view. Two observations are worth making. The spatial volume in the figure derives from the slightly receding body and from Leonardo's special painting technique. Based on his own scientific observations of the natural world, Leonardo came to understand that objects exist within atmosphere, and that the substance of air makes those forms appear slightly indistinct, especially at the edges. We do not see the world with strong linear contours, as in a Botticelli painting. Leonardo made the Mona Lisa seem more naturalistic, more living, by painting her form as if surrounded by atmosphere: the hazy, smoky effect (known as *sfumato*) is particularly visible in the contours of her face and neck and in the background. Strong highlights on her face and chest contrast with deep shadows under her chin (an effect known as *chiaroscuro*) and make her appear to project forward out of the misty shadows. Originally, she was framed by two painted columns resting on the wall behind her. The bases are still visible on either side, where the canvas has been cut down.

The sitter is a typical Florentine matron. She wears a fine but not ostentatious dress, embroidered at the neckline, with a heavy mantle slung over one shoulder and a diaphanous veil over her hair. There is no fancy jewelry, no elaborate decoration on the dress, none of the usual signals of social display found in such portraits. Her hair hangs loose, in a more casual fashion of the day. She has no eyebrows, and a remarkably high forehead. Both of these were beauty features at the time, and women were known to pluck their hair in order to achieve this effect. The smile, about which so much has been said, was (according to the sixteenth-century chronicler Giorgio Vasari) prompted by the jesters and performers Leonardo hired to perform in the studio for her amusement. Others see in the restrained half-smile the epitome of self-control and confidence that mark the sophisticated

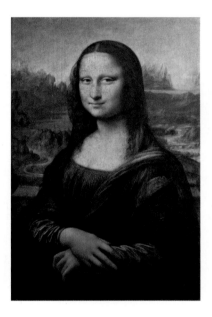

culture of Renaissance Florence. This reading is enhanced by the sense of movement stilled in her transient stance, and the recognition of the repose achieved in her calmly folded hands. However one reads it, clearly Leonardo meant to activate the portrait by conveying a sense of her momentary expression, her eternal presence, and her unique personality: all are highly unusual for portraits of women at the time.

The background is equally innovative. The strange craggy hills, mist-wrapped landforms, and desolate plains mark this as a fantastic location. Instead of a placid Tuscan setting, Leonardo places his lady in relation to the wilds of nature. The only signs of human habitation are a road and a bridge; the rest is untraveled, raw wilderness. A few details heighten the connection between woman and nature: her eyes are at the level of the misty mountains, and the gray, jagged peaks form a compelling contrast with her very present gaze. Also, Leonardo paints the locks of her hair tumbling over her right shoulder as if they merge with the rocks behind, and the curve of her mantle on the left shoulder as if continued in the bridge. Perhaps the connection between woman and nature should be read metaphorically, or poetically. Like Mother Nature herself, women— and the Mona Lisa—are, in their fecundity and physical beauty, mysterious and compelling but also dangerous.

Vasari spoke of this painting as Leonardo's masterpiece, and gushed over its miraculous naturalism. To him, all the lifelike details were worth praising: even "the nose, with its beautiful nostrils, rosy and tender, seemed to be alive." Vasari continued, saying that the perfection of the painting, which took three years to complete, was such that it could "make the strongest artist tremble with fear." A detail like the wispy veil shows Leonardo's absolute mastery of the medium, and his phenomenal ability to render the visible world in painted form. The veil is shown as a simultaneously tangible, tactile, and transparent entity; it both reveals and transforms the forms it covers. The silky fabric contrasts with the texture of her tumbling hair, it outlines the shape of her forehead, and its transparency changes the view of the landscape through it. Whether as a demonstration of his skill or because of a sentimental attachment to it, Leonardo kept the painting with him until his death, when it was bought by King Francis I of France. Today, more than five million visitors come to the Louvre each year to see the *Mona Lisa* in person.

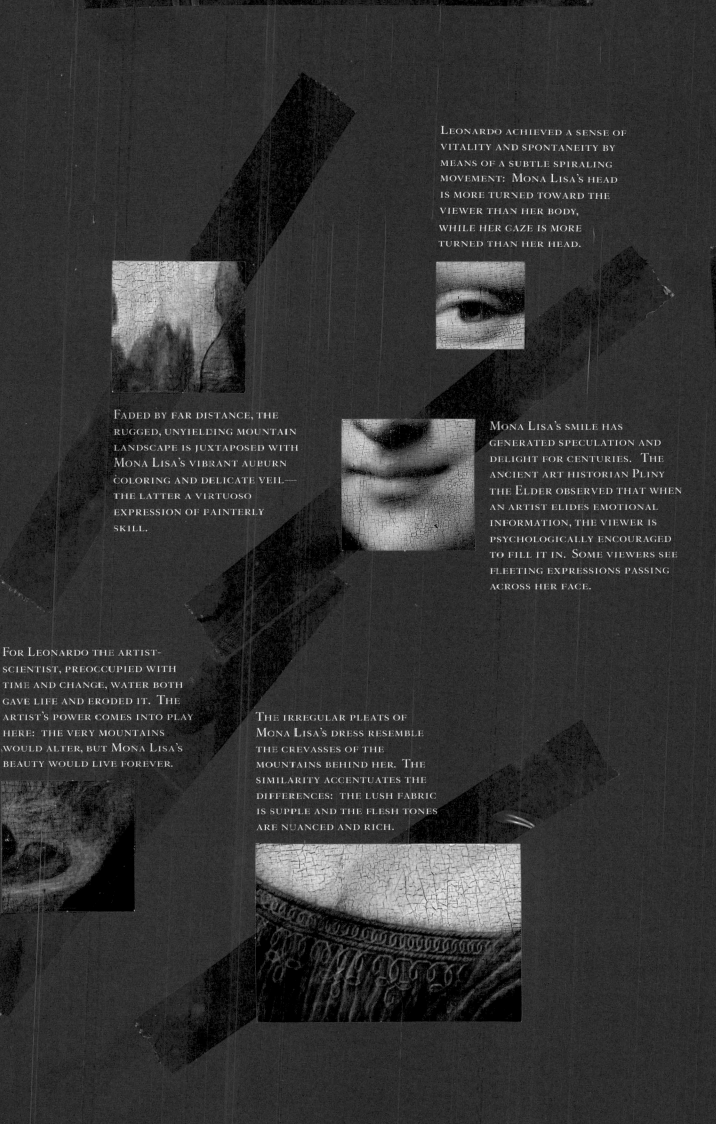

LEONARDO ACHIEVED A SENSE OF
VITALITY AND SPONTANEITY BY
MEANS OF A SUBTLE SPIRALING
MOVEMENT: MONA LISA'S HEAD
IS MORE TURNED TOWARD THE
VIEWER THAN HER BODY,
WHILE HER GAZE IS MORE
TURNED THAN HER HEAD.

FADED BY FAR DISTANCE, THE
RUGGED, UNYIELDING MOUNTAIN
LANDSCAPE IS JUXTAPOSED WITH
MONA LISA'S VIBRANT AUBURN
COLORING AND DELICATE VEIL—
THE LATTER A VIRTUOSO
EXPRESSION OF PAINTERLY
SKILL.

MONA LISA'S SMILE HAS
GENERATED SPECULATION AND
DELIGHT FOR CENTURIES. THE
ANCIENT ART HISTORIAN PLINY
THE ELDER OBSERVED THAT WHEN
AN ARTIST ELIDES EMOTIONAL
INFORMATION, THE VIEWER IS
PSYCHOLOGICALLY ENCOURAGED
TO FILL IT IN. SOME VIEWERS SEE
FLEETING EXPRESSIONS PASSING
ACROSS HER FACE.

FOR LEONARDO THE ARTIST-
SCIENTIST, PREOCCUPIED WITH
TIME AND CHANGE, WATER BOTH
GAVE LIFE AND ERODED IT. THE
ARTIST'S POWER COMES INTO PLAY
HERE: THE VERY MOUNTAINS
WOULD ALTER, BUT MONA LISA'S
BEAUTY WOULD LIVE FOREVER.

THE IRREGULAR PLEATS OF
MONA LISA'S DRESS RESEMBLE
THE CREVASSES OF THE
MOUNTAINS BEHIND HER. THE
SIMILARITY ACCENTUATES THE
DIFFERENCES: THE LUSH FABRIC
IS SUPPLE AND THE FLESH TONES
ARE NUANCED AND RICH.

MICHELANGELO

(1475–1564)

The Doni Tondo

1504

OIL AND TEMPERA ON PANEL
47 ½ IN. (DIAMETER)
UFFIZI GALLERY, FLORENCE

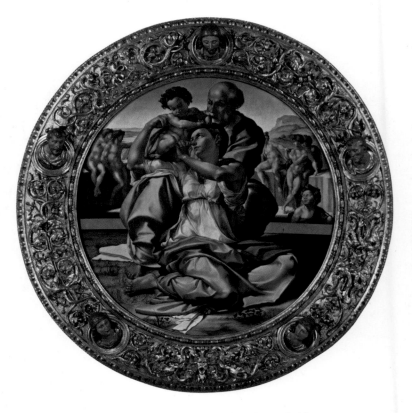

ROUND paintings, or *tondi*, were usually decorated with imagery of marriage or scenes of small children. The format in painting grew out of a tradition of delivering a round platter of fruits or other nourishing items to mothers after childbirth. Later paintings such as this one by Michelangelo, while they never would have carried this function, nonetheless preserved the relevant imagery. It was likely made for the weaver Angelo Doni, probably in 1503 on the occasion of his marriage to Maddalena Strozzi, daughter of a wealthy banking family.

Michelangelo's choice of the Holy Family as a subject for a *tondo* was not in itself unusual, but his manner of depicting the scene, from the grouping of the three main figures to the distribution and setting for the subsidiary figures, was wholly unprecedented. The main block of figures—meant to be reminiscent of an enormous piece of marble—dominates the center of the circle. The bald dome of Joseph gives him a patriarchal presence and echoes the arc of the outer rim. The bushy-haired young Christ tilts his head in toward the left, again to accentuate the curve of the frame, and the curve then continues into the arm of the Virgin Mary as she reaches back to support her climbing child. The genuineness of the scene, a rambunctious boy climbing on his parents, has a natural quality that emphasizes not only the humanity of Christ, but also the nurturing qualities of Joseph and Mary. The exposure of Christ's genitalia was also purposeful, and expected, as proof of his human nature. There may be a dual aspect that stresses his divine being as well: his act of climbing may have been meant as a preview of his later ascension.

Still a young artist, Michelangelo's early acclaim had been in sculpture, not painting. The most famous artist in Florence at that moment was still Leonardo da Vinci, and Michelangelo may have wanted to compete with Leonardo's efforts to depict figural groups in a natural and dynamic manner. Michelangelo went about it in his own way, however. In paintings like the *Adoration of the Magi*, Leonardo experimented with building up lighter colors and deep shadows from a medium ground. Michelangelo, like Leonardo, was beginning to incorporate the translucent oil paints long popular in Northern Europe, but his painting technique was still essentially suited to tempera, resulting in a brighter and lighter overall picture. The Virgin's pink shirt stands out clearly against the citrus combination of orange and yellow used for the cloak around Joseph's legs. Michelangelo did not blend figure into background, as Leonardo tried to do with his smoky, *sfumato* approach. Instead, he juxtaposed strong, acidic colors and further distinguished one form from another with clean, crisp outlines. The overall effect increased the sense of light hitting on polished stone, giving the figures a sense of weight and volume. Whereas Leonardo's compositions usually flowed in movement, Michelangelo created internal torsion by having his figures twist around on their own spinal axis. He called this type a *figura serpentinata*, a figure like a serpent, coiled upon itself. The Virgin exemplifies these early anatomical experiments, as her knees point in one direction, the feet and torso move in the other, and the

arms and head complete the corkscrew. The Christ child turns in an opposite direction along basically the same axis.

The Virgin sits on the ground, a traditional sign of her humility. The sprigs of clover amidst the tufts of grass may allude to the legend that Eve carried a four-leaf clover out of the Garden of Eden when she was expelled with Adam. Mary, the new Eve, has given birth to Christ, the new Adam, whose eventual death and ascension would redeem the original sin of the first couple. The stone wall that arcs behind the Holy Family may further allude to a garden enclosure, the traditional *hortus conclusus*, or closed garden that protected Mary's virginity, or the Garden of Eden itself.

What then, are we to make of the figures in the background, outside the garden? Just beyond the gray retaining wall stands John the Baptist, looking adoringly, and perhaps with a degree of childlike jealousy, at the joyful exploits of Christ. His placement in the painting mirrors the chronological role he played, as a transitional figure from pagan antiquity to the Christian world. The nude figures in the rear, then, are likely to represent a Platonic ideal of beauty and love, related but distinct from the Christian concept of Christ's kingdom. They embrace each other and tussle with an expanse of fabric, which together with the luminous collection of colored silks of the Holy Family would certainly have caught the eye of Michelangelo's patron in the textile trade. Michelangelo also designed the frame, with five figures' heads emerging from portholes to look upon the main scene within the painting. The top figure is likely meant to be Christ, while the lower two look alike and are perhaps angels. The two at the sides seem to have more specific features, and are perhaps members of the Doni family. The vine and vegetal motif in the frame is filled with hidden heads as well, both human and monstrous, making varied expressions.

MARY TAKES THE CHILD FROM
JOSEPH WITHIN A COMPLEX
SERIES OF GESTURES. THE CHRIST
CHILD GRASPS HIS MOTHER'S HAIR,
LIKE A SPECIAL BLESSING. IN
CERTAIN INTERPRETATIONS,
MARY, LIKE HER SON, WAS
WITHOUT ORIGINAL SIN.

THE MYSTERIOUSLY NUDE
FIGURES IN THE MIDDLE GROUND
MAY EXPRESS PLATONIC IDEALS
OF TRUTH AS BEAUTY.

THE YOUNG JOHN THE BAPTIST
OBSERVES HIS BABY COUSIN.
THE WALL IN FRONT OF HIM,
LIKE JOHN THE BAPTIST, MAY
STAND FOR THE TRANSITION
FROM THE OLD DISPENSATION
TO THE NEW.

A CLOSED BOOK SYMBOLIZES THE
KNOWLEDGE OF HIDDEN THINGS.
ACCORDING TO TRADITION, AT
THE ANNUNCIATION, MARY
RECEIVED A REVELATION OF
CHRIST'S FUTURE PASSION.

Hieronymus Bosch

(CA. 1450–1516)

The Garden of Earthly Delights

Ca. 1504

Oil on panel
Whole triptych: 7 ft. 2 ⅝ in. x 6 ft. 4 ¾ in., Central panel: 86 ⅝ x 76 ¾ in.
The Prado, Madrid

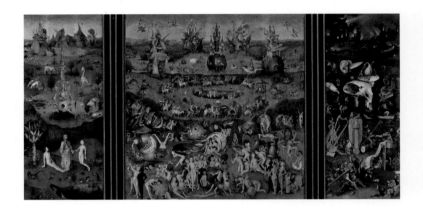

The title of this remarkable triptych is based on the eccentric subject of the central panel; the side panels depict Paradise and Hell. Many specific—and competing—interpretations of this painting exist, drawing upon symbols from a range of sources such as alchemy, emblematic literature, and proverbs.

The elevated viewpoint provides a sweeping view over an expansive landscape that appears to extend across all three scenes. From this omnipotent position, the viewer can delve into each scene, and peruse the myriad fantastic, amazing, and often disorienting details.

The left panel represents Paradise. Eve has just been created; God stands in the center and presents her to Adam, reclining at left. Adam looks in apparent bemusement at this lovely figure made from his own rib. Fertility is emphasized in the verdant landscape around them and the animals playing and feeding; yet a closer look shows strange mutations (note the three-headed bird by the pool and the platypuslike figure reading a book in the water), and already several animals fight and kill one another. An elephant and a giraffe share space with a unicorn in the middle distance. The large pink structure in the central pool may be the fountain of youth. However, an owl (connected to evil, and things of the night, as well as alchemy) sits in its central orb—and on the right, mutant, evil reptiles crawl out of the water. Thus, despite the presence of God and the dragonfruit tree at Adam's left (signs of eternal life), sinfulness is inherent in this Paradise.

The subject of the central panel appears to be an entirely new innovation in the history of art. Bosch shows hundreds of figures cavorting in a utopian landscape. The wholesale nudity and sensual behavior has suggested to some that these are the progeny of Adam and Eve, cavorting in Paradise. However, Adam and Eve did not procreate until after the Fall, when the pleasures of Eden gave way to mortal human life, complete with shame, work, pain, and death. In the foreground zone, figures enter the scene through a gate and indulge themselves by eating a variety of fruits, from enormous strawberries to pomegranates and cherries. In a grove of trees at the right, a man brings an enormous strawberry to a woman; in front of him, another man with the head of blueberry lies with a woman. Throughout this zone, the strawberry is particularly prominent; it was often associated with lasciviousness and excessive sensuality. Through imaginative hybridization (people wearing, becoming, and interacting with fruits and flowers, or animals) Bosch creates unbelievable forms. Their very strangeness signifies a world that defies the rules of nature.

In the pond zone behind the foreground, figures are encased inside fruitlike forms. Unlike the shameless cavorting at front, here the figures appear oppressed: one embraces an owl, another is trapped inside a blueberry, and yet another sits on the back of a bird with his head in his hands. The shifts in natural scale and proportion represent a world gone deeply awry. Looking to the background, women show off their charms inside a circular pool, while men ride strange beasts in a circle around them. This zone suggests the realm of Venus, where the magnetic pull of sexual

attraction keeps the men in orbit around the women. Behind them, large structures mark a lake created by four rivers. These may be the four great rivers of the globe, as they were understood at the dawn of global exploration.

The sensuality of the scene is apparent. Yet none of the behaviors has the attributes associated with traditional vices. The figures are remarkably innocent and childlike, both in their physical forms and in their playful games. The frequent, repeated motif of figures standing on their heads operates as a sign that this is a "topsy-turvy" world, the antithesis of proper society. As well, the frequent inclusion of transparent glass forms suggests alchemical equipment and the philosophy of alchemy, which focused on the interaction, fusion, and transformation of elements. And finally, the Garden is self-evidently a masterpiece of fantasy, and a forceful visual argument for the creative authority of art.

The right panel shows the torments of Hell. Instead of playing and cavorting, the figures here suffer unspeakable tortures. This is an infernal version of the landscape, complete with a busy foreground, middle lake with tree-man, and background view of a burning city. In the foreground a pig dressed as a nun lustfully assaults a man, while trying to get him to sign a financial contract. Gamblers are attacked and chastised brutally. Satan, enthroned, eats victims and defecates them out into a hole filled with figures and feces. His round crown may represent the universal aspect of Hell; it is all around us.

Musicians are punished in the middle zone, crucified and impaled on their instruments. Since music could be used as a tool for seduction and pleasure, it harnessed the senses to worldly things. The ears pierced by a blade behind this zone may reflect the horrific noise from the instruments and hellish singers. Next to the tree-man, a hunter is consumed by his own dogs; armies of soldiers wage war and destruction in the night scene behind.

The head of the tree-man has been traditionally seen as a self-portrait by Bosch, suggesting that the painter condemned himself as well as all of us. Whether Bosch meant to universally condemn mankind, or to provide complex allegories for an educated elite, he used here a vocabulary of fantasy and innovation so radical as to presage modern art.

Like a phallic juggernaut, this sexualized assemblage crushes bodies. Aroused by sounds, lust kills the soul amid the din of the damned. The letter M on the knife may stand for mundus—Latin for "world"—or, according to certain medieval prophecies, the name of the Antichrist.

Spiritual death is gaining on the tree-man. His trunk contains a tavern scene, site of debauchery, for which he is now paying the price.

Does he look at us, or at the dissolution of his humanness? The disk on the tree-man's head supports fanciful, unnatural creatures and a bagpipe, an instrument with sexual connotations. Here it is shaped like a womb, the source of carnal desire.

In the Christian tradition, the crescent moon (seen here atop the harp) has different and contradictory meanings. Here, in Hell, it may, like the owl, symbolize nighttime, when copulation, the making of sweet music, traditionally takes place.

He was skating on thin ice, now he's going down with the ship. Bosch depicted a number of proverbial phrases, which added to the viewers' pleasure of discovery as they explored his fantasy world.

HIERONYMUS BOSCH (CA. 1450–1516)

The Garden of Earthly Delights, CA. 1504

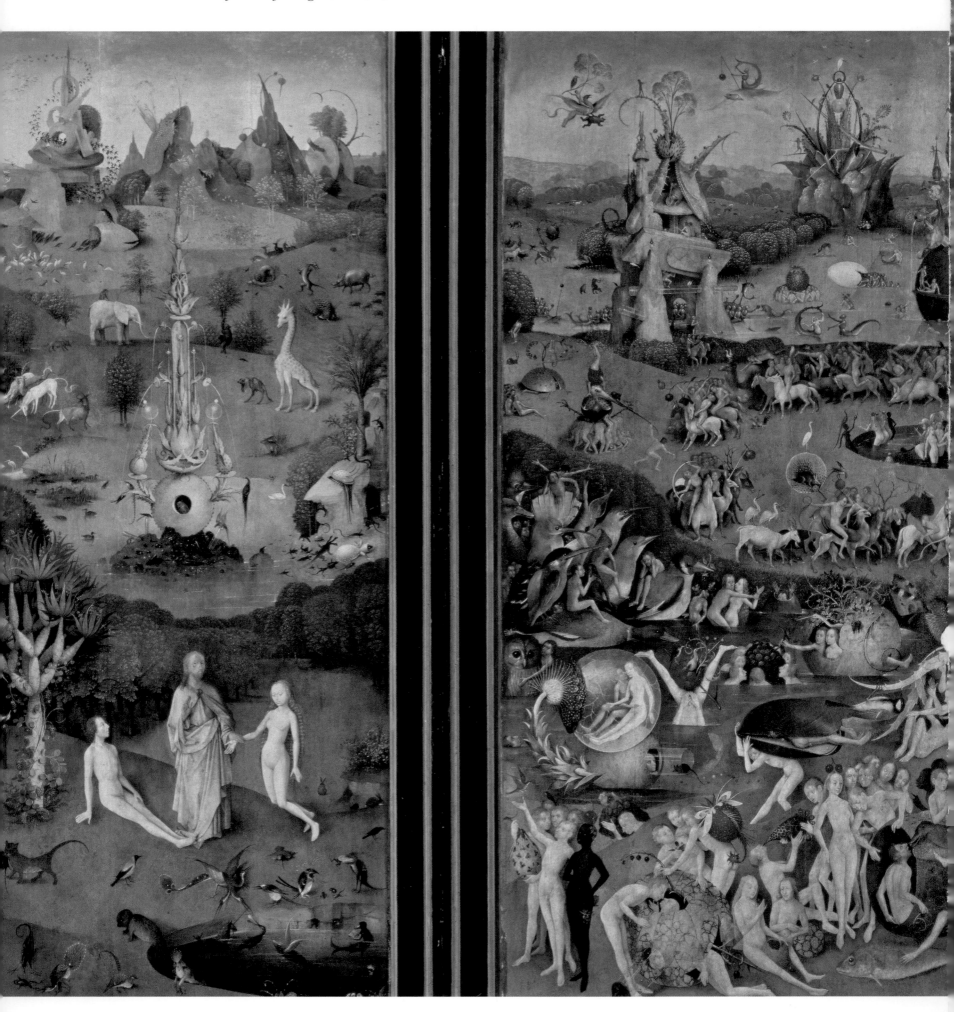

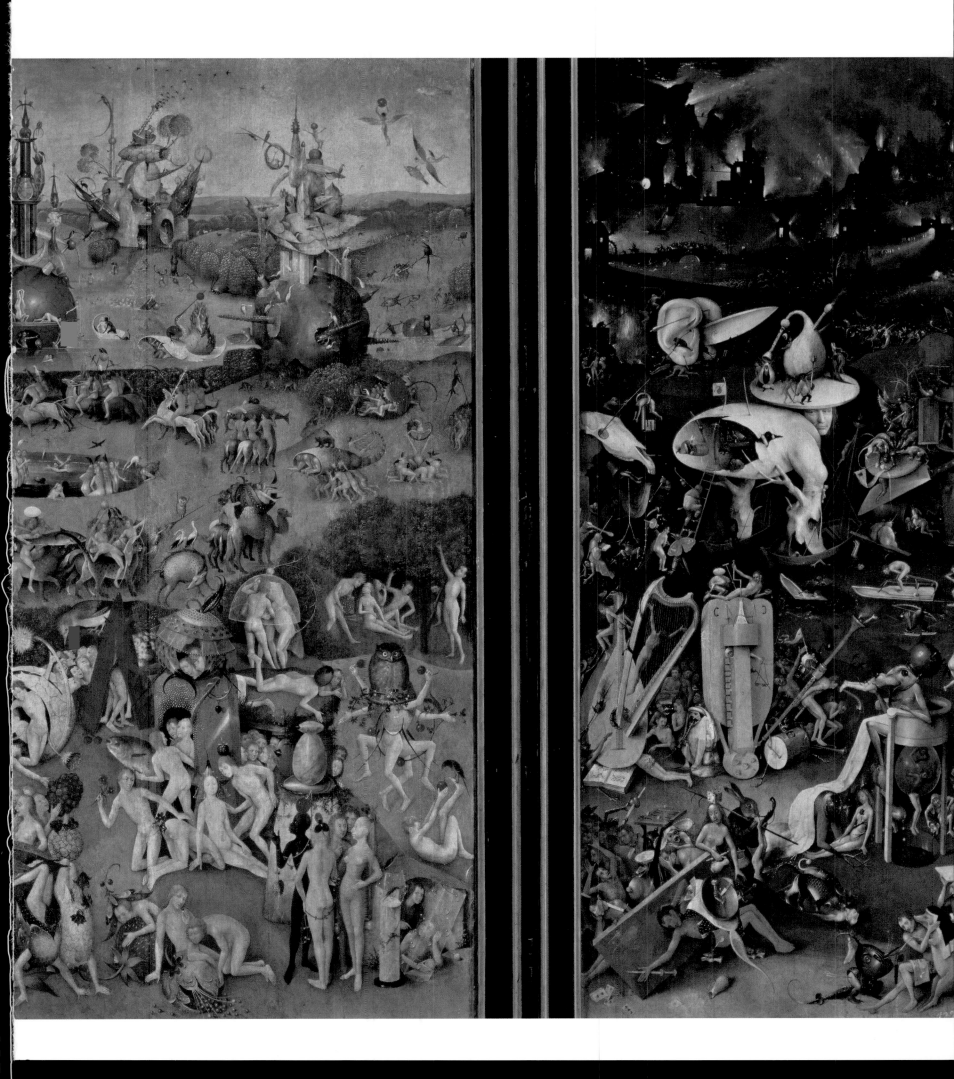

RAPHAEL

(1483–1520)

The Madonna of the Meadow

CA. 1506

OIL ON PANEL
44 ½ X 34 ⅝ IN.
KUNSTHISTORISCHES MUSEUM, VIENNA

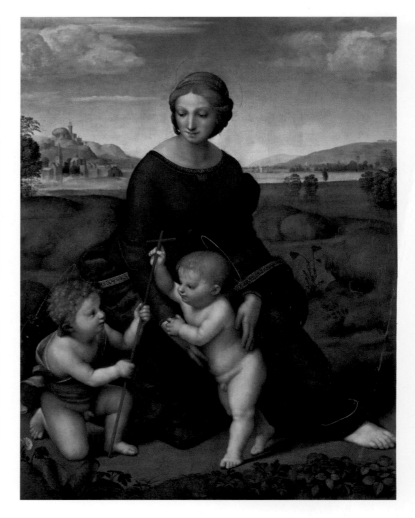

THE Virgin Mary sits in a lovely landscape, surrounded by lush fields and a placid view of mountains, a river, and city. She leans over to gently support the baby Jesus, her son. He is shown as a robust toddler, playing with the staff of St. John the Baptist. Raphael here creates a compelling image of the central Christian figures for private devotion by merging the divine and the natural into a seamless, perfect unity.

The Virgin is the centerpiece of the painting, in both formal and theological terms. Her body creates a stable pyramidal shape that dominates the composition. Even though Raphael activates her body by showing her seated in a sideways, twisting pose (probably derived from Leonardo's *Virgin with St. Anne*), the yards of blue drapery that fall over the side of her seat on the left enhance her bulk and her stability. The hills of the landscape behind are painted in shades of green and misty blue to show deep recession into the distance. The shapes of the hills merge gently with the forms of the Virgin, so that land and figure become one. Her youthful face and golden braids complete the image of a perfect woman, combining fecundity with modesty, and beauty with selflessness—all appropriate to the Mother of God.

Symbols abound in the painting. The blue mantle is traditional for the Virgin; the color blue was not only an extremely expensive pigment (made from ground lapis lazuli, an imported semiprecious stone), but had also been since ancient times an imperial hue. Here, the mantle is embellished with gold trim and embroidery (the date of the painting is partially embedded in the embroidered neckline). The red of Mary's dress references the Passion of Christ (the sequence of events leading up to her son's death), and serves as a prefiguring of her sorrow to come. Showing the Virgin seated on the ground conveys her humility. Raphael also depicted her surrounded by poppies, daisies, and strawberries. Poppies, by referencing sleep and death, refer to the death of Jesus to come; daisies may symbolize his innocence; and strawberries imply fertility.

The narrative here is conveyed through gesture and symbolic allusion. The Virgin turns and looks down at the infant John the Baptist (son of her cousin Elizabeth), who kneels in respect before the Christ child. Wrapped in a purple cloth (rather than his traditional animal skin), John is shown as a young boy. The reed staff he holds is his attribute, and the cross on it clearly refers ahead in time to the Crucifixion. The Virgin's maternal care is emphasized through her supportive gesture and tender oversight of the children. Her awareness of the future pain to come is conveyed in her sweetly sad face, and through the flowers strewn around. As the Christ child reaches out and grasps his playmate's toy, the viewer is encouraged to consider how the gesture of the baby records the intentions of the adult. Thus the apparently mundane interaction between the mother and the two children plays out, in this benign setting, the central drama of the Christian religion: God made human in the child, and the acceptance of death by the adult Jesus, which ensured salvation.

The engine driving the success of this painting is Raphael's ability to actualize a perfect, but natural ideal, which drives home the emotional poignancy of the message. Mary is the transcendent mother. She is young, beautiful, caring, supportive, and accepting of the future. The children she nurtures are strong, healthy, well fed, and display age-appropriate behavior. For example, her son, the Christ child, responds with affection to his mother's love, leaning on her body as small children do, and caressing her arm with his hand. In terms of social expectations, all is well with the family values conveyed here. In terms of narrative, it is the early calm before the later, tragic storm of the Crucifixion. In a theological sense, the divine love of God is embodied physically here, shown in the mother, son, cousin, and available to the pious viewer.

Raphael painted several small, personal images of the Virgin and Child during his time in Florence (1500–1506). The patron of this painting was a Florentine banker, Taddeo Taddei, who was a well-known collector at the time. Such images were extraordinarily popular among the elite patrons of Florence, for whom they operated not only as desirable works of art, but as a means to enhance prayer.

A MODEST, EARTH-COLORED
COTTAGE CONTRASTS WITH THE
VISIONARY TOWNSCAPE BEHIND
IT. THIS MAY RECALL CHRIST'S
HUMBLE BIRTH, NECESSARY TO
REDEEM HUMANKIND.

RAPHAEL DATED HIS PANEL ON
THE EDGE OF THE VIRGIN'S ROBE.
EMBROIDERED THROUGHOUT IS
LETTERING INTENDED TO LOOK
LIKE HEBREW. THESE FICTIVE
INSCRIPTIONS SYMBOLIZE THE
TRANSITION FROM THE OLD
ORDER TO THE NEW.

THE CHRIST CHILD GRASPS THE
EMBLEM OF THE CRUCIFIXION,
SIGNIFYING HIS ACCEPTANCE OF
HIS FUTURE SACRIFICE. HIS
COUSIN, JOHN THE BAPTIST,
WOULD ANNOUNCE CHRIST'S
DIVINE IDENTITY.

THESE FLOWERS STAND FOR
SLEEP—A DEATH FROM WHICH
ONE WAKES; THE RED REFERS
TO CHRIST'S PASSION. PLACED
BESIDE THE VIRGIN, THEY MAY
ALSO FORETELL HER OWN END
ON EARTH, SOMETIMES BELIEVED
TO BE NOT DEATH BUT SLEEP.

RAPHAEL
(1483–1520)

The School of Athens

1510–1511

FRESCO
19 X 27 FT.
STANZA DELLA SEGNATURA, THE VATICAN, ROME

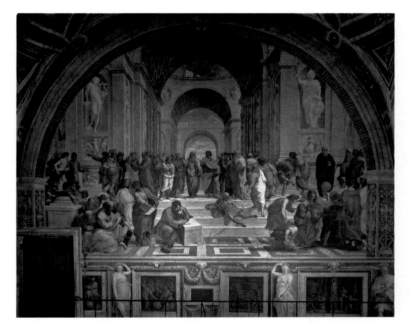

DECORATING a wall in the library of Pope Julius II (ruled 1503–1513) is *The School of Athens*. Along with depictions of Poetry, Law, and Theology, *The School of Athens* represented visually one segment of the pope's library collection (philosophy). In its scope, complexity, and overt classicism it made a grand statement about Julius's own aspirations to humanist learning. Though Julius was best known as a "warrior pope" interested in the pleasures of the temporal world, he also needed to demonstrate intellectual seriousness as a political attribute. His patronage of the arts has proved to be his greatest legacy.

Raphael blends past and present in this fresco, bringing the ancient world of classical learning to life in the pope's present quarters. He sets the stage with a classical architectural frame; the massive open coffered vaults recall both the glory of Imperial Rome and Bramante's audacious project to build a new St. Peter's (also commissioned by Julius). Statues of Apollo and Minerva, gods of music and wisdom, preside over the scene from the architecture above. On the steps and tiled plaza, figures mill about in small groups, studying, talking, demonstrating, and arguing. Intellectual activity is the subject of this fresco. Instead of traditional allegories, Raphael uses the physical arrangement of the figures to express the type of work undertaken by each person; the exterior person thus embodies the mind within. For example, the figure of Diogenes is sprawled on the steps, isolated from the others, and dressed in rags to represent that philosopher's independent mindset and disdain for human achievement.

Raphael organizes his composition to focus attention on the two main figures on the top step. They are Plato and Aristotle, and they represent different philosophical approaches to the understanding of man and nature. Using his system of embedding the philosophy within the figure, Raphael paints Plato as an old man, cloaked in red, who points upward to the sky. The gesture is a reference to Plato's interest in the world of ideas, a meta-world that exists beyond our comprehension of reality. He holds a copy of his book, the *Timaeus*. By contrast, Aristotle is a younger man, with a dark beard, who gestures outward, engaging with the world. Aristotle holds his own text, the *Ethics*.

The other figures are gathered and organized in terms of how their philosophy fits this overarching rubric. Thinkers who concerned themselves with ideas and abstract concepts, especially music, are on the left side of the work, in the realm of Plato. Here we see a figure who may be Socrates, on the upper step just to the left of Plato. Talking with a group of young men, Socrates ticks off points on his fingers in a classic visualization of the Socratic argumentation technique. The elaborately clad young man in helmet and armor has been variously identified but may represent Alcibiades, one of Socrates' most ardent followers, or perhaps Alexander the Great. In the foreground at left, Pythagoras sits reading from a text while one of the onlookers holds out a slate illustrating his musical theorem.

On the right side of the painting, under the statue of Minerva (goddess of wisdom and the sense of sight), are philosophers who address the Aristotelian world. Opposite from the Pythagoras group, another gathers around a figure who bends over to demonstrate on a slate. This is Euclid, traditionally identified as a disguised portrait of the architect and friend of Raphael, Donato Bramante. The students around him re-create the process of learning in an ascending arc of understanding. Behind Euclid stand two philosophers with globes: the geographer Ptolemy is seen from the back, holding an earthly globe, while the one behind is Zoroaster, the astronomer, with a sphere mapping the heavens. Tucked into a corner behind are two small heads: a portrait of the painter Sodoma (who did the ceiling in this room) and Raphael himself, in a black cap. In placing himself (and other artists) in the scene, Raphael asserts that art is, in fact, an intellectual enterprise—a form of study and enquiry, not merely a manual activity. It is no coincidence that Raphael places himself firmly on the Aristotelian side, among philosophers who work from observation.

Late in the painting process, Raphael added the foreground figure in brown, seated next to a block. This has long been seen as a portrait of Michelangelo, currently also busy in the Vatican painting the Sistine Chapel ceiling. Raphael puts Michelangelo in the guise of the philosopher Heraclitus, both of whom shared melancholy temperaments. In a tribute to Michelangelo's own efforts to portray divine creation in the Sistine (which Raphael may have seen in an unauthorized visit to the chapel in 1511), Raphael places him on the Platonic side, identifying his colleague as a philosopher-artist concerned with the realm of higher things.

THE GROUND PLAN OF *The School of Athens* CLOSELY RESEMBLES DONATO BRAMANTE'S PLANS FOR THE NEW SAINT PETER'S BASILICA. BRAMANTE MAY HAVE HELPED HIS FRIEND RAPHAEL DESIGN THE FICTIVE ARCHITECTURE OF HIS FRESCO.

THIS FIGURE WAS ORIGINALLY HYPATIA, THE PREEMINENT NEOPLATONIST OF THE CLASSICAL PERIOD AND THE ONLY WOMAN IN RAPHAEL'S FRESCO. RESPONDING TO OBJECTIONS FROM THE CHURCH ESTABLISHMENT, RAPHAEL TRANSFORMED HER INTO POPE JULIUS II'S NEPHEW, FRANCESCO MARIA DELLA ROVERE.

PLATO POINTS UPWARD, INDICATING THE REALM OF IDEAL FORMS, WHICH ARE MANIFESTED IMPERFECTLY ON OUR EARTHLY PLANE. IN PLATONIC PHILOSOPHY, THE MIND NATURALLY SEARCHES FOR THE HIGHEST SOURCE, ASSOCIATED IN THIS PAPAL CONTEXT WITH THE CHRISTIAN GOD.

THE FIGURE SPRAWLED ON THE STAIRS IS THE ASCETIC PHILOSOPHER DIOGENES, IDENTIFIABLE BY THE CRACKED CUP BESIDE HIM, A SIGN THAT HE SPURNED MATERIAL POSSESSIONS.

A MARKED AXIS DIVIDES PLATO'S REALM FROM ARISTOTLE'S. THE MAN WRITING IS PYTHAGORAS, WHO SPOKE OF MYSTICAL HARMONIES, SUCH AS THE "MUSIC OF THE SPHERES," ILLUSTRATED ON THE SLATE.

RAPHAEL MAY HAVE HERE DEPICTED HIS SATURNINE COLLEAGUE MICHELANGELO WEARING HIS TRADEMARK DOG-SKIN BOOTS. FOR GIORGIO VASARI, A LATER RENAISSANCE ARTIST AND WRITER, MICHELANGELO—POET, PAINTER, SCULPTOR, AND ARCHITECT—EPITOMIZED *disegno*, THE ABILITY TO CONCEPTUALIZE A MEANINGFUL IMAGE.

PIERO DI COSIMO

(1462–1521)

Mars and Venus

CA. 1500–1505

OIL ON PANEL
28 ⅜ X 71 ⅝ IN.
STAATLICHE MUSEEN, BERLIN

THE adulterous liaison between Venus, goddess of love, and Mars, god of war, was one of the most famous scandals among the classical deities. Venus was married to Vulcan, the ugly, lame god of fire, but her real passion was the handsome, athletic Mars. This painting is not a literal narrative of their specific affair. Instead, it functions as an allegory of love and its pacifying, tempering effects. The happy couple lies in a state of relaxation on blankets and pillows in the grassy foreground, surrounded by flowers and myrtle bushes (a symbol of Venus). This is a true *locus amoenus*, an idyllic pastoral landscape associated in classical literature with love and pleasure.

On the right, Mars sleeps, his arm crossed in an awkward gesture across his chest, showing his absolute unconsciousness. On the other side, in a pose that mirrors his, Venus also reclines on a pillow. She stares absently, even languorously, up into the sky. A fat baby Cupid nestles under her arm while a white rabbit peeks over her curvaceous hip. In the peaceful landscape behind, putti play with Mars's discarded armor. Bushes enclose the area where the lovers sleep, enhancing the sense of privacy and intimacy. As well, the contrast between the private arbor and the open landscape beyond highlights the immediacy of the moment.

Other contrasts highlight the sensual nature of the painting: Piero details carefully the texture of Venus's hair, and how tendrils escape from her rich headdress of gold and pearls. Her body, clad only in a transparent gray cloth, is propped, tilted, and twisted to provide maximum visual pleasure to the viewer. The rich textiles under the lovers' bodies, and the verdant grass and flowers around them, also highlight the earthly, sexy quality of the scene. A fly on Mars's pillow, and a butterfly resting on Venus's leg, serve as telling examples of this kind of tactile contrast. In painting these insects with such naturalism, Piero here repeats a humanist conceit based on classical stories of the power of art to deceive. The insects also highlight the absolute repose of the figures, which—in combination with the flushed cheeks of the lovers—may point to the recent consummation of this love.

The theme of love is embedded in the details throughout the painting. Turtledoves (the birds of Venus, known for their overt affectionate behavior) kiss in the foreground, next to a piece of empty armor. The position of the rabbit may highlight a pun deriving from the Latin words for the animal (*cuniculus*) and for female anatomy (*cunnus*). The sword and empty armor by the putti may be a phallic joke, referring to the couple's recent activity.

However, there are signs that this moment of peaceful love is a transient one. Cupid looks to his mother with a strange expression, which

Giorgio Vasari explained in his 1568 text was sparked by the boy's fear of the rabbit. Since Vasari owned this painting, it is a bit strange that he did not discuss Cupid's pointing gesture, which indicates something outside of the painting, beyond Mars. In fact, one of the putti in the middle ground, startled, turns in awareness of this outside force. Two tiny putti in the far landscape also point, turn, and flee. Piero does not specify what the threat to this *locus amoenus* is, but the classical model for the type often turned on a tragic end to the romantic idyll taking place in the garden of love. The educated viewer of this painting might have speculated on the famous discovery of the adulterous lovers by Vulcan, and how he captured them in a net for display and shaming before the other gods. Or, the painting may simply point to the transient nature of pleasure, and how the pacifying effects of love are never permanent.

Piero was an urbane, erudite man, though he did develop in old age rather strange personality traits, which Vasari describes with relish. Apparently, he was afraid of thunderstorms and fire, refused to cook or clean his house, and ate only boiled eggs. While Vasari's account is certainly entertaining and puzzling, Piero also enjoyed public success in Florence: he devised elaborate theatrical triumphs and allegories that took place in the streets, and had elite patronage, including a stint painting in the Sistine Chapel in Rome. The long, narrow proportions of this painting mark it as a kind of domestic painting known as *spalliera*. These kinds of panels were installed in interiors, on the upper part of a wall over a wainscoting. Such works often had a dual purpose, to be both decorative and didactic, and many were commissioned in this period to celebrate weddings. In that context, Piero's painting would have operated not only as an erudite work of fashionable classical subject matter, but as a witty, intentionally sexy painting intended to emphasize the conjugal love (and procreation) of the newlyweds.

A PUTTO DISPLAYS LOVE'S TROPHY. THE PAINTING'S MESSAGE WORKS BOTH WAYS: WHILE VENUS CAN UNARM EVEN MARS, LOVE—THAT IS, FECUNDITY AND PROSPERITY— CAN FLOURISH ONLY IN PEACETIME.

EVEN THE SHIPS ARE AT REST IN THE HARBOR, THEIR SAILS FURLED. THE WIND IS SPENT. THE PREMONITORY CLUES THAT SOMETHING IS ABOUT TO HAPPEN—PERHAPS THE ARRIVAL OF VULCAN—MAY ADD NARRATIVE INTEREST, RECALL THE ARCHAIC CONVENTION OF ADULTEROUS COURTLY LOVE, OR MANIFEST THE PAINTER'S ECCENTRICITY.

A LEG PIECE OF MARS'S ARMOR LIES DISCARDED BEHIND HIM, A MEANINGLESS TOY. IN TANDEM WITH THE STANDING RED SWORD TO THE RIGHT, IT MAY BE A BAWDY VISUAL JOKE.

THIS LESS-THAN-VERTICAL SPROUT POINTS TO MARS'S NO DOUBT EXHAUSTED GENITALS.

DOVES, SACRED TO VENUS, SYMBOLIZE FAITHFUL LOVE; THE *spalliera* WAS PROBABLY A WEDDING GIFT. THE YOUNG PEOPLE SUGGEST AN APPROPRIATE PAIRING, A RENAISSANCE IDEAL. PLACED OVER THE BED, THE HANDSOME COUPLE WOULD INSPIRE BEAUTIFUL CHILDREN.

PIERO DI COSIMO (1462–1521)

Mars and Venus, CA. 1500–1505

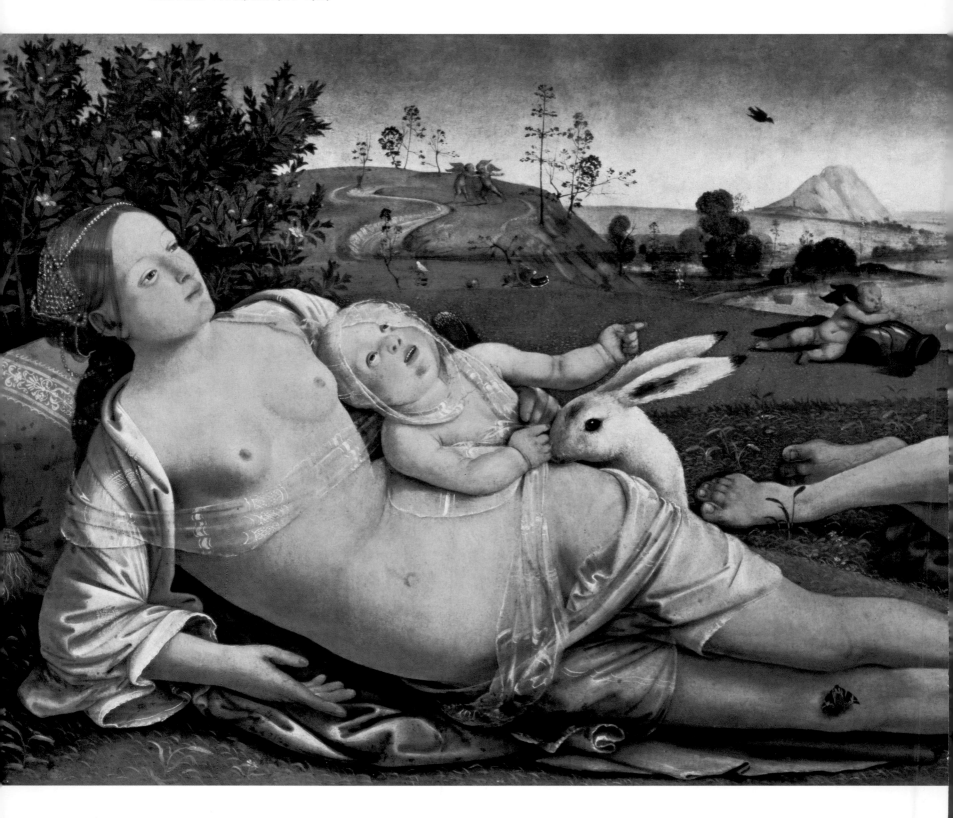

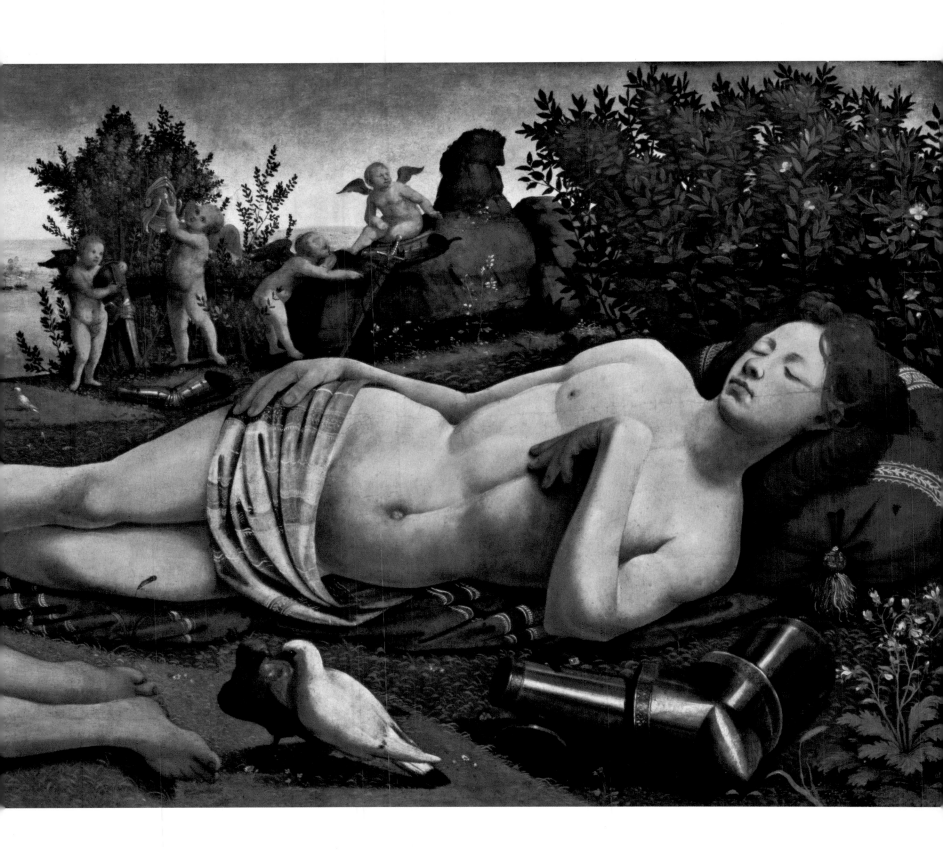

GIORGIONE

(1477–1510)

The Three Philosophers

CA. 1508

OIL ON CANVAS
48 ½ X 56 ¾ IN.
KUNSTHISTORICHES MUSEUM, VIENNA

THREE men, varying in age and costume, convene in a wood near the entrance to an outcrop of rocks. It was not a scene that was familiar in art in the first decade of the sixteenth century. Giorgione was known for mysterious subjects that appealed to humanists of Renaissance Venice who could identify such esoteric themes and characters. Most likely this painting was meant to represent the three Magi awaiting a sign from the heavens. The setting is almost certainly derived from the story of the Magi told by St. John Chrysostom, but Giorgione goes further to make an allegory of the stages of life, and perhaps also a comment on the geography and sources of knowledge in the ancient Near East.

In 1525, Marcantonio Michiel wrote that he saw the painting in the home of Taddeo Contarini "of Three Philosophers in a landscape, two standing and another seated, who contemplates the rays of the sun, with a rock that is miraculously rendered." The fact that he did not offer a more specific identification has vexed scholars for centuries.

The men display an interest in astronomy and land surveying. The youngest, seated to the left, looks outward and makes notations with a rule and a compass. Michiel's notation that he contemplates the rays of the sun indicates that he is surveying the land, in preparation for travel, and perhaps that he has noticed a strange phenomenon in the light of day. The sun sets in the distance, and yet the light appears to enter from the front of the scene. Has the magical star that shone brightly even in the daytime, according to many exegetical texts, already appeared? He is dressed in a simple tunic. and may represent the Greek world of ancient knowledge.

In the center, a short-bearded, finely dressed and turbaned character may represent the Babylonian civilization, rich in knowledge of the stars. He wears a cloth around his shoulders bound by a golden clasp somewhat reminiscent of an amulet. The hem of his tunic is highlighted in a golden thread that appears to render a script. Unfortunately it is illegible today, and may never have been specific.

To the right is a long-bearded elder, his thick robes offering the appearance of a prophet. He is likely a Jew, or perhaps associated with Moses himself, who was said to have learned astronomy from the Egyptians. He holds a scroll with diagrams of the earth and moon, and

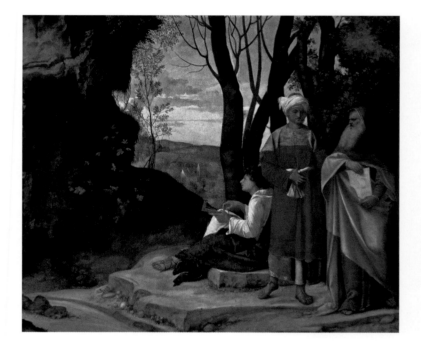

a partial view of an ancient instrument to measure the longitude by the position of the North Star. This device was particularly useful to travelers. The three, four, and five written on the top left of the sheet represent the simplest form of a Pythagorean theorem: as measurements of a triangle's two short sides and hypotenuse, three squared plus four squared equals five squared.

The patron Contarelli was said to be interested in alchemy, and this type of subject would have formed a foundation for Christianity in other ancient civilizations' knowledge of astronomy, mathematics, and mysticism. Giorgione's own star was ill-fated. He died of the plague in Venice in 1510, only in his early thirties. Isabella d'Este, one of the great collectors of the period, upon hearing of Giorgione's death wrote in vain trying to secure a nocturnal scene. The poetic melancholy of his work had a lasting influence on Titian, who went on to become the greatest artist of Venice in the sixteenth century, as well as on nearly every other artist in that region for decades to come.

THE SUN IS AT THE HORIZON, BUT THE LIGHT THAT ILLUMINATES THE MAGI IN THE FOREGROUND COMES FROM A DIFFERENT SOURCE. THE THREE FIGURES LIKELY REPRESENT THE MAGI AWAITING THE APPEARANCE OF A SIGN IN THE HEAVENS. PERHAPS THE SIGN THEY HAVE AWAITED HAS APPEARED, AND THEY ARE ABOUT TO EMBARK ON THEIR JOURNEY.

THE THREE FIGURES MAY ALSO REPRESENT STAGES OF LIFE OR GEOGRAPHIC AND CULTURAL SOURCES OF ANCIENT KNOWLEDGE. THE YOUNG PHILOSOPHER TO THE LEFT IS DRESSED IN GREEK FASHION, WHILE THE TURBANED PHILOSOPHER ALLUDES TO ARABIC OR BABYLONIAN SCIENCE — THE OLDER FIGURE IS DRESSED AS A JEWISH PROPHET.

THIS PHILOSOPHER USES A COMPASS AND RULE TO MEASURE THE MOVEMENTS OF CELESTIAL BODIES. THE CAVE BEFORE WHICH THE MAGI ARE PLACED MAY HAVE AIDED IN THE OBSERVATIONS OF THE STARS, EVEN DURING DAYTIME.

THE SCROLL CONTAINS INFORMATION THAT WOULD HAVE BEEN ESPECIALLY USEFUL TO TRAVELERS SUCH AS THE MAGI: CRYPTIC NUMERALS, DRAWINGS OF THE EARTH AND MOON, AND A DIAGRAM OF AN ANCIENT ASTRONOMICAL INSTRUMENT CALLED A NOCTURNAL, USED TO PLOT LATITUDE WITH RESPECT TO THE POSITION OF THE POLE STAR.

ALBRECHT DÜRER
(1472–1528)

The Adoration of the Trinity

1511

OIL ON PANEL
53 ⅛ X 48 ½ IN.
KUNSTHISTORISCHES MUSEUM, VIENNA

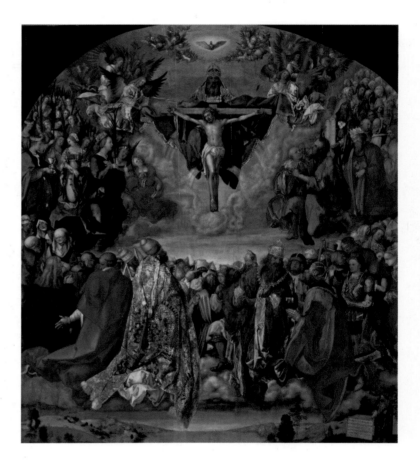

AT the center of this magnificent work from Dürer's mature period is the Trinity, one of the central theological concepts of the Christian church. As had been traditional in Christian art, Dürer shows the idea of a three-part god in three separate forms: God the Father (divine authority), the crucified Christ (God made man), and the dove (the divine spirit). Dürer here paints these complex theological ideas as emphatically physical, human, and real. Swathed in blue, his God's tangibility is belied by the fact that he sits solidly on a rainbow and uses another as a footrest. Between his outstretched hands hangs the body of Christ on the cross, while angels hold up a green cloth of honor embroidered with brilliant gold. Above, the dove descends from the heavens. This key group embodies the Christian concept of divinity—it also shows off Dürer's virtuoso abilities as a figure painter, and his mastery of Renaissance painting techniques.

The entire heavenly host is gathered around the Trinity figures. The multitude is hierarchically ranked and carefully arranged, giving an overview of the whole of Christian thinking. The earthly world is shown in the expansive landscape at the bottom, with a sweeping view over fields, hills, and a prosperous city. Although populated solely by the figure of Dürer at lower right, the landscape shows the evidence of human activity, in the houses, cultivated fields, and shipping boats. Above the landscape, on the next step of sanctity, are the clergy (nuns and monks at left), then kings and queens (to the right of center).

On the next level are the saints and biblical figures. The left shows a group of martyrs, who represent the age of Grace, or the time of Christ on earth. The choice of martyrs probably emphasizes sacrifice as a fundamental virtue for Christians. Female martyrs hold palm fronds; at the front is the Virgin Mary (in blue). St. Catherine of Alexandria and her spiked wheel are located directly behind Mary, with St. Christina (holding a millstone). Against the frame stands a crowned St. Barbara, holding a chalice (instead of her normal tower), while toward the center St. Agnes (with the lamb) turns and smiles. The objects signal the identity of the figures by referencing the martyrdoms and powers of the individual saints.

On the right side, we see John the Baptist heading up a group of mostly male saints, prophets, and Old Testament figures. The right side shows the figures associated with the era under the Law (the Old Testament); John provides the transition between the ages, since he first recognized the divinity in Jesus. An elaborately crowned King David

plays his harp (a reference to his authorship of the Psalms), and Moses stands solemnly behind, displaying the two tablets of the Commandments. Angels and seraphim take up the upper section, closest to the divine; with jocular smiles, they hold the instruments of the Passion (the column, spear, sponge, nails, and whip).

In its original setting, the painting served as the main altarpiece of the "Twelve Brothers House" of Nuremberg, a home for impoverished elderly men. It was originally surrounded by an elaborately carved frame depicting the Last Judgment. For those elderly viewers, one imagines the message about sacrifice, death, judgment, and salvation would have resonated powerfully. And, to make the connection between this world and the next even more clear, Dürer himself stands at the base of the painting, gesturing toward the paradise still to come for the worthy faithful.

THE TABLETS OF THE TEN
COMMANDMENTS LITERALLY
REPRESENT THE OLD LAW AND
ITS PROPHETS, ON CHRIST'S
LEFT. THE OLD ORDER WAS
SUPERSEDED BY THE NEW
DISPENSATION, SYMBOLIZED
BY THE SAINTS ON CHRIST'S
RIGHT HAND.

RAINBOWS ARE BRIDGES
BETWEEN HEAVEN AND
EARTH. IN THE OLD
TESTAMENT, THE RAINBOW
THAT FOLLOWED THE FLOOD
SYMBOLIZED THE COVENANT
BETWEEN GOD AND
HUMANITY.

IN THE CHRISTIAN TRADITION,
MARY AND CHRIST ARE HELD
TO BE DESCENDANTS OF KING
DAVID. DAVID IS THE REPUTED
AUTHOR OF THE PSALMS, A
SERIES OF HYMNS WHOSE NAME
COMES FROM THE WORD FOR
"HARP." THE STYLE OF DAVID'S
INSTRUMENT APPEARS IN MANY
IMAGES, FROM ILLUMINATED
MINIATURES TO PAINTINGS AND
SCULPTURE.

THE CLOSED CROWN CAN SIGNIFY
THE EMPEROR. THE CITY OF
NUREMBERG ANSWERED ONLY TO
THE HOLY ROMAN EMPEROR.
HERE, THE GREATS OF THE
EARTH, DISPLAYING ATTRIBUTES
SUCH AS CROWNS, SCEPTERS, AND
SPURS, ARE ALSO SHOWN CARING
FOR THE OLD AND POOR.

JOHN THE BAPTIST WAS AN
ASCETIC WHO LIVED IN THE
DESERT. IN CHRISTIAN BELIEF,
HE IS CONSIDERED THE LAST
PROPHET OF THE OLD ORDER,
BECAUSE HE PRECEDED
CHRIST. HERE, HE IS LARGER
THAN HIS OLD TESTAMENT
PREDECESSORS, AND THE ONLY
ONE LOOKING AT CHRIST.

MATTHIAS GRÜNEWALD

(CA. 1480–1528)

The Isenheim Altarpiece

1515

OIL ON PANEL
8 FT. 11 ⅞ IN. X 10 FT. ⅞ IN.
MUSÉE D'UNTERLINDEN, COLMAR

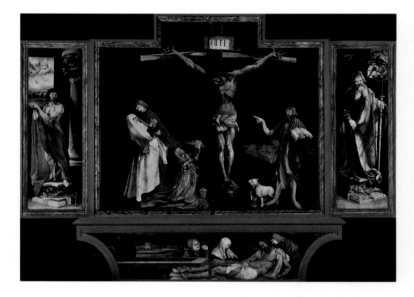

GRUESOME and resplendent, *The Isenheim Altarpiece* by Matthias Grünewald ranks among the most complex compositions of the Renaissance. The altarpiece actually opens in three stages. The outer view presents a grisly Christ, wretched, drained of color, swollen, bleeding from the customary crown of thorns and puncture to his side, as well as the nails of the cross in his feet and hands. But there is more here than usual: Christ is covered with sores. He is afflicted with St. Anthony's fire, a horrible condition caused by a fungus called ergot that grows on rye grass. The people of the time did not know the cause, but watched as those afflicted writhed in agony and went made with hallucinations.

The altarpiece was commissioned by a monastery for the chapel of a hospital in Isenheim, Germany. The monks offered aid to patients of this ailment, and the imagery was meant to connect the afflicted to Christ's own suffering and to inspire the monks in their thankless tasks of mercy.

The central crucifixion scene is haunting not only for the lacerated flesh of Christ's riddled corpse, repeated in the Entombment in the predella panel below, but also for the barren landscape and dark, unforgiving sky, the desperate gesture of Mary Magdalen at Christ's feet, the uneasy recline of the Virgin's swoon at the left as she laments, supported by John the Evangelist, and the unusual and eerie inclusion of a pointing John the Baptist on the right. He is set apart from the mourners because he acts not as a witness but as a prophet, declaring in the text inscribed over his shoulder, "He must increase, but I must decrease" (John 3:30). The Baptist's lamb wraps his leg around a crucifixion and paws a chalice. The inconsistent scale of the figures contributes to the sense of awkwardness and mystery. The landscape makes sense not only as a crucifixion event, but also as an embodiment of John's voice crying out in the wilderness.

The wings represent St. Anthony on the right, chosen because he was tormented by demons and persevered. Likewise, St. Sebastian, in the left panel, was shot by arrows but survived.

When the outer panels were opened on feast days, an incredibly luminous and joyous set of scenes was revealed. A Nativity stretched over the two central panels: the Virgin adoring her child is on the right half, while a chorus of angels set within an ornate structure, meant to invoke a chalice or perhaps the Temple of Solomon, occupies the left. The Nativity contains several peculiar details. The brightness of the angels' robes and the changing colors of the silk give them a heavenly countenance. One angel is feathered and looks not toward the Nativity but toward the sky. This is probably the fallen angel Lucifer, identifiable by his peacock crown, symbolic of pride, the deadliest of the sins. A tradition suggested that he was present at the Nativity, but was powerless to prevent Christ's incarnation. Yet another angel, adorned with a flaming crown, emerges from the temple structure and prays toward the Virgin and Child. She may be a spiritual incarnation of

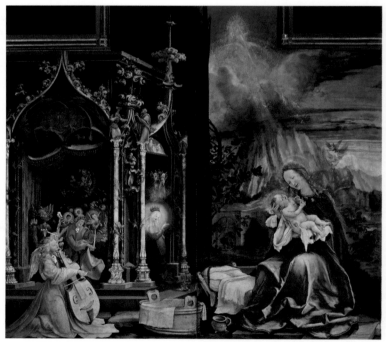

Mary herself as Queen of Heaven, or Ecclesia, the Christian Church. God the Father is seen above in the sky, orchestrating a cascade of cherubim. As she lifts the child to her face, he fondles a rosary. The Virgin sits on a low wall, to indicate the *hortus conclusus*, or closed garden so frequently seen in medieval imagery.

When the second set of panels was opened, viewers saw a combination of painted and sculptural images (not shown here), including other plague saints and a ferocious scene of St. Anthony tormented by demons of all sorts.

FROM THE THRONE OF GOD POURS
A BRILLIANT CASCADE OF ANGELS.
IF THE EFFULGENT SIGHT DID NOT
CURE THE SICK, IT COULD CONSOLE
THE DYING.

THE RADIANCE SURROUNDING THE
MYSTERIOUS CROWNED FIGURE MAY
HAVE BEEN INTENDED TO INDUCE A
HEALING TRANCE IN THE SUFFERING
VIEWER, AS WELL AS AN INSPIRING
VISION OF A HIGHER REALM.

THE CHRIST CHILD HOLDS A
ROSARY. THOUGH OFFICIALLY
APPROVED AROUND THE TIME
THE *Isenheim Altarpiece* WAS
MADE, THE CHURCH SUSPECTED
ROSARIES OF BEING USED IN
INCANTATORY MAGIC. SIMILARLY,
THE CORAL TOUCHING THE BABY'S
CHEST IS AN AMULET.

THE GLASS EWER CONTAINS WATER
OR PERHAPS A CHRISM, OR SACRED
OIL. ITS SHAPE CAN BE TRACED TO
PERSIA, AND MAY SUGGEST
ALCHEMICAL MEDICAL
EXPERIMENTS.

THE CLOSED DOOR WITH ITS
CROSS EMPHASIZES THE VIRGIN'S
IDENTITY AS *hortus conclusus*. THE
FIG TREE RECALLS THE GARDEN
OF EDEN AND THE TREE OF
KNOWLEDGE, AND SYMBOLIZES
THE LITURGICAL SEASON OF
ADVENT AND THE COMING OF
THE KINGDOM OF GOD.

Matthias Grünewald
(ca. 1480–1528)

The Isenheim Altarpiece
1515

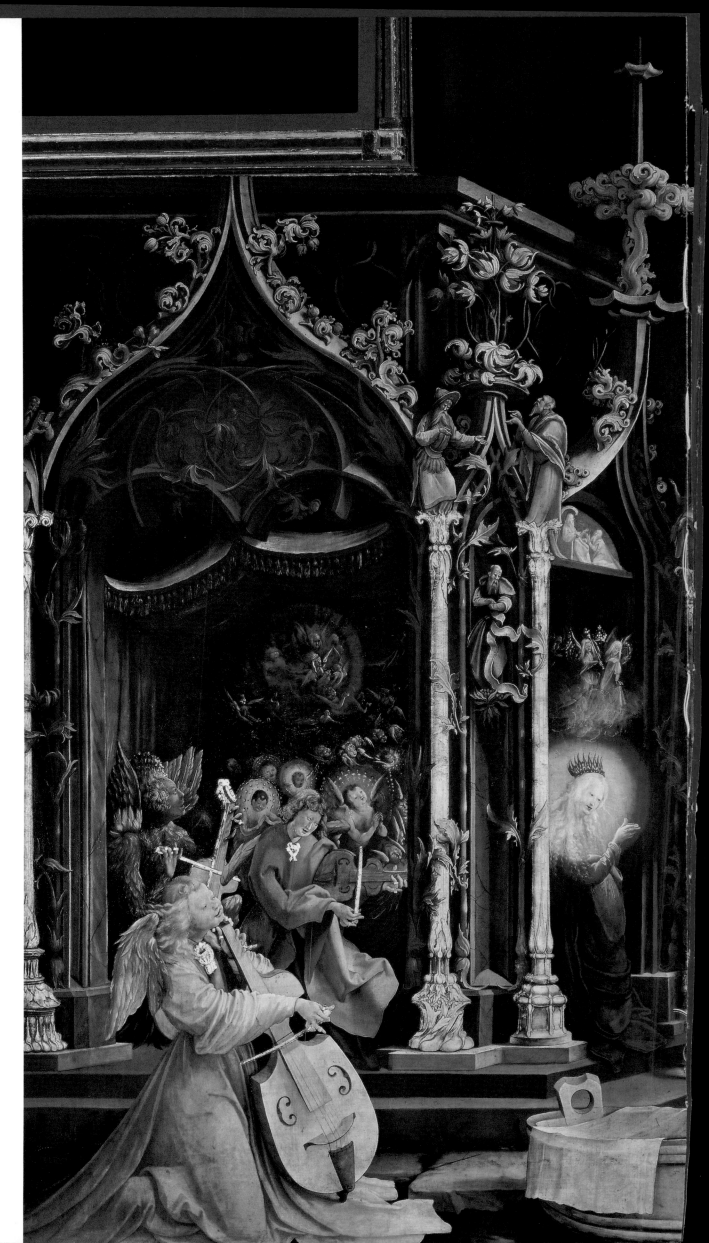

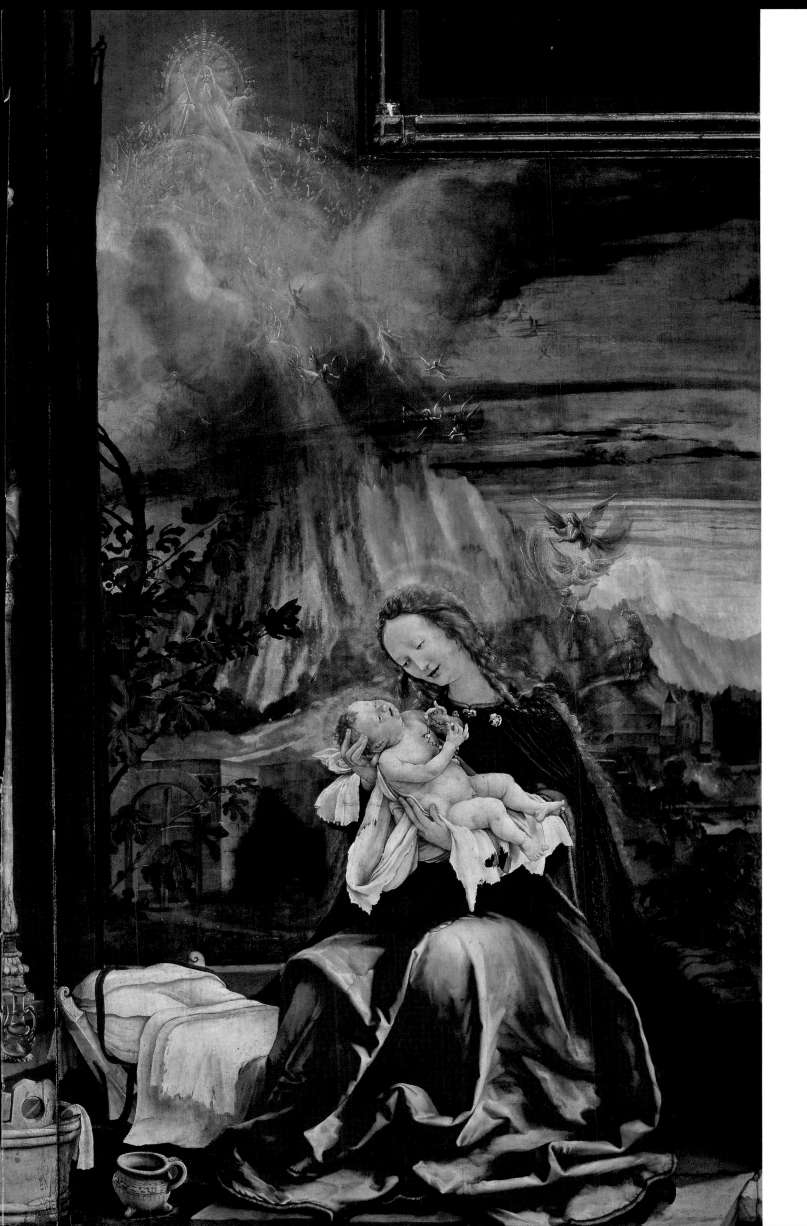

QUINTEN METSYS
(1466–1530)

A Banker and His Wife

1514

OIL ON PANEL
28 X 26 ¾ IN.
THE LOUVRE, PARIS

A MAN and a woman sit at a bench facing the viewer; behind them are shelves holding books and other objects. On the far right, a sliver of a view looks out onto a Netherlandish street, where two men converse. The scene is an unusual one in sixteenth-century art—as it apparently shows a view of a banker's booth or office. The overtly secular scene marks it as a product of the Netherlands, where images of everyday life (later known as *genre* pictures) flourished. Painted in a naturalistic manner, with careful attention to surfaces, textures, and detail, the painting contains layers of meaning within the carefully selected actions, objects, and spaces.

The fur-trimmed clothing and luxurious headdresses signal that the couple is clearly from the prosperous middle class. However, they are removed from the everyday by being dressed in old-fashioned clothing, dating from the fifteenth century. The man fingers coins in his right hand, and holds a set of scales in his left with which he is weighing. The large pile of coins in front of him marks him as a banker or moneylender. His attention is focused on that act; his wife looks on in a preoccupied manner. She turns the pages of a richly illustrated personal prayer book, known as a book of hours. Such books of hours were attributes of wealthy ladies, who carried them about as aids to devotion (and as status symbols). The felt-covered bench before them is tipped up slightly, and a variety of objects are scattered on the surface. These include a small circular mirror, a set of weights, a pile of pearls, and a Venetian glass container.

While some read the objects and the painting as a satirical critique of the commercial basis of Dutch society (following the moral criticisms of Erasmus), clues in the painting suggest rather that it is an essay—a sermon, even—on balance, both moral and financial. Written on the original frame was an inscription from Leviticus (19:36), which read: "Let the scales be true and the weights equal." This admonition to be righteous and fair helps us see the figures as everyday folks working hard and striving for virtue. Busy weighing, the man pays attention to what the scales tell. His wife looks up from her prayer book to watch her husband's efforts to find balance and fairness. The book is shown with the pages turned, so that an illumination of the Virgin and Child is visible; on the text page, an enlarged capital A is inhabited by an image of the Lamb of God, a reference to Christ and the Resurrection.

The mirror, which reflects outward into the viewer's space, shows an elderly man in a red hat sitting with a prayer book in front of a set of windows that frame a tall church spire is visible. By contrast, in the street view at rear, fools and simpletons argue. The carefully differentiated spaces here suggest that the banker and his wife occupy the difficult middle ground between folly and rectitude.

On the back shelves are a collection of books and accounts, strewn about. Each of these contains associations related to the theme of the painting. On the upper shelf sits a half-filled glass carafe. The light shining on the curve of the glass not only shows off Metsys's abilities, but also refers to purity. Such vessels are often found as a symbol of the virginity of Mary, referenced in the way that the glass is permeable to light but remains unbroken. (A similar point may be made in the covered glass in the left foreground.) These kinds of stoppered vessels filled with liquid also appear as allusions to the water of life. Prayer beads hang from the shelf below, and an apple sits on the shelf in front of a Chinese metal plate. A small box on the shelf below may be a visualization of the idea of the world as the *scrinium deitatis* (box of God). This combination of carafe, beads, and box reappears in many Renaissance paintings.

Books and papers are laid on the shelf, several projecting over the edge of the shelf. Another scale is set on the shelf behind the man's head. All of the objects convey associations: of wealth, of global reach, of luxury, of religion, of proper behavior. As a group, they show the way that sanctity and rectitude can permeate everyday life. Thus, the painting provides evidence of the two approaches to life—worldly and pious—and encourages the viewer to find the balance.

THE DISCREET JEWEL ON THE
WOMAN'S ANACHRONISTIC
HEADDRESS MAY REFER, POSSIBLY
IRONICALLY, TO THE BIBLICAL
PRAISE OF A VIRTUOUS WOMAN.
SOME ARTISTS OF METSYS'S
GENERATION LOOKED TO
PAINTINGS OF A CENTURY
BEFORE, A PERIOD THEY PERHAPS
PERCEIVED AS MORE PIOUS.

THE BANKER NEITHER
DESPISES NOR OVERVALUES
WORLDLY GOODS. HE GIVES
THE SCALE CAREFUL, BUT
SERENE, SCRUTINY.

A MANUSCRIPT BOOK OF HOURS
LIKE THIS ONE WAS A VASTLY
EXPENSIVE ITEM. THE WOMAN'S
COSTUME, TOO, WITH ITS SHOWY
RED COLOR, ORGAN-PIPE PLEATS,
AND EMBROIDERED CUFFS,
CONTRASTS WITH HER
HUSBAND'S SOBER DRESS.

IN AN AGE WHEN EACH CITY
MIGHT HAVE ITS OWN COINAGE,
THE VARIETY OF MONEY ON
THE BENCH ENHANCES THE
REFERENCES TO COMMERCE.

MIRRORS ARE OFTEN SYMBOLS OF
VANITY. HERE, TURNED OUTWARD,
THIS HANDSOME OBJECT, LIKE THE
PAINTING, INTERROGATES THE
VIEWER WITH A MULTIPLE CHOICE
OF REFLECTIONS.

TITIAN

(CA. 1488–1576)

Bacchanal of the Andrians

1523–1525

OIL ON CANVAS
69 X 76 IN.
THE PRADO, MADRID

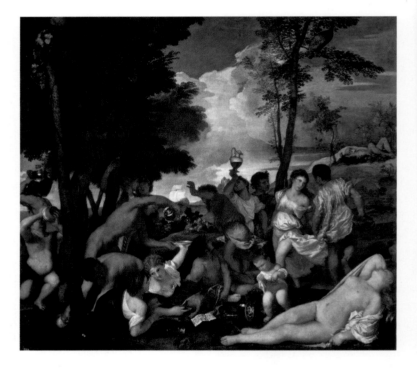

THIS scene of unbridled revelry and drinking was inspired by Philostratus the Elder's *Imagines*, in which he described a painting of "the stream of wine on the island of Andros, and the Andrians who have become drunken from the river." The river of wine can be seen on the lower edge of the painting, particularly on the left, where a figure bends around a slender tree to dip his jug into the flow. The wine-stream's source is the river god on the upper right, reclining on a couch of grape clusters, just as described in the text. According to Philostratus, the men were crowned with ivy and bryony, and danced, reclined, and sang the praises of wine to themselves and their wives. Sure enough, a group of five prances an interweaving pattern, no small feat when the glass pitcher raised in the air is half consumed already. A couple of men, including one with his arm wrapped around a tree, sing in the mid-ground, while two women reclining have set down their recorders. A sheet of music on the ground shows a canon for four voices, and the song in French reads: *"Chi boyt et ne reboyt, Il ne scet que boyre soit"* (He who drinks and does not drink again, does not know what drinking is). One of the women, true to the verse, reaches behind to have her drinking cup refilled. The ship of Dionysius can be seen moored in the harbor in the background, but he has not yet made the scene.

The two most curious figures in the painting are the urinating boy and the reclining woman at the lower right. They have been interpreted as personifying two other characters mentioned at the end of Philostratus's text: Gelos, or laughter, and Komos, or Revel. A boy "making water" was a common motif in Renaissance art, particularly for fountains, and was generally regarded as humorous and mirthful. The reclining nude, though, probably resulted from a mistranscription of the ancient text. Rather than Komos of the Greek original, some of the medieval and Renaissance transcriptions of Philostratus referred to Koma, or deep sleep. Sleeping figures were often represented with a raised arm in order to distinguish them from the deceased. She has finished drinking, the shallow cup still in her left hand, and reclines against a large water urn, associating her with fountain imagery just like the child. In other words, rather than laughter and revelry as the final companions of Dionysius, Titian gave us pissing and sleeping as the results of overindulgent drinking.

The *Bacchanal of the Andrians* was one of five major paintings made for the *camerino*, or small study, of Alfonso d'Este, Duke of Ferrara, between 1514 and 1529. Titian made three of the five paintings, and retouched a fourth, the *Feast of the Gods* (today in the National Gallery in Washington, D.C.), which had been started by Giorgione and then altered by Dosso Dossi. Titian's changes to the *Feast* made its background better accord with his *Bacchanal*, providing a unified look among the paintings altogether. The collection was dispersed at the end of the sixteenth century, and the *Bacchanal* went into the collection of the king of Spain and then to the Prado. It has always been highly praised, and was copied by Peter Paul Rubens and served as the inspiration for Matisse's 1906 painting *Joy of Life*.

Titian's style of painting differed from his contemporaries Michelangelo and Raphael. Following in the footsteps of Giorgione and other Venetian painters, Titian blurred the contours of his figures amidst richly saturated landscapes, rather than using the crisp outlines and bright, decorative colors favored in Florence and Rome. As his career progressed these coloristic effects became more prominent as he scumbled paint in rough patches over the surfaces. He preferred rougher linen, in contrast to the smooth surface of panels, in order to provide more texture to the surface of his paintings.

One of Bacchus's acolytes attempts a party game—dancing while holding a pitcher of wine aloft. Titian's mastery of line, color, and surface textures inspired his contemporaries to compare him to the legendary Greek painter Apelles.

The carafe is empty, but there's more where that came from. The shallow cup the woman on the right holds out for a refill is in the classical style. Renaissance painters enjoyed the challenge of ekphrasis, that is, painting an image known only from an ancient text.

The small boy urinating mirrors the drunken disinhibition of his elders.

Two young women in the clothing and hairstyles of Titian's time gaze into each other's eyes.

MICHELANGELO

(1475–1564)

The Last Judgment

1536

FRESCO
48 X 44 FT.
SISTINE CHAPEL, THE VATICAN, ROME

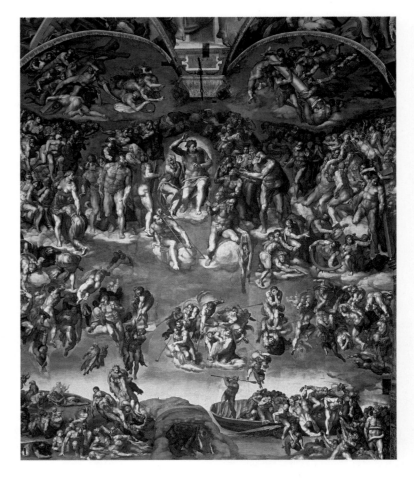

IN the Book of Revelation, the Last Judgment marks the end of Christian time. Angels with trumpets at the center of this composition herald the rolling back of the curtain of time. The dead climb out of their graves and are judged by the resurrected Christ; the Elect rise to Heaven on the viewer's left (Christ's right, or good, side), while the Damned tumble down on the right (the left side of Christ).

However, in this fresco, Michelangelo modifies and manipulates the standard narrative in significant ways. To begin with, he packs his composition with a tremendous crowd of nude figures. Even the saints (both male and female) are shown without clothes, in a rare departure from the standards of decorum at the time. For Michelangelo, the human form was the ideal vessel for representing the soul, and he imbued his figures with a superhuman stature and physical strength in order to convey the majesty of the spirit within.

Christ himself is a perfect male figure; he is flanked by John the Baptist (standing full length in the crowd on the left, with an animal skin) and St. Peter (twisting, with keys, on the right). St. Bartholomew (with the knife and skin from his martyrdom) and St. Lawrence (holding the metal grate on which he was burned) crouch on clouds below. Many of the figures in the *Last Judgment* convey Michelangelo's admiration for antique ideals of human perfection. Christ's twisting pose, known as *figura serpentinata*, references famous classical statues, and his superhuman physique recalls images of Apollo. The glow of light around his figure also merges the sun symbolism of Apollo with the traditional body halo (*mandorla*) surrounding the risen Christ.

Michelangelo creatively adapted tradition throughout this work. The whole composition is centripetal, revolving around the grand activating gesture made by Christ. The Elect do not rise naturally to Heaven; rather, they are lifted and pulled up with great effort by the saints and martyrs above. Near the center, one man hauls up two souls with the aid of a rope made from a rosary. Clearly, salvation requires not only pious effort but also divine assistance. Similarly, damnation also occurs because of divine will. Christ's energy and anger, conveyed in his dramatic gesture, send ripples of dismay and rejection throughout the crowd on the right. In the intermediate zone between Heaven and Earth, saints separate the Elect from the Damned, and defend Heaven from intrusion. From left in this group are Saints. Simon (with a saw), Philip (with a cross), Blaise (with spiked rakes), Catherine (holding her spiked wheel), and Saint. Sebastian (drawing an imaginery bow and holding arrows). The descending souls below struggle and fight as demons pull them into Hell.

Unusually, Michelangelo represents Hell following the descriptions of Dante's epic poem *The Inferno*. The classical figure of Charon herds the damned across the river Acheron; they spill out of the boat and face the figure of Minos. Dante tells us that Minos decided where souls belonged in Hell; the number of times his tail wrapped around his waist indicated the soul's ultimate level. Michelangelo paints a snake instead, a creative visual adaptation of Dante's poetry. Minos wears ass's ears and (according to Vasari) the features of Biagio da Cesena, a Vatican official and early critic of the painting. The gruesome head chewing on another behind Minos may be the famous cannibal Count Ugolino and his jailor Ruggieri. In Hell's mouth at the center more damned souls burn in the fires under the earth.

Commissioned by Pope Paul III, the *Last Judgment* is believed by many to reflect the turmoil in the church during the early Reformation. The prominent saints, and the display of their own instruments of martyrdom, stand in contrast to the Protestant discounting of both saints and church as intermediaries. Michelangelo's own beliefs may also be implied here; later, tradition identified the flayed skin held up by St. Bartholomew, suspended over the Damned, as a self-portrait of the artist. If true, the placement of the self-portrait in limbo between salvation and damnation may refer either to the dangers of the act of creation (à la Dante) or a personal statement of angst.

Michelangelo's work caused much controversy, in particular because of the consistent nudity of the saintly figures. In 1565 the outcry was sufficient to authorize censorship of the work. Daniele da Volterra, Michelangelo's pupil, painted draperies to increase the modesty of the figures, becoming known as a *braghetone*—a painter of underwear.

CHRIST LOOKS DOWN UPON THE
DAMNED, WHILE THE ATTENTION
OF MARY, THE INTERCESSOR, IS
ON THE RISING DEAD. SHE
OCCUPIES THE MANDORLA
WITH HER SON, SUGGESTING HER
IDENTITY AS CO-REDEMPTOR
OF HUMANITY WITH HIM.

SAINT PETER HOLDS THE KEYS
TO THE KINGDOMS OF HEAVEN
AND HELL. THE LARGE SIZE OF
THE KEYS MAY EMPHASIZE THE
ASSERTION, IN THE FACE OF
LUTHERAN OPPOSITION, OF
THE POPE'S POWER TO
GIVE ABSOLUTION OR
EXCOMMUNICATE.

SAINT BARTHOLOMEW WAS
MARTYRED BY BEING FLAYED.
THE FACE ON THE HANGING SKIN
IS MICHELANGELO'S OWN. HIS
REASON FOR INCLUDING THIS
MYSTERIOUS SELF-PORTRAIT IS
STILL UNKNOWN.

SAINT LAWRENCE WAS BURNED TO
DEATH ON A GRATE. ACCORDING
TO TRADITION, HE DEFIANTLY
EXCLAIMED, "I'M DONE ON THIS
SIDE, TURN ME OVER!"

THE ANGEL HOLDS A SMALL
BOOK CONTAINING THE NAMES
OF THE SAVED. THE MUCH
LARGER BOOK HELD BY THE
ANGEL TO THE RIGHT RECORDS
THE NAMES OF THE DAMNED.

IN VIRGIL'S *Aeneid*, THE ACHERON,
THE "STREAM OF SORROW," IS THE
PRINCIPAL RIVER OF HADES.
DANTE, EXTENDING VIRGIL'S
TEXT, DESCRIBES THE FERRYMAN
CHARON CHASING THE NAKED
SOULS OUT OF HIS BOAT.
MICHELANGELO , INTURN, RANG
CHANGES ON DANTE'S *Inferno*.

The Enigmas of Architecture

IN the Christian tradition, art was intended to teach theological concepts and inspire meditation. Altarpieces, frescoes, and other representations in churches and other public places were complemented by sermons and readings from the Gospels. The key event was, of course, the Redemption, prophesied since the world began, and Christ's incarnation was the hinge between the Old Dispensation and the New. Nativity and Adoration scenes especially take place in or near ruined buildings, which symbolize the end of the Old Law. In his *Adoration of the Magi* (page 24) Gentile da Fabriano placed the Holy Family before a castlelike building whose merlons at the top are elegantly distressed. The same painting may predict Christ's death and resurrection, with the grotto-stable foreshadowing the cave in which Christ would be buried, and the manger the tomb he left empty when he arose again after three days.

Classical architecture carries several meanings, in particular the Christian era as the successor of the Roman Empire. In the Renaissance, architecutre *not* inspired by (Italian) classical models was considered barbaric, and attributed—correctly—to the Goths of northern Europe. In *The Chancellor Rolin Madonna* (page 38), Jan van Eyck used the two styles of architecture to stand for the secular and the holy. A row of tiles between the patron and the Virgin is extended by a broad river. On the left bank is a prosperous Netherlandish town; on the right an agglomeration of buildings in the Gothic style, reserved for sacred structures. Domenico Ghirlandaio placed his Saint Jerome, who died in the fifth century, in a contemporary *studiolo* (page 66), perhaps to depict the saint's continuing relevance.

Architectural details can amplify central meanings, as in Andrea Mantegna's *Madonna della Vittoria* (page 94). The seated Virgin—the

Throne of Solomon, or of Wisdom—is atop a pedestal on which is a relief showing Adam and Eve with the serpent. Their sin will be redeemed by Christ, pictured above. In addition, Mary was viewed as the holy counterpart to the sinner Eve: it was noted that the annunciating angel's greeting, *Ave*, is *Eva* spelled backwards.

Artists usually distinguish human space and time from sacred space and timelessness. Paolo Caliari, known as Veronese, often created such divisions. In *Feast in the House of Levi* (page 200), he isolated the Last Supper in the center arcade, with only sky behind Christ. In the upper right corner of *Allegory of Sight* (page 214), by Jan Breughel the Elder and Peter Paul Rubens, light shines from a round opening called an oculus, or "eye." Light usually signifies God and understanding. This image also expresses the optics of the day, according to which the eye perceives by sending out rays that grasp the object.

Constantine brought back to Europe from the East twisted columns like those in Eustache le Sueur's *Fortitude Brings Peace and Plenty* (page 238). A medieval tradition held that they adorned King Solomon's temple in Jerusalem. Perhaps by association with Solomon—and Constantine—such columns came to symbolize kingly or imperial might established by God.

In the central panel of Matthias Grünewald's *The Isenheim Altarpiece* (page 144) the artist created a visionary sacred space with ambiguous elements: figures that oscillate between sculpture and "reality," flourishing vegetal forms that are and are not of immovable stone. Centuries later, to convey the realm of the Olympians, unfathomably different from the world of mortals, Gustave Moreau similarly constructed *Jupiter and Semele* (page 304) upon impossible physics, ambiguities of proportions, and a dreamlike fluidity between animate and inanimate.

GENTILE DA FABRIANO.
The Adoration of the Magi.
The ruined building symbolizes the end
of the Old Dispensation (page 24).

JAN VAN EYCK.
The Chancellor Rolin Madonna.
The biblical Law preceding Christ is
represented by Gothic architecture (page 38).

DOMENICO GHIRLANDAIO.
St. Jerome in His Study.
The contemporary setting indicates the eternal
truth of the Old and New Testaments (page 66).

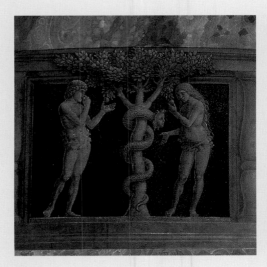

ANDREA MANTEGNA.
Madonna della Vittoria.
Adam and Eve's sin will be redeemed by
Christ's incarnation and sacrifice, portrayed
above (page 94).

PAOLO CALIARI, CALLED VERONESE.
Feast in the House of Levi.
Christ's Last Supper persists into the present
in the Eucharist (page 200).

JAN BREUGHEL THE ELDER
AND PETER PAUL RUBENS.
Allegory of Sight.
The oculus is both the eye of God and a
depiction of the mechanics of sight (page 214).

EUSTACHE LE SUEUR.
Fortitude Brings Peace and Plenty.
The twisted column symbolizes secular power
instituted by divine right (page 238).

MATTHIAS GRÜNEWALD.
The Isenheim Altarpiece.
The liveliness of the figures of Elijah and Malachi
represents the timeless relevance of God's Word
(page 144).

GUSTAVE MOREAU.
Jupiter and Semele.
A flowering architectural member indicates the
boundlessness of the imagination (page 304).

JOOS VAN CLEVE

(1485/90–1540/41)

Madonna and Child

CA. 1525

OIL ON OAK
29 ¼ X 22 IN.
KUNSTHISTORISCHES MUSEUM, VIENNA

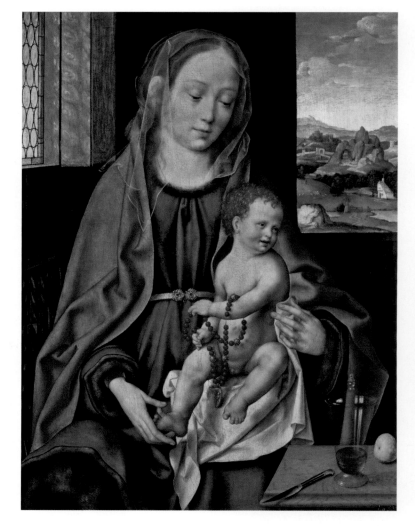

THIS painting is a fine example of Joos van Cleve's specialty, a new type of devotional image featuring the Virgin and Child in half length. Paintings like this one were enormously popular in Antwerp. Such images satisfied the new devotional techniques of the time, and also served as attractive works of art for a newly wealthy middle class.

The *Madonna and Child* shows the Virgin seated in the corner of a room. The walls behind her are punctuated by windows, and hung on the lower part with fabric, which operates as a modified form of a cloth of honor. The window on the right looks out onto a sweeping, fantastic landscape. The Virgin is dressed in a fur-trimmed blue robe; its richness is enhanced by a belt fastened with a clasp made from gold, pearls, and rubies. She wears a translucent white veil, and a red mantle hangs over her shoulders. The Christ child sits on her lap, though Van Cleve does not specify exactly how such sitting occurs. (Such lapses in spatial logic may indicate the hand of one of Joos van Cleve's many assistants.) A happy, well-fleshed baby with curly blond hair, he plays with a rosary. A small table at front holds an apple, a covered glass with liquid inside, and a knife.

Several details indicate foreknowledge of the later events of Christ's life. A viewer of the time would have been familiar with the layers of meaning in these objects, and the layers would have aided the viewer in his or her devotional techniques. For example, the red of the Virgin's mantle is the color associated with Christ's Passion, and her coming sorrow. Her slightly melancholy expression as she looks at the baby also reveals her awareness of his eventual fate. The white cloth wrapped around the baby's back, on which he sits, prefigures the shroud wrapped around the adult Jesus's body after the Crucifixion. The apple refers commonly to original sin, which for Christians was removed by Jesus's sacrifice. The glass contains wine, a reference to the Eucharist; its cover, and the careful reflections shown on it, reference the purity of the Virgin. While the knife may be simply the implement used to eat at this simple meal, knives were commonly connected with betrayal in Christian stories.

Sin, betrayal, and death appear on the table; the baby embodies salvation. The rosary he plays with is, for the viewer, the key, as it highlights the path of piety and devotion needed to reach Heaven. Praying the rosary was a practice that became very popular in the fifteenth century. The beads functioned as prayer counters; the gold orbs divide the beads into sets of ten. A pendant hanging from the rosary shows the head of a gaunt saint in profile; crosses were also common pendants.

The emphasis on the devotional path to salvation is also found in the landscape in the background. The sweeping view over a fantastical rock structure to a distant horizon may be a reference to the works of Joachim Patinir, a celebrated contemporary of Van Cleve's. This landscape shows a lake, fields with a shepherd and his flock, and a humble farmhouse, with a figure setting off down a road toward the distant city. Seen metaphorically, the walled city behind may be a representation of the heavenly Jerusalem. The viewer is encouraged to see him or herself as the penitent traveler, walking the long road from this world to salvation.

Such layers of possible meaning, from Mary as the ideal mother to the necessity of sin to the importance of private devotion, help reveal how such images operated for their original audience. Hung in a domestic setting (much like this one, perhaps) the painting offers inspiration and guidance for Christian viewers.

THE CAREFUL REPRESENTATION OF THE FUR TRIM IS IN ACCORD WITH NORTHERN ARTISTS' SCRUPULOUS RENDERING OF PHYSICAL REALITY. THE BABY'S MORE REGULAR, IDEALIZED CURLS MAY ILLUSTRATE LEONARDO'S THEORIES ABOUT NATURE.

THE SHEEP MAY BE SYMBOLS OF CHRIST'S "FLOCK," THAT IS, HUMANITY, REDEEMED BY HIS SACRIFICE. BUT A SHEEP AS SACRIFICIAL ANIMAL IS OFTEN ALSO A SYMBOL OF CHRIST HIMSELF.

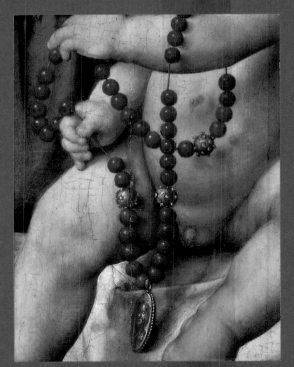

THE ROSARY IS ASSOCIATED WITH VENERATION OF THE VIRGIN. THE COLOR RED USUALLY INDICATES CHRIST'S PASSION—HIS SUFFERING AND DEATH—AND HERE, IT FORMS A CROSS SHAPE. THE PARTICULAR SHADE SUGGESTS CORAL, USED SINCE ANTIQUITY IN CHARMS TO PROTECT CHILDREN.

LIGHT PASSING THROUGH GLASS IS THE CLASSIC METAPHOR FOR THE CONCEPTION OF CHRIST: THE LIGHT ENTERS THE GLASS WITHOUT BREAKING IT.

HANS HOLBEIN THE YOUNGER

(1497/98–1543)

The French Ambassadors

1533

OIL ON PANEL
81 ½ X 82 IN.
NATIONAL GALLERY OF ART, LONDON

THIS painting portrays two influential political figures in mid-sixteenth-century London. On the left stands Jean de Dinteville, Lord of Polisy, who served as French ambassador to the court of Henry VIII between 1531 and 1537. On the right is Georges de Selve, bishop of Lavaur, who was in London secretly in 1533 to respond to the convoluted issue of King Henry's divorce, remarriage, and separation from the Catholic church. The painting contains the visual key to the political and religious agenda shared by these two men.

Holbein paints both Dinteville and Selve leaning ostentatiously on the top shelf of a piece of furniture, where one sees a jumble of objects connected to astronomy, the celestial world, and time. From left, we see a luxurious celestial globe, on which Jean de Dinteville's family estate is prominently marked. Next is a cylindrical instrument known as a shepherd's dial, used as a solar clock. Just to the right of these objects are two quadrants, which helped navigators and astronomers measure the altitude of the sun in relation to the horizon. The polyhegonal object is a common form of sundial, which could be set to a certain latitude. It used a small inset compass (seen on the top) to align with north. Next to Selve, one sees a tall instrument known as a torquetum, with which an astronomer could measure the positions of the moon and visible planets. On the edge of the book is text giving Selve's age (*aetatis suae* [anno] 25)

On the lower shelf are objects associated with the material world. Here are music, song, arithmetic, and a terrestrial globe. In front of the handheld globe on the left is a book providing instruction in arithmetic for merchants (published in 1527), with a square measure holding the place. Another instrument for measuring, the compass, lies on the shelf, behind a book of Lutheran hymns. To the far right are a set of flutes and a lute; a string on the lute is prominently broken. Together with the objects on the upper shelf, the instruments here describe the elements of the advanced program of study in the medieval university known as the "Quadrivium" (Music, Astronomy, Mathematics, and Geometry).

Two more objects complete the picture. A skull shown in anamorphic projection fills the foreground below the shelf. This kind of sophisticated visual trick was very fashionable in elite circles in London and elsewhere; the key was to find the optimal viewing position, from where the perspective "magically" resolved itself to show a three-dimensional skull. In addition to signaling the skill of the artist in this unusual way, the skull also functions as a reminder of death and mortality.

Lastly, at the far top left corner, Holbein shows the green damask hanging being pulled back to partly reveal a small silver crucifix. The contrast between the skull in the lower section, and the crucifix above may refer to the Christian belief in redemption and the afterlife through faith in Jesus. The shelves then become "steps" to Heaven, with the celestial world ranked above the worldly one. The flaw in transient, temporal pleasures (music, worldly knowledge) is conveyed in the broken lute. The anamorphosis of the skull may be meant to suggest to the viewer the importance of the right perspective, both physical and moral, on the

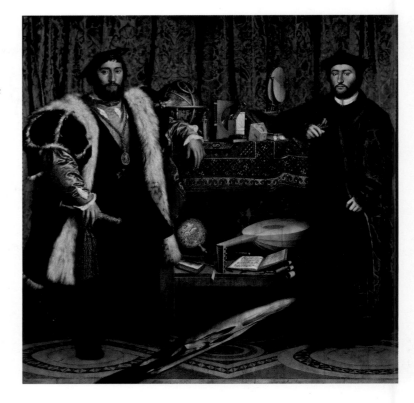

issue of death and redemption. This would have been particularly compelling in the light of Henry VIII's repudiation of the pope, and the Roman church, in that same year.

The composition here includes the two subjects in remarkably large scale, frontally posed (a mode reserved for kings in this period), which adds an aura of self-assurance, even defiance, to these figures. Their assertive gestures aligning themselves with the topmost shelf suggest they would like us, too, to see them as busy with "higher" things. Together, they represent two paths of virtuous service to king and God: the extravagantly dressed Dinteville (complete with pink satin slashed shirt, a cloak trimmed with lynx fur trim, a rich dagger—with his age, twenty-nine, inscribed on it—and a medal of the order of St. Michael) being the active, worldly path, appropriate to a courtier and diplomat. By contrast, Selve, dressed in somber hues but equally extravagant textiles, represents the important role of the Catholic church in society. Together, the figures connect and distinguish the various paths to human understanding represented in the objects, and provide a bridge to the divine above.

This extraordinarily expensive portrait, the largest private portrait of Holbein's career, glorifies these important French men, and serves as their repudiation of the self-serving, worldly, even amoral concerns of the Tudor court. The painting suggests that truth and understanding lie under a Catholic system. Thus, this work was not only a great work of art, but also carried a potent political message.

ASTRONOMY RELATED TO
ASTROLOGY AND TO THE FOUR
HUMORS, TENDENCIES THAT IN
VARIOUS COMBINATIONS WERE
BELIEVED TO DETERMINE HUMAN
CHARACTER. THE CELESTIAL
REFERENCE OF THE GLOBE MAY
ECHO THE COSMOLOGICAL
SYMBOLS IN THE MOSAIC FLOOR.

JEAN DE DINTEVILLE, AMBASSADOR
FOR THE FRENCH KING FRANCIS I,
WEARS A MEDALLION IDENTIFYING
HIM AS A MEMBER OF THE ROYAL
ORDER OF SAINT MICHAEL, A GROUP
OF THIRTY-SIX MEN WHO SWORE
AN OATH OF FEALTY DIRECTLY TO
THE KING.

THE PROXIMITY OF THESE
VARIOUS INSTRUMENTS OF
CELESTIAL MEASUREMENT TO A
MAN OF THE CHURCH ADVOCATES
FOR A HUMANIST APPROACH TO
RELIGION. THE HUMANISTS
SOUGHT TO PURGE RELIGIOUS
PRACTICES OF SUPERSTITION.

THE LUTHERAN HYMNBOOK
RECALLS THAT WHEN REFORMED
THEOLOGIANS WERE QUESTIONING
ROMAN CATHOLIC DOGMA, SELVE
WAS WORKING FOR UNITY.
ACCORDING TO A CONTEMPORARY
BOOK OF EMBLEMS, THE LUTE
SIGNIFIES A TREATY, ITS BROKEN
STRING, A BROKEN TREATY.

HOLBEIN'S VISUAL GAME—A
POPULAR ONE IN THIS PERIOD—
HAS A SERIOUS PURPOSE. IT ACTS
AS A *memento mori* OR *vanitas*,
REMINDING THE VIEWER OF THE
ULTIMATE EMPTINESS OF ALL
WORLDLY KNOWLEDGE.

JAN PROVOST

(CA. 1465–1529)

A Christian Allegory

1510–1515

OIL ON PANEL
19 ¾ X 15 ¾ IN.
THE LOUVRE, PARIS

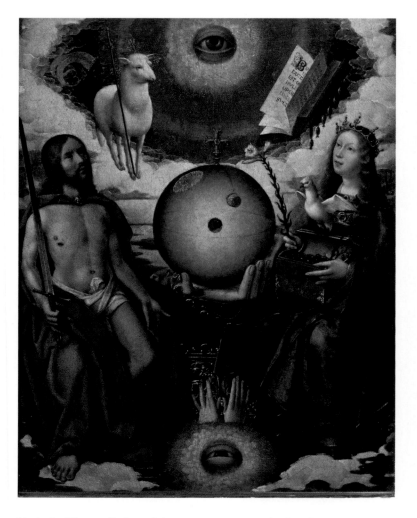

PROVOST'S enigmatic painting of Christian mysticism has presented a challenge to historians. Indeed, most sixteenth-century viewers would have found some of the details here obscure. Provost probably made this small painting for a specific patron, but unfortunately nothing is known of its origin or early ownership.

The painting contains three zones of imagery at top, middle, and bottom. The zones lay out the organization of the cosmos, with the divine realm at top, the sanctified Christian realm in the middle, and humanity below. Clouds cover the top, bottom, and background, suggesting that this is the end of time, when the veil of reality that makes up this world (note the vague landscape in the background center) is stripped away to show the next world.

The objects at the top refer to the Christian concept of the Last Judgment. In the front and center of the painting is the all-seeing eye of God. The eye is painted naturalistically, wide open, but it is disembodied, surrounded by a circle of light, fog, red seraphim (high angels), rays of light, and, at the extreme edge, puffy, natural clouds. Representations of the eye of God usually were reminders of the eternal divine presence, admonishing viewers to beware of sin and temptation. The eye is combined with two symbols of the Last Judgment. At right, the book of divine prophecy hangs in the air, adorned with seven seals. In the Book of Revelation of the Bible, the opening of these seals sets in motion the events of the end of the world. Since the book is already open, pages riffling in the wind, we must be witnessing a vision of the world after the Last Judgment.

At left, backed by a swirling white banner with a cross, is a lamb, holding a staff with a cross and crowned by a golden three-pointed halo. The lamb functions here as the "Lamb of God," a symbol for Christ. Used since Roman times, the lamb refers to Christ's innocence, his sacrifice and death, and to the idea of Christians as a congregation, or flock. The tripartite halo, the banner, and the staff here suggest a triumphant theme; this is the Christ who has conquered death, and brought salvation to humanity.

The realm at the center is grounded more concretely in the known universe. At center is a celestial orb surmounted by a cross. This is the Christian universe, held carefully in God's outstretched hand. Inside the orb are the sun, the moon, and the earth. The inscribed orbits around the earth indicate a pre-Copernican understanding of the movement of the planets. Left of the orb stands the resurrected Christ (with the signs of the stigmata visible), wearing a red cloak signifying the Passion and holding a sword. Christ is shown at the Second Coming, ready to judge humanity. His role as an intermediary between God and humanity is made clear by his upward glance to the eye, and the corresponding downward gesture. Right of the orb is a female figure who combines aspects of the Virgin Mary and Ecclesia (the Church). Since she is seated and crowned, dressed in blue and holding a lily, the woman clearly refers to the Virgin as Queen of Heaven. However, the jewel box (with a child's face, possibly representing the soul), the olive branch (symbol of peace and hope), and the dove of the Holy Spirit perched in front of her suggest identification with

Ecclesia. The conflation of the two was common in Renaissance art. Mary's role in Heaven was to intercede for humanity, and advocate for man's salvation.

The lowest level contains the most arcane subject matter. At center, among the clouds lining the bottom edge of the painting and aligned with the all-seeing eye of God above, is a second eye. This one is smaller, with a significantly reduced aureole of clouds and light. It is significant that the seraphim, who only occupy God's space, have been eliminated. The eye looks upward toward God, subservient to the direct gaze of the eye above. Two hands placed above the eye emphasize the human aspect of this realm. The meaning of the entwined gesture of the fingers has not yet been discovered. It may refer to alchemical symbols that conveyed the transformation of one form into another. In the context of the Last Judgment, that transformation would be of the human to the divine.

The puzzle of this painting may have been part of its appeal. Most likely a commissioned work, it reveals an abstract and personal set of symbols probably intended to enhance devotion by encouraging meditation on the end of all things, and the fate of one's soul.

The white lilies are an attribute of the Virgin. The seven seals on the book correspond to a passage in the Book of Revelation, and the words appear to be drawn from that visionary text describing the end of the world.

The Lamb bears a cross from which flutters a standard marked with another cross, identifying this being as the prophesied Risen Christ.

The hand of God, emerging from a richly jeweled sleeve, holds the universe. The Earth is at the center, and the sun and crescent moon are on the surface of the heavenly globe.

The human realm, like God's, is represented by an eye and hands. The hands together are a conventional expression of wonder. Were they wider apart they would manifest one of the oldest human gestures of prayer.

Decoding Flowers and Fruit

FLORAL and vegetal motifs have been represented since the dawn of art. Tendril patterns and leaf shapes are often found on prehistoric pottery, Egyptians used representations of staple goods (along with actual food) in tomb imagery to sustain a lifestyle of luxury into the afterlife, and ancient Greek architects incorporated acanthus leaves into basic structures like the column capitals of the Corinthian order of temples. Among these natural forms, flowers and fruit especially were incorporated in art to evoke the beauty and bounty of nature.

Because flowers and fruit also played a role in ancient natural science's attention to health and medicine, many specific types came to be classified and promoted for their inherent qualities such as the shapes, colors, or settings in which they could be encountered, and gradually were associated with particular notions of virtue and vice. A multiseeded fruit such as the pomegranate, for example, was often associated with fertility goddesses in Mediterranean cultures. Some of these associations fell into obscurity, but others were adopted by later cultures and religions. The lily of the valley, associated with the Hebrew *shoshana* in the Song of Solomon, in Christian art came to be a symbol of the purity of the Virgin Mary, used to reinforce the idea of her wholesomeness, as in Rogier van der Weyden's *Annunciation* (page 42). For the same reason it is still a popular choice for wedding arrangements today. Other aspects of the Virgin's integrity could be brought out by other flowers, such as the strawberries at her feet in Raphael's *The Madonna of the Meadow* (page 122). Raphael set the scene as a wide-open field, but the strawberry was long associated with images of the Virgin in a closed garden, the *hortus conclusus*. The Christ child, too, was associated with certain flowers. Red, juicy fruits like strawberries also alluded to the Passion of Christ. In Hugo van der Goes's *Portinari Altarpiece* (page 60), a vase contains purple

and white irises and a scarlet lily; the colors allude to the majesty, purity, and Passion of Christ. The drooping columbines next to these refer to Mary's sorrow for her child's fate.

Laurel wreaths served as signifiers of honor in ancient Greece and Rome, awarded to victors of athletic and scholarly competitions. Such ancient pagan iconography was incorporated into Renaissance and Baroque art's language of allegory. Johannes Vermeer adorned the model dressed as the muse Clio with just such a laurel wreath in his *Art of Painting* (page 284). Peter Paul Rubens made a variation on this theme in his *Education of Marie de' Medici* (page 224), where instead of laurel the Three Graces crown the young queen with a wreath of flowers. Gender identity was important to her regency, and continues to be a powerful association of floral imagery. Eustache le Sueur, in his *Fortitude Brings Peace and Plenty* (page 238), showed a cornucopia of fruits to demonstrate the prosperity of France.

Hieronymous Bosch used oversized fruits, especially luscious and juicy varieties of berries, to allude to the sinful pleasures of nature in his *Garden of Earthly Delights* (page 116). Negative connotations continued in still-life painting of the Baroque, where flowers and fruit came to hold a number of meanings associated with vanity. Jan de Heem's *Eucharist in Fruit Wreath* (page 248) represents wheat and grapes as symbols of the transformation of the Eucharistic bread and wine into the body and blood of Christ. The vegetation of the garland frame has only a short life span, in contrast to the spiritual sustenance of the Eucharist, which brings everlasting salvation. David Bailly incorporated peonies into his *Vanitas (Self-Portrait)* (page 252) not only because they are fragile and will soon wilt, but also to create a synesthetic comparison between the visual and the sense of smell. While paintings could preserve the fleeting appearance of fresh fruit and flowers, ironically, artworks too were recognized as objects of vain pleasure.

JAN DE HEEM.
Eucharist in Fruit Wreath.
Wheat and grapes stand for the body and
blood of Christ (page 248).

ROGIER VAN DER WEYDEN.
The Annunciation.
Lilies suggest the purity of the Virgin (page 42).

DAVID BAILLY.
Vanitas (Self-Portrait).
Peonies are associated with vanity, and a
sense of smell (page 252).

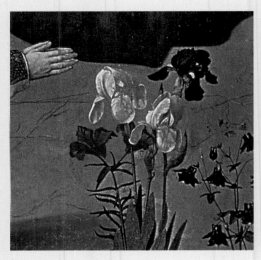

HUGO VAN DER GOES.
The Portinari Altarpiece.
The purple iris, white iris, and scarlet lily
symbolize the majesty, purity, and the Passion of
Christ (page 60).

JOHANNES VERMEER.
The Art of Painting.
A laurel wreath means honor (page 284).

RAPHAEL.
The Madonna of the Meadow.
The strawberries refers to the hortus conclusus
or the Passion of Christ (page 122).

EUSTACHE LE SUEUR.
Fortitude Brings Peace and Plenty.
The cornucopia alludes to abundance
(page 238).

HIERONYMOUS BOSCH.
The Garden of Earthly Delights.
Berries imply abundance and gluttony
(page 116).

PETER PAUL RUBENS.
The Education of Marie de' Medici.
A wreath of flowers indicates honor and grace
(page 224).

GIULIO ROMANO
(1499?–1546)

Allegory of Immortality
CA. 1535–1540

OIL ON CANVAS
27 X 27 IN.
DETROIT INSTITUTE OF ARTS

GIULIO Romano must have delighted the humanists of the Gonzaga court in Mantua with this puzzle piece that presents an allegory of immortality. At the top center a phoenix rises from its egg, engulfed by flames. A symbol of regeneration, the phoenix was easily converted into a Christian sign of Christ's resurrection. Below the phoenix to the right is an ouroboros, a snake biting its own tail. This is an allusion to eternity and a symbol of Gaia, mother earth. Her first offspring, generated without a partner, was Uranus, whom she then took as her consort to produce the Titans. Uranus is represented by the golden armillary sphere of the heavens. Below these two symbols is a sphinx balanced on a solid sphere, also a symbol of the earth, but of its instability, as opposed to the eternal majesty of the celestial sphere. Winged, with the haunches of a lion and serpent's tail, she holds chains that are not fetters but perches of the sort used in falconry. Their exact meaning is elusive, but must be an allusion to destiny, fortune, or fate. The object of her attention is the two figures in the boat.

At the top left is Leto, daughter of the Titans of intelligence and lunar brilliance, Coeus and Phoebe, respectively. When Hera discovered that Leto was pregnant by Zeus and that her offspring would upset the celestial balance, Leto was not allowed to give birth on "terra firma." Zeus raised the floating island of Delos from the sea, and there Leto delivered Artemis and Apollo while clasping a palm branch. She is upside down in part for the sake of decorum but also to emphasize the celestial nature of her offspring. Below Leto is Cronus, the Titan who slayed Uranus and devoured his own children. Gaia hid Zeus from his wrath, and he eventually induced his father to vomit out his siblings, including Poseidon, the god of the sea. These two figures on the left are thus generative, or birth, figures.

To the upper right Apollo rides his chariot amidst a glorious haze of sunlight. He is accompanied by a figure that is probably his sister Artemis, his lunar counterpart. The Olympian gods like Apollo and Artemis were often at odds with Gaia's other offspring, the chthonic monsters, of the underworld. Included among these was the Sphinx and his sibling the Chimera, represented in the painting on the middle right with three heads—a lion, goat, and dragon—all breathing fire. The Chimera was the offspring of Gaia and Tartarus, the Titan of the deep underworld where the worst of sinners were banished. The right side thus forms a type of juxtaposition similar to the Christian Heaven and Hell.

Finally, two figures in the boat whose journey seems to prompt this rune may be adduced. The man with fish tails for legs and carrying a staff is probably Nereus, the Old Man of the Sea who was also a son of Gaia. His companion is likely his daughter Thetis, shown steering the rudder. Thetis was a shape-shifter, and Romano has depicted her legs transformed from peacock feathers. The peacock was traditionally a sign of beauty and vanity, but the ancient Greeks believed the peacock's flesh never decayed, so it was also a symbol of immortality. Although he is not present, the allegory probably revolves around Thetis's ambitions and loss of her son Achilles in the Trojan War. The discord among the gods that led to the Trojan War had begun at her wedding to Peleus. Thetis tried to give her son immortality at his birth, but had failed to protect his ankles. After Achilles's death she came to mourn him and collect his ashes. Romano has depicted that journey.

THE ANCIENTS BELIEVED THAT
WHEN SERPENTS SHED THEIR
SKIN, THEY SHED OLD AGE AS
WELL. THE OUROBOROS,
SYMBOL OF INFINITE TIME,
FORMS A CIRCLE, THE PERFECT
SHAPE. IN THE CHRISTIAN
TRADITION, THE CIRCLE OFTEN
SYMBOLIZES GOD.

THE ARMILLARY SPHERE, AN
INSTRUMENT FOR FINDING
SIGNIFICANT CIRCLES IN THE
SKY, SUCH AS THE ZODIAC,
STANDS HERE FOR URANUS,
THAT IS, FATHER HEAVEN.

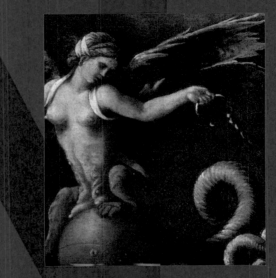

AT THE CENTER OF THE
COMPOSITION, THE COMPOSITE
SPHINX REPRESENTS ENIGMA,
BUT ALSO THE FOUR ELEMENTS.
SHE SITS ATOP A SPHERE,
WHOSE INCISED LINES
SUGGEST A GLOBE.

JUST AS THE SEA IS IN
CONSTANT FLUX, SO HYBRID
NEREUS AND SHAPE-SHIFTING
THETIS ILLUSTRATE CONSTANT
CHANGE AS AN ASPECT OF
IMMORTALITY.

Maerten van Heemskerck
(1498–1574)

St. Luke Painting the Virgin
Ca. 1545

Oil on panel
81 x 56 ½ in.
Musée des Beaux-Arts de Rennes, France

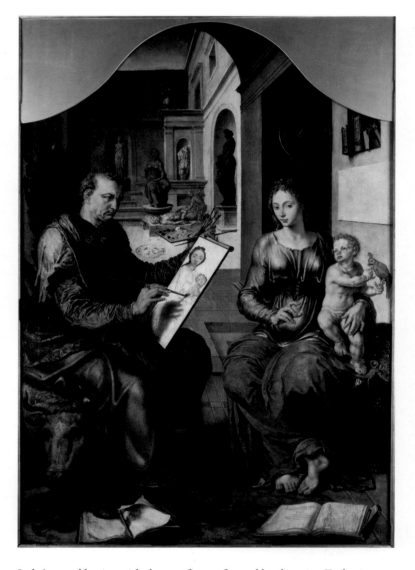

When Maerten van Heemskerck returned to the Netherlands from a sojourn to Italy, he sought a combination of styles informed by Italian concepts but true also to his Northern roots. These ideas, particularly the Italian influences, are manifested in his image of *St. Luke Painting the Virgin* of about 1545. The figures are heavily indebted to the work of Michelangelo that Heemskerck encountered in Rome and Florence. Compare, for example, the pose of the head of Heemskerck's Christ child to Michelangelo's young John the Baptist in the *Doni Tondo* (page 112). The volume of the forms and the twist of the torso of the Virgin are also reminiscent of Michelangelo's figures. The architectural setting and interior design are also quite Italianate. Severe and simple in structure, the space is an open-air courtyard decorated with ancient sculpture set in niches or archways. The marble tiles of the floor and the diagonal pattern of the white bricks in the far room, punctured by a dramatic mask roundel, are further infusions from the South.

The subject of St. Luke as a painter was strong in the Netherlandish tradition. He was the patron saint to painters and their guilds. A long-standing tradition that the evangelist was not just a writer but also a painter probably emerged because his gospel is the most vivid and descriptive. Numerous old icons of the Virgin Mary were alleged to be the true paintings of Luke.

Luke paints on a wooden panel, covered with a white gesso ground. The image is already sketched in with an earthen pigment, and he has begun to lay in the lights of the flesh. By tilting the panel toward the viewer, Heemskerck treats us to an alternate view of the Virgin and Child, seen from Luke's angle of view rather than straight on. The painter's fine silken clothes and fancy shoes, together with his signet ring, indicate that painting can be the calling of respectable gentlemen, engaged in the finest homes, who perform their task without making a mess. The sculptor in the distance, by contrast, labors hard, and must work in the outdoor space as his marble chips splatter all over the floor. Three more craftsmen, perhaps jewelers or engravers, work in the alcove at the rear.

The painter's studio is enhanced by several aspects of learning. An astrolabe rests on a shelf behind the Virgin, while above her head are several books in Greek. At her feet is a manuscript on anatomy by Heemskerck's Flemish contemporary Andreas Vesalius. The open page represents two skeletal and two partially flayed corpses with their interior organs exposed. Heemskerck in this way stressed the importance of anatomical knowledge for painters. Luke's ox rests his hoof on another book, this one unclear in its content but likely a Bible or Gospel, since it is leather bound with metallic clasps, and the pages are gilded along the edges. The evangelists' symbolic association with the animals and an angel derived from the Book of Revelation (4:6–8), where they are described surrounding the Throne of God. The ox was assigned to Luke because it was considered a sacrificial beast, and

Luke's gospel begins with the sacrifice performed by the priest Zacharias.

The Christ child feeds a nut to an exotic bird. The split walnut shell rests on the arm of the chair. This was an image evoked by Saint Augustine: the outer green case was the flesh of Christ, the shell the wood of the cross, the kernel his divine nature. Birds in antiquity signified the souls of men that flew away at their death. It is possible that Heemskerck intended this bird to have a more specific association, though, such as a phoenix, which would be associated with the resurrection of Christ, or a parrot, a creature lauded for its intelligence. The latter is more likely, because it would also carry that association to the painter's profession, along with the idea of mimicry. The painter had to be not only intelligent, but also skilled at the imitation of natural forms.

THE CLASSICAL STATUES TESTIFY TO
CHRISTIANITY'S TRIUMPH OVER (AND
CONTINUITY WITH) THE GREAT
CLASSICAL AGE. THE SCULPTURES
ALSO INDICATE THE IMPACT OF
HEEMSKERCK'S SOJOURN TO ITALY,
WHILE PERHAPS RECALLING THE
SMALL FIGURES ARTISTS USE TO
PERFECT THEIR SKILL.

ASTROLABES ARE SCIENTIFIC
INSTRUMENTS THAT USE STARS TO
CALCULATE DISTANCES. THIS ONE
IMPLIES THAT THE ARTIST
ENGAGES IN MATHEMATICS, THAT
IS, ABSTRACT THOUGHT—THE
HIGHEST KIND, IN THE DOMINANT
PLATONIC SYSTEM.

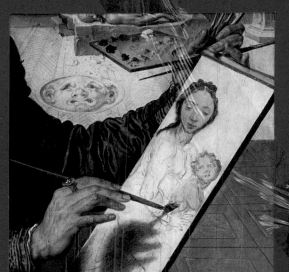

SAINT LUKE'S PAINTING IS
DIFFERENT FROM THE MODEL
BEFORE HIM, WHO LOOKS
DIRECTLY AT US, NOT AT HER
CHILD. THIS SUGGESTS THAT LUKE
WAS WORKING FROM VISION,
RATHER THAN FROM THE HISTORIC
FIGURE OF THE VIRGIN. THE
STRONG SHADOW THAT FALLS ON
HIS PANEL MAY ALSO CONVEY
DIVINE INSPIRATION, BUT ALSO
CALLS ATTENTION TO THE
HAND OF THE ARTIST.

BRIGHT HIGHLIGHTS ACCENTUATE
MARY'S BELLY AND BREASTS, A
THEOLOGICAL STATEMENT OF
CHRIST'S HUMANITY, THAT IS, OF
THE MYSTERY OF THE INCARNATION,
GOD MADE FLESH.

PIETER BRUEGEL THE ELDER

(CA. 1525/30–1569)

Fight between Carnival and Lent

1559

OIL ON OAK PANEL
46 ½ X 64 ¾ IN.
KUNSTHISTORISCHES MUSEUM, VIENNA

A FAT man sits astride a rotund barrel on a sled. He brandishes a metal spit on which are skewered choice meats. With his feet in improvised stirrups made from cooking pots, his head crowned by a fat pie, and a good push from an inebriated companion, the fat man rides into a mock jousting contest. His opponent is an impossibly tall and gaunt woman wearing a beehive shaped like an ecclesiastical hat. She is drawn into combat on a wheeled platform pulled by a monk and nun. The weapon of choice for her is a modified lance in the form of a baking paddle decorated with two very small fish. Children grasping pretzels and noisemakers gather as her retinue. This ridiculous match exposes the theme of this painting: the extremes of behavior found during the seasons of Carnival and Lent. Bruegel uses homespun details, folklore, and a hearty sense of humor to illustrate this scene of human folly.

In the Christian calendar, Carnival occurs during the two weeks prior to the forty days of fasting and atonement that make up Lent. Carnival (literally, "farewell to meat") is a time of merrymaking and feasting during which the people indulge excessively in the pleasures of wine and food (and dancing and carousing). The last day of Carnival, Shrove Tuesday (also known as Fat Tuesday), was a famous time of debauchery in the Netherlands; that is probably pictured here. During Lent, Christians mark biblical times of adversity and struggle (the Flood, and Jesus's forty days in the desert) by embarking on a month of self-denial. The diet is restricted—meat and other animal products are to be excluded—and sobriety and piety are expected.

Bruegel spreads the two disparate behaviors out in his upwardly tilted composition. Carnival revels are found to the left, and Lenten seriousness to the right. By setting his visual stage in the guise of a Netherlandish village, populated with everyday types, Bruegel in effect paints a portrait of his society.

At the left, the Carnival revelry is clear: behind the man on a barrel are his "troops," dressed in outlandish costumes and ironic masks, who carry a laden table at the ready. Broken eggs and other discarded food litter the ground, and a pig makes a hearty meal from the waste. In front of the inn, known by the sign of the blue boat (a colloquial euphemism for wastrels and drunkards), a crowd watches street performers perform a Carnival play called the "Dirty Bride." In the lower corner, gamblers crouch over their dice. Behind the old woman making pancakes, beggars and lepers dance in the streets. Two couples engage in a game of throwing (and breaking) old pots (which may have sexual connotations, referring to loss of virginity). Others play drinking games. A procession of singers led by a bagpiper (an instrument with a phallic form) makes its way through the streets in the background, while behind a group of music-makers strolls by an enormous bonfire. Everywhere, signs of plenty abound: note the heavy bags full of goods, the full wineskins, the gambling, and the excessively decorated costumes. Despite the wintry weather, conveyed by bare trees, the people play, and play some more.

By contrast, on the Lenten side the focus is on the church, and on pious austerity. The church has been prepared for Lent by draping the images in white cloths. The sermon over, a large congregation issues forth from front and side entrances, each worshipper marked with a cross of ashes on his or her forehead that suggests the service was the observation of Ash Wednesday; the extreme length of the sermon is indicated in the need for stools and chairs, which the people carry home. Cloaked in sober black, the figures in the lower right give alms to the various beggars and poor accumulated around for the occasion. These figures represent the Christian charities performed often during Lent, including healing, almsgiving, and burying the dead. Some of the faithful perform their piety publicly by praying against the wall of the church. By the church, children play at spinning their tops, while at the village well in the center, fishmongers sell their wares and housewives draw water. The greening trees indicate spring is coming, but the people are engrossed in their penitential behaviors; they don't seem to notice the corpse in the cart being pulled through the square.

Bruegel sets up many internal contrasts in the painting. Though the whole scene appears as a "natural" view of a village, pairs of opposites abound. The inn contrasts with the church. The old pancake woman, working over her fire with fat balls of dough, is set across from the fishmongers, with their cold, wet, lean products. The street performance (a folk tale of out-of-wedlock pregnancy) is opposed with the circle of almsgivers on the right. While it may be possible to read the Carnival side as a reference to Protestantism, and Lent as an allegory of Catholicism (mirroring the religious conflict of the time), there is no good vs. bad dichotomy here. Both sides exhibit extravagances of behavior, and neither set appears more virtuous than the other. The couple at the very center, being led into the scene by a fool in jester's costume, may provide the key to the painting: though like that couple we participate in these events, the viewer learns not to emulate such behaviors, but to laugh with Bruegel at them.

Bees leave the hive, an ancient symbol of the Catholic church, like the faithful leaving the church on the right side of the painting. Bees also symbolize Christ's resurrection, celebrated by Easter, the feast day preceded by the austerities of Lent, and therefore the theological virtue of hope.

The woman who calls attention to the cripple's plight may be his wife. She appears to wear a helmet, suggesting that the wailing man was wounded in the wars that devastated the Netherlands during Bruegel's lifetime.

This man and his companion, like other beggars, receive the charity of those exiting the church. On the left side of the painting, the mendicants are being ignored, so Bruegel may be hinting that charity is limited to periods of atonement.

Made only of flour, water, and salt, pretzels express the austerity of Lent. They are one of the earliest Christian foods, dating back to a time when people prayed with their arms crossed over their breast—hence the pretzel's shape.

Trailing Lent's float, people chat, eat, and work their noisemakers, perhaps a holdover from an ancient practice of chasing the evil spirits away.

Discovering the Great Masters

BEES LEAVE THE HIVE, AN
ANCIENT SYMBOL OF THE
CATHOLIC CHURCH, LIKE THE
FAITHFUL LEAVING THE CHURCH
ON THE RIGHT SIDE OF THE
PAINTING. BEES ALSO SYMBOLIZE
CHRIST'S RESURRECTION,
CELEBRATED BY EASTER, THE
FEAST DAY PRECEDED BY THE
AUSTERITIES OF LENT, AND
THEREFORE THE THEOLOGICAL
VIRTUE OF HOPE.

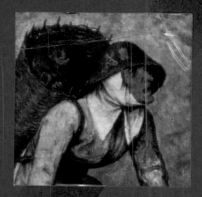

THE WOMAN WHO CALLS
ATTENTION TO THE CRIPPLE'S
PLIGHT MAY BE HIS WIFE. SHE
APPEARS TO WEAR A HELMET,
SUGGESTING THAT THE WAILING
MAN WAS WOUNDED IN THE
WARS THAT DEVASTATED THE
NETHERLANDS DURING
BRUEGEL'S LIFETIME.

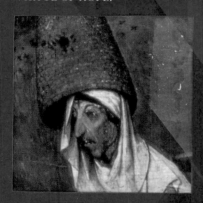

THIS MAN AND HIS
COMPANION, LIKE OTHER
BEGGARS, RECEIVE THE
CHARITY OF THOSE EXITING
THE CHURCH. ON THE LEFT
SIDE OF THE PAINTING, THE
MENDICANTS ARE BEING
IGNORED, SO BRUEGEL MAY
BE HINTING THAT CHARITY
IS LIMITED TO PERIODS
OF ATONEMENT.

MADE ONLY OF FLOUR, WATER,
AND SALT, PRETZELS EXPRESS THE
AUSTERITY OF LENT. THEY ARE
ONE OF THE EARLIEST CHRISTIAN
FOODS, DATING BACK TO A TIME
WHEN PEOPLE PRAYED WITH
THEIR ARMS CROSSED OVER
THEIR BREAST—HENCE THE
PRETZEL'S SHAPE.

TRAILING LENT'S FLOAT,
PEOPLE CHAT, EAT, AND WORK
THEIR NOISEMAKERS, PERHAPS
A HOLDOVER FROM AN ANCIENT
PRACTICE OF CHASING THE
EVIL SPIRITS AWAY.

PIETER BRUEGEL THE
ELDER
(CA. 1525/30–1569)

*Fight between Carnival
and Lent*
1559

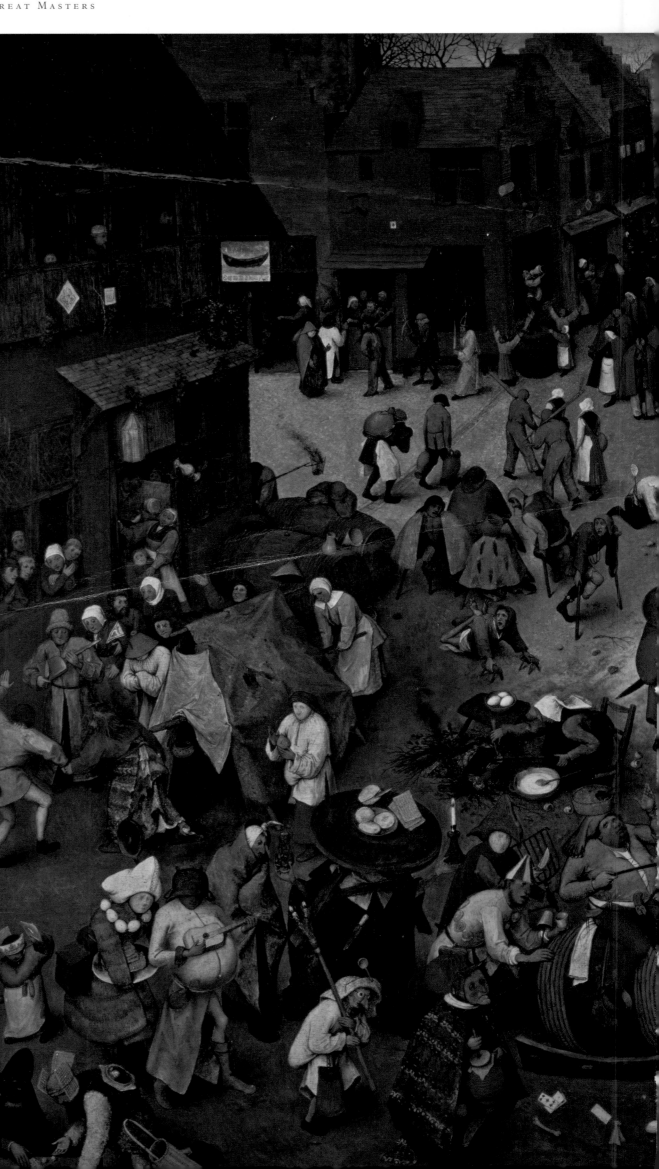

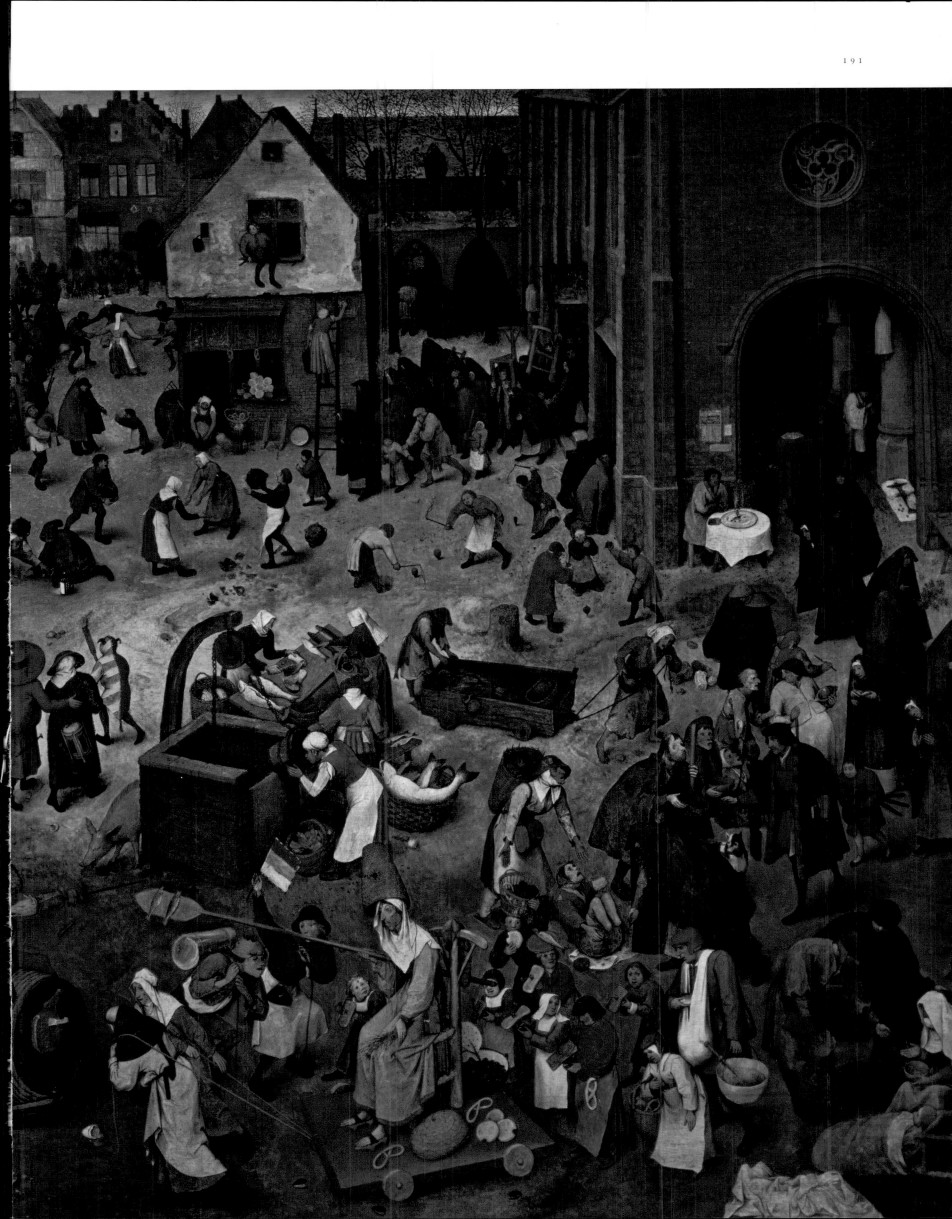

JAN VAN DER STRAET (JOHANNES STRADANUS)

(1523–1605)

Allegory of Vanity

1569

OIL ON PANEL
54 ¾ X 40 ½ IN.
THE LOUVRE, PARIS

JAN van der Straet trained as a painter in Antwerp. He worked in Venice, Florence, and Rome, painting altarpieces, designing hundreds of tapestries, and decorating important buildings such as the Palazzo Vecchio in Florence. He practiced a sophisticated style that was popular among courtly patrons throughout Europe. The style, later dubbed "Mannerism," was known for its elegance, virtuosity, and intellectual complexity. Those features can be seen in this allegory, which depicts personifications of Vanity, Moderation, and Death.

Two women sit on the edge of a bed under a rich set of hangings. The woman in front is mostly nude; her transparent white shift hides nothing. Her complex posture recalls Michelangelo's nudes in the Sistine Chapel, which Van der Straet certainly knew. Beside and behind her sits Moderation, modestly clothed in an embroidered yellow gown. The interaction of the figures provides the first clue as to the message here; Vanity's complex twisting posture is contrasted with the ease and security of Moderation. Their upper bodies repeat one another, so that the viewer grasps the opposition between the two clearly. For example, while Vanity's gesture emphasizes her full, lovely breasts, Modesty's arm is relaxed and unassuming (though equally beautiful in form and decoration). The positioning of the figures also reveals Moderation's conquest of Vanity; Moderation is higher, and looks down patiently at the other woman, with her left hand assertively on her hip. Vanity, by contrast, holds a bridle and gazes up with a plaintive expression. The bridle is a symbol of temperance and control. Here, it appears that Moderation has handed Vanity the bridle; Vanity is complaining about the curtailing of her instincts. Like an older sister, Moderation is firm but patient, and will prevail.

On the right side, a mirror, symbol of Vanity, sits on a chest. On the left, Death pulls back the bedhangings and holds up an hourglass. Interestingly, the mirror reflects back only the images of Vanity and Death, showing that the practice of Moderation will help avoid such dire outcomes. In the foreground are other emblems of the two approaches to life. The peacock next to Moderation is a symbol of immortality; the turtledoves refer to love and sex. The pearl necklace and woven gold belt are flashy pieces of self-adornment. At bottom, two vessels are tipped over, spilling their water and flowers onto the ground, where they will die.

This allegory does not advocate total poverty and self-denial, however. Moderation is a twin of Vanity—she is equally beautiful, luxuriously dressed, and wearing rich jewelry (a pearl bracelet, a brooch, a golden headdress). Rather, the message is about appropriateness—how one shows wealth and beauty matters more than the ostentatious display itself.

It is possible that the two figures also refer to the tradition of representing sacred and profane love. In this reading, the clothed figure, modest but sumptuously decorated, represents divine love. The nude figure is profane love, the embodiment of sensual and sensory pleasures. Such pursuits are by nature empty and transitory—thus the mirror and Death. Several details point to a particular message about sex here. The lovebirds

are the symbol of Venus, and suggest erotic activity. Similarly, the bedroom setting, and Vanity's sensual pose and gesture, seem to reference sexual license. The fact that Vanity is so obviously unbelted reveals her uncontrolled indulgence in sensual appetites. Moderation, by contrast, is belted and girdled.

It is clear that divine love triumphs over profane. Divine love is crowned, and does not appear in the mirror, so does not die. She also provides guidance to her counterpart, in the form of the bridle. The prominent brooch on her lovely thigh is a restrained version of the pendant on the pearl necklace below. Both feature crosses, which may stand for the true path to salvation and the divine.

The painting's message tells that audience what they want to hear— rich dress and beauty can be attributes of the divine if they indicate good decisions in life. In Italy, the artist adopted the Latinized version of his name, Johannes Stradanus, signaling his own stake in high social status— perhaps his own version of vanity.

THE PRACTICE OF CLOAKING
EROTICISM IN ALLEGORY IS
TIMELESS. HERE, VANITY
APPEARS TO ASK MODERATION
IF SHE MUST ABANDON ALL
SENSUAL PLEASURES.

VANITY HOLDS UP AN ORNATE
BRIDLE IN A QUESTIONING, EVEN
PLEADING GESTURE. MORE
DISCREETLY, MODERATION
HOLDS A SET OF REINS IN HER
LEFT HAND.

MODERATION WEARS A PRICELESS
FABRIC TRIMMED IN PEARLS AND
SPORTING AN ORNAMENT OF
PRECIOUS STONES IN A CROSS
SHAPE. THE CROSS SUGGESTS THE
SPIRITUAL REWARDS OF RESTRAINT,
BUT THE JEWEL'S PLACEMENT
ACCENTUATES THE SHAPELINESS OF
THE ALLEGORICAL FIGURE'S THIGH.

IN THE CHRISTIAN TRADITION,
THE PEACOCK STANDS FOR
IMMORTALITY AND THE VISION
OF GOD AFTER THE DAY OF
JUDGMENT. RENAISSANCE
READERS WOULD ALSO HAVE
IDENTIFIED THE BIRD WITH
JUNO, GODDESS OF MARRIAGE
AND CHILDBIRTH, HENCE WITH
LAWFUL SEXUALITY.

El Greco (Domenikos Theotokopoulos)
(1541–1614)

Burial of the Count of Orgaz

1586

Oil on canvas
16 x 12 ft.
Santo Tomé, Toledo, Spain

El Greco made his career in Spain, though his birthplace was in Greece and his training in Italy. The *Burial of the Count of Orgaz* was among the works he painted after arriving in Spain, and it garnered him a brilliant reputation as a painter of mystical events.

The *Burial of the Count of Orgaz* shows a scene from local history specific to the church of Santo Tomé. According to tradition, when the count (a great benefactor of that same church in the 1300s) died, his life of piety and charity was rewarded by the appearance of two saints at his graveside. This miraculous event is shown in the center foreground of the painting. The two saints lower the Count of Orgaz, in full armor and a deathly gray color, into his grave with their own hands—a visible testament to his saintlike life. The saints are distinguished from the surrounding crowd by their rich vestments. St. Stephen, on the left, is recognizable from the scenes of his martyrdom by stoning painted into his rich cope, while St. Augustine wears a bishop's mitre and a cope decorated with Old Testament figures. At either side are religious figures who represent the paths of Christian piety, among them a monk; the parish priest (identified as Andrés Núñez, his back to the viewer); a scholar; and a noted jurist and intellectual of Toledo, Antonio de Covarrubias y Leiva, gray-bearded and just to the left of the priest.

Behind this group stands a crowd of figures in current clothing, complete with lace ruffs. Remarkably, these are portraits of contemporary figures from Toledo. Their presence here, at an event supposedly taking place 300 years earlier, indicates the mystical nature of the scene. El Greco even placed his own son, Jorge, in the left corner. The boy's outward gaze and pointing gesture help guide the viewer, directing him or her to contemplate the event and discuss its significance, as do the portrait heads behind the central scene. The consequences of such contemplation are revealed in a blaze of light and color above.

In the upper part of the painting the soul of the count is conducted into Heaven in the form of a translucent baby cradled by an angel in brilliant yellow. Heaven is shown as banks of clouds, among which are angels making music, and saints, including St. Peter, with his keys prominently draped over a cloud at left. The Virgin Mary and St. John the Baptist are prominently placed at the center, poised on either side of the opening through which the new soul arrives. Traditionally, both the Virgin and St. John the Baptist served as intercessors for the people; here, they fulfill those roles by making gestures of supplication and introduction on behalf of the count. The kindly look of the risen Christ at the apex of the scene, and the sweeping upward movement of the

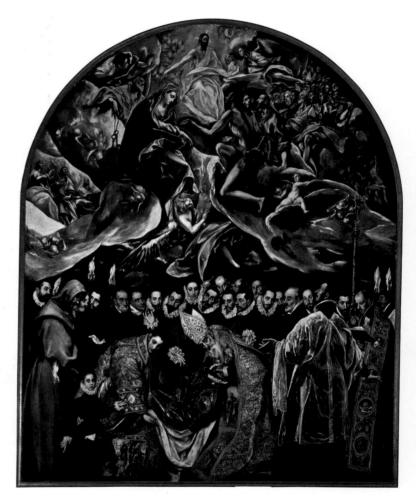

composition toward the holy figure suggest that the count is already welcome in Heaven.

El Greco carefully manipulated his style of painting to distinguish between the earthly realm of the burial below and the heavenly scene above. In contrast to the dark tones of the portraits and religious figures in the lower register, the upper part is painted with brilliant, jewel-like colors suffused with a streaming golden light. The suspension of natural forces such as gravity and volume in Heaven contrasts strongly with the earth-bound realm of the viewer below, where the figures move normally and display familiar proportions. Expressive and innovative, El Greco's painting captures the mystical fervor of Catholic Spain at a time of intense religious piety.

An angel carries the count's soul, which resembles the substance of the clouds of glory. In classical art, tiny souls ascend unaided, but there may be a theological principle illustrated here: the human incapacity to do good without divine power.

The face looking out at us is traditionally identified as El Greco himself. Like his son, the painter both invites the viewer to enter the spiritual zone of the miracle and visually asserts a place among the aristocracy.

The young saint who looks away from the dead man is St. Stephen, identified by the "painting" on his vestment, which shows him being stoned. Stephen was the first Christian martyr.

The solemn boy is usually identified as El Greco's son, Jorge. The handkerchief in his pocket bears a Greek inscription stating that El Greco "made [him]" in 1578—the year of Jorge's birth. This tender parody of how artists sign paintings may be a small, loving joke.

The count's armor identifies him as a *hidalgo*, or nobleman. The line of portraits—contemporary with the painting but not with the miracle—was one of the features that made the painting an instant success.

PAOLO CALIARI, CALLED VERONESE

(1528–1588)

Feast in the House of Levi

1573

OIL ON CANVAS
18 FT. 2 IN. X 42 FT.
GALLERIA DELL'ACCADEMIA, VENICE

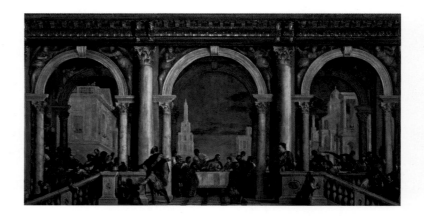

ON July 18, 1573, Paolo Veronese was called before the Holy Tribunal of the Inquisition to account for improprieties in his enormous, forty-two-foot-long painting installed just a few months earlier in the Refectory of the Convent of SS. Giovanni e Paolo in Venice. While the power of the Inquisition in Venice at the time was not as strong as in other locations, the climate of the Counter-Reformation and shifting religious concerns made everyone uncomfortable. Art was at the center of debates. It was a fearsome and embarrassing situation for the artist, and his friends and admirers feared his career was doomed. What had he done wrong?

The prior of the church had informed Veronese that the tribunal requested he change the dog in the center foreground to an image of Mary Magdalen, and he replied that he did not see how that was suitable in an image of the Last Supper that Jesus Christ took with his disciples in the house of Simon. Yet he had painted many other figures besides the Lord and his disciples, and was called to enumerate them. Veronese recalled placing Simon, the owner of the inn, into the picture. He stands before the right center column, wearing a striped shirt. He is attended by an African in red clothing and hat. He also painted a steward, dressed in black and green, before the left center column, who, the painter imagined, "had come there for his own pleasure to see how things were going at the table." The tribunal took great offense at these trivialities. There was also a man descending the stairs to the left, whose nose was bleeding. When asked to account for the significance of this detail, again Veronese resorted to his own musing, that he had encountered some accident. Galling to the tribunal were the German mercenaries with halberds at the right foreground. One has a plate of food and drinks from a cup. Veronese claimed that he took some license, as poets and jesters do, to fill out the scene with characters that he deemed appropriate to the household of a man who was great and rich, and should have such servants. Likewise, the man at the left dressed as a buffoon, with a bird on his wrist, was deemed to be ornament by the artist. At the table of the Lord, St. Peter, left of Christ, was depicted carving the lamb in order to pass it to the other end of the table. Theologically the sacrificial lamb had a place in the image, but Veronese made it seem like a mundane routine, as other apostles simply waited to receive their plates.

The size of the painting caused these issues, Veronese tried to explain. There was room, so he attempted to decorate the scene as he saw fit and was customary. The Inquisitors questioned Veronese's discretion and judiciousness. He responded by saying the buffoons, drunkards, Germans, dwarfs, and similar vulgarities, as they were branded, were outside the room of the apostles. The Germans, in particular, were singled out because those lands were under the sway of Protestantism, "infected with heresy [where it was] customary with various pictures full of scurrilousness and similar inventions to mock, vituperate, and scorn the things of the Holy Catholic Church in order to teach bad doctrines to foolish and ignorant people." Veronese recoiled by claiming others preceded him in taking such license, mentioning Michelangelo's nudes in the Sistine Chapel, painted in different poses with little reverence. The Inquisitors would have none of the comparison, claiming that "in painting the Last Judgment in which no garments or similar things are presumed, it was not necessary to paint garments, and that in those figures there is nothing that is not spiritual. There are neither buffoons, dogs, weapons, or similar absurdities."

Veronese escaped imprisonment, meekly admitting that he had not considered all these things and did not intend to confuse anyone. He was obliged by the tribunal to make appropriate changes to the painting within three months, at his own expense. He did not, instead mollifying his critics by changing the title of the painting from the *Last Supper* to the *Feast in the House of Levi*, the tax collector who followed Christ as his disciple Matthew.

VENICE EXCELLED IN THE
PRODUCTION AND DYEING OF
COSTLY FABRICS. IN PARTICULAR,
THE CITY'S ARTISANS PRODUCED
DOZENS OF SHADES OF THIS
REGAL COLOR.

WOMEN, CONSPICUOUSLY
ABSENT FROM THE TABLE, ARE
REPRESENTED BY SERVING MAIDS,
A POOR WOMAN BELOW THE
RIGHT-HAND ARCADE, AND THIS
WEALTHY WOMAN, PERHAPS
MARY MAGDALEN, WHO OBSERVES
THE LAST SUPPER ATTENTIVELY.
SHE STANDS IN FRONT OF A LARGE
CRUCIFIXION SCENE—WHICH HAS
NOT YET OCCURRED.

IT WAS THE RENAISSANCE
CUSTOM TO DISPLAY ONE'S
VALUABLE PLATE AT A BANQUET.
HERE, A MAN WHO IS PROBABLY
SIMON'S STEWARD DIRECTS A
TURBANED SERVANT.

THIS CORPULENT MAN TO WHOM
A SERVANT IS REPORTING MAY BE
SIMON, WHO HOSTED THE LAST
SUPPER. THE MIX OF FIGURES ON
EITHER SIDE OF THE CENTRAL
ARCADE REPRESENTS THE HUMBLE
AND FLAWED PEOPLE WHO WERE
THE OBJECT OF CHRIST'S MISSION.

PAOLO CALIARI,
CALLED VERONESE
(1528–1588)

Feast in the House of Levi
1573

CARAVAGGIO (MICHELANGELO MERISI)

(1571–1610)

The Calling of St. Matthew

CA. 1597–1601

OIL ON CANVAS
11 FT. 1 IN. X 11 FT. 5 IN.
CONTARELLI CHAPEL, SAN LUIGI DEI FRANCESI, ROME

A MYSTERIOUS diagonal shaft of light penetrates an unnaturally dark sidewalk table outside a building. The spare window frame, with one shutter, offers no evidence to place the scene in time or space, but serves to keep our focus on the panorama that plays out in the foreground. The swashbuckling figures gathered around the table are dressed in the fanciful wares of the artist's own day, while the two figures that emerge from the shadows on the right don robes from ancient times.

The standing figure with his arm extended is Christ. He is accompanied by St. Peter, whose back is to us as he points to the crowd. Christ emerges from the dark, the pale skin of his head and neck starkly set against the black, so deep that his hair blends completely into the shadow. Only a slender halo provides a sense of the top of his head. Christ extends his hand to call upon his disciple from the crowd. Caravaggio borrowed the gesture from Michelangelo's *Creation of Adam* in the ceiling of the Sistine Chapel. There, Michelangelo represented God the Father and Adam reaching toward one another but not quite touching, in order to emphasize a magical spark of life being infused into the first man. Here, Caravaggio extends the space between the principal characters, adding the shaft of light to activate the void and create a link. But to which one does Christ call?

Most viewers have assumed that Matthew must be the figure in the center of the crowd who points to himself, but it is not entirely certain that was Caravaggio's original intention. This painting has always hung on one of the long side walls in the Contarelli Chapel of San Luigi dei Francesi in Rome, and Caravaggio painted a *Martyrdom of St. Matthew* for the opposite side and *St. Matthew Writing His Gospel* for the space over the altar. The bearded figure pointing to himself in the *Calling* looks much like the figure writing his gospel over the altar, but differs in appearance from the figure who is martyred on the opposite wall. To complicate matters, the altarpiece with Matthew receiving inspiration from an angel to write his gospel was a second version, made after the initial version was rejected. The first version survived until World War II, and showed the saint bare-legged, with a dirty foot foreshortened to appear as if hanging above the altar. Moreover, the saint looked witless, as his hand was physically guided by the angel. Matthew in the first version of the altarpiece was dark haired, an older version not of the man pointing to himself in the *Calling*, but of the man at the far end of the table from Christ.

If Caravaggio intended Matthew to be the bearded figure, then he is cognizant of Christ and offers a "Who, me?" response. If, on the other hand, Matthew was meant to be the younger man at the end of the table, then he has not yet recognized Christ, and the drama unfolds as the man in the center points not to himself, but down the line. This narrative would thus emphasize the profound transformation of Levi, a tax collector, into Saint Matthew. The money on the table clearly identifies the activity, but whether the man on the end is counting his own money or the money of others is not certain. Either way, Caravaggio's artistic borrowing from Michelangelo proved more than a mere helping hand;

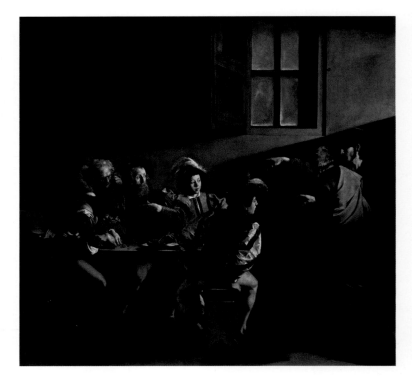

just as God created Adam, who sinned, Christ redeemed the sins of mankind by taking into his company the low, the outcast, and the sinful.

With deep contrasts of light and shadow, strong shafts of light, figures set starkly in relief, and restricted depth of space, Caravaggio ushered in a new brand of realism at the dawn of the Baroque era. His contrasting tonal effects came to be labeled by a compound word in Italian, *chiaroscuro*. Literally this meant light and dark, but *chiaro* also implied clarity while *scuro* connoted obscurity, and this manner of casting large portions of his scene into the shadows was criticized by some fellow artists, even while its stunning effects were readily adopted by many others. The new manner spread throughout Europe as artists traveled to Rome and then returned to blend the new ideas with their local concerns and styles.

Theologically, Caravaggio's style was also polarizing, raising an important issue of the reception of saints in Catholic Counter-Reformation Italy. Were the saints to be seen as ordinary men or were they to be elevated and revered? Obviously Caravaggio's first version of the altarpiece went too far and lacked decorum. But in the *Calling* he seems to have struck an appropriate balance, for the followers of Christ were indeed culled from the ranks of lower society, and that fact proved useful to theologians who espoused a populist approach to energizing the public with the visual arts.

These were the types of people who Caravaggio himself called friend and foe, young street dwellers who gambled and carried swords. Just a few years after this chapel was decorated, Caravaggio was forced to flee Rome after killing a man in an argument over a bet on a tennis match.

THE WINDOWS, MORE LIKELY OILED SKINS THAN COSTLY GLASS, ARE BARELY TRANSLUCENT. THEY SYMBOLIZE THE SINFUL NATURE OF HUMANITY, WHICH ONLY DIMLY PERCEIVES THE DIVINE LIGHT. YET A STURDY CROSS STANDS OUT AGAINST THE CLOUDY PANES.

CHRIST AND PETER OCCUPY A SEPARATE SPACE FROM THE MONEYLENDER AND HIS ASSOCIATES. THE DIMENSIONS OF ETERNITY AND TIME INTERSECT IN CHRIST'S GESTURE, LIT BY AN UNSEEN SOURCE.

CARAVAGGIO ACHIEVED THE DEPICTION OF TIME UNFOLDING BY STUDYING THE FIGURES' GRADUAL AND SERIAL AWARENESS OF THE SIGNIFICANT EVENT. THE BOY, IN HIS GAUDY GARB, IS JUST NOTICING, WHEREAS HIS COUNTERPART ACROSS THE TABLE IS TRANSFIXED.

THE TWO FIGURES AT THE END OF THE TABLE ARE ABSORBED IN COUNTING COINS, DEEPLY IMMERSED IN THIS MOST MUNDANE AND MATERIAL OF TASKS. THE CONTEMPORARY VIEWER, BY ANTICIPATING THE SPIRITUAL REVOLUTION ABOUT TO TAKE PLACE, THEREBY EXPERIENCES IT.

JOOS VAN WINGHE
(1544–1603)

Apelles Paints Campaspe

CA. 1600

OIL ON CANVAS
87 X 82 ¼ IN.
KUNSTHISTORISCHES MUSEUM, VIENNA

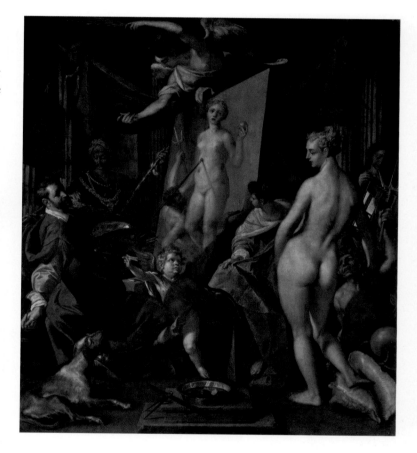

APELLES of Kos was the greatest painter of ancient Greece. None of his paintings survived antiquity, but stories of his art and life marveled Renaissance artists and patrons alike. Apelles lived during the fourth century B.C.E., and was the court painter for Alexander the Great. Only Apelles was allowed to paint the king's portrait, and some of his paintings were said to bring the price of whole towns.

Joos van Winghe chose one of the most popular stories of Apelles, his love for Campaspe. She was the favorite concubine of Alexander, but when Apelles was asked by the king to paint her he could not help but fall in love with his sitter's beauty, despite the female servant who hides Campaspe's lower body with a drapery. When Alexander realized this situation, he demonstrated tremendous magnanimity and favor to Apelles by giving him Campaspe as a gift. While the gesture was far from politically correct by today's values, the story nonetheless set a high standard for the patronage of artists in antiquity.

Van Winghe shows Apelles seated at the left, leaning backward in rapture as he looks to the bare body of Campaspe. Cupid eschews his bow and stabs the painter directly with his arrow of love. Apelles holds a paintbrush in his right hand, and his palette in the left. According to Pliny the Elder's *Natural History*, Apelles painted Campaspe as *Venus Anadyomene*, or Venus rising from the sea. The Latin text is inscribed on a tablet on the hanging in the upper left. This text was also the inspiration for Botticelli's *Birth of Venus*. Like Botticelli, whose earlier painting was well known, Van Winghe posed Campaspe as Venus emerging from a large shell, but in this case not a giant scallop but rather an enormous conch shell. Conchs were imported from the Far East, and hardly known in Europe during Botticelli's lifetime, but by the early seventeenth century they were among the most expensive and collectable shells as traders returned from ventures around the world. Van Winghe's patron, Rudolph II of Prague, would surely have appreciated these kinds of details, as he was a keen collector of rarities.

A male model sitting on the ground holds a trident; he is a merman. On Apelles's panel, Van Winghe has shown Venus holding a fruit, which curiously Campaspe does not do as she models. This may have been a deliberate conflation on the part of Van Winghe between Venus and Eve, whose temptation of Adam was perhaps seen as a parallel to these events. A woman at the far right holds a mirror for Campaspe, another symbol of beauty and vanity. The dog in the front left, traditionally a symbol of fidelity, complicates the relationship triangle even further. Plutarch praised Alexander for his ability to subdue his passions. Alexander lingers behind in the background, wearing a turban and glittering set of chains, and holding a long scepter. The turban may be a reference to Alexander adopting the ways of the Persians after conquering them.

Van Winghe explored many theoretical aspects of the art of painting. By showing Campaspe from the front on the artist's panel and from the rear in the foreground, Van Winghe engaged in a long-standing debate, o-*paragone*, between the arts of painting and sculpture. One of the benefits of viewing—and difficulties of making—sculpture was accounting for the multiple points of view in three dimensions. Painters countered this by inventing ways to show figures from different vantage points at the same time. In another version of this painting, Van Winghe showed Campaspe from the front, while Venus in the panel was seen from the side. There are many layers of conceit: the models dressed (or undressed as the case may be) as gods and goddesses mix easily with other figures who appear to be "real" deities, such as Cupid and Fame, who ascends the panel and reaches over to crown Apelles with a laurel wreath. On a pedestal in the foreground, a golden bowl with four open half-shells, each holding a different color of pigment, refers to Apelles's famous four-color technique, while the compass and ruler refer to his learnedness in geometry and measurement. The concept of measurement in painting referred not only to symmetry, but also a measured approach, that is, to know when to stop painting or to paint in a loose manner so that the final product did not appear too labored.

Pliny's tale of Apelles was important to later artists, who were attempting to raise their status. A winged figure approaches Apelles—who has the features of the painter Bartholomaeus Spranger—with the palm of victory and Apollo's laurel wreath.

Van Winghe may have emphasized the kismet of artist and model by casting the great king Alexander in shadow and endowing him with Orientalizing features: turban, mustache, and slightly almond-shaped eyes.

The golden apple is the prize Venus was awarded as the fairest of the goddesses. Her ambition to win indirectly caused the tragic Trojan War, and her awareness of this may be expressed on her face.

Cupid's flaming arrow ignites Apelles' ecstasy of passion for the emperor's lovely slave. The artist's palette and mahlstick, unlike Alexander's scepter, enable Apelles to capture Campaspe's beauty.

The servant hides Campaspe's sex with a red fabric, perhaps in honor the great king Alexander, whose mistress she is. The hard folds of the cloth suggest a precious taffetlike textile.

JAN BREUGHEL THE ELDER AND PETER PAUL RUBENS

(1568–1625) (1577–1640)

Allegory of Sight

1618

OIL ON PANEL
25 ½ X 43 IN.
THE PRADO, MADRID

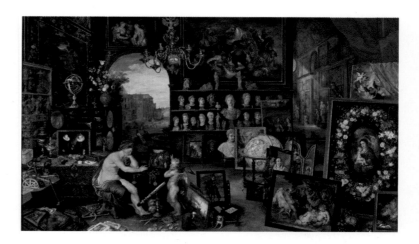

THIS painting is one of a set of five canvases painted by Jan Breughel the Elder and Peter Paul Rubens. It is an unusual piece, admired not only for the complexity of the allegory but also for Breughel's particular attention to meticulous depiction of detail and texture, which earned him the nickname "Velvet" Breughel. As well, the painting documents the complex ways in which art was produced, marketed, and understood in the sophisticated and competitive world of seventeenth-century Flanders.

A woman draped in blue and white sits at a table looking at a painting. Surrounding her is a plethora of fabulous items; the room itself is a kind of museum, crowded with paintings, sculptures, and rare and precious objects. This kind of multifaceted collection was known as an art and curiosities cabinet ("*kunst en wunderkamer*"). The ability to accumulate and possess so many fine, luxurious, and exotic objects was reserved primarily for the nobility. Indeed, by the end of the seventeenth century such encyclopedic collections were an expected attribute of kings, who used them as a way to demonstrate both wealth and global power. This particular collection is an imaginary one, but several factors suggest that it was meant to be associated with Archduke Albert and Archduchess Isabella, members of the Hapsburg family and rulers of the Southern Netherlands. Their portraits are found on the left side of the painting, prominently displayed on the table; the building seen through the archway is their Brussels palace known as Coudenberg (complete with peacocks, that noble bird); the chandelier hanging from the ceiling contains the double-headed eagle of the house of Hapsburg; and the archducal tastes in art and objects are prominently displayed here. The painting thus is a targeted allegory, a conscious compliment to the ruling couple that plays to their intellectual interests as well as their visual tastes.

All the objects in the painting are assembled because of their appeal to the visual. In general, the objects can be divided into two categories: those that aid or enhance the act of seeing, and those that delight and please the eye. In the first category we see many instruments associated with the science of astronomy. Note, for example, the large telescope in front of Sight, the astrolabe on the table at far right, and the armillary sphere on the cabinet at rear. Geography is included in the large terrestrial globe at right; architecture appears in the rules, measures, and compasses strewn about on the floor and on the left table. Other objects that enhance seeing include the magnifying glass lying on the table in front of Sight, and the pair of glasses held by a small monkey in the foreground.

The second category, however, dominates this painting. Breughel details with love the delights of seeing, from precious objects of gold and jewels to the finest furniture and carpets. He includes natural wonders such as parrots (on top of the large painting at right), Chinese porcelain (on the table behind Sight), luxurious vessels (on the left wall), and shells (in the foreground between the stacked paintings). Pride of place, however, is devoted to art. Though coins and jewels litter the table, Sight pays attention to the painting before her, indicating its value. Paintings decorate every wall surface, and where there isn't enough room they are stacked against each other on the floor. Drawings and prints litter the floor. Antique busts and sculptures line the back wall, and more appear in the gallery extending to the rear on the right side. Almost all the genres of art are illustrated here: landscape, seascape, still life, portraiture, history painting, etc. Works by great artists, including Titian, Raphael, and Michelangelo, as well as local heroes Cornelis Vroom and Pieter Bruegel, are visible. Breughel here does more than celebrate his own discipline; he advertises his own art, and that of his collaborator, Peter Paul Rubens, who painted the figure of Sight. The most prominent paintings are by those two artists. Breughel painted his own work as the central image, held up by a putto for Sight's inspection. He also replicated several compositions by Rubens (the archduchess's court painter), such as the *Lion Hunt* on the far wall, the portraits of Albert and Isabella, the equestrian portrait of Archduke Ferdinand, and *Drunken Silenus* in the right foreground. The grand painting of the *Virgin and Child in a Garland* on the right exemplified the two artists' collaborative efforts.

Beyond Breughel's slick self-promotion to his illustrious clients, however, another layer of meaning can be detected. The act of seeing had long been metaphorically connected to understanding and enlightenment. That metaphor is continued throughout the painting, so that perception is aligned with salvation. A theme of sightlessness can be detected in the works on display. For example, the painting in front of Sight depicts *Christ Healing the Blind*, showing the divine origin of sight, or understanding. Propped against the back wall is a partial view of Pieter Bruegel's image of *The Blind Leading the Blind*, a scene illustrating foolishness and lack of spiritual vision. The painting of the *Virgin and Child in a Garland* may be the true exemplar here; the skills of Breughel to replicate nature have here made a holy vision possible. His famed ability to paint flowers as metaphors for immortality and perfection is featured in this painting, and throughout the scene. Last but not least, the monkeys in the foreground are symbols of ignorance; they play with eyeglasses because they lack the ability to understand the truth and beauty before them.

This round architectural
element is called an
"oculus," or "small eye." In
the seventeenth century,
sight was theorized as
active rays emitted by the
eye. Here, the oculus and
the light streaming
through it suggest the eye
of God.

Traditionally, particularly
valuable paintings were
shielded with a curtain.
This was done either to
protect the surface or to
create a sensation of
surprise at the revealed
sight of the work—*voilà*!

Associated with mimicry, the
parrot may here emphasize
Breughel's talent for painting
flowers. Because their
feathers were believed to
stay dry in the rain, parrots
traditionally symbolize Mary
the Virgin.

Rubens was a wordly man, a
sophisticaed collector as
well as an artist. The
objects strewn about the
room came—literally—
from all over the globe.

Breughel's floral frame-
within-a-frame points to
the representation of
the Virgin and Child
as a vision.

JAN BREUGHEL THE ELDER
(1568–1625) AND
PETER PAUL RUBENS
(1577–1640)

Allegory of Sight
1618

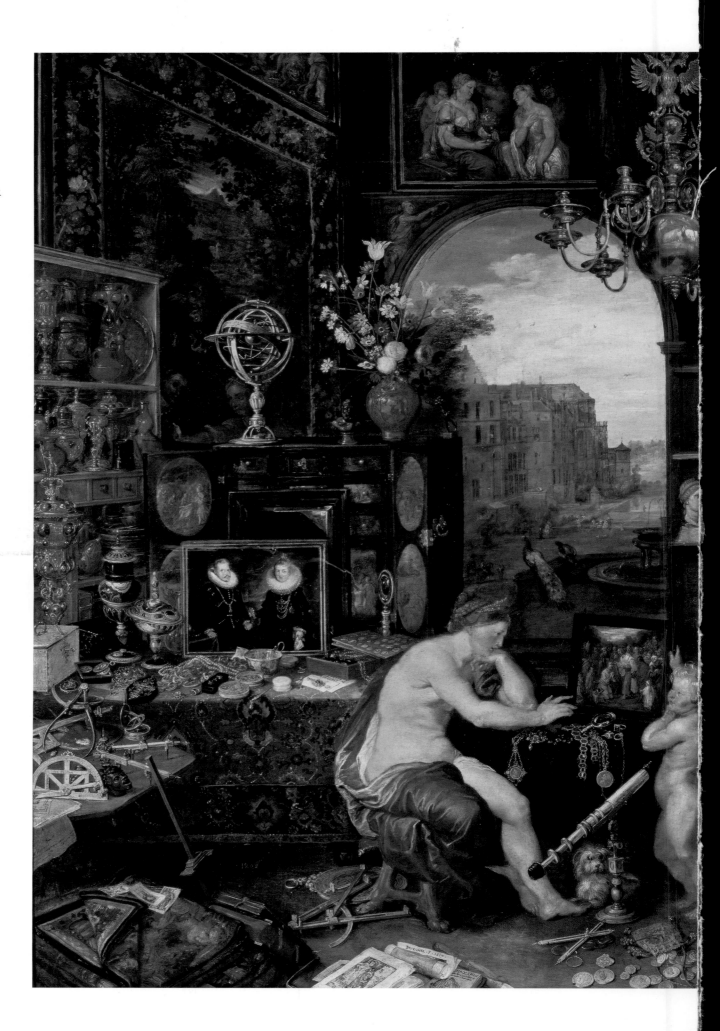

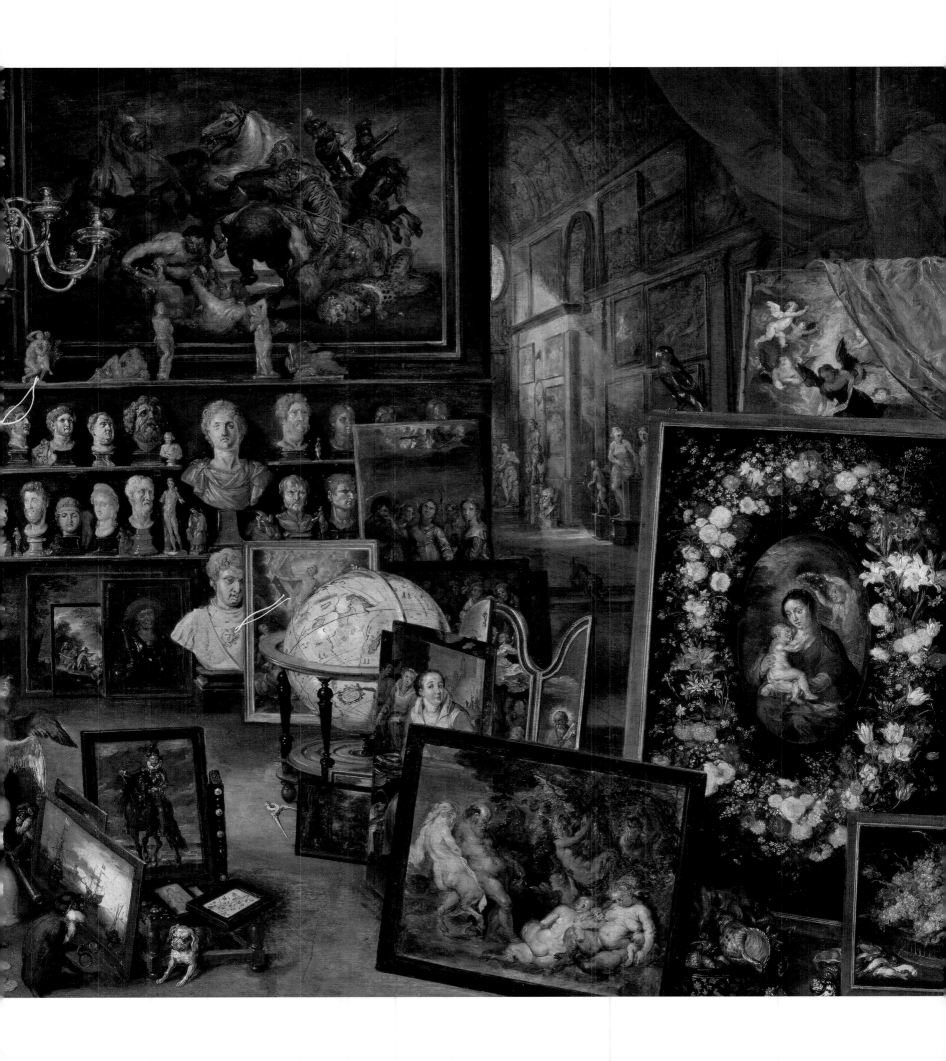

Bartholomaeus Spranger
(1546–1611)

Minerva's Victory over Ignorance
Ca. 1591

Oil on canvas
64 x 46 in.
Kunsthistorisches Museum, Vienna

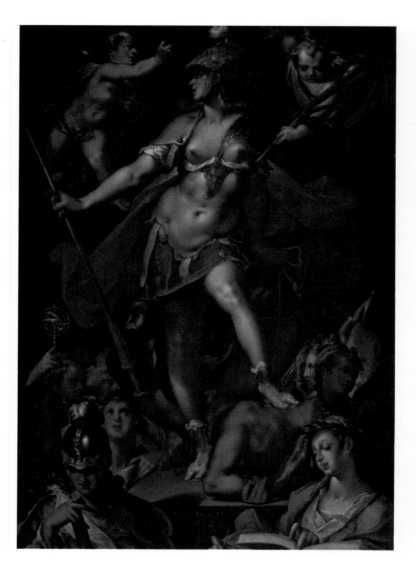

Minerva, the Goddess of Wisdom, stands triumphant over ignorance, an allegory of her protection of the liberal arts. She turns her head toward a putto, who crowns her with an honorary laurel, while another flies in from the right to present her with a palm of victory. In the earliest eras of antiquity she was a warrior goddess, but was gradually transformed in the Classical period, particularly in Athens, to be the protector of culture and civilized virtues. Her armor typically includes a helmet, body armor and lance, and often a shield, which Spranger omitted. The helmet here is surmounted by a sphinx and inset with the face of an owl. This is an unusual combination, presenting the riddler along with the wise problem solver.

Spranger's highly sexualized characters were much in favor at the court of the Holy Roman Emperor Rudolph II in Prague. The artist here reduced Minerva's body armor to a scaled shoulder harness and skin-tight torso covering, leaving her breasts exposed. This clearly marks the representation as an allegory, but may also allude to the nourishing power of knowledge. Spranger cut her a robust figure, but it is softened by the outward swerve of her hip and the inward bow of her legs, the elegant, pointed tips of her fingers, and the refined features of her face. Minerva presses her foot upon the neck of Ignorance, identified by his ass's ears, and holds him also by a somewhat delicate ribbon of rope. His awkwardly twisted arms and flailing legs demonstrate his submission. Two putti descend to offer Minerva a laurel wreath and palm of victory.

The theme of wisdom triumphant over ignorance was derived from a lost painting called *The Calumny of Apelles*, recorded by the writer Lucian. Apelles was the greatest painter of ancient Greece and flourished under Alexander the Great. When he later worked for Ptolemy in Egypt, however, he was slandered by a fellow artist and condemned. In the end, the truth of his innocence was revealed and the king, ashamed of his rash judgment, tried to make amends. Apelles refused the king's restitution, and instead decided to paint an allegory to demonstrate to the world the evils of slander. Lucian's description, or *ekphrasis*, of the personifications in the *Calumny* became famous. In the Renaissance, many artists like Botticelli, Raphael and Dürer, to name a few, tried to reconstruct the lost painting based on Lucian's description. Later, as such specific reconstructions became cliché, numerous variations like this one came to renew the pertinent themes. One of the primary figures in Apelles's allegory was a king with ass's ears like Midas, representing his ignorant judgment of art. Michelangelo picked up on this tale in his *Last Judgment* when he gave his character of Minos the features of one of his critics, and topped it off by adorning him with such ears.

Below Minerva's platform stands a crowd of onlookers, including two prominent foreground figures: Bellona, a goddess of war, and one of Apollo's poetic muses, perhaps Calliope, the muse of epic poetry such as the *Iliad* and the *Odyssey*. Directly to the right of Bellona's head is Mercury, identified by his winged helmet and scrolled message. He is often associated with allegories of art because of his influence over commerce. Above him, a figure holds aloft an armillary sphere, perhaps to refer specifically to the art of astrology, or maybe more generally to the fate of art and artists when they fall from royal favor. Rudolph II was very keen on astrology and employed astute observers of the stars to chart his fortunes. On the right side of the painting behind the poetic muse are personifications of the visual arts. The foremost is painting, wielding a palette with two brushes. Behind her a figure holds up a measuring compass and a large sheet of paper, representative of architecture, and the third, although not entirely clear, seems to hold a sculptor's scraping tool.

THE PALM OF VICTORY IS
MORE OFTEN BESTOWED ON
SAINTS, BUT HERE IT IS ONE
MORE DIAGONAL, ADDING TO
THE OVERALL DYNAMISM OF
THE WORK.

MINERVA OFTEN SPORTS A
HEAD OF THE SNAKE-HAIRED
GORGON MEDUSA ON HER
BREASTPLATE. THE MONSTER
MEDUSA HAD THE POWER TO
TURN TO STONE WHOEVER
GAZED UPON HER. HERE,
AS IN THE REST OF HIS
PAINTING, SPRANGER WENT
FOR A SLIGHTLY DECADENT
DECORATIVE EFFECT OF
SOLID GOLD.

THE RIBBON OF ROPE, GRASPED
NOT VERY CONVINCINGLY BY
MINERVA, ACTS AS A PLUMB
LINE, ONE OF THE FEW
VERTICALS IN A COMPOSITION
THAT IS BUILT ON STRONG
DIAGONALS. THE FLYING LOOP
IS IN KEEPING WITH THE
OVERALL AIRBORNE QUALITY
AROUND THE GODDESS,
APPROPRIATE TO AN ALLEGORY.

RENAISSANCE ARTISTS, BOTH
PAINTERS AND SCULPTORS,
OBSERVED A CLASSICAL
CONVENTION OF SEPARATING
THE FIRST TWO TOES AND
MAKING THE SECOND LONGER
THAN THE FIRST. LESS CLASSICAL
IS THE TELL-TALE PINK FLUSH,
WHICH TRANSFORMS THE
VIRGINAL MINERVA INTO A
SEXUAL WOMAN.

PETER PAUL RUBENS

(1577–1640)

The Education of Marie de' Medici

1622

OIL ON CANVAS
12 FT. 11 ⅛ IN. X 9 FT. 8 ⅛ IN.
THE LOUVRE, PARIS

MARIE de' Medici, a daughter of the familial dynasty from Florence, Italy, was the widow of King Henry IV of France. The future of her regency was in peril at the time she summoned Peter Paul Rubens from Antwerp in 1622. Rubens worked as painter and diplomat for most of the major monarchs of his day, specializing in a grand language of Baroque allegory and visual tribute. Marie desired two series of paintings to decorate her new Palais du Luxembourg, one depicting the deeds of her life and the other the history of her late husband. Despite the fact that they never really got along well, she owed her position and glory to Henry's legacy. In the end, Henry's cycle was never completed, but Rubens and his workshop did finish twenty-four large paintings relating the highlights of Marie's life.

One scene in the series represents the education of young Marie de' Medici. She is dressed in a simple yet elegant dress, adorned with strands of pearls around her neck and in her hair. The design of her hairstyle is reminiscent of the fanciful designs of beautiful heads that Michelangelo and other Florentine artists had drawn in previous generations. She learns, quite literally, at the lap of wisdom, holding an ink bottle and a crow-quill pen, and writing on a parchment supported by an album on Minerva's legs. The goddess gestures to her, but does not guide her hand directly. In the foreground, Apollo serenades her with music, while Mercury descends into this alcove near a waterfall to anoint her with his caduceus, his magic wand with two intertwined snakes. Apollo is shown in the guise of the god of poetry and music, and he inspires Marie with song. Mercury, often seen as the patron of travelers or in commercial enterprises, in this context personifies eloquence and reason, and the qualities of teaching.

On the ground can be seen Minerva's shield with the snake-haired head of Medusa. Minerva was the protectress of Perseus, who slayed the Gorgon sister. Representations of the aegis of Minerva provided artists an opportunity to portray a vigorous and fearful expression, and Rubens also adds reflections on the metal surface. Nearby are a lute, further reference to Apollo's training in music and poetry, and references to the visual arts, a sculpture bust and chiseling tools and a painter's palette and brushes.

Also prominent are the Three Graces, Aglaia, Euphrosyne, and Thalia. While the Graces could be interpreted in a number of diverse ways, Rubens may have intended them to be seen in a Neoplatonic fashion, following several Florentine scholars of the Renaissance. This interpretation traverses ancient Roman tradition to emphasize quasi-Christian virtues. Chastity would be the left Grace, her right hand modestly covering her nakedness, reminiscent of the ancient statue type of the *Aphrodite of Knidos* or the *Venus pudica*. The center Grace is Beauty,

the most prominent and on full display as she offers Marie a crown of flowers. The right is Love, warmly embracing the arm of Beauty.

Rubens reveled in the depiction of female nudes, and here he did not disappoint, although the fleshiness is slightly subdued compared to some of his other images. When asked how an artist knows that a painting is finished, Rubens allegedly responded, "When the woman's behind looks good enough to slap." Some scholars have suggested that Rubens turned to allegory and classical references because the life of Marie de' Medici was not exciting enough on its own merits, but Rubens painted in a manner that was over the top in every respect, and would have done so even if her exploits had indeed been worthy of his brush.

FOR RUBENS THE DIPLOMAT,
ELOQUENCE AND REASON,
SYMBOLIZED HERE BY MERCURY,
WERE THE MEANS TO PEACE AND
PROSPERITY—A RULER'S PRIME
RESPONSIBILITY. THE MESSENGER
OF THE GODS DESCENDS INTO THE
DARK CAVE, WHICH RECALLS
PLATO'S ALLEGORY OF HUMAN
CONSCIOUSNESS, ILLUMINATED
BY LEARNING.

THE JEWELED BRACELET SUGGESTS
SEXUAL ATTRACTIVENESS, WITH
WHICH THE GRACE ENDOWS THE
YOUNG MARIE—WHO WOULD BE
RESPONSIBLE FOR PERPETUATING
THE FRENCH ROYAL DYNASTY.

MARIE RESEMBLES A PREVIOUS
PORTRAIT OF HER BY RUBENS, BUT
HER FEATURES ARE GENERALIZED
ENOUGH TO SUIT THE ALLEGORICAL
STYLE OF THE PAINTING. HER
HAIRSTYLE AND COSTUME EVOKE
AN EARLIER PERIOD, REMINDING US
THAT RUBENS WAS FAMOUS FOR HIS
SENSE OF HISTORY.

IN THE ORIGINAL MYTHS, APOLLO
PLAYED A LYRE, HERE UPDATED TO
THE MORE CONTEMPORARY VIOLA, A
NOBLE INSTRUMENT. ON THE
GROUND BELOW, THE LUTE IS
ANOTHER EMBLEM OF SEXUAL LOVE.
MARIE'S HUSBAND, HENRY IV, WAS
A NOTORIOUS LADIES' MAN.

JAN MIENSE MOLENAER

(CA. 1610–1668)

The Artist's Studio

1631

OIL ON CANVAS
33 ⅞ X 50 IN.
STAATLICHE MUSEEN, BERLIN

ART imitates life, or so artists would have us believe. Jan Miense Molenaer depicted the interior of his studio, including a cast of characters taking a break from posing for the painting in progress on the easel. Molenaer was a painter of humorous, sometimes raucous, scenes of merrymaking and musical companies.

In the painting on the easel, just such a merry company is depicted. All four figures (and perhaps a fifth, who is barely sketched in the rear) play musical instruments when they are interrupted by the pouncing dog that has jumped on the arm of the lute-playing dwarf. The young boy has dropped his fiddle to the side, while the seated older man with the hurdy-gurdy and the standing woman with a rommel pot look on. These instruments were considered lowly and rather unsophisticated, and the rommel pot and hurdy-gurdy particularly rough in sound. The whole scene is meant for boisterous amusement.

Life doesn't stop, though, when the artist has to prepare a new palette. The dog and the dwarf do a playful dance, just as in the painting. A pewter tumbler has been tipped over on the floor. A pipe in the lower right corner is also on the floor, while another, along with a tin presumably for the tobacco, lies on the stool. Tobacco had only recently begun to be imported to Europe from the New World, and just as today, it was laden with positive and negative stereotypical associations. In the context of images of artists, it could allude to inspiration or to life's fleeting pleasures (just as painting itself). The lute has been put aside to the left of the room, and the fiddle hung on the wall alongside some crude wind instruments.

It is tempting to think that some of the models were among the artist's friends and family, although it might be wrong to assume too much specificity in this instance. In 1631 Molenaer was not yet married to Judith Leyster, the first woman inducted into the Haarlem painters' guild, but the woman in the painting does bear a resemblance to her self-portrait made about the same time. The boy in the painting within the painting turns out to be an apprentice, as he holds a palette and brushes and a mahlstick, a tool used to steady the wrist of the painting hand by propping it against the edge of the stretcher. The master's mahlstick rests against the stool in the foreground. Presumably the boy's easel is in the back room. There is a wooden panel on that easel, as opposed to the stretched canvas on the foreground easel. In the seventeenth century, most artists stretched canvas by threading it into a standard size, and mounting it on a reusable stretcher frame. The actual painting does not take up the whole space, and the warping from the taut areas of the threads can still be detected in many Old Master paintings. When the painting was finished, if sold, it could be removed and stretched over a more permanent and appropriately sized stretcher for framing.

The various vessels for grinding pigments and mixing solvents on the worktable were also typical of studios. While this studio is somewhat bare, there are a few signs of higher station: a small framed painting on the left wall, and the painter's fur hat atop the easel and cape resting on the chair. Presumably the artist donned these garments when he went out; for the moment, however, we catch his glimpse at work, or more precisely during a break in his work. The style of painting, with its quick and broken brushstrokes, mimics the rough and dashing style of Frans Hals, also a painter in Haarlem at this time. In fact, Leyster sued Hals around this time over a student that he took from her, depriving her of the income from the apprentice's training fee.

THE ARTIST PREPARES HIS
PALETTE. HIS ASSISTANT, WHO
HOLDS HIS OWN PALETTE,
PROBABLY PAINTED AREAS OF
THE FINAL WORK, BUT ALSO
LABORIOUSLY GROUND MINERAL
AND VEGETABLE PIGMENTS AND
MIXED THEM WITH OIL,
PROBABLY LINSEED OIL,
PRESSED FROM FLAX PLANTS.

THIS FASHION ACCESSORY IS A
ROSETTE MADE OF RIBBON LOOPS.
IT IS IN THE HIGHEST FRENCH
FASHION, LIKE THE BUTTONS
DOWN THE SIDE OF THE PAINTER'S
TROUSERS. THE RICHNESS OF HIS
GARMENTS CONTRASTS WITH THE
SPARE SURROUNDINGS, WITH ITS
BARE, WARPED FLOORBOARDS AND
UNGLAZED WINDOW.

THE OLD MAN IN HIS BAGGY
CLOTHES IS CRANKING A HURDY-
GURDY, A MECHANICAL MUSICAL
INSTRUMENT THAT REQUIRES NO
ARTISTIC SKILL TO PLAY.

THE DWARF DANCES TO THE
OLD MAN'S TUNE. THE DOG
EMPHASIZES THE MAN'S SMALL
STATURE, AND THEREIN LIES
THE HUMOR.

JAN MIENSE MOLENAER
(CA. 1610–1668)

The Artist's Studio
1631

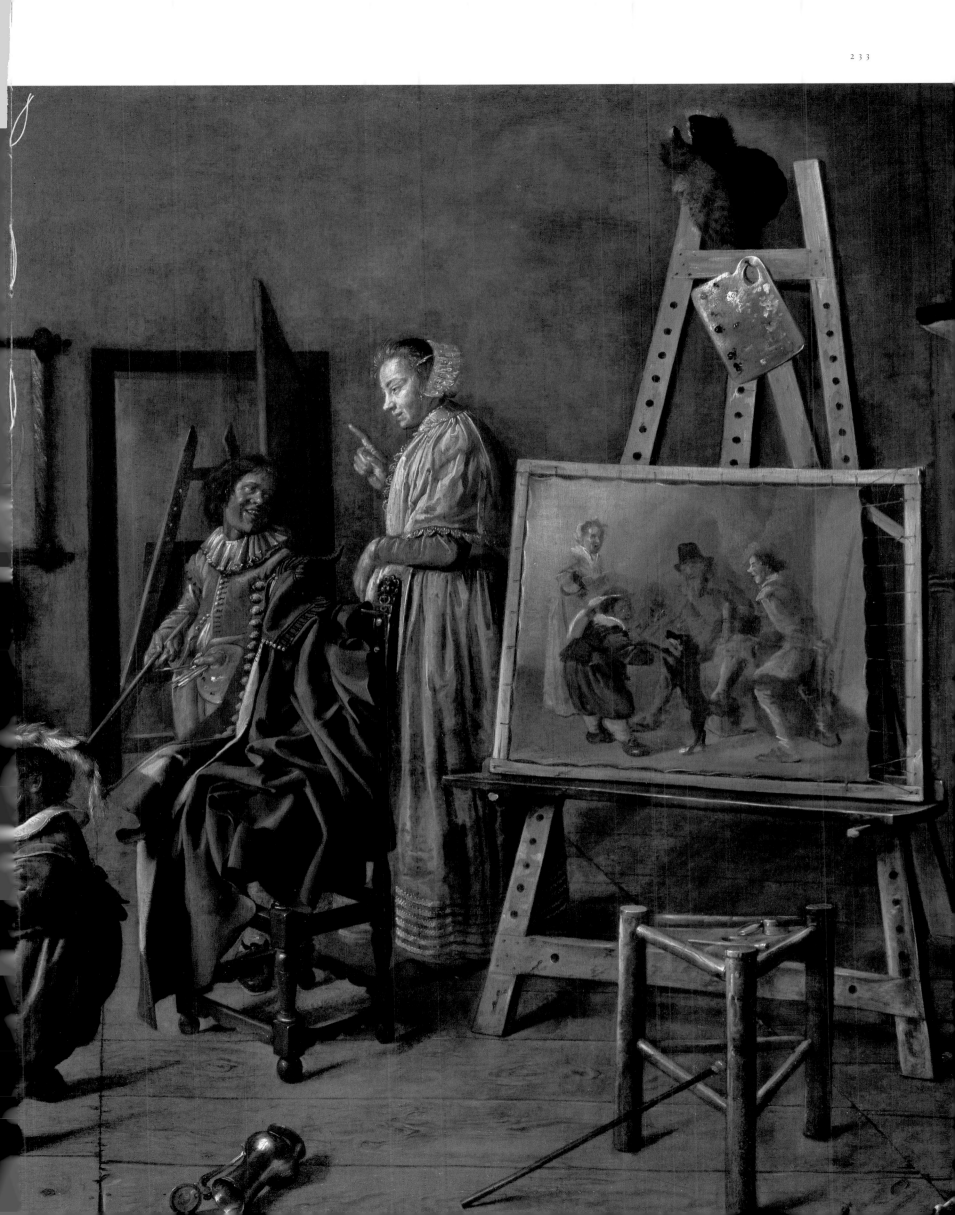

SIMON VOUET
(1590–1649)

Time Vanquished by Hope and Beauty
CA. 1640–1643

OIL ON CANVAS
73 ½ X 52 ¾ IN.
MUSÉE DU BERRY, BOURGES

THIS painting was part of a decorative cycle painted for a high administrative official at the French royal court. The owner, Claude Le Ragois de Bretonvilliers, was secretary to Louis XIII, and between 1637 and 1643 he constructed a new house for himself on the Île St. Louis in Paris. The Hôtel de Bretonvilliers was a famous example of the opulence and luxury of the French manner of living, and visitors from all around Europe came to visit. Vouet, who had trained in Italy and enjoyed great favor at court, decorated the cabinet of the owner. A cabinet was a small room used for private retreat and conversation; only the most intimate friends and colleagues of the owner would have entered here. Vouet's paintings were set into the architectural framework on the walls and on the ceiling.

Time is shown here as an old man with a long white beard cowering at the bottom of the painting. His wings fly out behind him, and he clutches his scythe in his right hand. His left arm is raised to ward off the figures above—but he is clearly weak, and he protests more than fights with them. To the left of Time is a fat little winged boy, an Eros figure often identified as Cupid (though there is no bow or blindfold to make the identification certain). He plucks feathers from Time's wings, effectively clipping him. The gesture shows how love can overcome time.

Above Time are two women in brightly colored robes. The figure to the right is Beauty, who according to Cesare Ripa's *Iconologia* (a compendium of ideas and personifications first published in 1593 and used commonly in the seventeenth century) is shown with her head in the clouds as a reference to her divine origin. Vouet paints a bank of clouds in the landscape behind this figure. She pulls on the wings of Time with all her strength. Hope is the figure in blue and white, with a crown of flowers in her brunette hair. According to Ripa, Hope wears flowers because they show expectation for the coming of fruit. She pulls Time's hair, and with her left hand prepares to thrash him with her white wrap. He really has no chance against their combined onslaught, as the painting makes clear.

Floating above Hope, continuing the upward curve of the composition, is the figure of Fame. A winged woman in pink with bared breast, she holds a long trumpet to her mouth with her left hand, and another in her right. Her arm wraps around her colleague, Fortune. Fortune reaches down, her hands filled with the fruits of temporal success. The crowns, baton of command, and gold chains all signal power and worldly recognition. Gold and silver coins rain down from her hand onto the ground, completing the circle of the composition and returning the viewers eyes back to Time.

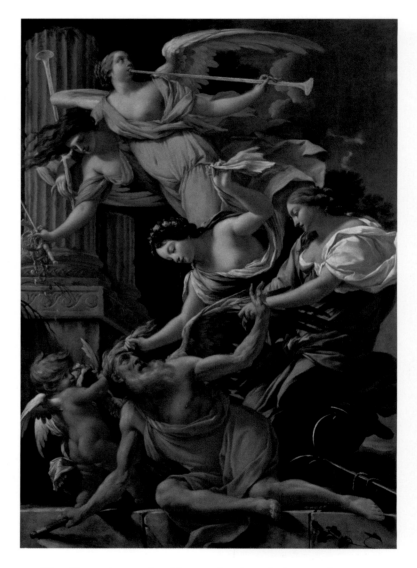

The allegory is completed by two details in the lower right corner. A bit of ivy climbs over the ledge on which Time is kneeling. Just above is a metal anchor, complete with rope. These two details refer to the Christian belief in an eternal life beyond the confines of Time. Ivy, which grows long after its support has died, is a symbol of persistence, and the anchor is commonly found on Christian epitaphs, where it is connected with hope based on a passage from the Bible: "Hope is the anchor for the soul" (Hebrews 6:19). Together, the ivy and the anchor suggest that the conquest of time can be spiritual as well as worldly.

THOUGH IT IS SOMEWHAT FRAYED,
THE TAIL OF HOPE'S WHITE DRAPE
FLUTTERS, ACCENTUATING THE
AIRY TIMELESSNESS OF TIME'S
CONQUERORS. THE FABRIC HAS
ACQUIRED A PINK SHADOW FROM
FAME'S GARMENT, BUT DIFFERENT
FROM THE ROSY HUE OF HOPE'S
DAINTY HAND. VOUET IS HERE
DEMONSTRATING HIS DECORATIVE
TALENT FOR COLOR.

HOPE'S SERENE EXPRESSION
IDENTIFIES HER AS AN
ALLEGORICAL IDEA. HER
GENTLE GAZE ALSO BELIES
THE VIOLENCE WITH WHICH,
ABETTED BY CUPID, SHE
PULLS TIME'S LOCKS. WITH
HER SISTER ALLEGORIES,
HOPE DEFEATS TIME. THE
FLOWERS SHE WEARS ARE
THE PROMISE OF FRUITION.

THIS FIGURE IS BEAUTY,
WHO, IN PLATO'S SYSTEM, IS
IDENTICAL WITH TRUTH—
HENCE HER DIVINE ORIGIN.

CAST DOWN BY ALLEGORIES OF
ETERNAL VERITIES, TIME IS
EARTHBOUND. ON THE STONE
LEDGE BELOW HIM, A CRACK HAS
FORMED, SYMBOL OF TIME'S
DESTRUCTIVE NATURE. WITH HIS
SCYTHE, HE MOWS DOWN THE
LIVING, BUT LIKE NATURE, THE
SOULS WILL BE REBORN.

ACCORDING TO THE CHURCH
FATHERS WHO EXPLORED THE
PASSAGE IN HEBREWS 6:19:
"HOPE IS THE ANCHOR FOR
THE SOUL, CHRIST IS HOPE,
CHRIST IS THE ANCHOR OF
THE SOUL." CHRIST IS THE
ANCHOR OF THE SOUL. IN A
SEAFARING CULTURE LIKE
THE MEDITERRANEAN, THE
ANCHOR WAS A FAMILIAR
SYMBOL OF SAFETY.

EUSTACHE LE SUEUR
(1616–1655)

Fortitude Brings Peace and Plenty

1645

OIL ON CANVAS
93 ¼ X 68 ⅞ IN.
PALAIS ROYALE, PARIS

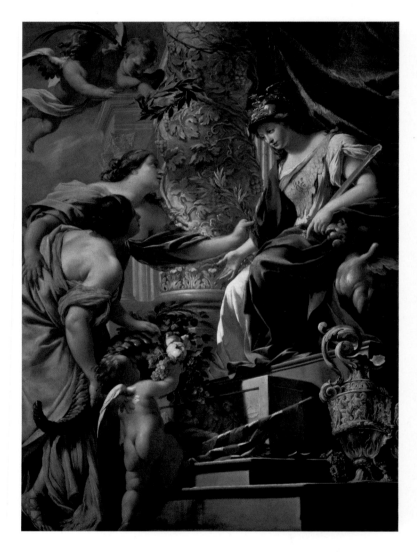

ORTITUDE sits enthroned, framed by a dramatic red curtain and an enormous carved, twisted column. She rests her left arm on a sculpted lion. The setting is classical, but indeterminate; a large Corinthian temple looms in the background, and an altar with a relief sits at her feet. On the left are two figures surrounded by putti. These are Peace (holding the olive branch) and Plenty (with a cornucopia). Two putti above fly down with the palm frond and laurel wreath of victory; it is unclear whether Fortitude, or Peace, is about to be crowned. In the near right corner, next to a pile of trophies, is a collection of elaborate vessels.

The narrative of the painting is direct, conveyed through costumes, gesture, and posture. Fortitude appears as a benevolent queen on her throne. She is dressed in armor, complete with metal helmet and a wrap that serves as a modified breastplate. It contains a representation of the face of Minerva. The magnificent sculpted column behind her is one of Fortitude's attributes; the peculiar twisted shape is known as Solomonic, since such columns are first recorded in the Temple of Solomon in Jerusalem. Later, Solomonic columns became an attribute of imperial power, and were used in both state and church commissions by artists such as Peter Paul Rubens. Fortitude receives Peace and Plenty with an outstretched hand. Peace offers Fortitude the olive branch; Plenty's cornucopia of flowers and fruit is the logical outcome of her wise and prudent rule. In a military sense, Fortitude also is shown as the reigning power. Her helmet is crowned with an eagle, and she grasps a sheathed sword. The trophies at her feet include a flag that may refer to the kingdom of Portugal. The crown of victory suggests that the strength, perseverance, and courage of Fortitude will eventually prevail. And then, of course, the delights of Peace and Plenty can be enjoyed.

The steep perspective and dramatic foreshortening of the forms in this painting make it clear that it was intended to be seen from below. We look up a set of steps, over a sculpted altar, to Fortitude on top of a pedestal; the column and temple stretch away from us, while the steps protrude dramatically outward. The painting was meant to be installed on a ceiling, most likely in the chambers of Anne of Austria, queen of France and princess of Spain and Portugal, in the Palais Royale in Paris. There, it would have been part of a larger decorative ensemble, which probably included the other Cardinal Virtues (Justice, Prudence, Temperance). The ensemble was keyed to the owner, and the noble attributes such as classical architecture, vessels of gold and silver, the

lion, and the sword carried like a scepter emphasized the status of the queen. Fortitude also is a role model, showing the importance of wise leadership on the part of the queen. Since Anne of Austria served as regent for her son, Louis XIV, between 1643 and 1651, the ensemble can also be seen as justifying the rule of a woman over the country, and asserting her readiness, and fitness, to rule. A physical resemblance between Anne and the figure of Fortitude may indicate that Le Sueur wanted the connection between the queen and Fortitude to be absolute.

FEMALE FIGURES OFTEN SERVE AS ALLEGORIES. HERE, THE PAINTER HAS EMPLOYED QUEEN ANNE'S PRETTY FEATURES TO SOFTEN THE MILITARISTIC ATTRIBUTES.

THE OLIVE TREE WAS SACRED TO MINERVA AND SUGGESTS HER WISDOM AND CIVILIZING ENERGIES, HENCE, PEACE, ITS MEANING IN THE JUDAIC AND CHRISTIAN TRADITIONS AS WELL.

MONUMENTAL SCULPTURE, ASSOCIATED WITH PUBLIC ACHIEVEMENT, IS TRADITIONALLY DENIED TO QUEEN CONSORTS. HERE PEACE AND PLENTY ARE RENDERED AS WOMANLY, YET IN AN EPIC STYLE.

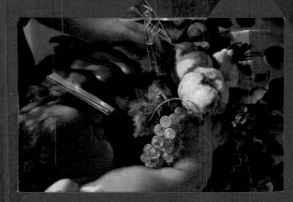

TROPHIES—REPRESENTING THE ACCOUTREMENTS OF WAR—ARE A SYMBOL OF THE PEACE THAT FOLLOWS VICTORY.

A CUPID OFFERS RIPE FRUIT TO FORTITUDE, SYMBOLIZING THE EQUATION BETWEEN PEACE, SEXUALITY, AND FERTILITY.

PETER PAUL RUBENS
(1577–1640)

The Consequences of War

1637–1638

OIL ON CANVAS
6 FT. 9 IN. X 11 FT. 3 ⅞ IN.
PALAZZO PITTI, FLORENCE

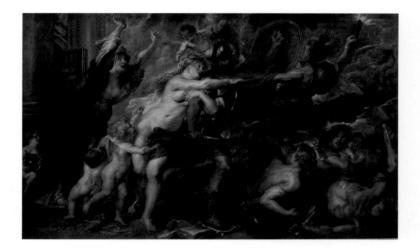

PETER Paul Rubens was the most famous artist of his day. Rich, handsome, well-traveled, erudite, and prodigiously skilled as both an artist and a gentleman, Rubens was respected and admired across Europe. His social gifts may well have been the reason that he was chosen by the Archduchess Isabella as her special diplomatic envoy. Rubens made trips to courts across Europe, from England to Spain, and France to Italy. As the archduchess's representative, Rubens's task was clear: to paint his way into the hearts of these art-mad kings, and negotiate for an end to the Thirty Years' War that was currently devastating his homeland of Flanders. His success at the first was resounding; Rubens received knighthoods from both the king of England and the king of Spain. Though Rubens never lived to see the end of the Thirty Years' War, he dedicated his adult life to the service of art and peace combined.

Rubens painted this work in 1638, while on a diplomatic mission to Italy. It is a visual manifesto of the benefits of peace over the consequences of war. At the left, clothed in black, is the figure of Europe (identified by the putto with a Christian orb at her feet), who throws up her hands in an attitude of sorrow and despair. She is set in front of an imposing edifice, the Temple of Janus of ancient Rome. Traditionally, the Temple of Janus was closed in times of peace; here, the open door indicates that war is at hand. At the center is Mars, armed as an ancient Roman and holding a bloodstained sword and upraised shield. He rushes forth from the stability of the temple into a maelstrom of deepening color and chaotic activity. The conflict surrounding Mars reveals the heart of the allegory.

Though shown in an active, striding pose, Mars looks back over his shoulder at the figure of Venus. In Greek mythology, Mars (the god of war) and Venus (the goddess of love) were the protagonists in a steamy, though adulterous, love affair. (Venus was married to the god of fire, Vulcan.) Although often shown as the incarnation of sensual desire, Venus also represents the pleasures of peace. While Mars was distracted with his lovely mistress, peace could rule the land. Here, Venus's desperate attempt to keep Mars's attention on her is shown through clinging gestures and in the acute twist of her luscious body. It is in vain, however—Mars abandons his love. The results are clear: the caduceus (symbol of commerce and medicine) lies forgotten on the ground. Nearby is a set of arrows (when bound, a symbol of unity) that have been loosed and cast aside, representing discord. With gathering velocity, Mars sets off to the right into the darkening clouds of war. In

his hurry, he tramples on a pile of books and papers, representing learning through the arts and letters.

At the right side the outcome of the unleashing of war is made clear. Dragged along by a Fury, Mars's onward rush knocks over several figures in his path, on whom he will soon trample. The woman with the broken lute is Harmony, while the mother and child pair represents fecundity and charity. In the near right corner, an outstretched man topples over, as if falling out of the painting. The man holds a compass, and can be identified as an architect. Such figures appear more often in allegories of peace than war; here, Rubens's own words provide the meaning. In a letter to a friend describing this painting, Rubens explains the presence of the architect: "that which in time of peace is constructed for the use and ornamentation of the City, is hurled to the ground by force of arms and falls to ruin." Above the supine architect, in the upper right corner, a Harpy (symbol of pestilence) leads the way forth, eager to wreak havoc on the hapless inhabitants of Europe.

Rubens's strong emotions on the subject of war are apparent here, and his letter describing the painting details his frustration at the years of "plunder, outrage, and misery" Europe had suffered. His own long years in fruitless travel and diplomatic pursuit of peace perhaps justify the bleak outlook in this painting. Made for the grand duke of Tuscany, with whom Rubens was negotiating, the painting can be seen as both a visualization of Rubens's political goals, and a heart-felt protest against the horrors of war.

MARS TURNS TOWARD HIS BELOVED, BUT ALL HER STRENGTH IS AS NOTHING COMPARED TO THE IRRESISTIBLE POWER OF THE FURY ALEKTO, WHO PULLS MARS INEXORABLY TOWARD WAR AND DESTRUCTION.

VENUS TRIES TO HOLD BACK HER LOVER, MARS, THE GOD OF WAR. IN HER DESPAIR, SHE IGNORES THE PAIN OF HIS METAL ARMOR AGAINST HER DELICATE FLESH. FOR RUBENS, VENUS REPRESENTED NOT ONLY LOVE, BUT ALL THE BLESSINGS OF PEACE.

IN THE BACKGROUND, AN ARMY RUSHES TO WAR, ITS DIAGONALS EMPHASIZING THE RIGHTWARD SURGE. THE GALLOPING HORSE RESEMBLES A COPY RUBENS MADE FROM A STUDY BY LEONARDO.

RED OVERTONES ON THE WAR GOD'S HAND ECHO THE BLOOD THAT STAINS MORE THAN HALF THE LENGTH OF HIS SWORD. RUBENS CONFORMED TO THE CLASSICAL TRADITION OF ASSIGNING DARK SKIN TO MEN AND FAIR SKIN TO WOMEN.

IN THIS PAINTING, RUBENS COMBINED CLASSICAL MYTHOLOGY AND ALLEGORY. THIS ALLEGORICAL FIGURE HOLDING A BROKEN LUTE SYMBOLIZES HARMONY, WHICH, RUBENS WROTE, "IS INCOMPATIBLE WITH THE DISCORD OF WAR."

Peter Paul Rubens
(1577–1640)

The Consequences of War
1637–1638

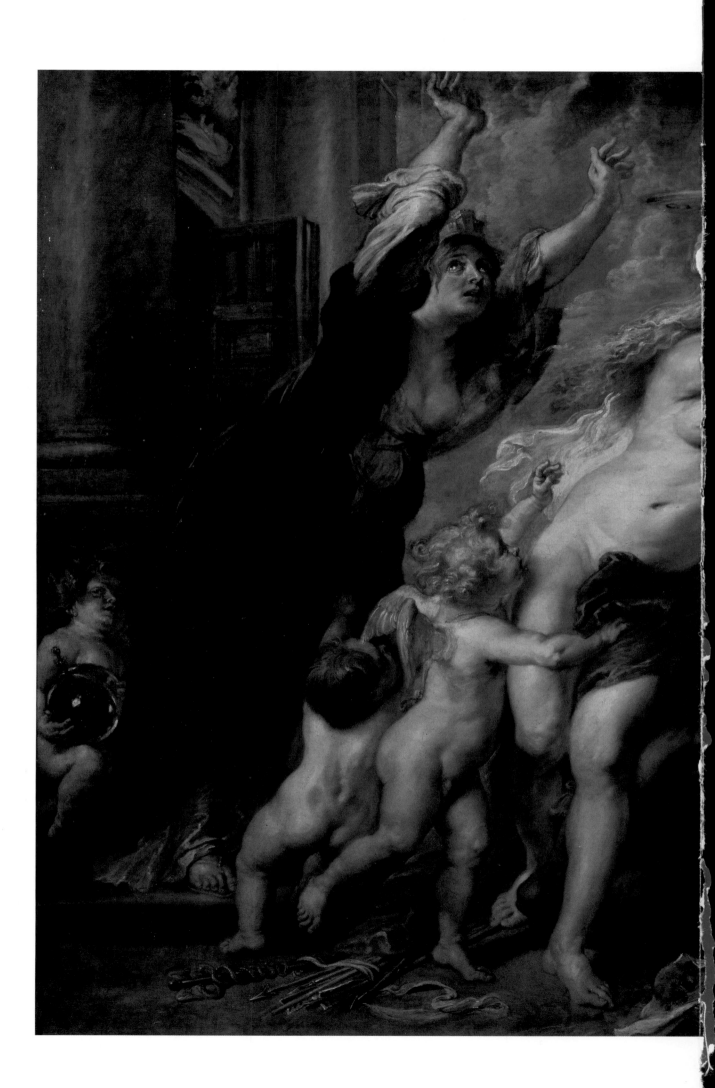

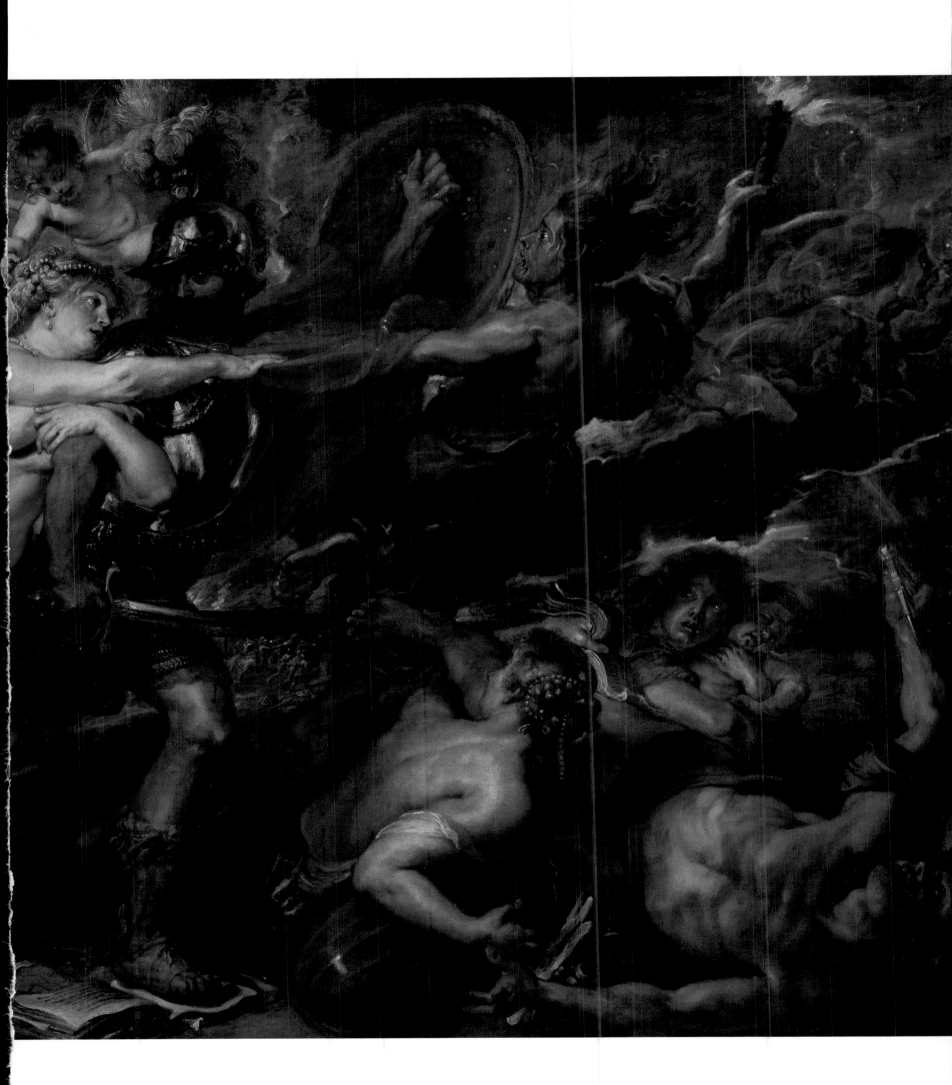

JAN DAVIDSZ. DE HEEM
(1606–1683/84)

Eucharist in Fruit Wreath

1648

OIL ON CANVAS
54 ⅜ X 49 ⅜ IN.
KUNSTHISTORISCHES MUSEUM, VIENNA

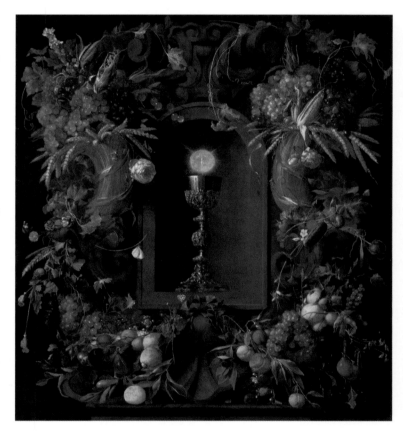

CARDINAL Federico Borromeo, a renowned collector in Milan, described the beauty of flower and fruit still lifes in a text of 1628. He enthused over the variety of colors in the flowers, noting how the painting captures their beauty forever; these flowers will never fade. Furthermore, Borromeo appreciated the abundance and inherent value of the objects represented in these paintings. Such rarity and bounteousness reflected the "wisdom and exquisiteness" as well as the "liberality and generous heart" of Divine Providence, of God. Paintings like this one were seen, thus, as both a skillful capturing of nature, and a means to experience the beauty of God's creation.

Jan Davidsz. de Heem's painting encourages this kind of connection between the visible, tangible world and the spiritual realm. His image shows us a sculpted cartouche, or frame, around a central niche. The cartouche fills the picture plane; only the top of the pedestal it sits on is visible. An elaborate gilt and silver chalice sits in the niche at the center. A Eucharistic wafer imprinted with the image of Christ on the cross floats above the chalice; the wafer glows with a supernatural light. The classical forms of the stone cartouche are decorated all around with bunches, swathes, and festoons of fruit and flowers. In the bright light, against the somber gray stone background, each blossom and fruit appears lush, ripe, and tangible. Three-dimensional effects are emphasized throughout: De Heem features the fruit and flowers from a variety of angles, and entwines the whole in a twisting, turning grapevine. Virtuoso skill is on display on the lower left, where the peaches are painted to show how they protrude over the edge of the pedestal, resting lightly on the viewer's side of the ledge. One leaf, on the right, curls self-consciously out, up, and around, lit by the bright light from left. The two sources of light (spiritual and natural) in the painting are entirely different. They do not compete; rather, they reveal the divine origin of all the beautiful objects so lusciously painted here.

The religious subject of the central niche helps reveal the symbolic nature of the fruits and flowers shown here. Practically, De Heem's festoons and bouquets reproduce the kinds of floral displays that were used at the time as decorations for shrines and altars. On a general level, the painting is religious in that it enhances pious appreciation for the abundance and fertility of the natural world as God's creation. More specifically, De Heem's flowers and fruit often function as symbols of religious beliefs. At either side of the central niche are sheaths of wheat stalks bound with a blue silk ribbon. At the top, the wheat bursts out, along with ears of corn. Wheat was connected with the Eucharist in that it referenced the bread of the Last Supper, consumed with the holy wine. The wine appears not only in the chalice, but in the prominent bunches of grapes at all four corners, and the vine that encircles the composition. Corn was often seen as a symbol of the Resurrection; here, De Heem shows the cobs open, contrasting the dry outer husks with the succulent kernels within. The prominent pink roses on either side of the chalice may be a symbol of the Virgin, or of worldly transience, since beautiful things like roses do not last. Cherries hang down over the front of the niche; these were known as the "fruit of Paradise" and are often held by the Christ child as a signal of Heaven.

Several layers of meaning are possible here, and not every object would have conveyed a religious message. Some may refer to a season, such as fall. Others appear to have been chosen for their rarity and value, referencing the global trade in foodstuffs. De Heem features several different varieties of grapes, for example, from the full, red Spanish grapes in the upper right corner to tart green grapes from eastern Mediterranean regions on the left. The multicolored corncob at upper left may refer to the burgeoning trade with Mexico and the Americas.

Close examination reveals several small insects among the garlands. Caterpillars climb up the vine above the chalice, while a moth and butterfly perch to its left. The transformation of caterpillar to butterfly was an allusion to the resurrection of the body after the Last Judgment. Other insects are less symbolic. A small beetle on the ledge, and the tiny ladybug on the niche, have a trompe l'oeil quality. Such details advertise the painter's mastery of the medium, and signal his ability to fool the viewer (and Mother Nature herself) into believing in the actuality of the objects displayed. Such conceits were based on classical accounts of famous ancient painters such as Zeuxis. It is perhaps no wonder that De Heem's paintings were highly valued in his lifetime, as masterpieces of the painter's art, as delightful celebrations of plenty and abundance, and as deeply meaningful explorations of the relationship of nature to God.

IN A RELIGIOUS CONTEXT, THE
ASSOCIATION OF MAIZE WITH
CATHOLIC MEXICO SIGNIFIED THE
GLOBAL REACH OF THE CHURCH.

THE PROTESTANTS OF THE
REFORMATION DENIED THE
"REAL PRESENCE" OF CHRIST
IN THE CONSECRATED WAFER.
THIS PAINTING AFFIRMS THE
COUNTER-REFORMATION
POSITION, AND THE MEMORY OF
CHRIST'S SACRIFICE IN THE
SACRAMENT OF THE EUCHARIST.

THE RED INSECT ON THE FRAME
OF THE NICHE EMPHASIZES THE
SEPARATION OF THE SACRED,
TIMELESS SPACE INSIDE AND
THE REALM OF TRANSIENCE
SURROUNDING IT.

LATE SUMMER AND FALL
PROVIDE A PROFUSION OF
SUCCULENT FRUITS AND
VEGETABLES. THESE SEASONS
ARE FOLLOWED BY WINTER,
THE SEASON WHEN LIFE GOES
UNDERGROUND BEFORE
SPRING'S RESURRECTION.

TRADITIONALLY, STONE LEDGES
RECALL THE STONE OF TOMBS AND
SO REPRESENT MORTALITY. BY
SIGNING HIS NAME ON THE LEFT
AND DATING THE WORK ON THE
RIGHT, THE ARTIST EXTENDED
HIMSELF AND HIS PAINTING PAST
HIS NATURAL LIFETIME.

DAVID BAILLY

(1584–1657)

Vanitas (Self-Portrait)

1651

OIL ON PANEL
25 ½ x 38 ½ IN.
STEDELIJK MUSEUM DE LAKENHAL, LEIDEN

THE array of splendid objects on the table combined with many layers of portrait images make this more than an ordinary self-portrait or commonplace still life. David Bailly shows off his skill in both areas, but also finds the common ground between these two genres of painting: both seek to preserve a fading and impermanent appearance.

Portraits are generally commemorative attempts to preserve the likeness of an individual for future generations, while still-life painting by its nature does the same, fixing a collection of objects that are otherwise subject to the effects of seasonal change, decay, or an especially fragile existence. The *vanitas* type of still life seeks to make the viewer aware of the impermanence of worldly items and desires in the hope of diverting attention instead to the eternal preservation of the soul. The paper on the lower right is inscribed "VANITAS.VANITUM.ET. OMNIA.VANITAS." (Vanity of Vanities. All is Vanity) along with the artist's signature and the date 1651. The handwriting is exquisite, a skill Bailly probably learned at a young age from his father, who was a calligrapher.

By quite literally spelling it out for us that the love of all things in the world is a futile exercise of pride, Bailly engages us in a test: do we dare to marvel at, appreciate, delight in his skills at rendering textures of bare bone, glittering gold, and reflective glass? We are implicated by simply looking at the collection of objects, all chosen to symbolize fleeting aspects of pleasure and enjoyment: coins, strands of pearls, tumbled glass, pipe, floating bubbles, blooming flower, extinguished candle with wafting smoke, bubbles that could burst at any second, an hourglass, and most prominently, a skull. A soprano-flared bell recorder is also seen on the table. These elements reinforce the idea that the visual arts and music are bound together as transitory pleasures. Certainly art, in the form of the two sculptures and several paintings and drawings hanging above, and knowledge, in the form of the books, are neither exempted nor absolved from association with these other guilty pleasures. Ironically, such paintings tend to celebrate the very pleasures they would have you deny.

Along with the *vanitas* theme of the transience of time, Bailly plays with various levels of illusion and reality. The "live" figure is Bailly as a young urban gentleman, wearing a fancy doublet and flat lace collar formally tied at the neck. He carries his mahlstick in his right hand, a device used by artists to steady their hand while painting by propping it against the side of the painting and resting the wrist upon it. He props up a picture of an older man with similar facial features. If this was all we knew of him, we would suspect the oval painting of the older man to be his father, but Bailly would have us fooled. For in 1651 he was already sixty-seven years old, so the "real" self-portrait is the older man.

Also represented in various forms is his wife, Agneta van Swanenburgh. Her oval portrait is a pendant to his, already cut into its final shape. She appears again, though, in a drawing directly on the plaster wall behind. Ingeniously, Bailly juxtaposed the black chalk drawing with the glass of wine. One of her eyes is framed by the shape of the glass and its reflection, and the shadow of the tall glass cast upon the wall marks the outer edge of her neck and face. Angeta, unlike Bailly, has not suffered the ill effects of time, it would seem from her two images. The theme of life's stages is further accentuated by the sculptural bust representing a small child and the skull. The small sculpture of Saint Sebastian may have been chosen to emphasize perseverance through life's most dire moments; despite being tied to a tree and pierced by arrows, Sebastian survived. The lower drawing unceremoniously pinned to the wall shows a figure with a long beard and monk's habit, while the higher represents a happy-go-lucky musician. These may be Bailly in yet other guises.

A fragile bubble rises, buoyed by the air, and paradoxically endures, preserved by the painter's art.

Candles are frequent metaphors for the mystery of the soul, which burns so brightly, then departs this world with a breath.

Bailly's *Vanitas* proclaims the transitory nature of all things and people while evoking art's ability to extend them beyond their natural span. Light, the most ephemeral of phenomena, is both reflected and absorbed by the glass and the wine within.

Northern European viewers had long prized an artist's ability to render the glints peculiar to metal. Coins by their nature are transient, passing from hand to hand. The metal ball may contain a perfume, perhaps to cover the odor of decay.

These scented blossoms, mainstays of still lifes, are already fading. The pearls, too, so luminous and costly in the present moment, will in time also turn to dust. And by analogy and proximity, so will the blossoming Agneta, the artist's wife, so beautifully rendered in the oval portrait.

Jacob Jordaens
(1593–1678)

The Banquet of the Bean King

Ca. 1655

Oil on canvas
7 ft. 11 ¼ in. x 9 ft. 10 in.
Kunsthistorisches Museum, Vienna

Jacob Jordaens was the best of Peter Paul Rubens's students who remained in Antwerp, but he never reached the grand eloquence of his master's style. In images like this one representing the Feast of the Bean King, Jordaens demonstrated all of his skills with luscious flowing paint, flickering lights, and hearty characters.

This raucous ceremony was enacted each year by families in the Netherlands on the Feast of the Epiphany, January 6. The evening before, citizens would travel from house to house, seeking alms for the poor and singing carols. On the day itself, tradition called for a pie to be prepared with a single bean inside. Whoever got the slice with the bean was named king for the day and allowed certain privileges, not the least of which was the right to call for a round of drinks for all present in the house. While the tradition had been in place for hundreds of years, Jordaens was the first to take up the subject in painting, and he did it several times. He built on a Netherlandish taste for scenes of merry companies, expanding the repertoire of his master Rubens and the heritage of earlier Flemish artists like Pieter Bruegel the Elder. Jordaens's work would become influential on artists like Jan Steen as well, also represented in this book (page 266), as he brought this type of painting to a new level of entertainment with his lively expressions and luscious handling of light and color.

The king, who wears a paper crown and drinks from a pitcher heavily encrusted with a grape motif, probably is a portrait of Jordaens's father-in-law and first teacher, the painter Adam van Noort. The king was allowed to choose the prettiest woman present as his queen, and for that role Jordaens cast his wife, Yelisabeth. She is shown full face with a slight smile, and a golden crown and strand of pearls atop her head. Pinned to her shoulder is a piece of paper designating her assigned office as queen. Other courtiers also have their positions spelled out by scraps of paper, including the tailor above the king and the fool in a cap standing at the rear, wincing and making a broad gesture as he raises his goblet of wine. This may be a fanciful portrait of the artist himself, contrasted somewhat with the long-haired man in the foreground who also lifts a goblet. It is tempting to think that both figures are based on the artist himself, even though they look quite different. Identification had much to do with persona in the seventeenth century, and only secondarily to do with likeness. Wittily and ironically, the sick figure in the lower left who vomits uncomfortably close to a child and a fine arrangement of polished silver is branded as the doctor.

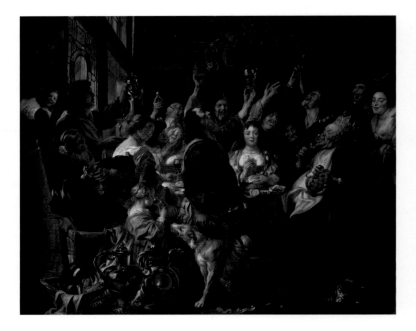

A placard attached to the wall above the scene reads, in Latin to provide a disingenuous gravity, *"Nil similius insano quam ebrius"* or "Nothing is more like a madman than a drunkard." Certainly a painting like this would appeal to citizens who enjoyed such activities, but it could equally have been seen as a negative exemplar of excess and loss of civility.

Jordaens enhanced the tenor of the scene by his crowded, claustrophobic composition, sweeping gestures, and inane facial expressions, executed in a flowing painterly style and soft lighting effects. The mirror hanging on the left wall implausibly reflects a detail of the two young women on the left, the one who turns to the viewer and the one whose chin is grabbed by a man. In certain areas he changed his mind as he painted, reducing the size of the profile face of the central man in blue, for example, and expanding the canvas altogether by adding a strip in the lower section, clearly visible through the dog and the man's leather boot. The happy-go-lucky canine emerges from beneath the stool to beg for wine, while a rather disquieting cat to the right chows on a fish. Left unclaimed on the floor are several job opportunities, including that of the house master. Clearly, this chaotic scene has no one in such a responsible role.

Beneath a sottish theatrical mask of Bacchus, a Latin inscription reads: "No one resembles the insane more than the drunk." The phrase is from the Roman comic playwright Plautus.

Leonardo da Vinci had popularized caricature more than a century before. This masklike physiognomy may be the drunken double of the artist, also depicted as the handsome man in profile at the center of the scene.

The paper identifies the woman in white as the queen of the festivities. She is a still center amid the raucous carrying-on, but the artist's association of her with oysters implies lasciviousness.

Her face less grotesquely distorted than those about her, a young woman invites the—presumably male—to join her in wine and wantonness.

The pie is cut open to reveal the bean. The celebrations may hark back to the Saturnalia, an ancient Roman commemoration following the winter solstice.

The fact that the dog's muzzle is so close to the child's emphasizes the scene's disorder. There is also an ironic visual suggestion that the human beings are more brutish than the animals.

Jacob Jordaens
(1593–1678)

The Banquet of the Bean King
Ca. 1655

DIEGO VELÁZQUEZ
(1599–1660)

The Spinners (The Fable of Arachne)

1657

OIL ON CANVAS
86 ⅝ X 113 ¾ IN.
THE PRADO, MADRID

VELÁZQUEZ's painting illustrates, and elaborates, the story of Arachne from the *Metamorphoses* of Ovid (43 B.C.E.–18 C.E.). Ovid tells the story of Arachne, a gifted but proud young weaver. Arachne even dared to compare her own work to that of the goddess Minerva. Eventually, filled with pride in her work and her powers of invention, Arachne challenged the goddess to a weaving contest. During the event, both contestants wove scenes displaying the power of the gods; however, while Minerva's tapestry showed a weighty and important event (her own contest with Poseidon for the patronage of Athens), Arachne slanderously depicted the gods' amorous adventures (including Jupiter's abduction of the maiden Europa) in lascivious detail. Though Arachne was in fact victorious (even Minerva admitted that her tapestry was equally good), the insult to the dignity of the gods enraged Minerva. She turned Arachne into a spider, punished for her willful and presumptuous pride and doomed to forever weave, but never to make art.

This story can be seen enacted at the rear of Velázquez's painting, through a framed doorway. Lit by a shaft of brilliant light, Arachne stands before her tapestry in her moment of triumph. Minerva, to the left, is recognizable by her armor; she raises her arm in a gesture of recognition, soon to become one of judgment. Arachne is shown as an artist of high stature; she is surrounded by ladies in rich dress, and her studio is embellished by musical instruments and tapestries. These are not mere props: the tapestry Velázquez paints as her masterpiece is a copy of a famous painting by Titian, which was at the time in the collection of the Spanish king. Titian, one of the most admired and respected artists of the Renaissance, was also fond of working to music, and was known to surround himself with gentlemen of high social status.

In the foreground of the painting, five women work at the labor associated with the art of weaving. To the left, an older woman spins while she talks to a companion; another cards wool at the center, and at right a young woman winds thread into a ball while another carries fabric in a basket. A cat waits in the shadows. These are anonymous figures. Their bodies frame the background scene, and their half-hidden faces allow no point of contact. While the role of these lower-class women in the painting has been debated, the emphasis on hard labor in the foreground versus the triumphant display of talent in the background suggests they epitomize the humble craft that makes great art possible.

Velázquez furthers the connection between art and craft by displaying a revolutionary technique in the painting. Throughout, he emphasizes his brushwork by allowing the strokes to remain visible on the canvas, using quick and feathery touches to create the forms of the figures and the rich atmosphere of the space. In a tour de force demonstration of his own virtuoso ability, Velázquez paints the spinning wheel on the left in motion, using the lightest touches of paint to suggest the spokes whirring at high speed. Similarly, the background scene conveys an ethereal quality, the divine light suffusing the scene so fully that the forms themselves become insubstantial. The contrast between the deep colors and shadows of the

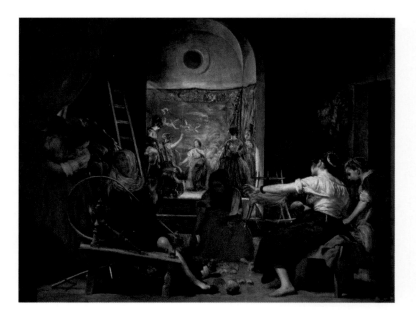

foreground and the brilliant background may be a reference to the two worlds depicted here: the "real" realm of mortal, everyday labor and the divine world of gods—and artists.

Velázquez layers many references to creativity throughout this painting. First, he paints the weavers of this world in a self-conscious display of painterly skill; the curtain being drawn at left highlights the scene as a construction by the artist. Second, Velázquez links the foreground weavers to the background realm through the device of the stairs at the center. As the viewer looks past the weavers, led there by the upraised arms of the craftswomen, he ascends the stairs to join the company of watching gentlewomen. The need to ascend to a divine realm is reiterated by the ladder at left. At the top of the stairs, one of the ladies turns to gaze outward, enhancing the invitation to look. Next, Velázquez recreates a famous scene of creative power by retelling Ovid's story of Arachne. Arachne's masterpiece is then framed as the work of Velázquez's own mentor, Titian. And finally, the image of the Titian painting is actually a re-creation by Velázquez himself. The chain of connections is powerful: Velázquez's work is akin to Titian's, Titian's work is (literally) the masterpiece of Arachne, and Arachne's art equaled that of the gods. The end result is a brilliant, and flamboyant, statement of the divine in art, and in artists.

In his own life and art, Velázquez was committed to raising the status of artists beyond that of lowly craftsmen, as had been traditional in Spanish society. He struggled for many years with the Spanish legal system to gain acknowledgment of his own status, and by extension, that of painters and painting. In his art, Velázquez worked to persuade his royal and aristocratic patrons of the inherent nobility and sublime meaning of the creative act. This late, large work appears to complete that life-long mission, which for the painter was only realized posthumously.

In Velázquez's day, a tapestry could be more costly and prestigious than a painting. A patron's coat-of-arms would be woven into the decorative borders.

Arachne stands beside Titian's design, representing the relation of craft to art. In this way, Velázquez made a distinction between invention and execution.

The woman winding yarn is strongly highlighted. According to one interpretation, she is Minerva, in a moment preceding that of the confrontation taking place in front of Arachne's weaving.

One of the spinners reaches for wool to card. Her hand is on an axis with Arachne, perhaps emphasizing the cusp of craft and art.

JAN STEEN
(1626–1679)

In Luxury, Look Out

1663

OIL ON CANVAS
39 X 57 IN.
KUNSTHISTORISCHES MUSEUM, VIENNA

THE seventeenth-century Dutch artist Jan Steen painted many images of domestic households in uproar. This one is a particularly fine example of how humor, mixed with moralizing symbols and proverbial thinking, can teach a lesson on proper behavior.

A young lady in a fabulous green silk dress is positioned at the center of the composition. Her extravagant costume displays fashionable slit sleeves and yards of fine white linen; the sharply pointed indoor shoes and the very low neckline give her an air of risqué fashion. Steen emphasizes her attractiveness and desirability with the rose tucked into her décolletage. He also makes it clear that she is sexually available, since she sits in close proximity to a man whose leg lies across her parted knees. A common visual metaphor for sex, the motif suggests they have an illicit liaison. Other details, including the very full glass of wine she offers him, which is positioned exactly at his crotch, and her bold outward glance and smile, identify her as a strumpet.

We are, however, in a domestic setting rather than a brothel, and further examination of the figures helps explain the role and meaning of the young girl. Next to her sits a man, probably the master of the house. His clothing is respectable, but he is in such a disheveled state (collar undone, doublet unbuttoned) and his posture is so undignified, that we have to assume he is drunk. He holds a spring of a rose bush, denoting love, in a cavalier gesture. Perhaps the young girl, probably the maid of the household, has been plying him with drink and using her charms to upset the natural order of things. The person who should be in charge is the mistress of the house. She can be seen in her proper fur-trimmed housecoat at left behind the girl, with her foot upon a warmer (a common domestic motif). But the coals in their clay pot are out of the warmer (making it nonfunctional), and the mistress too is absent, wrapped in a deep sleep.

The suspension of authority embedded in that figure allows all the members of the house to run amok. Not only does the master take up with the maid, but on the left we see a toddler in a high chair (wearing a fabric helmet used at the time to prevent head injuries) playing with the family jewels and hurling food upon the floor. A small brown-and-white dog is on the table, helping itself to the half-eaten pie that has been left out. In the back corner a girl steals from an open cupboard, and a small boy smokes a pipe. All throughout the foreground are domestic objects that convey the chaos and dissolution of this household; wine pours from the barrel at left, important legal documents (note the seals hanging out) are left carelessly on the floor, vessels are overturned, pretzels and bread lie on the floor, and the dice and cards refer to gambling. The prominent white pipe lying next to the master's empty black hat is probably a sexual pun. On the cabinet at far right a half-peeled lemon (imported from the Mediterranean, and thus relatively expensive) denotes the waste and transience of the scene. The pig entering at right sniffs at a rose on the floor; this not only shows the breakdown of normal inside/outside boundaries, but acts as a visualization of the proverb "roses before swine." In the far right corner a slate contains the saying "In luxury, look out."

The bad behavior depicted here is engendered by several factors: the suspension of the wife's authority, the influence of drink, and general human folly. The foolishness of man is made clear in the couple at the right side. They are dressed in sober dark clothes, and they discuss a book, but several details indicate they are not as virtuous as they seem. The man is painted with a brutish face and confused expression; he reads, but does not understand. The woman is a classic nag, with her finger upraised as she tells the central man what he should (and should not) be doing. The duck sitting on the shoulder of the man behind probably refers to this opinionated busybody, who has a lot of meaningless words to say; she "quacks like a duck," according to the proverb. A monkey at the top plays with the clock, signifying foolishness and transience. In the face of all this disorder, a man in back (perhaps a self-portrait of the artist) plays the fiddle, egging everyone on.

We are meant to laugh, of course, at such flouting of the rules of proper behavior. The details are based firmly in reality (toddlers throwing food, pets on the table) to allow the viewer to relate to the scene. But the density and proximity of the details highlight the constructed nature of the scene; this is not a picture of an actual household, but a seemingly real assemblage put together to make a point. Steen uses the negative exemplar as his didactic method, and courts our sense of humorous identification with the scene before he makes his final point.

The conclusion of the piece is in the basket hanging above, suspended from outside the painting. The ordinary woven basket contains objects associated with poverty, disease, and sin. We can see a cripple's crutch lying across the basket, in conjunction with a switch (used for punishment of crimes) and a beggar's cup; a leper's rattle hangs from the left side. The consequences of the behavior depicted below are made clear. Unlike the figures in the painting, the viewer sees the signs of waste, sin, and financial ruin throughout—and though we laugh at their folly, we are also meant to learn from their (bad) example.

THE THIEVING SERVANT GIRL
MAY BE THE SWEETHEART OF
THE MUSICIAN WHO LOOKS
APPROVINGLY TOWARD HER
AS HE FIDDLES.

EVEN THE HOUSEHOLD'S PET
DOG IS UNKEMPT, EMBLEM OF
THE DISORDER THAT OCCURS
WHEN THE HOUSEWIFE DOZES.
UNDERNEATH THE CHAOTIC,
GOOD-NATURED HILARITY IS A
PROFOUNDLY PESSIMISTIC
VIEW OF HUMAN NATURE, IN
KEEPING WITH DUTCH
PROTESTANTISM.

THIS FLACCID OBJECT MAY BE AN
EMPTY WATERSKIN, WINESKIN, OR
BAGPIPE, BUT ITS RIBALD SEXUAL
MEANING IS CLEAR. THROUGHOUT
THE PAINTING ARE ELONGATED
OBJECTS AND CONCAVE OBJECTS,
WHOSE CONNOTATIONS ARE JUST
AS EXPLICIT.

MUSICAL INSTRUMENTS
TRADITIONALLY SIGNIFY
CARNAL PASSION. IF THIS IS
A SELF-PORTRAIT POSING AS
A MUSICIAN, THE ARTIST IS
DECLARING HIS OWN
FALLIBLE HUMANITY.

CLASS DISTINCTIONS ARE
REVEALED BY DRESS. UNLIKE
HER DRABLY GARBED COLLEAGUE,
THIS YOUNG MAID FLAUNTS A
GAUDY BUT EXPENSIVE GOWN
AND RUMPLED LINEN SHAWL
COLLAR. HER COSTUME SUGGESTS
THAT SHE IS HER MASTER'S
MISTRESS, RECEIVING HIS
GIFTS FOR HER FAVORS.

NICOLAS POUSSIN

(1594–1665)

The Gathering of Manna

1637–1639

OIL ON CANVAS
58 ⅜ X 78 ¾ IN.
THE LOUVRE, PARIS

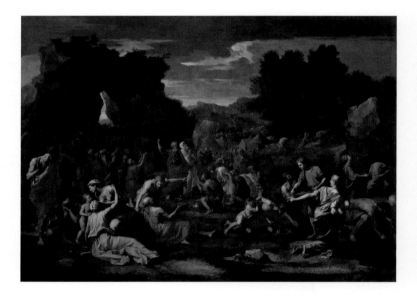

POUSSIN illustrates here the scene from Exodus (16:11–18) when the Israelites are starving in the desert. God causes manna to fall from the sky. In the right foreground we see figures gathering the food into baskets and vessels, and in the center middle ground are Moses and Aaron, giving thanks. Moses, in red and blue, raises his finger to the sky, while a hooded Aaron prays. In the rocky landscape behind, the Israelites are encamped; the difficulty of the terrain (and of their mission to find the promised land) is conveyed through the thick trees and sharp hills that encircle their compound.

There are several departures from the biblical narrative here, however, which provide a unique moralizing message for this well-known story. The choice of a backdrop of hills and woods rather than the biblical desert allowed Poussin to enliven his scene with features like the strange rock arch formation, which derives from ancient Roman prototypes. Although the story is about the privations of the Israelites, and how their hunger is satisfied by God, hardly anyone in this painting eats. Following the narrative from left to right shows instead a focus on charity and good works rather than serving the self.

On the left side are the starving Israelites. The main vignettes are highlighted by shafts of breaking sunlight across the foreground. By contrast, the background groups are more anonymous, and cast into shadow. The main group at left is a modified version of the scene known as "Roman charity"; a woman who offers her breast to an elderly lady (probably her own mother) instead of her child. A man in red stands watching, his arm upraised, conveying both amazement and respect for this act of charity. He serves as an exemplar for the viewer, commanding us to do—and feel—as he does. Behind the scene of charity is an old man who has collapsed on the ground. A youth bends over him, providing hope by pointing across the scene to another young man who rushes forward with a full basket of manna. A young woman with a child directs the youth toward the needy old man. Though distressed, her pose and gesture demonstrate respect for elders and recognition of others' needs over her own. Equally telling is the old man's emotional gesture of outstretched arms, which is a heartfelt indication of thanksgiving. Poussin wrote in a letter that he strove to give the figures the most naturalistic depiction of their emotional states—in this case, astonishment, succor, resolve, and gratitude. Poussin used color not only to mark the progress of the narrative, but also to emphasize the sanctity of his featured vignettes. Combinations of clear primary colors (red and blue) appear throughout the foreground, tying the groups back to the central figure of Moses. The two women who provide examples of charity are dressed in the heavenly colors of blue and yellow.

On the right side of the painting less honorable activities are shown. Two young men fight over the manna, and in the process spill the precious food. The people farthest to the right greedily gather and eat the manna without thought for anyone else. A woman stands with her skirt outstretched, unwilling to do anything but wait for God to shower food upon her. By contrast, the group around Moses and Aaron in the center of the painting perform the appropriate activities: they pray, give thanks, and honor their leaders. Clearly, the divine food that was provided to the Israelites also helped them overcome the most basic human needs in favor of saintly behavior. Poussin shows a chosen people, elected by God because of their true, honest, and essential worth.

For the Christian faithful, the gathering of manna was an Old Testament prefiguring of the institution of the Eucharist. The central liturgical ritual of Christianity, the Eucharist (or Mass) was founded on the example of the Last Supper. The Eucharist also revolved around providing a divinely blessed bread to a large congregation. Eating the bread created community among the faithful, and provided all recipients with a connection to the divine figure. Divinity here is shown not in non-naturalistic falling loaves of bread, but in the rising sun, which suggests a new day, and refers to the Resurrection.

Poussin derived much of his style from Renaissance and classical prototypes, which he admired both for their visual stability and harmony, and for their ability to engage with high moral concepts. Some see this painting as a conscious reference to Raphael's *School of Athens*. However, Poussin strove to find a generic, universal quality in his scenes. The clarity and rigor of the poses and postures convey the moral of this story; specific symbols and details are less relevant. Poussin encouraged the patron of the work, his friend Paul Fréart de Chantelou, to read the painting as a story. In so doing, Chantelou would have recognized the course of the drama and identified with the emotional states depicted in the figures. In the end, the viewer is compelled to learn the lesson as well: that God's grace can (and should) propel humans to a more elevated moral plane.

In the Christian tradition,
Old Testament passages
portended events of the
New Dispensation. The
rock formation resembles
a triumphal arch, perhaps
opening to the promised
land, the redemption won
by Christ's sacrifice. But
the way of salvation is
narrow.

Moses, the man of action,
calls the Israelites'
attention to the source of
their spiritual sustenance
with a gesture recalling
the prophesying John the
Baptist. The priest Aaron
prays. The two may also
represent the active life
and the contemplative life.

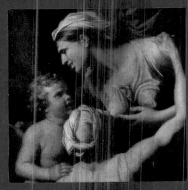

With noble severity, a
woman teaches her son the
lesson of charity. Poussin's
cultivated viewers would
have recognized the source
of the image in the writings
of Valerius Maximus, a first-
century Roman author.

An old man looks up in
pleading inquiry. The
Christ-like figure
provides reassurance and
points towards a youth
who bears a tray of the
holy food, suggesting the
value of the Eucharist to
the dying—a value the
Protestants denied.

Nicolas Poussin
(1594–1665)

The Gathering of Manna
1637–1639

JUAN DE VALDÉS LEAL
(1622–1690)

In Ictu Oculi (In the Twinkling of an Eye)
1670–1672

OIL ON CANVAS
86 ⅝ X 85 IN.
CHURCH OF LA CARIDAD, SEVILLE

THIS painting is in the church of La Caridad in Seville, which was associated with a lay confraternity known as the Brotherhood of Charity. Juan de Valdés Leal was commissioned by the head of the confraternity to participate in a cycle of paintings aimed at illustrating the importance of charity as a means to salvation. Valdés Leal's two paintings, *In Ictu Oculi* (In the Twinkling of an Eye) and *Finis Gloria Mundi* (The End of Worldly Glory), hung immediately inside the church. Both paintings are what are known as *vanitas* paintings. They illustrate the meaninglessness of worldly things, and the vain pursuit of honor and power. Together, the paintings urged the churchgoer to abandon such activities; then, as the visitor progressed into the church, paintings by Valdés Leal's friend and competitor Bartholomé Murillo illustrated the importance of charity and good works to overcome death and achieve salvation.

The painting is dominated by a large standing skeleton representing Death; he holds a coffin, a shroud, and a scythe. As he moves into the painting, Death steps on a large terrestrial globe in the lower right corner, and reaches out to extinguish a tall candle, representing life. The words *"In Ictu Oculi,"* written against the darkness around the candle, make it clear that Death can come at any moment—and the skeleton's aggressive outward stare makes the point chillingly clear.

Objects representing power are strewn about on the stone tomb at the center of the painting. Valdés Leal does not distinguish between ecclesiastical and earthly power: on the left there is a liturgical cross (carried in church processions) leaning at a drunken angle, while a bishop's staff, or crozier (with swirled finial), lies on the tomb. Nearby, a group of hats refer to high church positions: the red flat-brimmed hat is that of a cardinal, the papal crown (embellished with gold) is behind, and a bishop's mitre lies on its side to the right. Several batons of command lie on the table, amid the crowns of king and emperor. Finally, an elaborate jeweled collar with a pendant of a sheep (signifying membership in the prestigious courtly Order of the Golden Fleece) hangs over the edge of the tomb, which is conspicuously crumbling.

On the floor, at the foreground of the painting, are objects associated with learning and martial activity. A pile of books at the left appears to have fallen over; several are open, bent, or crumpled, showing their texts and illustrations. These are weighty tomes, including Pliny's *Natural History*, Sandoval's history of Charles V, and theological works by Suárez and Castro. At center is an open book that contains a prominent engraving. It has been identified as a design by the Flemish artist Peter Paul Rubens for a triumphal entry of Cardinal-Infante Ferdinand into Antwerp. Such structures were erected on a temporary basis to celebrate the visit of a ruler or a recent victory—indeed, Valdés Leal himself had worked on several such projects. The objects piled to the right of the books concern military glory. Here is a set of discarded armor, swords, and plumed helmets, all being trampled by the skeleton above.

This macabre scene is intentionally scary, painted with insistent and relentless detail. The deep black background makes the rich red fabrics and twinkling gold highlights jump out at the viewer. We are meant to see, literally, the futility of the pursuit of earthly honors and learning, and to remember that death conquers all.

SOMBER, NEARLY MATTE BLACK, THE COLOR OF MOURNING, THIS CANDLESTICK SUGGESTS DEATH'S WAITING INEVITABILITY.

THE SCYTHE CARRIES IMPLICATIONS OF SUDDENNESS AND VIOLENCE, APT FOR THE WAVES OF PLAGUE THAT PERIODICALLY SWEPT THROUGH EUROPE. THE AGRICULTURAL ALLUSION, HOWEVER, CARRIES WITHIN IT A PROMISE OF RESURRECTION, JUST AS MOWN CROPS GROW AGAIN.

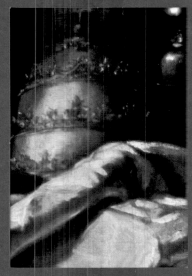

THE SHAPE OF THE PAPAL TIARA SYMBOLIZES A BEEHIVE, AN ANCIENT SYMBOL OF THE CHRISTIAN CHURCH. ADORNED WITH THREE PRECIOUS DIADEMS, SYMBOLIZING THE PONTIFF'S SECULAR MIGHT, IT IS ASSOCIATED ONLY WITH POMP, NEVER WITH THE POPE'S PRIESTLY FUNCTIONS.

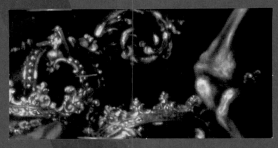

THE GOLDEN CIRCLET ON A SWATH OF REGAL RED FABRIC IS A ROYAL CROWN, THE DOMED PIECE BESIDE IT, AN IMPERIAL ONE. THE GLEAMING PILE STANDS FOR POWER AND WEALTH, BAUBLES AT DEATH'S KNEE.

THIS TRIUMPHAL ARCH WAS DESIGNED BY ONE OF EUROPE'S MOST FAMOUS ARTISTS TO WELCOME THE NEW SPANISH GOVERNOR OF THE SOUTHERN NETHERLANDS. THE TRANSIENT NATURE OF THE STRUCTURE POINTS TO THE PASSING OF ALL: ARCH. ARTIST, GOVERNOR, EVEN SPANISH RULE IN NORTHERN EUROPE.

DEATH TRAMPLES UNDERFOOT THE PRIDE AND VAINGLORY OF WAR, SYMBOLIZED BY THE GILT-HILTED SWORD AND PLUMED HELMET.

DIEGO VELÁZQUEZ

(1599–1660)

Las Meninas

1656–1657

OIL ON CANVAS
10 FT. 5 IN. X 9 FT. 1 IN.
THE PRADO, MADRID

THIS remarkable group scene provides a glimpse into the life of the Spanish royal court, seemingly spontaneous but in actuality full of pomp, circumstance, and coded hierarchy. The painter has positioned himself as blessed by royal favor, at ease with the family of King Philip IV and Queen Mariana. And why not? Velázquez had risen through the court ranks from assistant court painter to chief steward of the king's chamber. This hall in the palace of the Alcázar was adjacent to the quarters given to the painter, and among his duties was care of the king's entire art collection. When Rubens visited Spain in September of 1628, he and Velázquez must have marveled at the fantastic paintings by Titian that Philip had recently acquired from Italy. Velázquez's main activity as court painter was portraiture, and none exceeded his skills in this genre. He is known to have painted at least forty portraits of Philip.

The young Infanta Margarita, born in July 1651, is dressed in dazzling white at the center of the composition. She is attended by her maids, who offer varying degrees of attention. A small boy plays with the mastiff, none too amused by the foot resting on his back. Velázquez and Margarita turn, seemingly spontaneously, to look out of the picture. The mirror on the back wall reveals the object of their attention: the king and queen themselves. Velázquez likely got this idea of the mirror from Jan van Eyck's *Arnolfini Portrait*, which was also in the Spanish royal collection at that time. Are Philip and Mariana the ones being painted on the large canvas, or are they just passing through? The figure at the back door would seem to favor the latter suggestion, as he was the *aposentador*, or palace marshall, to the queen, who precedes the royal pair to open doors and call attention to their arrival. Regardless, they are the ideal viewers for the painting, and every action revolves around them. Such was the patronage of the Spanish court: all endeavors were done in service to, and for the pleasure of, the king. In viewing the painting, he would quite literally see himself reflected in it.

Velázquez's representation of himself in the casual company of the royal family was unprecedented. He had several reasons to do so. At this moment he sought a position of far grander prestige, a knighthood. His request was hotly contested by the nobility because he could not definitely prove nobility in his heritage, and because as a painter he practiced a manual profession. He secured letters of recommendation from highly placed officials in the Vatican whom he had met on a trip to Rome for the jubilee year in 1650, when he painted Pope Innocent X and was presented with a medal and golden chain as a reward. But still he

needed more to convince others of h——— and this scene may have been a testament to his favor within ——— household. Intimacy with the royal family was highly sou——— ——rt, and Velázquez rightly claimed his share. Moreover, the cha——t—— he enormous painting, with its bravura of brushstrokes and —— ——sion of its spatial rendering, proved a demonstration that the art —— p—— g should be seen as more than just a manual craft. He professe— th—— — was never paid for painting, but did it only to serve the k—— ——ntually, in 1659, Velázquez was granted the honor of knighthoo— ——— —— red cross emblazoned on his chest, symbol of the Order of ——— must have been added at that time. The Italian painter Luc— ———o, serving the Spanish court later in the seventeenth centur— ——— to *Las Meninas* as "the theology of painting."

KING PHILIP IV AND QUEEN MARIANA ARE REFLECTED IN THE MIRROR. VELÁZQUEZ BORROWED THIS IDEA FROM JAN VAN EYCK'S ARNOLFINI PORTRAIT, WHICH WAS IN THE SPANISH ROYAL COLLECTION. PHILIP WAS A GREAT COLLECTOR OF OLDER PAINTINGS, AND TODAY HIS COLLECTION FORMS THE FOUNDATION OF THE PRADO MUSEUM. THE POSITION OF THE KING AND QUEEN IN THE MIRROR, TOGETHER WITH THE RESPONSES OF THE FIGURES IN THE PAINTING, SUGGEST THAT THE ROYAL COUPLE HAS JUST ENTERED THE ROOM, FURTHER THAT THEY ARE THE IDEAL AUDIENCE FOR THE PAINTING AND WILL SEE THEMSELVES WHILE VIEWING IT.

THE SILHOUETTED FIGURE STANDS IN THE DOORWAY AT THE END OF THIS LARGE GALLERY IN THE PALACE OF THE ALCÁZAR THAT IS DECORATED WITH PAINTINGS BY PETER PAUL RUBENS. HE PRECEDES THE ROYAL COUPLE AS THEY PASS THROUGH THE PALACE, READY TO ANNOUNCE THEIR PRESENCE.

THE PAINTER WEARS THE SIGN OF THE ORDER OF SANTIAGO, A KNIGHTHOOD THAT HE CAMPAIGNED FOR WHILE MAKING THE PAINTING. THIS WAS A RARE HONOR FOR A PAINTER, AND MANY SPANISH COURTIERS OPPOSED VELÁZQUEZ'S NOMINATION BECAUSE HE DID NOT CLEARLY PROVE ARISTOCRATIC LINEAGE. THE SIGN WAS ALMOST CERTAINLY ADDED A FEW YEARS AFTER THE PAINTING WAS COMPLETED, AFTER HIS KNIGHTHOOD WAS APPROVED.

THE INFANTA MARGARITA, TENDED BY THE MAIDS OF HONOR FOR WHOM THE PAINTING IS NAMED, PEERS OUT TO HER PARENTS, THE INTENDED AUDIENCE FOR THE PAINTING. AT THE TIME SHE WAS THE SOLE HEIR TO THE THRONE. AN OLDER HALF-SISTER HAD BEEN FORCED TO RELINQUISH RIGHT OF SUCCESSION, BUT THE THRONE EVENTUALLY PASSED TO HER BROTHER CARLOS, BORN LATER.

VELÁZQUEZ DEMONSTRATES HIS PAINTERLY TECHNIQUE WITH THE DASHING REFLECTIONS IN THE DRESS OF THE PRINCESS. A FELLOW ARTIST REFERRED TO *Las Meninas* AS "THE THEOLOGY OF PAINTING."

JOHANNES VERMEER

(1632–1675)

The Art of Painting

1665

OIL ON CANVAS
47 ½ x 39 ⅜ IN.
KUNSTHISTORISCHES MUSEUM, VIENNA

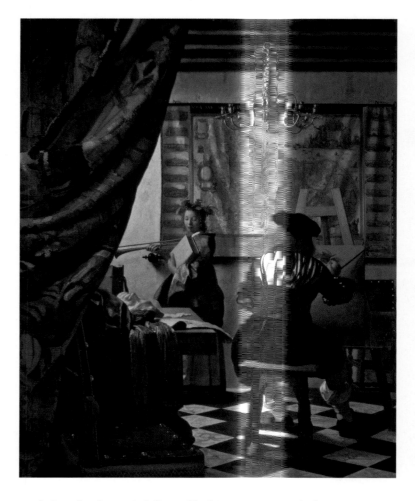

WHEN Vermeer died at the age of forty-three, his wife was burdened by debt and was forced to declare bankruptcy. For most of his career Vermeer enjoyed the patronage of two of Delft's wealthiest citizens, Maria de Knuijt and her husband Pieter Claesz van Ruijven. But when Van Ruijven passed away and the Dutch Republic was caught in the throes of a plummeting economy following an invasion in 1672, the painter was unable to support his large family. His widow tried to hide this precious painting in her mother's house, to keep it from his creditors. This document refers to the painting as "The art of painting," a title that tells us it was always held to be more than a mere studio scene.

A painter, seated on a stool before a large panel resting on an easel, sets his brush to the task of coloring a laurel wreath. In ancient Greece such wreaths were granted as signs of victory or honor, and it is no coincidence that Vermeer has chosen this detail to highlight. The painter's attention turns from his panel to the model who wears the wreath, dressed in a long fabric reminiscent of antiquity and holding several attributes that identify her as Apollo's muse Clio. Her tome records the deeds of men whose fame she trumpets. Clio was the muse who presided over history, and she personified fame and honor. These ideals, Vermeer tells us through his work, are the goals of painting.

The means to attain those goals are also evident. A mastery of illusion is demonstrated by the foreground curtain pulled aside, a reference to the ancient tale of the duel between Zeuxis and Parrhassios. Whereas Zeuxis painted grapes so lifelike that birds tried to eat them, Parrhassios triumphed because he painted a curtain that fooled Zeuxis himself. The recession of space in the room is clearly marked by the marble floor tiles, intrinsically also a sign of wealth and high station of the artist's household. Other furnishings are also well-appointed, including velvet-covered chairs and a brass chandelier. The studious foundations of art are noted by the plaster cast and drawing book on the table. Vermeer mastered like no other the art of depicting natural light streaming into a room. It comes from an unseen window to the left, reflecting in the chandelier and filtering across the map that hangs on the back wall. To render these compositions and lighting effects, Vermeer made use of a *camera obscura*, a forerunner to the photographic camera invented in the nineteenth century. The earlier devices used a lens to reflect images, but they lacked the technology to record them on a plate or film. The phrase *camera obscura* means "dark room," a notion still associated with the development of photographs but originally referring to a room blacked out except for a pinhole or oculus to let in the streaming light. Images seen in this way were inverted, and focus was limited to a singular depth of field with other planes suffering a blurring effect. Vermeer does not mimic that effect in this painting as readily as he had done in others, but nonetheless the accuracy of his rendering of real space is informed by his experience with the instrument. He could not have used it to paint directly, however, one cannot readily paint in the dark. Neither does the insight of his interaction with the *camera obscura* even begin to explain the many conscious decisions that went into composing scenes and representing visual effects by the manipulation of textures, subtle juxtaposition of colors, and his deft painterly touch.

The map on the rear wall was already an antique in Vermeer's day, a unified map of the Netherlands that long before had been split by religious strife. The boundary between the Catholic southern Netherlands, to the left on the map, and the Protestant Northern Netherlands, to the right, is marked by a crease in the paper. Vermeer lived in the North but converted to Catholicism at the time of his marriage. His map may thus have served as a personal statement, to a degree, about his own mediation of the religious discord of his country, but in general it also alluded to the fame that an artist could bring to his homeland.

THE MODEL IS DRESSED AS
CLIO, THE MUSE OF HISTORY
AND PERSONIFICATION OF
HONOR AND FAME. SHE HOLDS
A LARGE HISTORY BOOK
RECORDING GREAT DEEDS OF
MEN, AND A TRUMPET TO
ANNOUNCE THEIR FAME

THIS MAP, CALLED THE "LEO
BELGICUS," WAS ALREADY AN
ANTIQUE, AND SHOWED A UNITED
NETHERLANDS. A CREASE IN THE
MAP REVEALS THE POLITICAL
REALITY OF VERMEER'S DAY, AS IT
SEPARATES THE NORTHERN
NETHERLANDS (TO THE RIGHT)
FROM THE SOUTHERN NETHERLANDS
(TO THE LEFT). THE NORTHERN
PROVINCES HAD REVOLTED AGAINST
THEIR CATHOLIC SPANISH RULERS,
AND COME UNDER PROTESTANT
RULE. VERMEER, HOWEVER,
CONVERTED TO CATHOLICISM
WHEN HE MARRIED.

THE PAINTER BEGINS WITH THE
LAUREL WREATH THAT CLIO
WEARS, AN ANCIENT SYMBOL
OF VICTORY FOR SOLDIERS AND
ATHLETES, OR EXCELLENCE FOR
SCHOLARS AND ARTISTS.

PLASTER MASKS, DRAWINGS,
AND DRAPERIES ALLUDE TO AN
ARTIST'S TRAINING. VERMEER'S
WIDOW, DEEP IN DEBT WHEN
HE DIED, TRIED TO CLAIM THIS
PAINTING—DOCUMENTED AS
"THE ART OF PAINTING"—
BELONGED TO HER MOTHER.

THE TILES IN THE FLOOR SERVE
A DUAL PURPOSE: SYMBOLICALLY
THEY REPRESENT WEALTH AND
ADD GRANDEUR TO THE ROOM;
TECHNICALLY THEY PLOT THE
LINEAR PERSPECTIVE RECEDING
INTO SPACE.

The Secret Language of Myth

ROMAN mythology survived the so-called Dark and Middle Ages and blossomed once more in the arts of the Renaissance. Christian monotheism, however, could not accept the myriad classical gods and goddesses, who became allegories, that is, personifications of qualities. Likewise, certain images taken from classical sculpture were adopted in the Renaissance and given wider metaphorical meanings. One of the most popular, borrowed from relief sculpture and translated into every medium, was the triumph, originally a strictly military ritual, though with its own metaphorical charge. On the reverse of Piero della Francesca's portrait of Federico da Montefeltro (page 56), the triumphal procession became a concise symbolic celebration of personal virtues.

The new fascination with Greek culture, especially Plato, took the form of an idealized culture coherent with Christian notions of perfectibility. Sandro Botticelli's *Birth of Venus* (page 88) combines references to Roman sculpture and literature with Neoplatonic allusions to produce one of the world's most famous pin-ups. The Greek myths often express disturbing truths. Take the case of centaurs, for example, who are half-human, half-horse—the latter an ancient symbol of power. There are two families of centaurs, and the males of one of them are given to violence, especially war and rape. By the time Andrea Mantegna made *Pallas Athena Expelling the Vices* (page 98), these bestial beings were symbols of mere "vice."

Above the busy scene and on either side, Raphael's *School of Athens* (page 126) is dominated by two sculptures in the ancient style. On the viewer's left Apollo holds a lyre; his instrument signifies not only music and the other arts, but celestial harmony. On the right is Athena,

identifiable by her armor, including a breastplate bearing the head of the Gorgon Medusa. Athena is the patron of the arts that make civilization possible, such as weaving. Piero di Cosimo transformed the adulterous passion of Venus and Mars into a scene of postcoital languor, in which the god of war has been unmanned by love (page 130). Venus snuggles her son, Cupid, also known as Amor or Eros. This mischievous love hovers over the central figure in Botticelli's *Primavera* (page 74), asserting Springtime's alternative identification as Venus.

The armor and Gorgon's head on the breastplate identify Bartholomaeus Spranger's striding female hero as Minerva, the Roman version of the Greek goddess Athena; both figures are personifications of wisdom (page 220). In Spranger's interpretation, her bare breasts associate this figure with the female warriors known to classical antiquity, the Amazons. Minerva is featured as well in Peter Paul Rubens's *Education of Marie de' Medici* (page 224). The young Maria, destined to take her place as the queen of France, learns wisdom at the goddess's knee. Apollo, god of the arts, plays a Baroque instrument instead of his lyre, while the Three Graces endow the future regent with feminine attributes. Hermes, god of commerce and thus of prosperity—descends into the scene. His attribute is the caduceus, an ancient symbol of his role as divine messenger.

By placing him before a temple, Jean-Auguste-Dominique Ingres portrayed the great Greek poet Homer in godlike (page 298). A winged being, symbol of inspiration, approaches with a wreath. This scented garland, which historically crowned the victors of poetry competitions, was made from the leaves of the laurel, Apollo's tree.

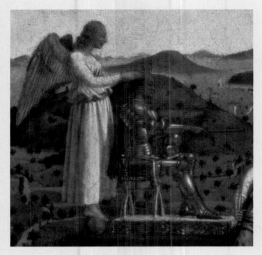

PIERO DELLA FRANCESCA.
The Triumph of Federico da Montefeltro.
The winged figure behind Federico is a
personification of Victory (page 56).

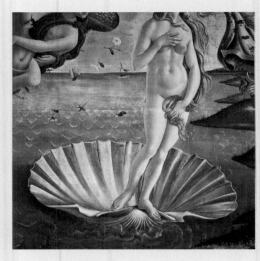

SANDRO BOTTICELLI.
The Birth of Venus.
Both the scallop shell and the sea are symbols
of female sexuality and fecundity (page 88).

ANDREA MANTEGNA.
Pallas Athena Expelling the Vices.
The centaur stands for the "bestial" part of
human nature (page 98).

RAPHAEL.
The School of Athens.
The vanquished Gorgon Medusa, shown on the
shield, represents civilization curbing the
instincts (page 126).

PIERO DI COSIMO.
Mars and Venus.
Mars's broken armor illustrates the power of
love. (page 130)

SANDRO BOTTICELLI.
La Primavera (Spring).
Cupid's flaming arrow conveys the sudden
piercing of ardent passion (page 74).

BARTHOLOMAEUS SPRANGER.
Minerva's Victory over Ignorance.
Sprung armored and full-grown from Jupiter's
head, Minerva was the protector of civilization
(page 220).

PETER PAUL RUBENS.
The Education of Marie de' Medici.
The serpents show that Mercury was once
messenger of Pluto, god of the Underworld
(page 224).

JEAN-AUGUSTE-DOMINIQUE INGRES.
The Apotheosis of Homer.
The laurel recalls Apollo's unrequited desire
for the nymph Daphne (page 298).

Francisco de Goya

(1746–1828)

The Spell

1797–1798

Oil on canvas
17 x 12 ½ in.
Museo Lázaro Galdiano, Madrid

Goya's painting is one of six in his Witchcraft series of 1797–1798. These paintings delved into the world of the occult, describing scenes of witchcraft and satanic ritual for the delectation of an elite audience. The fashion for the macabre was popular among those audiences, who found the horrific and the grotesque to be titillating ways to access the sublime. Goya sold the paintings to the Duke and Duchess of Osuna in 1798.

In *The Spell*, it is the dark of night. The only light is a spooky glow around the central figures; a horned moon shines in the midnight sky but gives off no light. In a sign that a dark gathering is happening, owls (creatures of the night, often associated with death and evil) swoop down from all directions. The connection between these birds and the gathering below is made obvious by the witch who dives down vertically from the sky. She bangs a pair of human thighbones together to signal the beginning of the event. The central witch, a haggard, gray-haired crone in a yellow robe, reaches out to a cowering man in the right corner. He is dressed in a nightshirt, and makes a gesture of supplication. Terrified, the man shrinks away from the gnarled hands and leering mouth of the witch. Like the popular literature of the time, the painting suggests that dark forces are at work in the world, and they might at any moment appear to take one away.

The witches behind perform satanic activities. Goya increases the poignancy of the scene by making those activities inversions of accepted Christian rituals. The figures personify all the popular myths about witches. The bald, toothless witch on the right carries a basket of babies. Witches were often accused of abducting and ritually murdering babies as part of a sacrifice to Satan; as such this demonlike witch is the reverse of the Virgin, who is charged with protecting the young and innocent. To the left a witch holds a spluttering candle (possibly made from human fat), which provides an eerie light for reading from a book of spells. She may be chanting. This is an infernal version of the reading of the Holy Scripture in the standard liturgy. Next, a witch with a hood crowned with horns and bats sticks a long pin into an effigy. Her gleeful grin shows her pleasure in the torture. At far left, an aged, hunched witch makes a gesture with her upraised hand; she appears to be saying the spell, making a satanic version of the blessing gesture used by Christ. Goya conveys the power of the witches' incantations visually in the shadowy black forms that arise from the indistinct landscape and merge into the falling dark.

Similar subjects can be found in contemporary plays, especially in the work of Madrid playwright Antonio de Zamora, which Goya appears to have referenced directly. The effect of the Witchcraft series on the audience remains debated; were these meant to be evocations of a present danger? A satire poking fun at outdated beliefs? For centuries the Catholic church had upheld the existence of witches.

However, in the post-Enlightenment era such superstitions had been largely debunked by the new rational empirical mindset.

Goya occupies an unusual middle ground between these two poles. Goya himself was a skeptic, writing in letters of his utter unbelief in such demons and phantoms. However, in much of his art (especially his prints), he shows his fascination with the superstitions of the lower classes, and respect for their absolute faith in the existence of a satanic world. This painting appears to embody that frisson between sympathy for the power of belief, and scorn for the belief itself. This scene can thus be seen as an emblem of outdated superstitions, a scornful skewering of the follies of those who believe such things. At the same time, it is an imaginative opportunity to participate in those foolish actions. As in some modern films, Goya allows his audience to enjoy a scarily enjoyable fright, but always to know that the horror is nothing more than an invention.

THE PYRAMIDAL STRUCTURE OF THE GROUP RECALLS DEVOTIONAL PICTURES BY LEONARDO AND RAPHAEL. AT THE SAME TIME, IT OPENS UP AND OUT INTO AN ALTERNATIVE UNIVERSE OF EVIL, WHICH POURS DOWN INTO THIS MOMENT.

THE OWL'S SHINING GAZE MAKES THE VIEWER A WITNESS—IF NOT A PARTICIPANT—AT THE PERVERSE CEREMONY THAT IS ABOUT TO TAKE PLACE. IF NATURAL LIGHT REPRESENTS DIVINE GRACE, THEN NIGHT, SYMBOLIZED BY THE OWL, STANDS FOR ITS ABSENCE.

THIS FIGURE PROBABLY REPRESENTS A YOUNG WOMAN, BECAUSE SHE HAS ALL HER TEETH. SHE THUS SYMBOLIZES THE PERPETUATION OF THESE DISMAL RITES.

THE FRIGHTENED, THRASHING INFANTS ARE CONTAINED IN AN ORDINARY, CHEAP BASKET, ACCENTUATING WHAT HAS BEEN CALLED THE BANALITY OF EVIL. WITH THIS DETAIL, THE ARTIST ALSO ASSIGNED SUCH SATANIC PRACTICES TO THE HUMBLE CLASSES.

THE ARTIST LEAVES SOME ELEMENTS TO THE VIEWER'S IMAGINATION, SUCH AS THE CONTENTS OF THE WITCH'S POUCH.

THE INCARNATION WAS A PURELY SPIRITUAL EVENT, BUT ITS SINISTER PARODY IS ABOUT TO TAKE PLACE IN A MORE CARNAL FASHION, TO THE TERROR OF THE HELPLESS YOUNG MAN IN HIS NIGHTGOWN.

EUGÈNE DELACROIX
(1798–1863)

Liberty Leading the People

1830

OIL ON CANVAS
8 FT. 6 ½ IN. X 10 FT. 8 IN.
THE LOUVRE, PARIS

DURING the Romantic period of the nineteenth century, many artists turned to contemporary events and exercised a critical political role through their art. Often the art transcends the particulars of the moment and continues to engage viewers through the course of time, but reconstructing the details can be enlightening. This is true of Delacroix's allegory of *Liberty Leading the People*.

Created just a few months following the tumultuous events of July 1830, in France, the painting employs generic personifications mixed with specific references to this popular uprising against the government of Charles X. Delacroix had made earlier politically oriented paintings, particularly taking up the cause of the Greeks against the Turks, but with *Liberty Leading the People* he brought his dramatic style of painting to bear on the fervent events of his home rather than distant shores and the evocative but long-lost heritage of Greece.

In the rhetoric and in reality, the Revolution of 1830 mirrored the French Revolution of 1789: the poor rebelled against the monarchy, the aristocracy, and the priests. Charles abdicated and was soon replaced by Louis-Philippe, whose reign until another revolt in 1848 was known as the July Monarchy. While Louis-Philippe was called King, he repudiated the doctrine of divine right and derived his power from a constitutional agreement. Largely an urban uprising against dreadful labor conditions and reshuffled jobs that resulted from the industrial revolution, 1830 secured a voice and organization for the working class to air their complaints and effect change thereafter. Wages increased and standard hours were limited, contracts were more actively enforced by the government, prices for bread and wine were lowered, and an influx of foreign and out-of-town workers was halted. Delacroix was influenced by popular documentary illustrations, specifically from the events of July 28, but he focused not only on the poor. His view of the revolution stretched across a broad swath of society.

Liberty thrusts aloft the tricolor banner representing liberty and freedom of the French Revolution, conducting the charge of the insurgency. In her other hand she wields a bayoneted musket, old-fashioned but again reminiscent of the earlier revolution. Her bare chest and feet make it evident that she is an allegorical figure, and she wears a scarlet Phrygian cap symbolic of freed slaves in antiquity. To the right a street urchin blares his pistols. He may have been the inspiration for the character of Gavroche in

Victor Hugo's 1862 novel *Les Miserables*. [...] ft a worker with an open shirt and messenger bag brandishes a [...] ear the center a dandy, wearing a top hat and bowtie, grasps a [...] rary musket. This may have been a self-portrait of Delacroix, [...] y no means poor and did not participate in the uprising, but sym[...]d with the spirit of the revolt. He wrote in a letter to his brother, "I [...] barked on a modern subject—a barricade. And if I haven't [...] my country I'll at least paint for her." At Liberty's feet, another [...] dressed in the colors of France struggles to join the surging ba[...] about are the fallen, including a half-naked man to the left [...] poleonic-era veteran soldier to the right. Many of the fighters in the [...] on of 1830 had served as soldiers under Napoleon but grew dis[...] ring the depression of the 1820s. Through the fog of gunfire and [...] n, a glimpse of the Church of Notre-Dame in Paris can be seen in [...] ound.

The painting was purchased by [...] government, meant to hang in the throne room of the Palai-d [...] mbourg to remind the new king Louis-Philippe of his rise t [...] and its roots in the power of the people, but was deemed too in [...] ry and was removed from public view.

DELACROIX DEPICTED LIBERTY
AS MARIANNE, A SYMBOL OF THE
EARLIER REVOLUTION, AND STILL
TODAY THE PERSONIFICATION OF
FRANCE. THE PAINTER
SUCCESSFULLY MERGED SYMBOL
AND REALISM: LIBERTY'S WHITE
BREASTS MARK HER AS AN
ALLEGORY, BUT HER TANNED
SKIN IS THAT OF A WORKER.

THE ARMED BOY REPRESENTS
THE SPONTANEOUS ENTHUSIASM
OF THE PEOPLE, AND ALSO THE
REVOLUTIONARY FUTURE.

WITHIN AN ALMOST MONOCHROME
WORK, THIS MAN'S BLUE SHIRT
STANDS OUT. DYED WITH
INEXPENSIVE INDIGO, IT IS THE
UNIFORM OF THE LABORER.

HIS TROUSERS ARE WORN HAND-
ME-DOWNS, A REALISTIC DETAIL.

BARE FEET, LIKE BARE
BREASTS, ARE A CLASSICAL
CONVENTION. THEY
IDENTIFY THIS FIGURE
AS TRANSCENDENT—
AN ALLEGORY WITH
OVERTONES OF DIVINITY.

JEAN-AUGUSTE-DOMINIQUE INGRES

(1780–1867)

The Apotheosis of Homer

1827

OIL ON CANVAS
12 FT. 8 IN. X 16 FT. 11 IN.
THE LOUVRE, PARIS

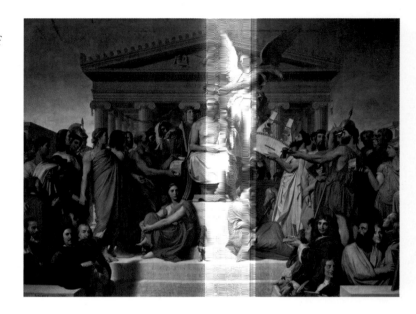

ORIGINALLY commissioned to decorate a ceiling in the Louvre, *The Apotheosis of Homer* is the artist's most complete statement of the classical ideal, the artistic theory that he made his life's work. It is also a visual embodiment of the sources for knowledge, thinking, and art.

The classical allusions in this work operate on several levels. First, the composition refers to the famous painting by Raphael of *The School of Athens* (page 126) Like that work, Ingres's *Apotheosis* uses steps and classical architecture to organize a historical gathering of figures. Second, like Raphael, Ingres invents portraits of writers, thinkers, poets, and artists throughout the ages, and assembles them in groups around the enthroned Homer, who sits on a wooden throne at the apex of the scene, holding his staff. Third, Ingres makes it clear that Homer is being elevated to the ranks of the gods in this artistic apotheosis. A winged victory figure (*nike*) in pink sets a crown of laurels on the poet's head. All the figures demonstrate their allegiance to Homer, and Ingres's agenda here becomes clear: he is asserting the importance of the classical model for all artistic endeavors, in art and in literature, in both ancient and in modern times.

The poets and writers who lived during classical times are set high in the hierarchy, just below Homer. They stand in full length on the top of the steps. Ingres pairs the figures across the scene: directly to the left of Homer is Aeschylus, who holds a scroll containing the names of his tragedies—it refers to the textual tradition of classical literature. Opposite, on the right of Homer, is Pindar, raising a lute to emphasize the importance of the oral basis of sung poetry. Next to Aeschylus is the artist Apelles, court painter to Alexander the Great and the most famous artist of antiquity, dressed in a blue robe and holding brushes. Apelles's counterpart on the right side is Phidias, the renowned sculptor of Athens, in pink on the left; his gesture with outstretched mallets echoes that of Apelles. Interestingly, the only nonclassical figures allowed access to this semidivine realm are escorted by their intellectual mentors: Raphael is being led into the scene by Apelles, and down below, Virgil introduces Dante, in red cloak and with his signature hook nose and jutting chin.

The figures in the middle frieze can be identified, since Ingres based all his portraits on historical examples, such as classical busts. Just left of Phidias, in a helmet, is Pericles, the fifth-century leader of Athens who began the Acropolis rebuilding project. Talking behind him are Socrates (with bald head, blue robe, and argumentative stance) and Plato (facing outward). The warrior Alexander the Great stands at the very right side. Alexander, who studied Homer as a young man, holds a casket containing Homeric manuscripts. On the left side, behind Raphael, are Sappho and Alcibiades. To the right of Apelles, we see Euripides (holding a dagger, a symbol of tragedy), Menander, and Demosthenes. Herodotus adds to the smoking incense burner to the left of Homer.

On the lowest level, shown in half-length, are modern artists and writers—though worthy, they are necessarily far from the elevated ranks of their predecessors. The painter Nicolas Poussin dominates the left group; behind him are Pierre Corneille and possibly Wolfgang Mozart. In the left corner are William Shakespeare and Torquato Tasso. On the right side, the pairing is completed by the dramatist Molière, who holds up a mask, symbol of the playwright's craft, and Jean Racine (in blue behind), who proffers a sheet with titles of his works. These figures make the connection between the admired classical past and the stature of French letters at the time. That connection would certainly have been valued by the French king as a mark of the cultural importance of France.

Seated below the throne are personifications of the texts that were the source of the inspiration pictured here: the *Iliad* is in red at left, with a sheathed sword referencing the battle of Troy. At right is the *Odyssey*, with a broken oar from Odysseus's long and difficult voyage. On the steps between them written in Greek is the following text: "If Homer is a god, let him be revered among the immortals. If again he is not a god, let him be thought to be a god." Clearly, the relationship between this founder of the classical tradition and divinity is not to be questioned.

Ingres's painting is remarkable for its absolute seriousness, both in concept and in execution. As the primary proponent of classicism, and a fervent supporter of the French Academy, Ingres attempted to define in this painting the best in art: what appropriate style was, and what types of subject matter were sufficiently elevated for public display. Though admired when it was first unveiled, Ingres's painting came to be seen by later artists as the epitome of the dry and cold classicism of the Academy. For Ingres, though, the refined, dignified, and serious legacy of the classical contained the inspiration through which the modern world could be transformed. To make the world a better place was, in effect, the purpose of his art.

INGRES DEPICTED THE EPIC POET
IN HIS VIRILE PRIME TO EXPRESS
THE POWER OF HIS VERSE. SEATED
AND BARE-CHESTED, HOMER IS
PORTRAYED AS AN ANCIENT HERO,
OR EVEN ZEUS.

THE ANCIENT GREEK HISTORIAN
AND TRAVELER HERODOTUS
PULLS HIS CLOAK OVER HIS HEAD
IN A PRIESTLY GESTURE BEFORE
A BRASS TRIPOD. THE TRIPOD
SYMBOLIZES APOLLO'S GIFT OF
DIVINATION OR PROPHECY, AN
EMBLEM OF HOMER'S MORE THAN
MORTAL INSIGHT.

ARCHEOLOGY AND ORIENTALISM
INFORM THE SHAPE OF THIS LARGE
LYRE. ITS SIZE SYMBOLIZES THE
GRANDEUR OF HOMER'S ART. THE
BLIND POET, WHO IS LIKEWISE
LARGER THAN LIFE, IS PORTRAYED
IN GODLIKE FRONTALITY.

THIS FIGURE SYMBOLIZES
HOMER'S EPIC *Odyssey*. HER
INWARD GAZE AND PATIENT
POSTURE RECALL ODYSSEUS'S
WIFE, PENELOPE, WHO IN THE
POEM FAITHFULLY AWAITED
HIS RETURN.

THIS FIGURE, REPRESENTING THE
Iliad, IS DRESSED IN A HOT COLOR.
HER DRAPERY IS CARVED IN
ENERGETIC VERTICALS AND
HORIZONTALS, UNLIKE HER
COUNTERPARTS'. SHE IS THE VERY
IMAGE OF THE ENERGY OF WAR.

THE OAR SANDS FOR THE
Odyssey. IN HOMER'S
SEAFARING EPIC IT TOOK
ODYSSEUS TEN YEARS AND
MANY ADVENTURES TO SAIL
HOME TO ITHACA AFTER THE
TROJAN WAR. INGRES, FAMOUS
FOR HIS METICULOUSNESS,
PAINTED NEARLY AS SLOWLY.

HOMER'S *Iliad* RECOUNTS THE
TRAGEDY OF THE TROJAN WAR—
ILIUM IS ANOTHER NAME FOR
TROY. THE RED-RIBBONED DAGGER
STANDS FOR A TIME WHEN BATTLES
WERE FOUGHT HAND-TO-HAND.

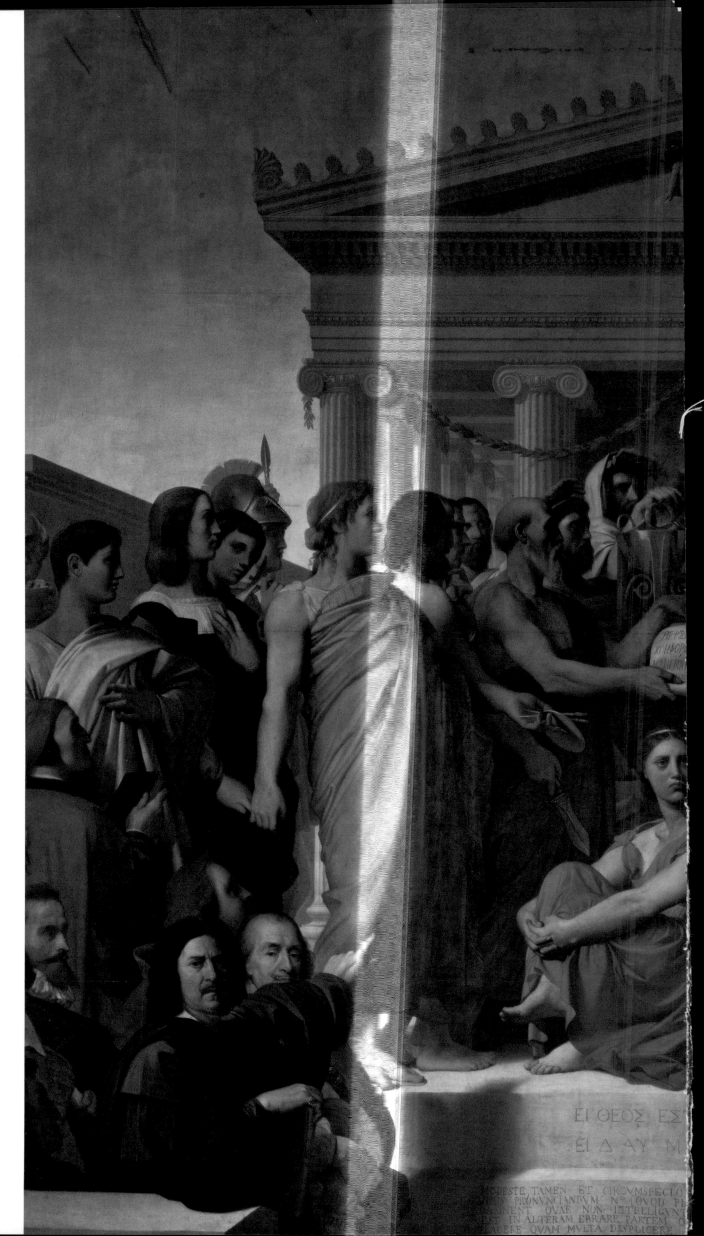

Jean-Auguste-Dominique
Ingres
(1780–1867)

The Apotheosis of Homer
1827

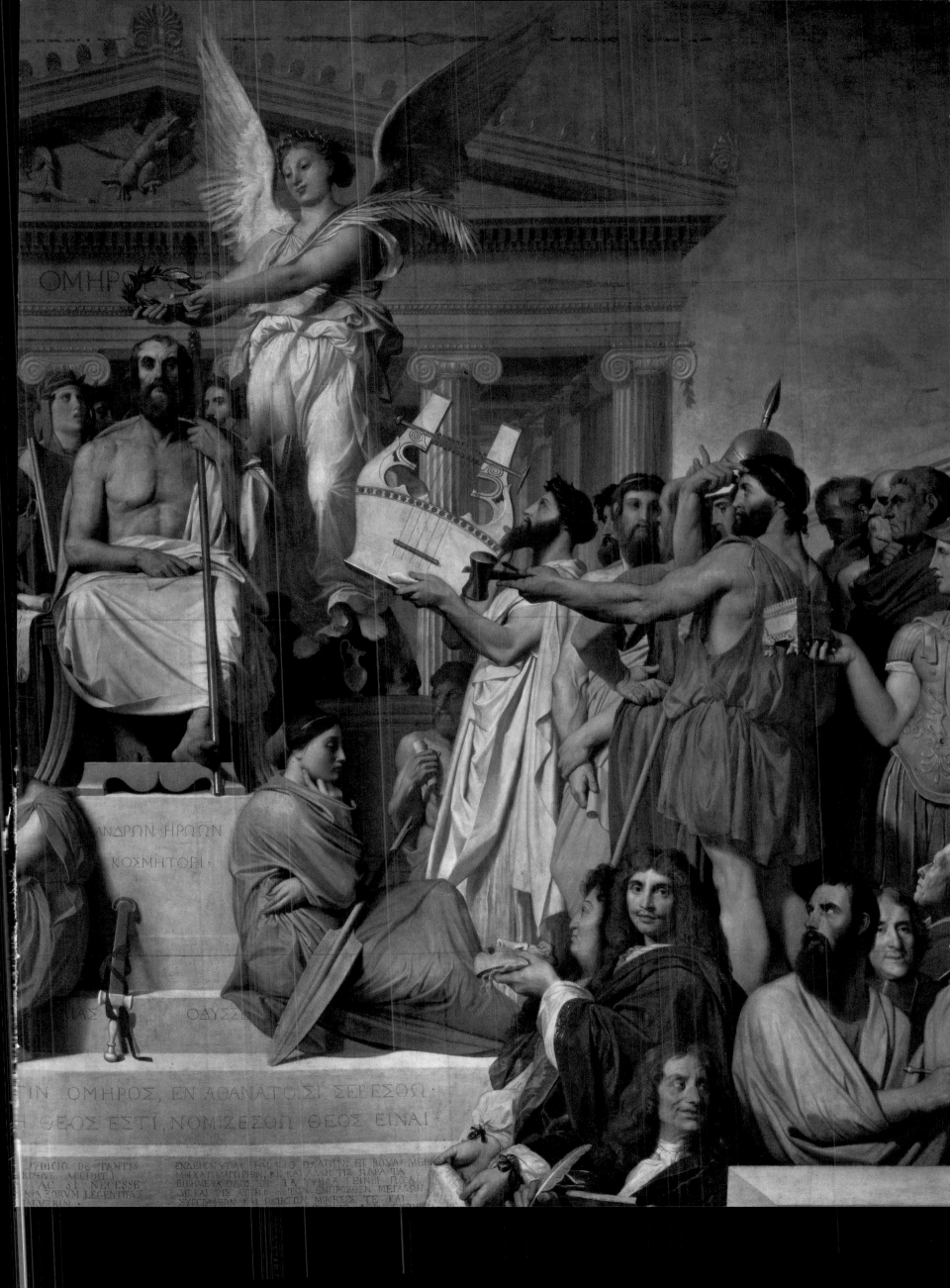

GUSTAVE MOREAU

(1826–1898)

Jupiter and Semele

1894–1895

OIL ON CANVAS
84 X 45 IN.
MUSÉE GUSTAVE MOREAU, PARIS

THE story of Jupiter and Semele is one of the central tales about the Olympian king of the gods. Recounted by Ovid in the *Metamorphoses*, the tale turns on the jealousy of Juno (Jupiter's wife) toward Semele, the latest of Jupiter's love interests. To Juno's fury, Semele, daughter of King Cadmus of Thebes, had become pregnant with Jupiter's child. Juno inflamed Semele's mind with doubt about her lover, and Semele then demanded that Jupiter appear to her in his full divine form. Reluctantly, Jupiter honored her request. He came to her crowned with clouds and whirlwinds and armed with lightning and thunder. Semele's mortal body was unable to withstand Jupiter's divine embrace, and she died. Mercury rescued the unborn baby and sewed the fetus into Jupiter's thigh for the rest of the pregnancy. That boy was the god Bacchus.

Jupiter stands on a magnificent throne inside an architectural setting entirely covered with thick flowers and encrusted with decorative detail. He is at the apex of the scene, backed by a view into the heavens. Light emanates from his head; he holds a lily in his right hand (symbol of purity) and rests his left hand on a lyre, the instrument of poets. For Moreau, the lyre stood for human intelligence, which provided the means to transcend this world. Hindu symbols of the lotus (female principle) and Egyptian symbols of the scarab (divinity) are embedded on Jupiter's breastplate. Indeed, his frontal face, with its wide, staring eyes, derives from the style of ancient Egyptian art. As well, the flowing locks recall images of Christ and the smooth features refer to Apollo. Under his foot is the symbol of eternity, the ouroboros, the snake biting its own tail. Below the throne sits Jupiter's eagle, in front of the lingam (the gold object, in the Hindu religion the symbol of the male principle and used for pouring offerings). This god, then, represents the unity of all things into a single ideal.

Semele falls back on Jupiter, her astonished eyes raised to his face while blood spurts from her side. As she expires, an Eros figure flies away, his face hidden in his hands. Her death invokes a kind of "sacred exorcism" that purifies the scene; hundreds of heads emerge in the architecture in this zone. On either side in this zone are two winged figures worshipping the divine being. Below, the figure of Pan sits just right of center. Half man, half goat, and covered with plants, Pan represents the earthly world. His morose, defeated expression reflects his enslaved position, as a divine figure doomed to life on earth. Flanking him are two female figures who set out the confines of human existence. Death, with a bloodied sword, sits to the left. She has an hourglass on the ground next to her, and two winged creatures bearing the caduceus (symbol of commerce, and of healing) support her. Suffering (on the right) wears a crown of thorns.

On the lowest level, nearest to the viewer, is the realm of Hecate, goddess of the Moon and Erebus, in the zone of Darkness—the antithesis of Apollo. Here are all the terrible things that plague humanity and keep mankind from reaching the ideal. Moreau paints them as vague figures emerging partially from the encompassing darkness, visualizations of nightmares and monsters. Some have been seen as planetary figures, but

Moreau describes them as divine ... of death: "destiny, death, sleep, misery, fraud, age, and discord." Fraud ... at the front and center, with a beautiful face and set of wings. ... below, however, she has the body of a snake. Moreau used many ... of sources, from ancient Roman, Phoenician, and Egyptian myth ... symbols from world religions and witchcraft. This figure appears ... refer to the creature Geryon from Dante's *Inferno*, a classic example of the power of art to invent, and to deceive.

THE ARTIST EVERYWHERE COMBINED SEEMINGLY OPPOSITE QUALITIES, CARRYING OUT HIS SYNCRETISTIC THEME IN EVERY DETAIL. JUPITER IS BOTH FLESH AND DIVINE, DEPICTED FRONTALLY LIKE ANCIENT EGYPTIAN STATUARY. HIS FEATURES ARE ANDROGYNOUS, MALE AND FEMALE. MASSIVELY PRESENT, HE STARES INTO ANOTHER REALITY.

SEMELE, THE ONLY HUMAN FIGURE, IS MORE STYLIZED— LESS "REAL"—THAN ANY OTHER FIGURE IN THE PAINTING. THE BLOOD ON HER SIDE MAY INDICATE THAT HER CHILD, BACCHUS, HAS ALREADY BEEN TAKEN FROM HER.

A SMALL WINGED FIGURE IS ONE OF TWO SIMILAR BUT NOT IDENTICAL ELEMENTS FLANKING JUPITER'S PEDESTAL. THE FOUR CREATURES RESEMBLE GRIFFINS, HYBRID BEINGS LONG ASSOCIATED WITH WESTERN AND CENTRAL ASIA. THE PAINTING'S "EXOTIC" REFERENCES ENDOW IT TO EUROPEAN EYES WITH AN OTHER-WORLDLY FEELING.

DEATH, GARLANDED WITH ROSES AND FACE HALF-HIDDEN, SHOULDERS A BLOODY BLADE. THE PAINTING'S RICHNESS IS PRODUCED IN PART BY MOREAU'S ATTENTION TO TINTS AND SURFACE TEXTURE: THE COLUMN BEHIND THIS FIGURE SUGGESTS THE SHEEN AND DELICATE HUES OF CHINESE PORCELAIN.

THE ALLEGORICAL FIGURE OF SUFFERING IS PORTRAYED AS THE VIRGIN OF THE ANNUNCIATION. HOLDING A LILY, SYMBOL OF HER PURITY, MARY LOOKS SORROWFULLY AWAY FROM THE ANNUNCIATING ANGEL, GABRIEL. ALTHOUGH THE CROWN OF THORNS SHE WEARS IS USUALLY AN INSTRUMENT OF HER SON'S PASSION, HERE, IT MAY BE AN EMBLEM OF HER OWN PRESENT AND FUTURE GRIEF.

Index